The Munich Secession

The Munich Secession

Art and Artists in Turn-of-the-Century Munich

Maria Makela

Princeton University Press, Princeton, New Jersey

Published by Princeton University Press,
41 William Street, Princeton, New Jersey 08540
In the United Kingdom: Princeton University
Press, Oxford

*Library of Congress Cataloging-in-Publication
Data*
Makela, Maria Martha.
The Munich Secession : art and artists in turn-of-
the-century Munich / Maria Makela. p. cm.
Revision of thesis (Ph.D.)—Stanford University,
1987
Includes bibliographical references.
ISBN 0-691-03982-8 (alk. paper)
1. Verein Bildender Künstler Münchens
"Secession." 2. Art, German—Germany
(West)—Munich. 3. Art, Modern—19th cen-
tury—German (West)—Munich. 4. Art,
Modern—20th century—German (West)—
Munich. 5. Artists—Germany (West)—
Munich—Biography. I. Title.
N6867.5.M83M35 1990
709.43′364′09034—dc20 89-36934

This book has been composed in Linotron Century
Schoolbook type

Printed in the United States of America by
Princeton University Press, Princeton, New
Jersey

10 9 8 7 6 5 4 3 2 1

For Neal

Contents

List of Illustrations *ix* Abbreviations *xv* Preface *xvii*

1. The Context: Art and Artists in Nineteenth-Century Munich *3*

 The Making of a Cultural Metropolis *4* The Münchener Künstlergenossenschaft: Populism in a Liberal Era *6* A Golden Age: The Munich Art Community after 1871 *14*

2. The Gennossenschaft "Annuals": 1889–91 *19*

 The First Munich Annual in 1889 *23* The Second Munich Annual in 1890 *36* The Third Munich Annual in 1891 *45*

3. The Founding of the Munich Secession *58*

 The Secession's First Munich Exhibition *67*

4. The Lyric Tradition: The Secession in the 1890s *80*

 Max Liebermann *81* Fritz von Uhde *89* Leopold von Kalckreuth *100* Franz von Stuck *104* Richard Riemerschmid *113* The Lyric Tradition *125*

5. Personalities, Politics, and Poverty: The Secession's Demise after 1900 *133*

 Fritz von Uhde and the Munich Secession: Intolerance Takes Its Toll *134* "Münchens Niedergang als Kunststadt": Cultural Chauvinism and the Secession *137* Money and Misery: The Secession and the Munich Art Market after 1900 *139*

Appendixes *143*

 I. First Announcement of the Founding of the Verein Bildender Künstler Münchens *143* II. Memorandum of the Verein Bildender Künstler Münchens *145* III. Membership Roster of the Verein Bildender Künstler Münchens *151*

Notes *155* Select Bibliography *187* Index *197*

Illustrations

English translations are followed by the original titles in parentheses.

Dimensions have been verified whenever possible but in most cases have been supplied by the owners of the works. They are given in centimeters, height preceding width. A third dimension, depth, is given for furniture, and a fourth, seat height, is cited for chairs.

Collections have been identified in accordance with requests by owners.

Fig. 1. Art and Industry Exhibition Building (Kunst- und Industrieausstellungsgebäude), view from 1910
Photograph (Jaeger & Goergen), 19.8 × 29.2 cm.
Munich, Münchner Stadtmuseum

Fig. 2. Glass Palace (Glaspalast), view from 1931
Photograph (W. Walcher), ca. 18 × 24 cm.
Munich, Münchner Stadtmuseum

Fig. 3. Interior of the Glass Palace, Seventh International Exhibition of 1897
Photograph, 23.6 × 29.5 cm.
Munich, Münchner Stadtmuseum

Fig. 4. Heinrich Zügel, *Shepherdess at the Fence* (*Schäferin am Zaun*), 1889
Oil on canvas, 44 × 56 cm.
Private collection

Fig. 5. Gotthard Kuehl, *View of the St. Jacobikirche in Hamburg* (*Blick in die St. Jacobikirche in Hamburg*), 1890
Pastel on paper, 79 × 61.5 cm.
Hamburg, Hamburger Kunsthalle

Fig. 6. Arnold Böcklin, *Calm at Sea* (*Meeresstille*), 1886–87
Oil on wood, 103 × 150 cm.
Bern, Kunstmuseum

Fig. 7. P. J. Dagnan-Bouveret, *Breton Women at a Pardon* (*Bretonnes au Pardon*), 1887

Oil on canvas, 49 1/4 × 55 1/2 inches
Lisbon, Fundaçao Calouste Gulbenkian

Fig. 8. Edouard Dantan, *Pottery Workshop* (*Töpferwerkstatt*)
Oil on canvas, 130.2 × 97.6 cm.
Munich, Bayerische Staatsgemäldesammlungen

Fig. 9. Fritz von Uhde, *The Playroom* (*Kinderstube*), 1889
Oil on canvas, 110.7 × 138.5 cm.
Hamburg, Hamburger Kunsthalle

Fig. 10. Fritz von Uhde, *Suffer Little Children to Come unto Me* (*Lasset die Kindlein zu mir kommen*), 1884
Oil on canvas, 188 × 290.5 cm.
Leipzig, Museum der Bildenden Künste

Fig. 11. Edouard Grützner, *Cheers* (*Prosit*), 1884
Oil on wood panel, 36.6 × 29.2 cm.
Milwaukee, Milwaukee Art Museum, Gift of the René von Schleinitz Foundation

Fig. 12. Franz von Stuck, *The Guardian of Paradise* (*Der Wächter des Paradieses*), 1889
Oil on canvas, 250 × 167 cm.
Munich, Museum Villa Stuck

Fig. 13. Gabriel Max, *Monkeys as Critics* (*Affen als Kunstrichter*), 1889
Oil on canvas, 84.5 × 107.5 cm.
Munich, Bayerische Staatsgemäldesammlungen

Fig. 14. Max Liebermann, *Jesus in the Temple* (*Jesus im Tempel*), 1879
Oil on canvas, 151 × 131 cm.
Private collection, on loan to the Hamburger Kunsthalle

Fig. 15. Adolf Echtler, *The Accident* (*Gestürzt*)
Oil on canvas, 174 × 230 cm.
Munich, Bayerische Staatsgemäldesammlungen

Fig. 16. Adolf Echtler, *Woman by the Fireplace (Frau am Kaminherd)*
Oil on canvas, 43 × 67 cm.
Munich, Bayerische Staatsgemäldesammlungen

Fig. 17. Fritz von Uhde, *Difficult Path (Schwerer Gang)*, ca. 1890
Oil on canvas, 117 × 126 cm.
Munich, Bayerische Staatsgemäldesammlungen

Fig. 18. Max Liebermann, *The Netmenders (Die Netzflickerinnen)*, 1887–89
Oil on canvas, 180.5 × 226 cm.
Hamburg, Hamburger Kunsthalle

Fig. 19. Franz von Stuck, *Lucifer (Luzifer)*, 1890
Oil on canvas, 161 × 152 cm.
Sofia, Nationale Kunstgalerie

Fig. 20. John Lavery, *The Tennis Party*, 1885
Oil on canvas, 77 × 183.5 cm.
Aberdeen, Aberdeen Art Gallery and Museums

Fig. 21. David Gauld, *St. Agnes*, 1889
Oil on canvas, 61 × 35.5 cm.
Collection Andrew McIntosh Patrick

Fig. 22. George Henry and Edward Hornel, *The Druids*, 1890
Oil on canvas, 152.4 × 152.4 cm.
Glasgow, Art Gallery and Museum

Fig. 23. George Henry, *A Galloway Landscape*, 1889
Oil on canvas, 121.9 × 152.4 cm.
Glasgow, Art Gallery and Museum

Fig. 24. Gustav Schönleber, *Moonlit Night at the Dam Near Besigheim (Mondnacht am Enzwehr bei Besigheim)*, 1890
Oil on canvas, 118.5 × 147 cm.
Karlsruhe, Staatliche Kunsthalle

Fig. 25. Arthur Kampf, *The Lying-in-State of Kaiser Wilhelm I in the Berlin Cathedral (Die Aufbahrung Kaiser Wilhelm I. im Dom zu Berlin)*
Oil on canvas, 114.5 × 159.8 cm.
Munich, Bayerische Staatsgemäldesammlungen

Fig. 26. Erik Werenskiold, *A Country Funeral (En bondebegravelse)*, 1883–85

Oil on canvas, 102.5 × 150.5 cm.
Oslo, Nasjonalgalleriet

Fig. 27. Albert Edelfelt, *Christ and the Magdalene (Kristus ja Mataleena)*, 1890
Oil on canvas, 221 × 154 cm.
Helsinki, Ateneumin Taidemuseo

Fig. 28. Anders Zorn, *The Large Brewery (Stora bryggeriet)*, 1890
Oil on canvas, 68 × 100 cm.
Gothenburg, Göteborgs Konstmuseum

Fig. 29. Anna Ancher, *The Maid in the Kitchen (Piken i kjøkkenet)*, 1883–86
Oil on Canvas, 80 × 67 cm.
Copenhagen, Den Hirschsprungske Samling

Fig. 30. Jules Bastien-Lepage, *Love in the Village (L'Amour au village)*, 1882
Oil on canvas, 194 × 180 cm.
Moscow, Pushkin Museum

Fig. 31. Edouard Manet, *Departure from Boulogne Harbor (Sortie du Port de Boulogne)*, 1864–65
Oil on canvas, 73.6 × 92.6 cm.
Chicago, The Art Institute of Chicago, Potter Palmer Collection

Fig. 32. The Spirit of the Times, or: The Thief in the Studio (Geistesgegenwart, oder: Der Dieb im Atelier), Part I
Fliegende Blätter, 94 (1891)

Fig. 33. The Spirit of the Times, or: The Thief in the Studio (Geistesgegenwart, oder: Der Dieb im Atelier), Part II
Fliegende Blätter, 94 (1891)

Fig. 34. Eilif Petersssen, *Summer Night (Sommernatt)*, 1886
Oil on canvas, 133 × 151 cm.
Olso, Nasjonalgalleriet

Fig. 35. Pierre Puvis de Chavannes, *Game for the Fatherland (Pro Patria Ludus)*, 1883
Oil on canvas, 114 × 197 cm.
Baltimore, Walters Art Gallery

Fig. 36. Hans von Marées, *The Hesperides (Die Hesperiden)*, 1884–87
Oil on wood, 341 × 482 cm.
Munich, Bayerische Staatsgemäldesammlungen

Fig. 37. Max Klinger, *The Blue Hour (Die blaue Stunde)*, 1890
Oil on canvas, 191.5 × 176 cm.
Leipzig, Museum der Bildenden Künste

Fig. 38. Secession Gallery, view from 1893
Photograph, 18 × 24 cm.
Munich, Architektursammlung der Technischen Universität München

Fig. 39. Max von Schmädel, *His Everything (Sein Alles)*
Oil on canvas, 78.5 × 95.5 cm.
Kaisersläutern, Pfalzgalerie

Fig. 40. Jacob Maris, *Allotments Near the Hague (Slatuintjes bij den Haag)*
Oil on canvas, 62.5 × 54 cm.
The Hague, Haags Gemeentemuseum

Fig. 41. Willem Maris, *Drinking Cow (Drinkende Koe)*
Oil on canvas, 50 × 80 cm.
Private collection, on loan to Noordbrabants Museum, 's-Hertogenbosch

Fig. 42. Eilif Peterssen, *Mother Utne (Mor Utne)*, 1888
Oil on canvas, 85 × 110.5 cm.
Oslo, Nasjonalgalleriet

Fig. 43. George Clausen, *Haying*, 1882
Oil on canvas, 68.6 × 57.8 cm.
Toronto, Art Gallery of Ontario

Fig. 44. Wilhelm Trübner, *Landscape Near Cloister Seeon, with Telegraph Pole (Landschaft bei Kloster Seeon, mit Telegraphenstange)*, 1891
Oil on canvas, 62 × 77 cm.
Karlsruhe, Staatliche Kunsthalle

Fig. 45. Max Liebermann, *Mayor Carl Friedrich Petersen (Bürgermeister Carl Friedrich Petersen)*, 1891
Oil on canvas, 206 × 119 cm.
Hamburg, Hamburger Kunsthalle

Fig. 46. Charles Cottet, *Evening Light: The Port of Camaret (Rayon du soir: Port de Camaret)*, 1892
Oil on canvas, 72 × 110 cm.
Paris, Musée d'Orsay

Fig. 47. Peder Severin Kroyer, *Summer Evening on the South Beach at Skagen (Sommeraften på Skagens sønderstrand)*, 1893

Oil on canvas, 100 × 150 cm.
Skagen, Skagens Museum

Fig. 48. Otto Eckmann, *Spring (Frühling)*
Oil on canvas, 60 × 42 cm.
Hamburg, Hamburger Kunsthalle

Fig. 49. Franz von Stuck, *Sin (Die Sünde)*, 1893
Oil on canvas, 95 × 60 cm.
Munich, Bayerische Staatsgemäldesammlungen

Fig. 50. Carl Strathmann, *Victor (Sieger)*, ca. 1893
Ink and watercolor on paper, 66.5 × 88 cm.
Munich, Städtische Galerie im Lenbachhaus

Fig. 51. Carlos Schwabe, *Angélique on Her Deathbed (Angélique évanouie)*, 1892
Watercolor on paper, 30 × 22 cm.
Geneva, Musée d'Art et d'Histoire

Fig. 52. Gerhard Munthe, *The Suitors (Friere [Nordlysdotrene])*, 1892
Watercolor on paper, 77.3 × 94.2 cm.
Oslo, Nasjonalgalleriet

Fig. 53. Gerhard Munthe, *Horse of Hades (Helhesten)*, 1892
Watercolor on paper, 79 × 112.5 cm.
Oslo, Nasjonalgalleriet

Fig. 54. Max Liebermann, *The Goosepluckers (Die Gänserupferinnen)*, 1871–72
Oil on canvas, 119.5 × 170.5 cm.
Berlin, Hauptstadt der DDR, Nationalgalerie

Fig. 55. Max Liebermann, *Recess at the Amsterdam Orphanage (Freistunde in Amsterdamer Waisenhaus)*, 1881–82
Oil on canvas, 78.5 × 107.5 cm.
Frankfurt am Main, Städelsches Kunstinstitut

Fig. 56. Max Liebermann, *Garden of the Retirement Home for Men in Amsterdam (Garten am Altmännerhaus in Amsterdam)*, 1880
Oil on wood, 55.3 × 75.2 cm.
Schweinfurt, Sammlung Georg Schäfer

Fig. 57. Max Liebermann, *Woman with Goats in the Dunes (Frau mit Ziegen in den Dünen)*, 1890
Oil on canvas, 127 × 172 cm.

Munich, Bayerische Staatsgemälde-
sammlungen

Fig. 58. Max Liebermann, *Parrot Way
(Papageienallee)*, 1902
Oil on canvas, 88.1 × 72.5 cm.
Bremen, Kunsthalle Bremen

Fig. 59. Max Liebermann, *The Beer Garden
"Oude Vinck" (Biergarten "Oude Vinck")*,
1905
Oil on canvas, 71 × 88 cm.
Zürich, Kunsthaus Zürich

Fig. 60. Adolf Hölzel, *Devotions at Home
(Hausandacht)*, 1890–91
Oil on canvas, 40 × 32 cm.
Munich, Bayerische Staatsgemälde-
sammlungen

Fig. 61. Wilhelm Trübner, *Prince Regent
Luitpold of Bavaria (Prinzregent Luitpold
von Bayern)*
Oil on canvas, 70.4 × 50 cm.
Private collection

Fig. 62. Fritz von Uhde, *The Singer (La
Chanteuse)*, 1880
Oil on canvas, 135 × 199 cm.
Munich, Bayerische Staatsgemälde-
sammlungen

Fig. 63. Fritz von Uhde, *The Big Sister
(Die grosse Schwester)*, 1885
Oil on cardboard, 48.5 × 33 cm.
Munich, Städtische Galerie im Lenbach-
haus

Fig. 64. Fritz von Uhde, *The Gleaners (Die
Ährenleser)*, 1889
Oil on canvas, 61 × 74.5 cm.
Munich, Bayerische Staatsgemälde-
sammlungen

Fig. 65. Max Liebermann, *The Potato
Harvest (Die Kartoffelernte)*, 1875
Oil on canvas, 108.5 × 172 cm.
Düsseldorf, Kunstmuseum Düsseldorf

Fig. 66. Fritz von Uhde, *Grace (Tischgebet)*,
1885
Oil on canvas, 115 × 155 cm.
Berlin (West), Staatliche Museen Preu-
ssischer Kulturbesitz, Nationalgalerie
Berlin

Fig. 67. Adolf Hölzel, *Birches in the Moor
(Birken im Moos)*, 1902

Oil on canvas, 39 × 49 cm.
Mainz, Mittelrheinisches Landesmuseum

Fig. 68. Adolf Hölzel, *Black Ornaments on
Brown Ground (Schwarze Ornamente auf
braunem Grund)*, ca. 1898
Ink on paper, 32.6 × 20.9 cm.
Stuttgart, Galerie der Stadt

Fig. 69. Ludwig Dill, *Poplar Forest (Pappel-
wald)*, ca. 1900
Oil on cardboard, 93 × 73 cm.
Munich, Bayerische Staatsgemälde-
sammlungen

Fig. 70. Fritz von Uhde, *Near the Veranda
Door (An der Verandatür)*
Oil on canvas, 64.5 × 54 cm.
Munich, Bayerische Staatsgemälde-
sammlungen

Fig. 71. Fritz von Uhde, *In the Autumn
Sun (In der Herbstsonne)*
Oil on canvas, 70 × 91 cm.
Munich, Bayerische Staatsgemälde-
sammlungen

Fig. 72. Gotthard Kuehl, *Sunday Afternoon
in Holland (Sonntagnachmittag in
Holland)*
Oil on canvas, 82 × 61 cm.
Munich, Bayerische Staatsgemälde-
sammlungen

Fig. 73. Leopold von Kalckreuth, *The Days
of Our Years Are Threescore Years and
Ten (Des Menschen Leben währet sieben-
zig Jahre)*, 1898
Oil on canvas, 163 × 296 cm.
Munich, Bayerische Staatsgemälde-
sammlungen

Fig. 74. Leopold von Kalckreuth, *Summer
(Sommer)*, 1890
Oil on canvas, 356 × 294 cm.
Bremen, Kunsthalle

Fig. 75. Leopold von Kalckreuth, *On Sun-
day Afternoon (Am Sonntagnachmittag)*,
1893
Oil on canvas, 53.5 × 85 cm.
Hamburg, Hamburger Kunsthalle

Fig. 76. Leopold von Kalckreuth, *The Rain-
bow (Der Regenbogen)*, 1896
Oil on canvas, 70 × 100 cm.
Munich, Bayerische Staatsgemälde-
sammlungen

Fig. 77. Leopold von Kalckreuth, *Storm Clouds (Gewitterwolken)*, 1899
Oil on canvas, 180 × 200 cm.
Karlsruhe, Staatliche Kunsthalle

Fig. 78. Karl Haider, *Haushamer Spring Landscape (Haushamer Frühlingslandschaft)*, 1896
Oil on wood, 95.5 × 127 cm.
Munich, Bayerische Staatsgemäldesammlungen

Fig. 79. Walter Leistikow, *Schlachtensee (Am Schlachtensee)*
Oil on canvas, 73 × 93 cm.
Berlin, Berlin Museum

Fig. 80. Franz von Stuck, *The Hunt (Die Jagd)*, 1883
Zincograph, 19.8 × 27.9 cm.
Munich, Zentralinstitut für Kunstgeschichte

Fig. 81. Franz von Stuck, *Innocence (Innocentia)*, 1889
Oil on canvas, 68 × 61 cm.
Present location unknown

Fig. 82. Bruno Piglhein, *The Blind Woman (Die Blinde)*, 1889
Oil on canvas, 93.5 × 140 cm.
Kassel, Staatliche Kunstsammlungen, Leihgabe der Bundesrepublik Deutschland

Fig. 83. Arthur Langhammer, *Peasant Girls from Dachau (Dachauer Bauermädchen)*, ca. 1900
Oil on canvas, 100.5 × 81 cm.
Munich, Städtische Galerie im Lenbachhaus

Fig. 84. Franz von Stuck, Poster for the First Secession Salon of 1893
Lithograph (Wolf & Sohn, Munich), 99 × 70 cm.
Munich, Münchner Stadtmuseum

Fig. 85. Franz von Stuck, Poster for the Seventh International Exhibition of 1897
Relief print (Meisenbach Riffarth & Co., Munich), 72 × 100 cm.
Munich, Münchner Stadtmuseum

Fig. 86. Franz von Stuck, *Pallas Athena (Pallas Athene)*, 1898

Oil on wood, 77 × 69.5 cm.
Schweinfurt, Sammlung Georg Schäfer

Fig. 87. Franz von Stuck, *Riding Amazon (Reitende Amazone)*, 1897
Bronze (cast after 1906), 67 × 33.5 cm. (with base)
Munich, Museum Villa Stuck

Fig. 88. Richard Riemerschmid, *In the Open (In freier Natur)*, 1895
Oil on canvas, 87 × 63 cm.
Munich, Städtische Galerie im Lenbachhaus

Fig. 89. Richard Riemerschmid, *In Arcadia (In Arkadien)*, 1897
Oil on canvas, 100.5 × 140.5 cm.
Munich, Städtische Galerie im Lenbachhaus

Fig. 90. Richard Riemerschmid, Title page to *Jugend*, 19 June 1897
Color lithograph, 28.2 × 21.2 cm.
Munich, Städtische Galerie im Lenbachhaus

Fig. 91. Richard Riemerschmid, *"And the Lord God Planted a Garden in Eden." Genesis 2:8 ("Und Gott der Herr pflanzte einen Garten in Eden." I Mos. 2:8)*, 1900
Oil on canvas, 160 × 164 cm. (with frame)
London, K. Barlow Ltd.

Fig. 92. Richard Riemerschmid, Study for *"And the Lord God Planted a Garden in Eden." Genesis 2:8 (Vorstudie, "Und Gott der Herr pflanzte einen Garten in Eden." I Mos. 2:8)*, 1896
Pencil, ink, and ink-brush on paper, 24 × 30.2 cm.
Munich, Städtische Galerie im Lenbachhaus

Fig. 93. Ludwig von Hofmann, *Spring Dance (Frühlingsreigen)*
Oil on canvas, 63.6 × 76.2 cm.
Bremen, Kunsthalle

Fig. 94. Hans Olde, *Grand Duchess Caroline von Sachsen-Weimar (Grossherzogin Caroline von Sachsen-Weimar)*, ca. 1903
Oil on canvas, 198 × 134 cm.
Munich, Städtische Galerie im Lenbachhaus

Fig. 95. Hans Olde, *Sleigh Ride (Schlittenfahrt)*, ca. 1893

Oil on canvas, 74 × 97 cm.
Munich, Städtische Galerie im Lenbach-
haus

Fig. 96. Richard Riemerschmid, Buffet,
1897
Executant Wenzel Till, Munich
Yew, iron metalwork, doors of American
maple, H 176 cm., W 113 cm., D 50 cm.
London, K. Barlow Ltd.

Fig. 97. Richard Riemerschmid, Table and
Two Armchairs, 1898
Executant Vereinigte Werkstätten für
Kunst im Handwerk, Munich
Cherry wood
Table: H 76 cm., W 82 cm., D 82 cm.
Chairs: H 78.5 cm., W 48.5 cm., D 53 cm.,
Sh 44 cm.
London, K. Barlow Ltd.

Fig. 98. Richard Riemerschmid, Music
Room at the Deutsche Kunst-Ausstellung,
Dresden, 1899

Fig. 99. Richard Riemerschmid, Music
Room Chair, 1898–99
Executant Vereinigte Werkstätten für
Kunst im Handwerk, Munich
Bog oak with leather upholstery, H 78.5
cm., W 49 cm., D 48 cm., Sh 45 cm.
London, K. Barlow Ltd.

Fig. 100. Richard Riemerschmid, Door to
the Room of an Art Lover (Zimmer eines
Kunstfreundes) at the Paris World's Fair,
1900

Fig. 101. Henry van de Velde, Study
(Herren-Arbeits-Zimmer) at the 1899
Secession Salon

Fig. 102. Fritz Erler, Parlor (Empfangs-
Zimmer) at the 1899 Secession Salon

Fig. 103. Akseli Gallen-Kallela, *Defense of
the Sampo* (*Sammon puolustus*), 1896
Tempera on canvas, 122 × 125 cm.

Turku, Turun Taidemuseo/Åbo, Åbo
Konstmuseum

Fig. 104. Wassily Kandinsky, *Study for
Composition II* (*Skizze für Komposition
II*), 1909–10
Oil on canvas, 97.5 × 131.2 cm.
New York, Collection The Solomon R.
Guggenheim Museum

Fig. 105. Franz Marc, *White Bull* (*Stier*),
1911
Oil on canvas, 100 × 135.3 cm.
New York, Collection The Solomon R.
Guggenheim Museum

Fig. 106. Paul Klee, *Screen with Aare River
Landscape Scenes* (*Wandschirm mit Aare-
landschaften*), 1900
Oil on canvas, each panel 144 × 48 cm.
Collection Felix Klee

Fig. 107. Hermann Obrist, *Whiplash*
(*Peitschenhieb*), ca. 1895
Executant Berthe Ruchet
Gold silk embroidery on gray wool, 119.4 ×
183.5 cm.
Munich, Münchner Stadtmuseum

Photo Credits

Photographs reproduced in this volume
have been provided in most cases by the
owner or custodians of the works, as indi-
cated in the List of Illustrations. The follow-
ing list applies to photographs for which a
separate acknowledgment is due.

Maurice Aeschimann: 51; Jörg P. Anders:
66; Courtesy of the Art Institute of Chicago:
31; Hans-Joachim Bartsch, Berlin: 79; P.
Richard Eells Photography: 11; Ralph
Kleinhempel: 5, 9, 14, 18, 45, 48, 75; Jac-
ques Lathion: 26, 34, 43, 52, 53; Robert E.
Mates: 104, 105; Hans Petersen: 29; Carole
Tormollan, Chicago: 32, 33, 98, 100, 101,
102

Abbreviations

AZ	*Allgemeine Zeitung*
BayHStA	Bayerisches Hauptstaatsarchiv
BSB	Bayerische Staatsbibliothek
BSBHSmlg	Bayerische Staatsbibliothek, Handschriften Sammlung
MNN	*Münchener Neueste Nachrichten*
SAM	Stadtarchiv München
VdKdAbg	*Stenographische Berichte über die Verhandlungen der bayersichen Kammer der Abgeordneten*
VdKdRr	*Stenographische Berichte über die Verhandlungen der bayerischen Kammer der Reichsräthe*

Preface

Cultural myths die hard, and one of the most enduring in the history of nineteenth- and twentieth-century art has been that of the alienated vanguard artist, misunderstood and maltreated by powerful art reactionaries fearful of innovation. First as a student and then in maturity, the progressive painter or sculptor of this oft-told tale is repeatedly barred from exhibitions and, thus cut off from a potential clientele, forced either into obscurity and poverty or into a radical renunciation of the established system. There is indeed a great deal of fact in this fiction, and the history of modern art is replete with examples of frustrated artists. In the early nineteenth century the Nazarenes felt so repressed in the academy in Vienna that they left Austria for Rome, where they set up their own insular artist's colony. Later Courbet, whose *Painter's Studio* and *Burial at Ornans* were rejected by the jury of the 1855 Universal Exposition, constructed his own "Pavilion of Realism" where he held a one-man show in competition with the official exhibition. Likewise, Manet, angered at the exclusion of his name from the official lists of artists invited to attend the 1867 International Exposition, erected a building at his own expense to present his work to the public. And then there were the Impressionists, barred from exhibiting in Paris by the Salon establishment. Unwilling to compromise with authority, they joined forces in 1873 as the Société Anonyme des Artistes Peintres, Sculpteurs, Graveurs, etc. and mounted the first of many shows (1874) in the vacated studio of the photographer Nadar.

The secessionist movement of the 1890s has, with good reason, also served the image of the persecuted modernist. Although Gustav Klimt had already had a degree of

official success when the Vienna Secession came into being in 1897, he and a number of younger artists had been excluded from the most important exhibitions of Austrian art abroad and snubbed in shows at home. The situation was far worse in Berlin, where Emperor Wilhelm II himself set the repressive tone. An implacable foe of modern art, he used all the means at his disposal to limit the opportunities of vanguard painters and sculptors, who, exasperated with what seemed to them a stultifying system, finally founded a new exhibition society, the Berlin Secession, in 1898.

Though any attempt to do away entirely with this paradigm of the persecuted modernist/secessionist would certainly be misguided, the aim of this book, in part, is to modify the stereotype. The Munich Secession, similar though it may be in many ways to other groups of alienated vanguard artists around the turn of the century, did not fulminate in the sort of repressive atmosphere that characterized Berlin. To be sure, the Munich secessionists represented the young, progressive element of the local art community, and debates about modern art played an important role in the controversy that ultimately resulted in the founding in 1892 of the Munich Secession, the first such separatist movement in German-speaking Europe. But these discussions took place in a context that was, in general, comparatively tolerant of artistic enterprises of all kinds, and modernist experiments in the visual arts, though hotly contested by some, rarely provoked in Munich the kind of hostility that led elsewhere to persecution. Indeed, the history of the Munich Secession suggests above all that a repressive environment was not a necessary precondition of the secessionist moment, which in the Bavarian capital occurred only when aesthetic, political, cultural, personal, and above all economic pressures were brought *simultane-*

ously to bear on the art community. Ironically, the Secession itself could not withstand these pressures, and ultimately it too fell prey to the very forces out of which it had initially emerged.

If this book is about the rise and fall of a cultural institution, it also concerns the works of art that were integral to that institution. In the past, such works have generated little interest among art historians, who, with few exceptions, typically regard German painting and sculpture of the late nineteenth century as merely a pale reflection of its counterpart in France. After all, the German "Impressionists" Fritz von Uhde, Lovis Corinth, Max Slevogt, and Max Liebermann generally did not dissolve form in their work prior to the turn of the century or adopt the high-keyed color of their peers in Paris, nor did they demonstrate particular interest in the modern-life themes of their French colleagues, preferring instead to paint rural, mythological, literary, or religious subjects. Likewise, the German "Post-Impressionists" typically steered their paintings clear of the intensity and anguish that generally characterize the work of Vincent van Gogh, Felicien Rops, Edvard Munch, and James Ensor, exploring instead more subtle emotions in their evocative and filtered work. Art historians, particularly American art historians, have thus rejected German artists of this period out of hand, branding them timid and conventional, somehow incapable of nurturing the seeds of a nascent modern art.

But to judge German art of the period by French standards, to compare it negatively to the sort of work that was being produced elsewhere on the continent, is both to neglect its unique qualities and to ignore the specific context in which it was produced. Munich was not Paris, and Berlin was not Brussels, and the artists whose sensibilities were, in part, shaped by these cities were as necessarily different as apples from oranges. Thus, though it is partly my intention here simply to identify the distinguishing characteristics of Munich's early modern art, I also try to set these characteristics in their specifically Munich context. That is, by identifying the work that was and was not exhibited at the various Munich exhibitions in the late 1880s and 1890s, and by focusing on five artists—Max

Liebermann, Fritz von Uhde, Leopold von Kalckreuth, Franz von Stuck, and Richard Riemerschmid—whose work represented broad trends at the Secession salons, I trace what might be termed a lyric tradition in Munich art at the turn of the century, which was later elaborated by a number of the Blaue Reiter artists.

To be sure, by stressing the connections between late-nineteenth- and early-twentieth-century Munich artists I run the risk of presenting the secessionists of the 1890s merely as precursors of Kandinsky, Marc, Macke, Münter, and others, of casting their achievements in the shadow of the "greats" who now dominate our modernist canon. I nevertheless do so consciously, in the hope that by linking, however tenuously, the secessionist enterprise of the 1890s to the far more familiar and celebrated modernist experiments of the Blaue Reiter artists, I demonstrate the pitfalls of always using a French yardstick to measure German or other European products. Indeed, by recognizing that turn-of-the-century Munich painting, sculpture, and design hold important keys to the history of modern German art, rather than by continually comparing them negatively to the contemporaneous and very different French products, we take an important and necessary step toward appreciating in and of itself an art that has traditionally been considered inferior.

This said, I feel it necessary to issue a disclaimer of sorts. Particularly in comparison to what we know about late-nineteenth-century French art and artists, the state of research on contemporaneous German art is still in its infancy. There are relatively few essays on individual artists or single works of art, almost no iconographical, patronage, or institutional studies, and very little that might be called theoretical. Indeed, the most basic inquiries have just begun for the vast majority of nineteenth-century German artists, while more complicated questions of political affiliation or social sympathies have generally not yet been asked of even the most talented painters, sculptors, and designers. It is precisely this lack of secondary resource material that makes the field so exciting, but it also creates problems for those like myself who attempt a synthetic approach to the period. Merely locating those works that were exhibited in the vari-

ous Munich salons was extraordinarily difficult, for instance, simply because definitive monographs still remain unwritten for virtually all the German artists involved. In this scholarly vacuum it proved difficult to answer many of the questions I initially posed of the material, and I can only hope that the lacunae in this book encourage further work in a field that is still virgin territory.

I CANNOT possibly thank all the institutions and individuals who have assisted me in this project, but a few deserve special mention. The book was begun as a dissertation at Stanford University, when it was generously supported by the Stanford Art Department, the Stanford Humanities Center, and the Kress Foundation. Financial assistance for its revision was later provided by the National Endowment for the Humanities, Travel to Collections Program, and by the Fulbright Commission. Lorenz Eitner, Albert Elsen, Wanda Corn, Russell Berman, and Peter Paret each read the manuscript in its dissertation form, and I offer more than the conventional thanks for their many comments and suggestions, while absolving them of all responsibility for that which is printed here. Above all I owe a debt of gratitude, which I fear I will never be able to repay, to Peter Paret, whose enthusiasm for this project meant more to me than he probably realizes. Thanks are extended also to Reinhold Heller and James Sheehan, who each read and offered incisive comments on parts of the manuscript in one or more of its revised versions.

In Germany the staffs of numerous museums, archives, and libraries provided unfailingly helpful and friendly assistance. I wish particularly to mention Wolfgang Venzmer of the Landesmuseum in Mainz and Claus Pese of the Archiv für Bildende Kunst am Germanischen Nationalmuseum in Nürnberg. The current president of the Munich Secession, Johannes Segieth, was a source of constant encouragement, as was Herbert Paulus, the grandson of Adolf Paulus, the Secession's first business manager. Without their help it is unlikely that this book could have been completed. Robin Lenman of the University of Warwick deserves special note, for he kindly shared with me many of his own discoveries and insights about the Munich art world, while his publications led me to a number of valuable sources that I might otherwise have missed. I wish also to thank the custodians of the Munich museums, who preside over a large cache of secessionist work. Armin Zweite, Rosel Gollek and Annegret Hoberg of the Städtische Galerie im Lenbachhaus, Christian Lenz of the Bayerische Staatsgemäldesammlungen, and Volker Duvigneau of the Münchner Stadtmuseum all accommodated, with good humor, my repeated requests to see archival material and works in storage.

I should also like to express my gratitude to Elizabeth Powers and Cynthia Parsons of Princeton University Press, and, most especially, to Eric Van Tassel, who turned my murky prose into readable text.

Finally, and above all, I wish to thank Neal Benezra, who has read all these pages several times. His personal and professional contribution to this project is probably greater than even he would readily recognize.

The Munich Secession

1. The Context: Art and Artists in Nineteenth-Century Munich

 Munich was radiant. . . . Young artists with little round hats on the backs of their heads, flowing cravats and no canes—carefree bachelors who paid for their lodgings with colour-sketches—were strolling up and down to let the clear blue morning play upon their mood, also to look at the little girls, the pretty, rather plump type, with the brunette bandeaux, the too large feet, and the unobjectionable morals. Every fifth house had studio windows blinking in the sun. . . . Little shops that sold picture-frames, sculptures, and antiques there were in endless number; in their windows you might see those busts of Florentine women of the Renaissance, so full of noble poise and poignant charm. And the owners of the smallest and meanest of these shops spoke of Mino da Fiesole and Donatello as though he had received the rights of reproduction from them personally. . . . If you looked into the windows of the book-shops your eyes met such titles as Interior Decoration Since the Renaissance, The Renaissance in Modern Decorative Art, The Book as Work of Art, The Decorative Arts, Hunger for Art, *and many more. And you would remember that these thought-provoking pamphlets were sold and read by the thousand and that discussion on these subjects were the preoccupation of all the salons. . . . You might see a carriage rolling up the Ludwigstrasse, with such a great painter and his mistress inside. People would be pointing out the sight, standing still to gaze after the pair. Some of them would curtsy. A little more and the very policemen would stand at attention. Art flourished, art swayed the destinies of the town, art stretched above it her rose-bound sceptre and smiled. On every hand obsequious interest was displayed in her prosperity, on every hand she was served with industry and devotion. There was a downright cult of line, decoration, form, significance, beauty. Munich was radiant.*
—Thomas Mann, "Gladius Dei," 1902

With these words Thomas Mann—just one of *fin-de-siècle* Munich's many prominent artist-residents—recalled the widespread fascination in Munich with art and artists during the last decades of the nineteenth century.[1] To be sure, Mann did not necessarily approve of the city's many art dilettanti: a central message of "Gladius Dei," a story that describes the confrontation between a dealer in "pornographic" art and a zealous monk determined to purge Munich of smut, is that the passionate interest in the visual arts was sometimes counterproductive, particularly around the turn of the century, when opinionated Catholic moralists consolidated their power and were able to influence the city's cultural policies. But "Gladius Dei," along with countless other memoirs, stories, novels, and letters of the period, is nevertheless an eloquent testimony to the central role that the visual arts played in the Bavarian capital in the late nineteenth and early twentieth centuries. Indeed, the local art community and its endeavors seemed so integral to the city's identity that a municipal committee specially formed in 1892 to investigate the Secession controversy unequivocally asserted: "Munich owes its outstanding importance among German cities to *art and artists*, however highly one may rate other factors in its development."[2]

Since the large size and importance of the Munich art community played a key role in the Secession controversy, both in shaping the disagreements that preceded the founding of the association in 1892 and in determining subsequent reactions to it, the many and diverse reasons for the community's rapid growth in the second half of the nine-

teenth century are of considerable interest here. Public museums that housed a singular state collection of painting and sculpture; an academy that concentrated its prodigious efforts solely on teaching; a lively exhibition program of international contemporary art, organized by a professional and social artists' society that enjoyed a great deal of support from the public, the crown, and the state while nevertheless maintaining its independence—all these were unique to mid-century Munich, and increasingly attracted both German and foreign artists to the Bavarian capital. Ultimately, the tremendous allure of the city was its own nemesis, for the community of local artists eventually grew so large that it could not be sustained. But for most of the latter half of the nineteenth century, the rising numbers of resident painters, sculptors, graphic artists, and designers seemed only to bode well for the city, whose reputation both at home and abroad depended largely on its vigorous art community.

The Making of a Cultural Metropolis

Though it had not always been a cosmopolitan art center, Munich had a rich tradition of cultural activity prior to the nineteenth century. Not only was the Catholic Church in Bavaria among the most important patrons of Baroque painting, sculpture, architecture, theatre, and music, but the Wittelsbach family—which had ruled the state since the twelfth century—was also committed to supporting the visual arts. Between the late sixteenth and early nineteenth centuries the Wittelsbachs put together one of the foremost collections of Central and Northern European art in the world, which includes such masterpieces as Albrecht Dürer's *Four Apostles* (1526) and Peter Paul Rubens' *Rape of the Daughters of Leucippus* (ca. 1618). Yet despite the importance of individuals like Maximilian I (1573–1651), who aggressively pursued and obtained numerous key works by Dürer, and Maximilian II Emanuel (1662–1726), who acquired outstanding paintings by masters of the Dutch and Flemish school, it was probably Ludwig I (1786–1868) who had the greatest impact on the evolution of Munich's artistic culture.[3]

Ludwig's father, the Bavarian Elector Maximilian IV Joseph (1756–1825), was proclaimed King Maximilian I by Napoleon in 1806 in gratitude for his support during the continental wars. Max Joseph's elevation to royal status was coupled with the territorial expansion of Bavaria through the incorporation of mostly Protestant lands to the north. This consolidation of Wittelsbach power awakened in father and son the desire to transform the Bavarian capital from a relatively provincial town into a cultural and administrative center worthy of the family name. Proclaiming that he intended "to turn Munich into such a city that no one shall know Germany who does not know Munich," Ludwig initiated a massive building program that changed the face of Munich irreversibly. The city's Gothic and Baroque core was now surrounded by imposing Neoclassical structures like the Ludwigskirche, the Ludwig-Maximilians University, and the State Library, which share a monumentality that impressed and overwhelmed contemporary residents and foreign visitors alike. The Viennese author Heinrich Laube wrote that even horses were intimidated by these massive buildings, while the American poet Thomas Wolfe felt "helpless as a child in a world of giant objects" in front of the monumental facades.[4]

Ludwig's urban renewal project was a magnet not only for some of the best architects, sculptors, and painters of the period, but also for their students, who cut their teeth on his building program. But if the monarch contributed to the growth of the Munich art community simply by providing work for large numbers of artists, ultimately more important in the transformation of the Bavarian capital into a city of cultural importance were the museums he built for the Wittelsbach art collections. The Glyptothek—the first public museum of any kind in Germany—opened in 1830. Designed by Leo von Klenze, it housed Ludwig's impressive collection of antiquities. The Pinakothek, also designed by Klenze at Ludwig's initiative, was completed only six years later to house the Old Masters amassed by the Wittelsbachs. At its opening in 1836 the Pinakothek, like the Glyptothek before it, was the only such

public museum in Germany. More unusual still was the Neue Pinakothek, which Ludwig had built for his collection of contemporary art. Since its completion in 1853 it has housed only works executed after 1800. Though the advantages such an arrangement offers for the study of contemporary art are obvious, it was not until the Nationalgalerie opened in Berlin in 1876 that another German museum would limit its acquisitions to works by living or recently deceased artists, or would even unite such works under one roof.[5]

If Ludwig's foresight in establishing a museum of contemporary painting and sculpture was exemplary, so too was his catholic taste. Although other major private patrons of contemporary art—such as the Berlin residents J.H.W. Wagener and Athanasius Raczynski, whose collections formed the nucleus of the Nationalgalerie—collected the work of foreign artists, their focus was German painting and sculpture. By contrast, Ludwig I's purchases included an unusually high proportion of foreign art. At his death in 1868 nearly one-half of the artists represented in his collection were non-German. In fact, until the 1890s, when Alfred Lichtwark and Hugo von Tschudi began purchasing foreign art for the Hamburger Kunsthalle and the Nationalgalerie in Berlin respectively, the Neue Pinakothek offered the largest public repository of contemporary international art in Germany.[6] In short, by the early 1850s the Wittelsbach family had collectively carved a unique cultural niche for Munich. With its singular collection of antiquities, Old Masters, and contemporary German and foreign art—all on public view in the city's museums— Munich offered unequaled facilities for the study of painting and sculpture.

The informal lessons that an aspiring artist might learn from the works displayed in Munich museums augmented the formal course offered at the Royal Academy of the Fine Arts, by mid-century the preeminent teaching institution in Central Europe.[7] The Munich Academy had opened in the 1760s as a private art school with only two teachers and forty pupils drawing from plaster casts and from life, but in 1808 Maximilian I granted the school a royal charter and increased its state subventions, thus provid-

ing it with the means to expand. Although the academy in Düsseldorf overshadowed the school during the second quarter of the century, by the time all the Munich museums were in place and open to the public, the fame of the history painter Karl Theodor von Piloty—teacher at the Munich Academy since 1855 and director from 1874 to 1886—and of his younger colleagues Wilhelm Lindenschmit and Wilhelm Diez was drawing students from all over the world. An entire generation of American Realists studied in Munich in the 1870s, as did many Scandinavian, Russian, and Polish students. Enrollment figures give some indication of the institution's renown. Even in 1908–9, almost a decade after Berlin had displaced Munich as Germany's art center, the Munich Academy still had over five hundred students, three hundred more than its counterpart in Berlin.[8]

If the Bavarian capital thus presented mid-nineteenth-century artists with a singular opportunity to study painting and sculpture—informally in its unusual permanent collection on public display, and formally in its preeminent art academy—it also offered them a unique exhibition program. This was possible because Munich, unlike other German cities, possessed by the 1850s two buildings large enough to house art shows of significant scope. The Kunst- und Industrieausstellungsgebäude (fig. 1), erected opposite the Glyptothek on Königsplatz in 1845 at the initiative of Ludwig I, was frequently used for exhibitions of German art, especially of works by local painters, sculptors, and graphic artists. The Glaspalast (fig. 2), designed by August Voit to house the German industrial exhibition of 1854 (Allgemeine Ausstellung Deutscher Industrie- und Gewerbeerzeugnisse des Zollvereins), was subsequently used for important exhibitions of both historical and contemporary painting, sculpture, prints, and drawings. Between 1858 and 1888 six major salons were mounted here, four of which featured the work of both German and foreign artists.[9]

The 1869 exhibition exemplifies the importance of such shows for resident artists. It consisted of 3,411 works of art, half of which originated outside Germany. Artists, dealers, collectors, and a curious public

from all over Europe poured into the Glaspalast, swelling ticket sales to over 100,000—an astounding figure considering that at the time Munich itself had only 160,000 inhabitants. France was represented by the Barbizon painters Camille Corot, Jules Dupré, and Théodore Rousseau, as well as by Gustave Courbet, who was exhibiting in Germany for the first time and was one of only fifteen artists honored that year with the coveted St. Michael's Cross. His seven paintings, including the controversial *Stonebreakers* (1849) and *Woman with a Parrot* (1866), were installed in a room of their own. In Munich to receive his award, Courbet met the painter Wilhelm Leibl, and the warm friendship that developed between the two led a number of Munich Realists—including Leibl and Carl Schuch—to visit Paris. There they assimilated a variety of influences that ultimately proved crucial to their development.[10] Notably, artists living outside Munich had far fewer opportunities to make such contacts, for not until the Landesausstellungspalast—a large glass and iron structure similar to Munich's Glaspalast—opened in a suburb of Berlin in 1886 could exhibitions of similar scope be mounted elsewhere in Germany.[11]

Significantly, it was not the academy that mounted such salons, but the Münchener Künstlergenossenschaft (Munich Artists' Association), a social and professional association of artists established in 1868. Although the Genossenschaft was to achieve its greatest notoriety in 1892, when a number of artists seceded from its ranks, its lively and unique program, as well as the relative freedom it enjoyed in comparison to other similar organizations, must be included among those attractions that increasingly lured artists to the Bavarian capital.

The Münchener Künstlergenossenschaft: Populism in a Liberal Era

The origins of the Genossenschaft lay in the Royal Academy of the Fine Arts, which, like academies in other major European art centers, controlled both teaching and exhibitions in the first half of the nineteenth century. The charter granted this institution in 1808 by King Maximilian I stipulated that it must, in addition to training artists, make the arts accessible to the public in major exhibitions. These were to be mounted every three years and were to include the work of students, faculty, and

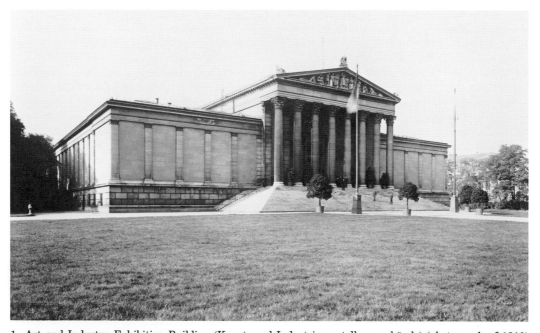

1. Art and Industry Exhibition Building (Kunst- und Industrieausstellungsgebäude) (photograph of 1910)

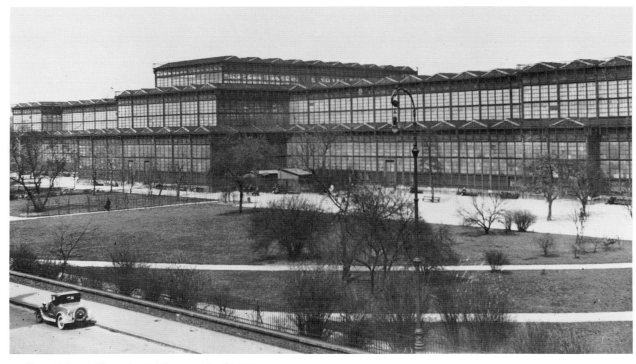

2. Glass Palace (Glaspalast) (photograph of 1931)

independent German and foreign artists.[12] Under the guidance of Johann Peter Langer, the first director of the Munich Academy, the opening exhibition took place in 1811. Yet, though they were thereafter held every three years, the shows did not otherwise fulfill the spirit of the charter, which had intended the salons to evolve into an enterprise of some importance. Small in size, of brief duration, and dominated by student works, they were relatively insignificant affairs, of interest only to the students and faculty of the academy.[13] The state itself was partly responsible for this, for although it required the academy to mount these shows it neither granted additional funds to defray the significant expenses that accompanied them nor provided a suitable locale in which they might be mounted. Equally important was the appointment of a series of directors whose talents or interests did not lie in the area of exhibitions.[14] In 1838, in fact, the faculty of the academy even voted against its charter to discontinue the salons. They were resumed in 1845 when King Ludwig I provided the academy with the newly completed Kunst- und Industrieausstellungsge-

bäude to house the exhibitions, and foreign and non-student participation increased considerably. Nevertheless, the salons continued to close with deficits, and respected critics still attacked their quality.[15]

Seemingly unable to transform the salon into a financially or artistically successful enterprise, the faculty voted in 1851 to try and involve independent Munich artists in the organization of its exhibitions.[16] It was not until 1856, however, when the Allgemeine Deutsche Kunstgenossenschaft (General German Art Association) was founded, that an appropriate institutional mechanism existed to facilitate such cooperative endeavors.[17] A professional artists' association with chapters in twenty-one German and Austrian cities, including Munich, the Allgemeine Deutsche Kunstgenossenschaft took as one of its central goals the organization of exhibitions of German art, which were to be administered by the local chapters. The Munich branch of this national society was thus a convenient support group for the academy, which just at that moment wished to delegate some of its own exhibition responsibilities. Hence, the 1858 exhibition—the first to be mounted in Munich

after the founding of the Allgemeine Deutsche Kunstgenossenschaft—was a joint effort that not only commemorated the seven-hundredth anniversary of Munich and the fiftieth anniversary of the academy, but was also the first in a series of exhibitions sponsored by the new national organization.[18] The moving force behind the salon was Feodor Dietz (1813–70).

A painter of modest talent who had been trained at the Munich Academy, Dietz possessed personal qualities and professional skills that past directors of the academy had lacked.[19] Energetic, tactful, and a talented administrator, he was repeatedly elected to the board of the Kunstgenossenschaft, whose goals and structure he influenced considerably. It was he who secured for the German historical exhibition of 1858 works from various state institutions throughout Germany, even persuading the King of Prussia to lend important paintings in his collection. In contrast to the predominantly local character of the previous Munich shows, this exhibition represented the breadth of past and contemporary German art. From an artistic as well as a financial viewpoint, this was the first successful show to take place in the Bavarian capital, and it was apparent that the academy's faculty had played but a minimal role in its organization.

The success of this exhibition was the beginning of the Münchener Künstlergenossenschaft. Anxious to rid itself of unwelcome duties, and now assured that the art community at large was capable of managing such enterprises, the academy petitioned King Maximilian II to amend its charter. In 1863, responsibility for organizing exhibitions thus passed from the academy to the independent Munich artists,[20] and five years later, on 7 June 1868, Maximilian's son and successor—King Ludwig II—granted the group a royal charter under the now formal name of the Münchener Künstlergenossenschaft.[21]

Among the stated goals of the new association was the "encouragement of relationships of artists to each other and to friends of the arts, especially through the promotion of a common social life."[22] The Genossenschaft took this mandate seriously, believing that a unified and highly visible art community would ultimately better the position of resident painters, sculptors, and graphic artists. Thus the association regularly organized functions intended to foster collegiality and improve the standing of local artists in the community. In January 1887, for example, the Genossenschaft staged an elaborate torchlight parade with the Munich Academy in honor of Prince Luitpold, who had assumed the regency of Bavaria after the death of Ludwig II in 1886. Six horses pulled an elaborately decorated float, the centerpiece of which were four allegorical figures of genius sitting on a platform supported by gilded columns. Holding palm branches, they were surmounted by a sign inscribed with the words "Luitpoldus, artium protector." Given the some eight hundred torches carried by the parade participants and the trumpet fanfares that accompanied the procession along the Ludwigstrasse to the Residence, probably no one noticed that the specially installed gasometer designed to illuminate this sign had failed to function in the cold January weather.[23] Though it was one of the more spectacular events staged by the Genossenschaft, the parade was standard fare for the association, whose frequent dinners, costume balls, and processions entertained Munich residents on many an occasion and helped create a warmly sympathetic and supportive public for local artists. As one contemporary noted, "a single successful fête organized by the artists, an effective parade, did more to popularize Munich art than half a dozen auspicious exhibitions."[24]

Nevertheless, exhibitions were the primary focus of the Genossenschaft, which mounted shows of various sorts with increasing frequency after the academy gave up its claim to such enterprises in 1863. Between 1870 and 1889, for example, the association used the exhibition hall on Königsplatz to mount annual exhibitions of works by mostly local artists. On view for several months in the autumn, these comparatively modest shows usually comprised several hundred paintings, sculptures, drawings, and prints. After 1889 the building was open all year round, with exhibitions changing every few months.[25]

By contrast, salons of much larger scope were mounted in the Glaspalast. After the 1869 exhibition, the Genossenschaft voted

to hold international salons quadrennially. Following a show in 1876 that included only German work, three international exhibitions—each comprising thousands of works of art—were mounted prior to the founding of the Secession in 1892. These took place in 1879, 1883, and—to coincide with the centennial of Munich's first exhibition in 1788—not in 1887 but in 1888. Generally on view from the beginning of June through the end of October, they included contemporary German and foreign art as well as historical works.[26]

While the manner in which these exhibitions were organized varied slightly from year to year, it is noteworthy that the elected representatives of the Genossenschaft always retained ultimate authority over all individuals and committees involved in arranging the exhibition.[27] As a rule, non-German committees such as the Société des Artistes Français—the exhibition society that organized the Salon in Paris after 1880[28]—assisted in the selection of foreign works for exhibitions in Germany. Other local chapters of the Allgemeine Deutsche Kunstgenossenschaft that also mounted exhibitions regarded the recommendations of these foreign bodies as more or less inviolable, almost always accepting without question the works they chose. In Munich, however, the Genossenschaft frequently reversed decisions made by the foreign bodies or bypassed these committees completely, inviting both foreign and domestic artists to participate in the shows as unjuried guests of the association.[29] This power was frequently and liberally exercised. In 1888, for instance, approximately 236 of the 1,643 exhibitors, or roughly 15 percent, were *invités* of the Genossenschaft and therefore were exempt from jurying.[30]

Representatives of the Genossenschaft also retained authority over those designated by the academy and the government to sit on the exhibition committees. In the case of the large internationals in the Glaspalast, for instance, the central committee in charge of the exhibitions consisted of the entire executive committee of the Genossenschaft (which grew in size from fifteen members in 1882 to eighteeen by 1900), four appointed representatives of the academy, and one official designee of the government. The academic and state appointees were

thus a distinct minority, who possessed no veto power and could thus influence policy only in instances in which the vote was split.

This arrangement was in fact agreeable to both the academy and the Bavarian state ministries. As noted, the Munich Academy wished to rid itself of exhibition responsibilities completely, and the Genossenschaft itself was largely a product of this unusual situation. The state administration, while not uninterested in the affairs of the art community,[31] also preferred to let the Genossenschaft manage its own affairs as it deemed appropriate. This is noteworthy, since the government did in fact contribute a great deal to the exhibitions. Not only did it allow the Genossenschaft to use the Glaspalast free of charge, often preempting other organizations that wished to have access to the state exhibition hall,[32] it also provided the association with substantial subventions for the salons and purchased works for state collections from the exhibitions.[33] Yet despite this considerable power over the art community, the ministerial bureaucracy, which administered the funds approved by Parliament, consistently refused to use the government's support of the arts to influence the Genossenschaft in aesthetic issues. When, in 1879, state spending on the arts was questioned in Parliament because of the inclusion in that year's exhibition of a particularly controversial painting, the Minister of Church and School Affairs, Johann von Lutz, succinctly stated the administration's position: "The government cannot function as a superjury."[34] Although it became increasingly difficult for the royal cabinet to maintain this policy of neutrality, the ministers managed to defend it against attack at least until the 1890s.[35]

It is worth emphasizing that the Genossenschaft's independence of both the academy and the state was quite unusual, if not unique. Not until 1892, for example, did the Verein Berliner Künstler—the Berlin chapter of the Allgemeine Deutsche Kunstgenossenschaft and thus the approximate equivalent of the Münchener Künstlergenossenschaft—become an equal partner with the academy in the management of its salon. Until then it had had only minimal influence on the organization of exhibitions.

In 1892, when membership on all exhibition committees was divided equally between the academy and the Verein, the association had to pay the price of closer government control. Even the juries of the exhibitions were merely advisory bodies in Prussia, their recommendations subject to ministerial and imperial confirmation.[36] In Bavaria, by contrast, the ministerial representative simply advised the head of state *ex post facto* of the actions of the democratically elected juries.[37] In Belgium, an alternative exhibition mechanism to the academy-sponsored salon, the Société Libre des Beaux-Arts, existed as early as 1868, yet its exhibitions were small affairs, and the association disintegrated in the mid-1870s. While other similar societies, such as La Chrysalide and L'Essor, were founded to take its place, they too did not compare with the Genossenschaft in size, importance, or longevity.[38] In Paris, the academy controlled the juries of admission and awards at the biennial Salons until 1881. Even when the state approved a petition by independent artists to be allowed to participate in the jury selection, it limited participation to those artists whose work had previously been accepted to the Salon.[39] By contrast, any regular member of the Munich Genossenschaft could participate in jury elections.

Notably, membership in the Genossenschaft was not exclusive in terms of either social class or artistic talent.[40] In 1882 any practicing male artist of good reputation [*unbescholten*] was eligible to become a "regular" member, whose rights included participation in election of officers and committees and in the frequent exhibitions that the association organized. By 1900 the Genossenschaft had restricted membership to male artists living in Bavaria; female artists and males living outside Bavaria were eligible only for "irregular" membership, which excluded them from elections but allowed them to submit works to the exhibitions. Nominations for membership in the association required approval only by the elected executive committee, and membership statistics show that such nominations were rarely rejected. Just prior to the fracture of the Genossenschaft in 1892, roughly 1,020 artists belonged to the association,[41] a figure that represented a very

large percentage of the entire artist population in Bavaria.[42] The Genossenschaft was thus an odd combination of successful, established painters, sculptors, graphic artists, and architects—many of whom even served on the faculty of the academy—and the so-called *Kunstproletariat*, the far larger mass of artists struggling to make a living in the Bavarian capital.

Since all regular members could participate in elections,[43] the officers and committees of the association reflected this peculiar heterogeneity. In 1888, for example, twelve of the twenty-six members of the central committee for the international exhibition were affiliated with the Munich Academy, and eight of the twelve were elected rather than appointed. Among them were such luminaries as the director of the academy, Fritz August von Kaulbach, and the popular painter of Bavarian peasant life Franz von Defregger. Fourteen members of this committee, however, had no academic affiliation whatsoever, and today only historians of Munich art would recognize the name of the committee's secretary, the painter Karl Albert Bauer, or of member-architect Albert Schmidt.

Given the heterogeneous composition of the Genossenschaft and the unusual control that its members exercised over the association's programs, it is not surprising that the exhibitions themselves assumed a democratic character. Several exhibition policies, for instance, were designed to ensure equitable treatment for all artists, regardless of reputation or position.[44] Primary among these was a regulation that prohibited artists whose works had previously been honored in any of the international exhibitions from again receiving recognition, regardless of their talent or the quality of their submitted pieces. Although the Genossenschaft admitted their work jury-free to future salons, it preferred to commend those artists who had not yet been granted awards. Moreover, the jury was required by the exhibition statutes to confer at least one medal for every forty to fifty works, regardless of the number of objects evidencing real talent. Another policy limited to three the number of works any given artist could exhibit within one medium, the intent being to provide unknown or young artists

with the same opportunities available to established artists. In practice, of course, there were exceptions to this rule. Some artists, most notably Franz von Lenbach, consistently received preferential treatment, and on occasion small retrospectives—like the show of fourteen paintings and twenty-seven watercolors and pastels by James Abbott McNeill Whistler in 1888—were mounted within the exhibitions. But for the most part the Genossenschaft maintained the *drei-Bilder-System*, as it was known, preferring to let as many artists as possible exhibit up to three works rather than showing numerous works from the hand of several genuinely talented artists.

The thrust of these regulations was to promote fairness rather than quality, and to encourage all artists whose work was competent, if not inspired. To be sure, more often than not the greater talents suffered under such a system. But at least through the 1880s, most Genossenschaft members believed that all those who pursued their work with dedication and perseverance deserved a chance to prove themselves, and they were thus unwilling either to single out for repeated recognition the most talented, or to exclude from their exhibitions any but the most incompetent. Even in 1888, when the Genossenschaft mounted a large historical exhibition of early-nineteenth-century Munich art in the Glaspalast, thereby drastically limiting the space available for contemporary painting and sculpture, the jury rejected only about 24 percent of the works submitted to the salon by artists living in Germany. Yet even this was unprecedented, prompting a number of angry artists to organize a Salon des Refusés in protest.[45] By contrast, the 1863 Salon des Refusés in Paris was spearheaded by a 60 percent refusal ratio.

Such egalitarian attitudes were not uncommon in Munich art circles of the late nineteenth century, and they manifested themselves in a variety of ways. In 1888, for instance, the jury of a large exhibition of applied arts commended so many artists in its effort to be fair and equitable that the prestige accorded a medal winner was negligible at best. In a letter to the Prince Regent outlining the jurying process, the state representative who attended the delib-erations—Minister of the Interior Max von Feilitzsch—approvingly described the jury's egalitarian policies:

At first, the prize jury of specialists was inclined to set a very high standard and only to award medals to especially excellent achievements, above all to those that constitute an advance in the applied arts. If this view had prevailed, barely 30 percent of the exhibitors could have been awarded prizes. It was only in the course of deliberation that a milder view was adopted; awards were conferred on those objects that are irreproachable in form and technical execution. The end result is that . . . of the 1,038 exhibitors approximately 600 or 60 percent will receive recognition.[46]

Significantly, Feilitzsch went on to note that the jury also chose to withhold publication of the names of the honored artists so as to prevent those who were not commended from being disadvantaged in selling their work. Though extreme, the incident is nevertheless symptomatic. For much of the latter half of the nineteenth century, Munich art organizations in general, and the Genossenschaft in particular, sought to maximize the number of exhibiting artists while minimizing external influence on the market—including any influence they might themselves exert. Though the Genossenschaft never went so far as to eliminate a selection and prize jury completely, ultimately its egalitarian policies shifted the responsibility of distinguishing and encouraging quality in art from the juries to more or less discerning collectors.

Not surprisingly, the Genossenschaft underscored its populism by instituting features at the salons that would attract a heterogeneous audience. Beer gardens were erected within the Glaspalast, and concerts by groups ranging in size from small chamber orchestras and military bands to choirs of five hundred voices were held regularly.[47] For the 1889 exhibition the contents of the Prince Regent's greenhouse were transferred to the Glaspalast, and the Genossenschaft press releases described the exotic plants in as much detail as the sculpture that was scattered throughout the garden.[48] State-approved lotteries were held, for which one could purchase inexpensive tickets and possibly win valuable paintings, sculptures, prints, or drawings. This event

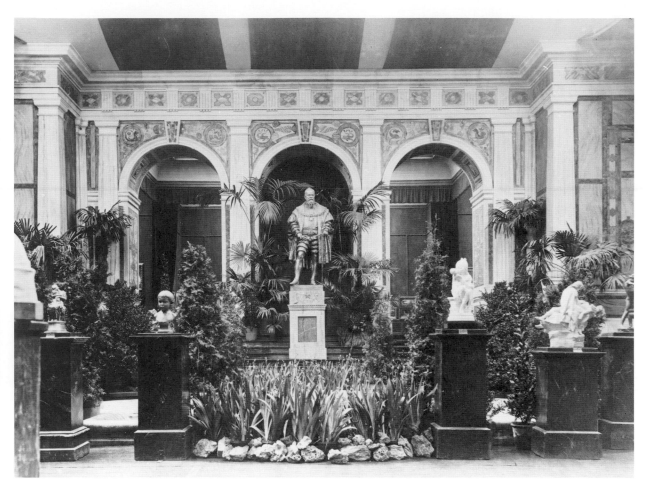

3. Interior of the Glass Palace, Seventh International Exhibition of 1897

was particularly popular, since many of the winners promptly sold their prizes to a dealer or collector for a price greatly under value and pocketed the money themselves.[49] Even the interior architecture of the building was used to attract visitors. Made of plywood, plaster, chickenwire, and papier maché painted to simulate fine wood and marble (fig. 3), the *trompe-l'oeil* columns, archways, architraves, and friezes were publicized as a must-see technical marvel for anyone interested in craftsmanship and handiwork.

By adopting such populist policies the Genossenschaft hoped to accomplish a number of things, not the least of which was to attract as many visitors as possible so as to cover the expenses of the exhibitions. But the populist element in the Genossenschaft program, good business though it may have

been, probably also had a moral dimension to it. Indeed, there is little doubt that the founders of the Genossenschaft hoped to combat with their programs what were widely perceived as the negative effects of Germany's industrialization, which occurred in the 1850s and 1860s with a speed unparalleled elsewhere in Europe. Between 1850 and 1869, for example, the production of coal grew from 5.1 to 26.8 million metric tons, pig iron from 0.2 to 1.4; steam power capacities increased from 260,000 to 2,480,000 horsepower and railroad lines from 3,639 to 10,834 statute miles.[50] This exceptionally rapid growth of industry at a time of relatively low production costs and high prices brought tremendous profits to financiers and industrialists, who—as contemporaries noted time and again—were not only more aggressive and

profit-oriented than the small manufacturers and merchants of the 1840s, but also more willing to disregard community obligations and religious values, and more given to luxury and ostentation in their private lives.[51] Simultaneously, a self-conscious working class, with an economic position and social identity that were clearly separate from those of the master craftsman and his apprentices, began to develop as well. Together, the acquisitive spirit and ostentatious lifestyle of the new entrepreneurial class with the material poverty of the manual laborers made for a society that quite suddenly seemed harsher, more spiritually degraded, than that of pre-revolutionary Germany. Indeed, these changes were so thoroughgoing that even largely unindustrialized areas felt their impact.

The policies of the Genossenschaft can be placed within this context. Defining itself as guardian of what appeared to be quickly disappearing values, the association saw its exhibitions as the cornerstone of an outreach program that would counter the spiritual poverty of the age by educating and enlightening the public through art. *Bildung*—that peculiarly German concept that combines the meaning of the English word "education" with notions of character formation and moral cultivation—was a primary goal, and the association was willing to adopt unorthodox measures to implement it. The popularization of the salon by beer gardens, lotteries, and the like—though vehemently criticized by some contemporaries[52]—was thus precisely the intent of the Genossenschaft, which hoped to attract to its exhibitions an audience that might otherwise be uninterested in art. Indeed, it was customary for the central committee to distribute passes to various Munich associations for sale at reduced rates to members who could not afford the regular entrance fee. In 1888, when the committee learned that these tickets were being misused, its prompt response was angry and genuine. "In no way was it the intent of the central committee to enable affluent citizens to attend the exhibition at reduced rates merely because they are members of some association," the letter stated, "but, rather, to enable only *those of moderate means* not in a position to pay the full entrance fee to visit and study the exhibition."[53] On occasion the association even eliminated admission fees entirely so that those whose income did not allow even small luxuries might attend the show free of charge.[54] Notably, this focus on popular enlightenment was an essential element of a broader movement that had gained particular currency by the 1860s. Liberalism, seemingly on its deathbed in 1850, was resurgent in the very years that the program of the Genossenschaft was shaped.[55]

When Frederick William IV (1795–1861), King of Prussia, categorically refused the imperial crown offered by the Frankfurt Assembly in 1849, thus destroying the democratic constitution drafted by that body, many contemporaries proclaimed the end of the liberal movement that had led the revolutions of 1848. But by the end of the 1850s an almost unbroken string of election victories brought liberals to positions of importance on the state level. Even in Bavaria, where anti-liberal forces remained strong in the staunchly Catholic countryside, the movement was powerful enough to return a vigorous faction to Parliament. The electorate of Munich was primarily responsible for this, for it, like that of most other major cities in Germany, voted overwhelmingly liberal after mid-century. In 1869, for example, all of Munich's seven representatives to the state Parliament belonged to the liberal party, and thirty-seven of the sixty city council seats—an absolute majority—were held by liberals.[56] Indeed, the *Münchener Neueste Nachrichten*, the mouthpiece of the liberal party in Munich, enjoyed a circulation far larger than that of any other newspaper in Bavaria.[57] In short, not two decades after the collapse of the revolution, liberalism was again on the rise, without a doubt the most energetic and popular vehicle for political participation both in Germany as a whole and in Munich.

Though German liberals were divided on many issues in the 1850s and early 1860s, there was relative consensus in a few key areas. One of these was the continued belief in a constitutional system based on national unity, whereby a powerful Parliament would enact legislation according to majority opinion. Another was a growing faith in the progressive impulses of a free-market economy. Convinced that laws limiting the economy were unproductive and ultimately

disastrous, one state after another lowered tariffs in the 1850s and 1860s, signed commercial agreements, and removed or weakened remaining restrictions on economic activity. At the same time, however, many liberals felt it wrong to emphasize material interests and issues over *Bildung*, which they believed would ultimately enable the proletariat to attain the skills and spiritual qualities necessary to transcend their working-class roots and enter the middle class. Consequently most liberal reform proposals of both pre- and post-revolutionary Germany had some educational dimension, which included not only improved formal schooling, but the creation of associations for adult education, cooperative saving, the learning of special skills, and the improvement of moral and spiritual life. In short, German liberals coupled their support of an unrestricted economy with an emphasis on popular enlightenment.

These three elements of German liberal thought of the 1850s and 1860s—faith in a parliamentary system, in a free, unrestricted market, and in popular enlightenment—found expression in the program of the Genossenschaft, albeit in somewhat altered form. As noted, the Genossenschaft was a professional association whose members determined their own policies by popular vote. Those policies were egalitarian in nature, designed to give as many artists as possible a chance to prove themselves to the public without undue influence exercised by the Genossenschaft. This faith in a relatively unrestricted market, and in its ability to weed out the least competent while rewarding the most talented, was nevertheless accompanied by a belief in the necessity of popular enlightenment. By exposing broad segments of the populace to art, the Genossenschaft hoped to reaffirm what seemed to be rapidly disappearing spiritual values.

If certain aspects of the Genossenschaft program can be seen in light of German liberalism, so too can the remarkable independence the association enjoyed. As we know, the Genossenschaft had far more freedom than other such organizations, and, unlike its counterparts, it was usually able to act as it saw fit without fear of interference or reprisal from the state. This was primarily because liberalism was the pre-dominant ideology of the Bavarian state administration from the time the Genossenschaft was founded until well after the turn of the century. Despite the dominance of Parliament by the Catholic Center Party from 1869 to 1893, and again from 1899 on, Bavarian monarchs consistently appointed liberal (and usually Protestant) ministers to the royal cabinets. Though they were increasingly forced to make concessions to the politically hostile Parliament, at least until the 1890s the ministers successfully defended the quintessentially liberal position that the evolution of culture, like that of the economy, should not be tampered with. The Genossenschaft was perhaps the primary beneficiary of this policy, for throughout the latter half of the nineteenth century it received considerable financial support from the state with few strings attached. By contrast, liberalism played a subordinate role in both imperial and Prussian politics after the unification in 1871, and the affairs of the Verein Berliner Künstler—the approximate equivalent of the Genossenschaft—were subjected to considerable state and imperial interference.

A Golden Age: The Munich Art Community after 1871

A singular art collection on display in public museums, a vigorous art academy, a lively exhibition program of contemporary art, and a professional association more democratic and independent than other similar organizations—these were among the most important factors in the growth of the Munich art community. Coupled with less tangible aspects of the city—including its relatively low cost of living, its relaxed atmosphere and looser morals, its proximity to the Alps, and its position at the intersection of two principal railway routes (from north-central Europe to Italy, and from Paris to the Orient)—such attractions increasingly induced artists to move to the Bavarian capital in the last half of the century.[58]

Statistics, rough and scanty though they may be, nevertheless indicate the magnitude of this phenomenon. By 1895 around 1,180 painters and sculptors—over 13 percent of the total number in Germany—lived in Munich. That same year there were only

1,159 painters and sculptors working in Berlin, which by then was more than four times as populous as the Bavarian capital and was the only German city whose artist community even approached the size of that in Munich. The next largest urban art community in Germany was that in Düsseldorf, where 335 painters and sculptors practiced their profession. Dresden followed, with 314 resident artists, and Hamburg, Frankfurt, and Hannover came next, with only 280, 142, and 88 painters and sculptors respectively.[59]

A community of this size was bound to command attention anywhere and at any time, but Munich's resident artists played a special role in Bavaria, particularly after 1871. That year, on 18 January, Prussia's King William I was proclaimed emperor of a united Germany, and the independent states south of the Main joined the North German Confederation to form a powerful Reich under the Hohenzollerns. Bavaria, as the largest South German state, was granted certain special privileges for its participation in the unification, including the right to retain its own railway, postal, and telegraph systems, and the right to maintain full command of its armed forces in peacetime. But there was little doubt that of all the states Prussia wielded the most power in the new nation. By virtue of its size and influence in Germany as a whole, it possessed seventeen of the fifty-eight votes in the newly formed Federal Council—more than enough to enable it to block constitutional amendments that were not in its own interests or in those of the Reich.

Those Bavarians who welcomed the unification believed that it would open opportunities in all fields of human endeavor and encourage new triumphs in science, technology, art, literature, education, and politics. But even the strongest partisans of national unification could feel nostalgia for Bavaria's lost autonomy, and many others had considerable difficulty in making a positive identification with the new national state.[60] Indeed, many elements in the particularist forces that had opposed unification from the outset continued to believe that the advantages of belonging to a German federal state in no way compensated for the diminution of Bavaria's sovereignty. Twenty years after

the unification, in fact, anti-Prussian sentiment was still so intense in Bavaria that it frequently took visitors from the north by surprise. The young artist-designer August Endell, for example, who spent some time in Munich in 1892, wrote to a cousin in Berlin that the city harbored "enough Bavarians who are nationally oriented, but very many more who are so stubbornly and idiotically particularist that one might think they had lost their minds."[61]

It was in this context that Munich's local artists assumed increased importance, for their achievements now came to be regarded as a kind of substitute for Bavaria's independence. To be sure, the state could no longer exert the political influence it once had, nor could it wield economic power because of its failure to industrialize. But, residents reasoned, Bavaria could still function as the nation's cultural and spiritual leader, for unification did nothing to displace Munich as the preeminent art center in Germany. This role was proudly defended, particularly against real or presumed attacks from Prussia. As we will see, among the most powerful motivating forces in the local art community was the fear that Berlin, in addition to having usurped Bavaria's political power, might also now displace Munich as the nation's cultural leader. Minister of Foreign Affairs Krafft von Crailsheim was most succinct on this. "If in the course of our political development," he stated in a parliamentary debate over the art budget in 1890, "we have had to relinquish certain political privileges, we nevertheless do not want to let ourselves be supplanted in the domain of art."[62]

It is perhaps not surprising that in such a context exaggerated respect was paid to resident painters and sculptors. Even Thomas Mann's comment that "the very policemen would stand at attention" with the passing of a famous painter was not mere hyperbole; time and again contemporaries noted how artists were accorded far more status in Munich than elsewhere in Europe. The English painter John Lavery, for example, concluded that in Munich of the 1880s "the status of a painter was equal to that of a general in the army; he was covered with decorations at public functions and saluted as a person of distinction."[63] Similarly, the art and theater critic Theodor Goering,

having moved from Berlin to Munich, noted that the painter in Bavaria possessed

an officer's position in "society," with rank determined by the value or success of his pictures. The composer or musician is another matter, and regardless if he is the most gifted virtuoso, his talent is not nearly as highly regarded as the painter's. A musician is always considered more bohemian—somewhat like an actor. It would not be easy for an aristocrat conscious of his social prerogatives to include a musician among his most trusted friends, as a painter frequently is. The latter is invited to the summer villas of the aristocracy, where he is regarded as a companion, a chum, as it were. Here he makes sketches, which is almost as respectable an occupation as the hunting or racing of the cavaliers with whom he shares the same social status.[64]

Even the middle classes in Munich, Goering remarked, were unusually involved with the art community. Contemporary painting, he noted,

elicits an exceptionally high level of interest. The Kunstverein, where the newest works of many artists are shown in weekly exhibitions, is regularly visited by all classes of the populace. Everyone takes a lively interest in the more important manifestations of this genre; art criticism (or, more correctly, art reportage) has with the theater and music reviews a regular column in the daily press, much more so than in other cities. Everywhere one sees people peering into the windows of the art galleries, and a newly exhibited picture by Lenbach or Max, by Grützner, Defregger, Kaulbach, Piglhein—to name only a few of the best-known—is the talk of the town; anyone who pretends to be cultivated must know about it.[65]

But if the artist's profession was among the most highly respected in Munich during the last decades of the century, was it also lucrative? In fact, the unusually warm tribute paid to Munich artists and their endeavors did not always translate directly into sales or commissions. For one thing, royal patronage declined in the last half of the century.[66] To be sure, Ludwig I, who was forced to abdicate prematurely during the revolutions of 1848, nevertheless continued to purchase art until his death in 1868. His successor and son, Maximilian II (1811–64), was keenly interested in developing Bavaria by encouraging technological and scientific advances, and he was much

involved in the applied arts and modern architecture. But the ascent of Maximilian's son Ludwig II (1845–86) to the throne in 1864 signaled a new era in Wittelsbach patronage. Already showing signs of schizophrenia, Ludwig planned to replace his father's pragmatic attitude toward public service with a charismatic mode of rule intended to overwhelm the court and people by the spectacle of royal aura. He inaugurated his reign by summoning to Munich Richard Wagner, whose extravagant and adulterous personal life, however, led to his expulsion from the city after little more than a year. Angered by the hostility shown to his favorite composer, Ludwig turned his back on the Bavarian capital, reserving his patronage for the Wagnerian festival theater erected in Bayreuth in 1876, as well as for Linderhof and Neuschwanstein, the fairy-tale palaces that he commissioned amid the mountains of southern Bavaria. By the early 1880s he had withdrawn from society almost completely, to lead an eccentric life of seclusion.

Ludwig's rejection of Munich marked the end of large-scale monarchical sponsorship of the city's cultural development. When he drowned in 1886, amid rumors that he had been murdered by power-hungry liberal politicans, his already elderly grand-uncle Luitpold (1821–1912) assumed the reins of government as caretaker for Ludwig's fully schizophrenic brother, King Otto I (1848–1916). A passionate advocate of the visual arts in Munich, Luitpold was probably more directly involved with the art community than any of his predecessors, and he counted numerous artists among his closest friends. Yet for legal reasons connected with his position as Regent, Luitpold controlled only some of the funds normally available to the sovereign. As one recent study has shown, he was really Munich's most illustrious private collector, rather than a royal sponsor on the scale of Ludwig I.[67]

Moreover, the Bavarian capital lacked wealthy resident collectors to fill the gap left by the Wittelsbachs. Unlike other German *Grossstädte*, Munich failed to develop into a major industrial center in the latter half of the nineteenth century;[68] consequently there was less surplus wealth in Munich than in cities like Berlin and Hamburg, and a smaller pool of affluent collec-

tors. Moreover, those who could have afforded the cost of a major collection of contemporary art, such as local brewers like Matthias Pschor and Johann Sedlmayr, evidently preferred to bequeath money for the creation of public monuments. Thomas Knorr, co-owner of the *Münchener Neueste Nachrichten*, was among the few Munich residents who both wanted and had the means to build a collection of contemporary painting and sculpture.[69]

Nevertheless, for most of the century these problems were offset by the fact that Munich was the only German city with large exhibition halls. As noted, not until the Landesausstellungspalast opened in a Berlin suburb in 1886 could any other German academy or exhibition society mount salons of significant scope. Collectors and dealers not resident in Munich thus visited the Bavarian capital regularly, for only in the Glaspalast or the Kunstausstellungsgebäude could they get a broad overview of contemporary German and foreign art. Notably, between 1879 and 1892, when the Secession was founded, three-quarters of the turnover of the Glaspalast exhibitions came from buyers who were not resident in Munich, with 42 percent of this money coming from foreigners.[70] Americans were particularly aggressive buyers. In 1879 their purchases accounted for 19 percent of the total sales at the Genossenschaft exhibition, and in 1883 for an astonishing 31 percent. Even when the United States government drastically curtailed their patronage by trebling in 1883 the import tariff on art from Germany, from 10 to 30 percent, Americans continued to support the Munich art market.[71]

To be sure, local painters and sculptors were not the only beneficiaries of such largesse, for other German and foreign exhibitors shared the profits. In fact, Munich artists sold fewer than one-third of the objects they offered to the buying public at each of the 1879, 1883, and 1888 salons.[72] Moreover, many resident painters and sculptors were not even given the chance to exhibit, their submitted work having been rejected by the Genossenschaft even before the shows opened. Nevertheless, statistics seem to indicate that collectors placed a higher premium on art produced in Munich than other work. Not only did local artists consistently sell more than their German and foreign colleagues, their work commanded higher prices.[73] Even those Munich artists who sold nothing at the exhibitions got valuable exposure that frequently led to studio sales and commissions. Richard Riemerschmid, for example, was asked to design a title page for *Jugend* (Fig. 90) after Fritz von Ostini admired one of the paintings he exhibited in 1896.[74] For most of the century artists living elsewhere in Germany had no comparable outlet to exhibit and sell their work, and were thus at a decided disadvantage.[75]

One indication of the relative prosperity of Munich artists during the 1860s, 1870s, and 1880s is the absence of complaints about their situation. In contrast to the years around the turn of the century, when members of the art community frequently bewailed their economic plight,[76] before 1890 they protested hardly at all. Certainly some had trouble making ends meet, and many supplemented their income with side employment like retouching photographs, teaching, or cleaning and restoring the work of others. But only rarely were resident artists impoverished before 1890, and most seem to have been able to make a living at their profession. Indeed, it is not insignificant that the careers of Munich's so-called *Malerfürsten*, or painter-princes, were established during the years prior to the turn of the century, when Munich art was at a premium and even painters or sculptors of modest parentage could quickly amass fortunes if they were crafty and their work appealed. The painters Franz von Stuck and Franz von Lenbach, for example, had each earned enough to build electrically lit mansions in the best sections of town by the 1890s, and Stuck, Lenbach's widow, and Fritz August von Kaulbach were included with the royal princes and the big Munich brewers in a register of Bavarian millionaires published in 1914.[77]

In short, the 1860s, 1870s, and 1880s were something of a golden age for Munich artists. Not only did they live and work in a city that offered them more professional advantages than elsewhere in Central Europe, but particularly after Bavaria lost its political autonomy in 1871, they were accorded more status than virtually any of their European colleagues. Moreover,

despite the decrease of royal patronage after mid-century and the lack of wealthy resident collectors in Munich, local artists were relatively prosperous during this period, their work in demand by other German and foreign collectors who came to the Bavarian capital to attend the exhibitions in the Glaspalast and the Kunstausstellungsgebäude. Yet the events of 1889, 1890, and 1891 effectively demonstrated that even as strong and vigorous an art community as Munich's was not infallible. In those years personal, aesthetic, political, and, above all, economic issues joined forces to confound local artists, and ultimately the Genossenschaft fell prey to their combined onslaught.

Sooner or later an overload, a crisis, had to occur. . . . Almost all these talents were concentrated in Munich, and were supposed to live off of Munich—an almost grotesque disparity between artistic supply and demand set in; the more the young people streamed into Munich year after year to get training in one of the branches of the arts, the more threatening the situation became. This crisis is what set the scene for all the dissension, the covert and overt hostility, the conflicts and the formation of factions that have so influenced Munich's art life in the last years, not exactly to its benefit.—Kunst für Alle, 15 April 1907

With the advantage of considerable hindsight, this reporter for a Munich art journal identified in 1907 the primary source of the controversies that beset the local art community in the early 1890s and after.[1] But in October 1888, when the Genossenschaft's third international exhibition closed, hardly anyone would have predicted the forthcoming economic crisis. To the contrary, revenues from the third international seemed only to confirm that the local artists were at the peak of their power. Not only were more works of art sold than ever before, with Munich painters and sculptors among the primary beneficiaries, but income from ticket and catalogue sales exceeded expenses of the show, leaving the Genossenschaft with an unexpected profit.[2] Indeed, the exhibition was so successful that some members of the art community began to ask if Munich, like Paris, might not now be able to support an annual salon rather than just a quadrennial. The debate and resolution of this issue brought to power a number of artists whose policies ultimately led to the founding of the Munich Secession.

Several individuals were influential in propagating the concept of annual exhibitions, but its actual begetter was probably Adolf Paulus, the business manager of the Genossenschaft, who would later leave this association to work in the same capacity for the Secession.[3] Born in Möttlingen in Württemberg in 1851, Paulus was raised in a family that had inherited an art collection of some importance, and he developed an interest in the visual arts through the pictures that surrounded him in his youth.[4] At school Paulus demonstrated a marked talent for languages, becoming proficient in English, French, Spanish, Portuguese, and Italian. This gift would later serve him well, for his position with the Genossenschaft required that he handle all foreign correspondence and travel extensively outside of Germany. Once he completed his education, Paulus was apprenticed to a Munich import firm, for which he later served both as salesman and manager, and it was here that he developed the necessary business acumen for his subsequent work with the Genossenschaft.

If his initial training prepared Paulus well for his future duties, so too did his influential contacts. He married into a family of Irish and Scottish descent, which collected contemporary art and was thus acquainted with numerous artists from Great Britain.[5] More important was Paulus' close, indeed intimate, relationship with Luitpold, the Wittelsbach prince who would become Regent of Bavaria in 1886. Paulus' father was the chief forester in Württemberg, and through the hunting expeditions he organized the family had repeated contact with members of the German aristocracy. Luitpold was a particularly frequent guest of the family, and he and the younger Paulus developed a close friendship. When Luitpold assumed the Regency in 1886 he appointed Paulus as one of his privy coun-

cillors, and henceforth relied heavily on Paulus' judgment in aesthetic matters. It was customary, for example, that Luitpold and Paulus visit the Genossenschaft exhibitions together before they opened to the public, so that the Regent might utilize Paulus' expertise in his purchases.[6] Their relationship had obvious advantages for the Genossenschaft, as Paulus often used his influence to sway the Prince Regent in matters that affected the association.

Although Paulus was only twenty years old when he assumed his post in 1871, he was nevertheless accorded a great deal of responsibility and power. His contract specified that he was subordinate only to the chairman and vice-chairman of the association, and he was granted voting rights at the meetings both of the Genossenschaft and of the central committee of the quadrennial exhibitions. In addition to managing the accounts of the association, advising the executive board in financial matters, and handling all correspondence, he also played a significant role in the development of all Genossenschaft exhibitions. His duties included such diverse tasks as readying the Glaspalast for shows, sitting on funding committees, preparing catalogues, and, perhaps most important, helping to obtain foreign works of art. Because of his English contacts Paulus was most frequently sent in this capacity to the British Isles, and on occasion he also went to Austria, France, or the Netherlands. In addition, he functioned as a middleman between local artists and prospective clients, who often contacted Paulus instead of the artist when they wished to purchase a work or make a commission.[7] As Paulus matured, his circle of contacts expanded and his power and influence increased, and by the end of the 1880s he was virtually indispensable to the Genossenschaft and its members.[8]

So valuable were Paulus' services to the association that it was willing to accord the business manager privileges not generally extended to others in similar posts. In addition to his regular salary as business manager, for example, the Genossenschaft gave him a 5 percent commission on any work that was sold at the association's exhibitions. In the context of the debate about annual salons, this arrangement assumes considerable significance. Since Paulus' income could only be augmented by increased sales of art, it is hardly surprising that he wished to mount exhibitions annually rather than only every four or five years.

But Paulus' motives for supporting the annuals were not entirely opportunistic. To the contrary, the business manager was genuinely concerned about the welfare of the Munich art community and convinced that it needed the vitality that annual international exhibitions would provide. Indeed, Paulus risked his considerable reputation by originating and supporting this concept, the success of which was by no means guaranteed in 1888. Preliminary discussions about the idea with the painters J.H.L. de Haas, Wilhelm Lindenschmit, and Gustave Schwabenmeyer, and the art publishers Edgar Hanfstaengl and Georg Hirth, convinced Paulus that some members of the art community already supported the concept, and he informally enlisted them to lobby for its institution.[9] Thus, when the question of the annuals was first raised publicly in August 1888, artists and critics were already familiar with the issue. As autumn approached and the 1888 exhibition neared its conclusion, the possibility of an annual salon increasingly occupied the attention of the Munich art community.

Perhaps the most vocal opponent of an annual exhibition was Friedrich Pecht, an influential art critic who wrote for the *Allgemeine Zeitung* and also published the art journal *Kunst für Alle*. Pecht argued that salons would force artists to work too quickly, thereby vitiating real quality while fostering sensationalism. Moreover, he reasoned, the public would quickly lose interest in art if it were inundated with annual exhibitions. Yet his primary objection to the salon was not practical but cultural in nature. As a staunch supporter of Bismarck and of national unification under Prussia, Pecht propagated a nationalist ideology in his criticism, repeatedly pleading for the development of a unique "Germanic" sensibility in art. It is hardly surprising that he should thus find the concept of annual international exhibitions abhorrent. "Experience teaches," he stated,

that nothing is worse for artists than over-whelming them with impressions of all different types, which such 'international' exhibitions would regularly and necessarily bring with them. [The artists] will be pulled in all different directions, so that in the end the young ones will no longer know what they want or what they are capable of, and will generally degenerate into mere imitators of the works of others.[10]

By contrast, supporters of the annuals considered the overwhelming success of the 1888 exhibition proof that Munich was capable of organizing annual international shows, and their arguments, which set forth the aesthetic, economic, and cultural benefits that would accompany the salons, countered the criticisms offered by Pecht and like-minded pessimists.[11] Arguing that the foreign presence at annual exhibitions would increase the vitality of the art community, proponents suggested that it would also eliminate the need for artists to leave Munich to seek inspiration elsewhere in Europe. Unlike Pecht, who maintained that a salon would tax the limited enthusiasm of the public, advocates believed that it would foster increased understanding of and enthusiasm for art in broad segments of the population. Important, too, were the financial benefits that enthusiasts felt the shows would bring. Not only would the art market expand incrementally, since dealers and collectors would now come to Munich even more frequently, but the large crowds of tourists who would flock to Munich for the annuals would spend their money in Munich hotels, restaurants, and stores, thereby benefiting the entire community. In a request for state support of the annuals, the president of the Genossenschaft, Eugen von Stieler, even mentioned the profits that the Bavarian train system would reap from the increased tourist travel.[12]

If the supporters and opponents of the annuals disagreed on almost every issue, they nevertheless shared a concern about Berlin's resident art community, which by the late 1880s seemed on the verge of a renaissance. Not only did the Landesausstellungspalast open in a Berlin suburb in 1886, thereby making possible the organization in Prussia of major exhibitions, but the capable and energetic Anton von Werner

(1843–1915) assumed leadership of the Berlin art community. Already director of the Institute for the Fine Arts in Berlin, Werner was elected in 1887 chairman of the Verein Berliner Künstler, which like the Genossenschaft in Munich was its city's most important professional art association. This dual position gave him unusual influence, and as a resourceful administrator and determined advocate of Berlin artists he wielded it effectively, improving the scope and quality of the annual salon during these years and vigorously pursuing government support of the arts.[13] This worried both supporters and opponents of annual exhibitions in Munich, who time and again justified their positions by warning of Berlin's ominous specter. Opponents of the concept maintained that the negative effects of yearly salons would permit Berlin to displace Munich as the German center of the arts, while proponents argued that if Munich did not institute annual international salons it would not be able to keep pace with the capital of the Empire. "If Munich gives up hope on the project," said one advocate,

Berlin will soon institute it, and the more we withdraw fearfully into a corner, the more certainly and easily that will happen! But once it's instituted in Berlin, then we can give up even on the five-year exhibitions in Munich, and with the honor the substantial material advantages will also disappear![14]

The forum for the debate about the exhibitions was the *Münchener Neueste Nachrichten*, whose co-owner, Georg Hirth, would later become one of the Secession's staunchest supporters. A publisher and author, Hirth was born in 1841 in Graefentonna bei Gotha.[15] After fighting in the Franco-Prussian War, he moved to Munich to assume the position of editor of foreign affairs and politics for the *Allgemeine Zeitung* in Augsburg, and it was here that Hirth embarked on his lifelong career as a supporter of liberal causes. When his father-in-law died in 1881 he became co-owner of the *Neueste Nachrichten*, in which he devoted increasing space to aesthetic issues as the decade passed. This was in fact a logical development of Hirth's growing interest in the arts. In 1875 he had founded

Knorr und Hirth, a publishing company renowned in Germany for its high-quality limited-edition art books,[16] and in 1896 Hirth would finance *Jugend*, the German *art nouveau* journal whose name engendered the term *Jugendstil*. Yet the publisher's commitment to the arts was not merely professional. On the contrary, he was a passionate collector who also wrote extensively and sensitively on art and aesthetics.[17]

Hirth was an advocate of annual exhibitions from the outset. Throughout the summer and early autumn of 1888 he and his editors consistently published evidence of the need for annuals, while effectively countering all criticism of the concept. No other Munich newspaper or journal dealt with the issue so extensively, and the public was effectively inundated with pro-annual rhetoric. When Genossenschaft members met in a special meeting on 16 November 1888 to discuss the issue, there was little question of the outcome. Hirth and his newspaper had done such an excellent job of shaping public opinion that few artists spoke out against the proposition, and the association voted by an overwhelming majority to institute an annual salon in Munich.[18]

If members of the Genossenschaft had reached a consensus in favor of annual exhibitions, they nevertheless remained divided about the specific nature of the shows.[19] Particularly controversial was the issue of foreign participation at the salon. Very few Genossenschaft members sought to exclude foreign and non-Munich artists completely, but some favored significant participation while others supported only minimal representation of artists from outside the city. Economic factors were of course paramount here, since many artists feared that the market for Munich art would suffer if collectors and dealers had the option to purchase non-Munich work. The final decison was a compromise: although the annuals would primarily serve the Munich art community, other artists would be invited to submit works; but members of the association agreed that—in contrast to the "international" exhibitions, for which foreigners were aggressively wooed—no special effort would be made to secure foreign participation at the annuals.[20] This is an important point, as it would shortly become the cause of considerable friction within the association.

In addition to limiting the participation of non-Munich artists, Genossenschaft members also passed a series of resolutions designed to foster and reward quality at the salons. Three of these were of particular significance. First, the jury was freed of its statutory obligation to grant at least one medal for every forty to fifty works, and was permitted at the annuals to confer as many or as few commendations as the submitted work justified. Notably, this seems to have been particularly controversial, as many Genossenschaft members believed that a reduced number of awards would lead to a reduction in the sales.[21]

Second, the common practice of inviting artists to exhibit unjuried work was prohibited. In the past this was frequently used to entice established painters, sculptors, and graphic artists to participate in the Genossenschaft shows,[22] yet many members rightly felt that the *invités* frequently submitted mediocre works which then had to be exhibited. The practice not only lowered the quality of the exhibitions but also placed the uninvited artists, who were required to submit their work to a full jury, at a decided disadvantage. Henceforth individual jurors were permitted to issue invitations only in highly exceptional cases, and then only for specific works.

Third, the Genossenschaft voted to change radically the installation of the exhibitions. Formerly the shows had been arranged by country, so that most of the works by artists of one nationality were in the same general area in the Glaspalast. This frequently resulted in the superior installation of the work of mediocre artists at the expense of the more talented. In 1888, for example, most of the German work was hung in the best locations in the Glaspalast, whereas all the Italian pictures were installed in the so-called "death chambers," the rooms on the south side of the Glaspalast with inadequate lighting. Henceforth, installations at the annuals would be determined solely by the quality of the submitted works: all the best pictures would be grouped together in superior locations, with lesser works relegated to the undesirable rooms.[23]

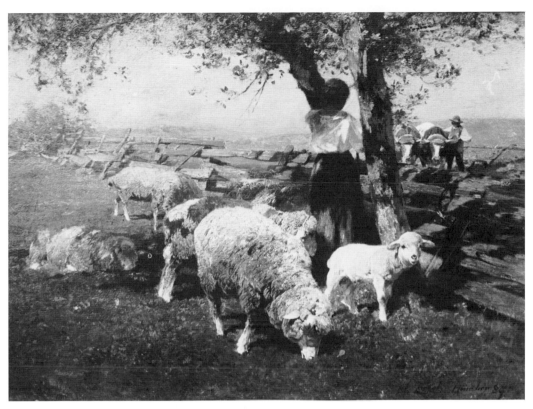

4. Heinrich Zügel, *Shepherdess at the Fence*, 1889

While these measures were in fact nothing more than a codification of standard salon practice in Paris, they nevertheless signified a major policy shift for the Genossenschaft, which since its inception had tried to treat all artists equitably, regardless of reputation, age, or talent. Indeed, in the past the association's egalitarian policies had shifted the responsibility for distinguishing and encouraging quality in art from the juries to more or less discerning collectors, who were credited with the ability to separate the wheat from the chaff. By approving the new resolutions, however, Genossenschaft members called into question such laissez-faire policies and acknowledged instead the value of more selective exhibitions that would clearly define and reward quality in art from the outset.[24]

Yet it is worth emphasizing that this reformulation of the Genossenschaft's program was controversial. The meetings in early 1889 at which these issues were debated were stormy affairs at which tempers flared and grievances were aired.[25] And, as will become evident, if Genossenschaft members ultimately accepted these changes in principle, many nevertheless balked when they were put into practice. Indeed, the association's first annual exhibition, which was held from July to mid-October 1889, was beset with controversy from the outset. Ultimately the furor died down, but it set the tone for the subsequent three years of internecine struggles that finally split the Genossenschaft in two.

The First Munich Annual in 1889

The Genossenschaft got a late start on organizing its first annual exhibition, for the debates about the nature of the salons lasted through February. Elections for the jury, which was to consist of fifteen painters, three sculptors, three architects, and three graphic artists, were not even held until April.[26] With less than three months remaining before the show was to open in early July, many artists, German and foreign alike, were still unaware that an exhibition was to take place in the Glaspalast, which the Bavarian state had again lent to

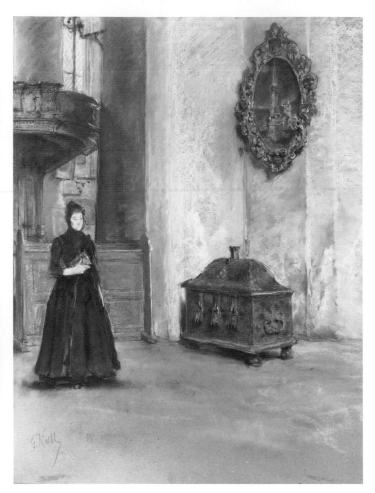

5. Gotthard Kuehl, *View of the St. Jacobikirche in Hamburg*, 1890

Germany. Ten of the fifteen painting jurors, for instance, had studied or worked in foreign countries, a practice hardly customary for Munich artists at that time. Significantly, eleven of the twenty-four jurors would later join the Secession, which would actively promote foreign participation at its exhibitions. Not surprisingly, then, the jury of the first annual used the statutory dispensation to issue a large number of invitations to foreign painters, sculptors, and graphic artists, many of whom accepted.[29]

This aggressive courting of foreign artists was indeed effective. Almost as many foreigners exhibited at the first annual as at the preceding "international," and they actually outnumbered both the local exhibitors and those Germans not resident in Munich. In the end, only slightly more than one-third of the participating artists actually lived in the Bavarian capital, a statistic that troubled Genossenschaft members who had wanted the annuals to favor local painters, sculptors, graphic artists, and architects.[30] Certainly the jury had acted within its rights in issuing the invitations to the foreigners, since it had been granted full authority to disregard the statutes of the annuals. But many had believed that the jurors would proceed in the spirit in which the annuals were conceived—that is, primarily to foster Munich art—and they now felt betrayed.

The jurors exacerbated the conflict by applying unusually high standards in their judgment of German work. To be sure, the Genossenschaft had approved measures designed to improve the quality of the exhibitions, but some members now felt that their enforcement was particularly unjust, since much of the foreign work was from the hands of the *invités* and therefore was unjuried. One artist, whose remarks stand out for their temperance and objectivity, addressed this issue in a letter published in the *Neueste Nachrichten*:

We agree with the majority of the artists that everything that smacks of dilettantism, mass production ("Kitsch"), and the pathological abuse of the mania for originality should be rejected ruthlessly and without regard to the name or reputation of its maker. But here the line should be drawn. If the picture demonstrates artistic effort and talent, the artist should be admitted to the competition: general

the Genossenschaft for the occasion.[27] By the deadline in late May relatively few works had been submitted to the jury for consideration, and the new enterprise seemed doomed to failure.

A special general meeting of the Genossenschaft to discuss the problem was held on 20 May, at which time the jury was granted permission to take any action necessary to ensure the success of the first annual, including extending the submission deadline and issuing the highly controversial invitations that permitted the *invités* to exhibit unjuried work.[28] This statutory dispensation was significant, for unlike the majority of the Genossenschaft most members of the jury, including Ludwig Dill, Gotthard Kuehl, Bruno Piglhein, and Victor Weishaupt, favored significant participation of foreigners at the annuals. Many had themselves spent considerable time outside

opinion, the critique of the artists and the public, will put him in his place. . . . Pictures of average quality do not harm any exhibition.[31]

None of these issues, however, was as divisive as what almost all contemporary observers perceived as the bias of the jury. Even before the exhibition opened, rumors abounded that contemporary trends in art had been favored over more traditional styles, and complaints from members of the art community began to flood the editorial pages of the newspapers.[32] In fact, when the doors to the first annual opened on 1 July, critics invariably commented on the startling differences from the 1888 exhibition. Karl von Vincenti was among the most succinct:

One would have to be blind not to see the remarkable change that has occurred since last summer; for at first glance it practically dazzles the eyes. No doubt but that the diehards have been defeated, and the fanfares of the young *plein air* movement ring out in clear tones. . . . Today only one thing is certain: painting is in the midst of a transitional phase. The so-called new direction is here; it is gaining ground and must be taken into account.[33]

Others identified a pronounced difference in the themes of the pictures at the first annual, and noted that a sober realism had replaced the usual idealized historical and humorous anecdotal subjects. Otto Julius Bierbaum, for instance, remarked that the "social picture is particularly well represented at this year's exhibition, the picture of workers that leads us into the hard reality of anxiety and trouble,"[34] while Friedrich Pecht petulantly questioned whether the physiognomies of laborers would now replace the ideal of the plaster cast in pictures, and complained that "nothing was so apparent at this exhibition as a certain plebeian character, a distaste for everything noble, exalted, and powerful."[35] That Bierbaum could find this praiseworthy while Pecht thought it deplorable exemplifies the variety of responses to the first annual. What is significant, however, is that all Munich artists and critics, whether they applauded or denigrated the tone of the exhibition, agreed that the majority of works at the first annual were exceedingly progressive in style, theme, and sentiment.

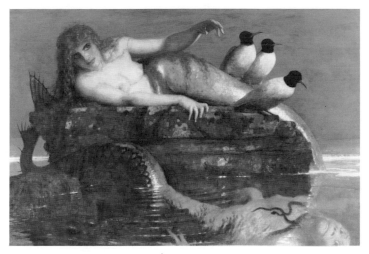

6. Arnold Böcklin, *Calm at Sea*, 1886–87

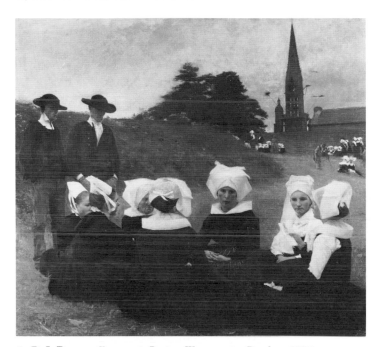

7. P. J. Dagnan-Bouveret, *Breton Women at a Pardon*, 1887

Still, to a twentieth-century sensibility these works hardly seem an expression of "the hard reality of anxiety and trouble," nor do they appear particularly "plebeian." To the contrary, the majority of German pictures at the salon simply and soberly rendered aspects of late-nineteenth-century life without recourse to humorous, historical, or sentimental anecdote. Heinrich Zügel (1850–1941), for example, exhibited a painting similar to his 1889 *Shepherdess at the Fence* (fig. 4), and Gotthard Kuehl (1850–

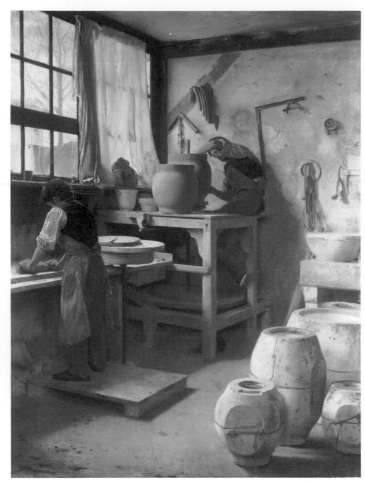

8. Edouard Dantan, *Pottery Workshop*

If the German work was thus relatively traditional in subject and style, so too was that of the foreign exhibitors. Notably, none of the French Impressionists participated in the annual, nor did any of the Symbolists. The Swiss painter Arnold Böcklin (1827–1901) came closest to expressing a Symbolist aesthetic in the four works he exhibited, among which was *Calm at Sea*, 1887 (fig. 6), yet his pictures were exceptional at the salon. The majority of the foreign works at the first annual were characterized by the same sobriety as that of the German pictures. Visitors to the show could admire, for instance, the hard-edged, airless realism of P.A.J. Dagnan-Bouveret (1852–1929), whose image of Breton peasants, *Breton Women at a Pardon*, 1887 (fig. 7), caused something of a sensation that year. Having already received a silver medal at that year's Paris Salon, it was now commended with one of the five first-class gold medals distributed at the first annual. Or they might contemplate a painting by the French artist Edouard Dantan (1848–97), whose *Pottery Workshop* (fig. 8) unpretentiously and without anecdote represents two potters in a workshop softly illuminated by patches of afternoon sunlight. While Otto Julius Bierbaum may have thought this work an expression of the "hard reality of anxiety and trouble," the vaporous haze that suffuses the composition quite literally softens the edge of the potters' labor. Indeed, most of the foreign works at the exhibition, whether defined by the descriptive realism of a Dagnan-Bouveret or the more impressionistic naturalism of a Dantan, represented nineteenth-century life either prosaically, without comment, or with a touch of quiet lyricism.

Even the most daring works at the first annual, among them *The Playroom*, 1889 (fig. 9), and *Suffer Little Children to Come unto Me*, 1884 (fig. 10), by Fritz von Uhde (1848–1911), were firmly rooted in tradition. The former, a remarkably fresh and straightforward genre scene, represents the artist's three daughters and their governess quietly entertaining themselves in a sharply foreshortened room viewed from above. Bright sunlight streams through a window behind the figures, splashing on the floor and casting strong shadows throughout. *Suffer Little Children* is less daring

1915) showed a picture like his *View of the St. Jacobikirche in Hamburg* (fig. 5).[36] Like many of the exhibited works, these compositions unpretentiously record the simple visual presence of figures and objects in their environment. If any sentiment disturbs their otherwise pervasive sobriety, it is a kind of quiet lyricism that originates in the pictures' softly modulated illumination and in the tranquil activities of their subjects. Nor can it be said that a majority of the German works at the first annual were technically innovative. Most were indeed characterized by a painterly surface texture and a light palette, and did in fact render light and shade fairly convincingly, thereby evoking the epithet *plein air*. Yet unlike the pictures of the most daring late-nineteenth-century artists, those that dominated the first annual were invariably finely detailed, well drawn, and conventionally composed.

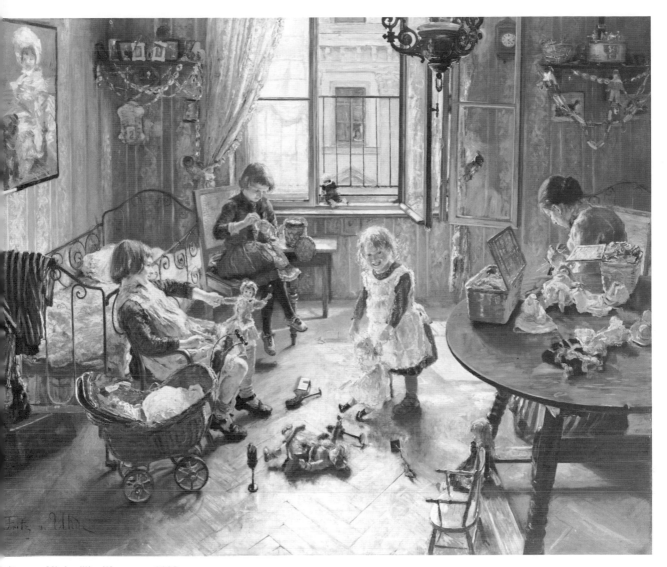

ritz von Uhde, *The Playroom*, 1889

compositionally but was, with its anachronistic subject of Christ in a nineteenth-century schoolroom, among the most radical of the religious pictures at the exhibition. In contrast to the fresh, vibrant colors of *The Playroom*, muted gray-brown tones pervade this image of poverty-stricken children waiting to greet a rustic and bedraggled Christ.

Both works provoked considerable criticism, the former for its radical composition and rendition of light, the latter for its unidealized interpretation of Christ. Karl von Vincenti, for instance, whose remarks about *The Playroom* are notable for their moderation, said of the picture that "the

children trip over all the strident color flecks, and it is a real miracle that the atmospheric perspective of the room—the only saving grace of this *plein air* calamity—doesn't also collapse in this piercing light."[37] Contemporaries were still more distressed by Uhde's anachronistic renditions of Christian lore. *Suffer Little Children* was so controversial that it even caused Uhde considerable embarrassment in Parliament, where conservative representatives attacked the artist for his purportedly crude and brutal renditions of Christ.[38]

Yet, aside from the aerial perspective of *The Playroom* there is little in the picture that was exceptionally innovative in 1889.

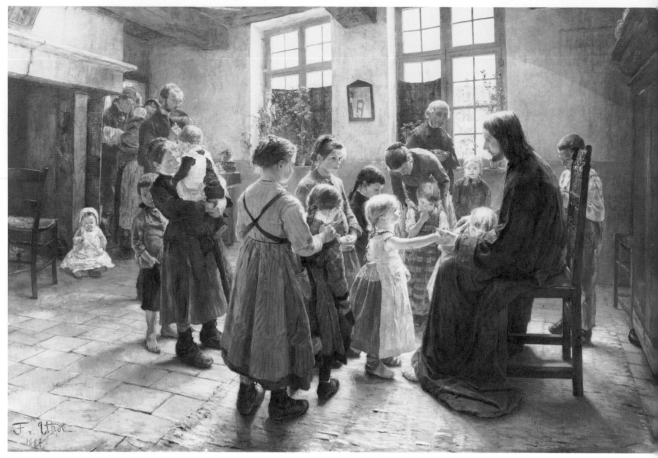

10. Fritz von Uhde, *Suffer Little Children to Come unto Me*, 1884

The figures and objects are not only solid and sculptural, they are rendered with the minuteness of detail and fine draftsmanship that most vanguard French painters of the period had already rejected. Even the vibrant light that so upset Uhde's contemporaries is generated not by unblended complementary colors but by the more traditional addition of white. And while *Suffer Little Children* did in fact represent the indigence of the small children waiting to greet Christ, the image is not one of hopeless destitution. The two small girls nearest Christ appear to glow supernaturally, apparently through the touch of the Savior, whose head is conveniently silhouetted within the frame of the window. His presence seems in fact to fill the room with dancing, darting bits of sunlight that ultimately ameliorate the children's impoverished circumstances.

Albert Boime has used the term *juste milieu* to describe the pictures of a number of artists in the Third Republic who adopted the loose technique and light palette of the Impressionists while giving their canvases a carefully drawn underlying structure absent in the works of their more innovative colleagues.[39] By thus modifying the disquieting features of Impressionism while rejecting the polished technique of the academic painters, artists such as Jules Bastien-Lepage, Paul Albert Besnard, Eugène Carrière, and Alfred Philippe Roll appealed to a heterogeneous French public that appreciated the combination of modernism and tradition. The works that dominated the first Munich annual might be described in similar terms. Technically they unite a relatively light palette and loose technique with solid draftsmanship, while spiritually often joining detailed observa-

tion of people and objects with a lyrical sensibility. The *juste milieu* works that dominated the first annual thereby fused tradition with innovation in both style and sentiment.

Yet, as we have seen, Munich contemporaries did not generally acknowledge the traditionalism of these pictures, but considered such works, and the jury that accepted and commended them, very progressive—even radical. The explanation for this lies in the remarkable popularity and continuing ubiquity in Munich of what might be termed *Lederhosen* painting: cheery, idyllic representations of non-urban life in Bavaria and the Tyrol, which in no way convey the actual existence of the South German and Austrian rural population. This genre, which originated in the 1860s and continued to flourish throughout the 1890s, reached its most accomplished expression in the hands of Franz von Defregger and was popularized by scores of mediocre yet nonetheless sought-after Munich practitioners. Generally characterized by a pervasive gold-brown tonality, pictures of this type most often represent groups of jolly peasants who sing, dance, or drink. The men invariably wear *Lederhosen* and hats with jaunty feathers, and flirt with plump, smiling *Mädeln* dressed in their Sunday finery. A related and equally popular genre translated the cloying sentiment of such works into images of the Franciscan, Benedictine, and Augustinian friars in the Munich monasteries. In *Cheers*, 1884, (fig. 11), for example, Eduard Grützner (1846–1925) depicted an elderly monk, jolly and rosy-cheeked, pausing in his mundane work to lift his beer glass in salutation. In these popular traditions an image that accurately conveyed the realities of either rural or monastic life was a rarity. As one astute observer remarked, such pictures

make one suppose that there is always sunshine in the happy land of Tyrol, that all the people are chaste and beautiful, all the young fellows fine and handsome, all the girls smart, every household cleanly and well-ordered, all married folk and children honest and kind. . . . A rosy glow obscures sadness, ugliness, wretchedness, and misery, and shows only strength and health, tenderness and beauty, fidelity and courage.[40]

It is thus not surprising that Munich contemporaries failed to acknowledge the traditional elements of the works at the first annual, for next to such saccharine renditions of the Bavarian folk most of the pictures at the salon do indeed seem radical in style and sentiment.[41]

Although Defregger exhibited three works at the first annual, many of his colleagues were absent. Grützner, for example, had always been a regular participant in the Munich exhibitions, yet he was not represented with any pictures at the 1889 salon. Indeed, critics who discussed the exhibition invariably noted that the jury had rejected the work of numerous older established artists or relegated it to the "death chambers" in the Glaspalast. Writing for the *Allgemeine Zeitung*, Hans Eduard von Berlepsch praised the jurors for this, gratefully acknowledging that "the dominance of *Lederhosen* and *Landsknechtskittel* has thankfully ended, and in its place is the serious observation of nature as she shows herself without 'marketable' historical garb."[42] Not everyone, of course, saw this in such a positive light, and many members of the Genossenschaft were troubled by the exclusion at the first annual of this popular genre.

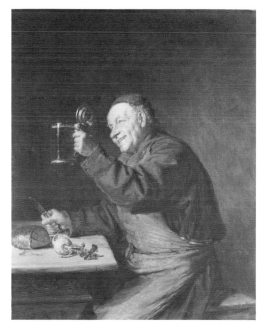

11. Eduard Grützner, *Cheers*, 1884

12. Franz von Stuck, *The Guardian of Paradise*, 1889

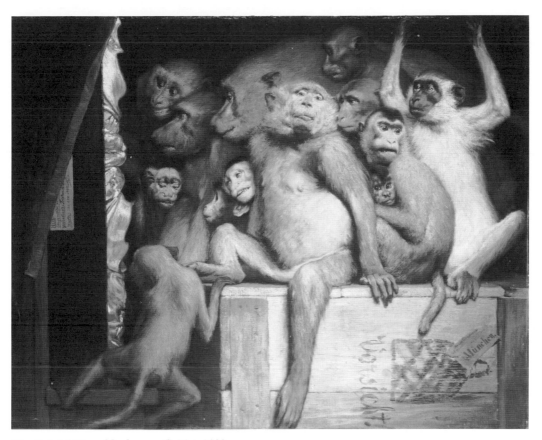

13. Gabriel **Max**, *Monkeys as Critics*, 1889

If a *juste milieu* Naturalism thus dominated the exhibition at the expense of this *Lederhosen* genre, one work nevertheless stood out at the first annual for its innovative technique and unusual subject matter. Franz von Stuck (1863–1928) made his Munich debut in 1889 with three paintings, the most notable of which, *The Guardian of Paradise*, 1889 (fig. 12), received a second-class gold medal. An over-lifesize, androgynous angel stands silhouetted here on a shimmering background of scumbled touches of green, violet, yellow, and orange that increase in brilliance directly behind the winged figure. This is not a chaste, virtuous angel, but an erotic hermaphrodite whose thick, pouty lips and suggestive stance allude to a sensual "paradise." Although the picture was an isolated example at the first annual, it nevertheless heralded a *fin-de-siècle* decadence that would increasingly figure in the Munich exhibitions. For much of the Munich art community, the jury's acceptance and commenda-

tion of such a work was as disturbing as the exclusion from the exhibition of the popular *Lederhosen* paintings.

Gabriel Max (1840–1915) effectively visualized the widespread discontent with the jury's choices in his entry to the first annual, *The Ladies' Club*, ca. 1889 (fig. 13). Later retitled *Monkeys as Critics* by the artist, the painting was among the most cynical at the exhibition. Thirteen apes of varying shapes, sizes, and characters examine a painting visible to the viewer only by its gold frame. A label on the back of the canvas identifies the concealed image as *Tristan und Isolde*, and lists its selling price as 100,000 DM. The work has traditionally been interpreted either as an expression of the artist's well-known fascination with Darwinian philosophy or as a satirical attack on art critics. In the context of the first annual, however, its subject assumes different connotations. Notably, Max was among the opponents of a salon in Munich, and he initially refused to participate in the

first annual. When he finally did submit *Monkeys as Critics*, it was only after the exhibition had opened.[43] The results of the jurying, which generally favored the lighter palette and looser technique of the artist's younger colleagues, could only have increased Max's antagonism toward the enterprise. Ultimately the picture must be read as a satire on the jurors of the first annual, whose work on the show Max likened to that of mere monkeys. A tremendous popular success at the exhibition, the work was ironically, and perhaps somewhat defensively, awarded a second-class gold medal.

But despite the dissatisfaction with the first annual, Genossenschaft members could not deny that it had been a great financial success nor that, dire predictions to the contrary, Munich artists had done remarkably well at the show. Not only did they outsell their other German and foreign colleagues by far, their work commanded substantially higher prices. Moreover, revenues from entrance fees, catalogue sales, and commissions from the sale of art works exceeded expenses by nearly 24,000 DM.[44] It is thus not surprising that, despite the widespread conviction that the jury had betrayed the majority of the Genossenschaft in favoring foreign and younger artists, no significant opposition to the annuals emerged at this time. In fact, the salon already seemed such a permanent fixture in the Munich art community that even before the show closed Genossenschaft president Eugen von Stieler (1845–1929) sought state support for subsequent annuals.[45] Both in informal conversations and correspondence with the Minister of Church and School Affairs, Johann von Lutz, and in a formal petition to the legislature, he requested that the state budget an annual purchasing grant to be used at the Genossenschaft salons for the acquisition of works for the Neue Pinakothek.[46]

Stieler's arguments set forth the reasons why such an allocation of funds was important not only to the Genossenschaft, but to all of Bavaria. Astute enough to recognize the continuing animosity of many Bavarians toward Prussia, he painted a threatening picture of an art conspiracy in Berlin determined to topple Munich from its position as the German center of the arts.

Under today's political conditions, art and science are the only areas in which Bavaria can assume the leading and controlling position in Germany, and as far as art is concerned, it is the only area in which Bavaria still maintains leadership.[47]

But all stops are being pulled out in Berlin to overtake Munich. If anyone, it is Anton von Werner with his energetic character and his great influence at the court who will be able to pull it off.[48]

Stieler easily won the sympathies of the royal cabinet, convincing the ministers that an increase in the annual purchasing grant from 20,000 DM to 120,000 DM was in fact justified.[49] Unfortunately for the Genossenschaft, however, the budget was controlled by the legislature, which was dominated by the conservative Center Party. And not only did the Center reject the kind of art that dominated the first annual, for the first time in decades it was in the position to get its own way in cultural matters.

To be sure, the Center Party—which represented the Catholic, rural, and particularist majority of the state's population—had gained an absolute majority of seats in the Bavarian Landtag as early as 1869, thus wresting control from the liberals and their urban, mainly Protestant and Unitarian constituency. Yet during the 1870s and 1880s the royal government was able to limit clerical influence. For one thing, both Ludwig II and Luitpold continued to appoint liberal cabinets so as to maintain their independence from the Church. For another, the Bavarian government both restricted parliamentary voting to the upper tax brackets, thereby favoring those with education and property, and skewed the franchise to favor cities and Protestant regions over the Catholic countryside. The inequality of this system, and the extent to which it limited clerical influence in Parliament, was evident in elections like that of 1875, when liberals, with 196,700 votes, gained seventy-six seats in parliament, while Catholics, with 280,000 votes, had only seventy-nine delegates.[50]

But by the time Eugen von Stieler sought an increase in the art budget, the liberal government's opposition to the Center had been considerably weakened by the crisis of 1886. That year the schizophrenic King

Ludwig II was ousted by his ministers and drowned soon thereafter while attempting to escape house arrest. Even though the death was accidental, many suspected foul play by the liberals. To make matters worse, Ludwig could not be succeeded by his psychotic brother Otto, so their uncle Luitpold assumed the post of Regent. With both the prestige of the crown and trust in the liberal cabinet so severely shaken, Bavarian Prime Minister Johann von Lutz believed that compromise with the Catholic Landtag was imperative, as did his successor of 1890, Krafft von Crailsheim.

This had ominous implications for the evolution of the arts in Bavaria, for the Center Party's record on culture was by no means encouraging. Indeed, the party saw itself as a kind of cultural watchdog whose duty was to attack anything that questioned the traditional values upon which modern Catholic faith rested. Unfortunately for the Church, changing socio-economic forces in the course of the nineteenth century had already severely undermined these values. Secularization, urbanization, and industrialization produced not just a decrease in church attendance in Germany, but also an increase in geographical mobility that severed family ties and resulted in high rates of illegitimacy, non-marital households, and prostitution. Small wonder, then, that the Church would strongly oppose those aesthetic orientations that, by openly scrutinizing sexual mores and religious beliefs, might further weaken its position. Above all, it was the Naturalists who came under attack for their "blasphemous" and "pornographic" plays, novels, paintings, and sculpture.[51]

Max Liebermann, who exhibited his picture *Jesus in the Temple* (fig. 14) at the Genossenschaft's 1879 salon, was among the first of the Naturalist painters to experience the wrath of the Center Party. The work portrays the young Jesus *sans* halo, in an interior adapted from the Portuguese Synagogue in Amsterdam, conversing vivaciously with the elderly scribes who surround him. One appears mesmerized, shocked into silence by the boy's words, while another listens seriously but apparently withholds judgment. Still another, his back turned toward us, seems frightened,

raising his hand slightly as if to shield himself from some unseen force. It is a remarkable picture that vividly captures the varied responses of individuals confronted by a shock, and it created a sensation in the art community, whose leading figures all proclaimed it a masterpiece. Conservatives, however, lambasted the picture, with one critic describing Liebermann's Jesus as "the ugliest, most impertinent Jewish boy imaginable," a boy, furthermore, who emphasizes his arguments with intense "Oriental" motions of his hands.[52] Center Party representatives concurred, condemning this untraditional, unidealized treatment of Jesus as perverse and sacriligious. Indeed, the Catholics were so incensed at the picture's very inclusion in the exhibition that when the state's grant to the Genossenschaft salons came up for renewal they held a debate about the work on the floor of Parliament. "The noble, divine subject of this picture," said Center representative Balthasar Daller in the session of 15 January 1880, is

portrayed in such a vulgar and vile manner that every devout Christian must feel deeply insulted by this blasphemous image. [In the meeting of the finance committee] I called attention to a famous and qualified art critic, Pecht, who declared explicitly in the *Allgemeine Zeitung* that this picture does not just injure the eyes, it is also a stench in the nostrils of decent people. . . . It should have been up to the entire art community to remove this scandal from the exhibition. I do not wish to violate the religious beliefs of the painter, who, as is well known, is not of the Christian confession, nor do I wish to force him to see as we do the subject of the picture, the divine Savior in whom we place our faith; but that the Munich art community, which wants [our] support, did not prevent such an incident, this, gentlemen, I must firmly censure, and I am horrified that this picture was accepted in a state that is dominated by devout Christians.[53]

Fortunately for the Genossenschaft and for Liebermann, the Center Party at that time had insufficient power to block passage of the grant or to demand removal of the picture from the exhibition, and the painting was merely rehung in a side room to avoid further controversy. But Center representatives made it clear that they could not be counted on for future support if the associa-

14. Max Liebermann, *Jesus in the Temple*, 1879

tion continued to exhibit such works, and
the events of 1886 gave them the necessary
leverage to make good their threats.

In fact, the Genossenschaft's 1890 request
for an increase in the art acquisition budget
was greeted with outrage from the right. In
parliamentary debates the Catholics deliv-
ered rambling speeches as notable for their
illogic as for their deep and almost hopeless
conservatism. Arguing that the Naturalism
that had dominated the Genossenschaft's

first annual exhibition would degrade even
the most holy figures by presenting them as
common street people, they maintained that
pious Christians could not fail to be
offended at such images. Representative
Eugen Jäger was particularly bellicose.
Using one artist's rendition of the Sermon
on the Mount as a repugnant paradigm of
Naturalist painting, Jäger complained that
Jesus was represented in the picture merely
as a common boor,

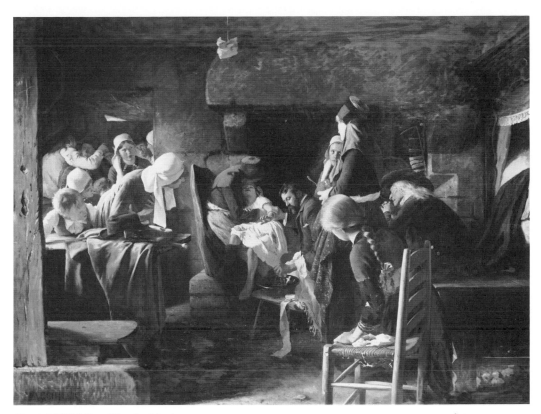

15. Adolf Echtler, *The Accident*

his mother as an old dairymaid, his apostles in such a way that one would think they were taken from a prison or penitentiary. . . . Is it conceivable that with such physiognomies the twelve apostles . . . could have built a church which has imprinted its stamp on the last two thousand years and which will continue to influence society until the end of time? For that, other types are needed than those who are represented in these pictures.

Gentlemen! That is not yet the worst of it. The main originality in a certain branch of the new art is that it paints nature exactly as she appears; Naturalism, which Zola introduced into novels and which has found many imitators in France, is beginning to bloom even here in Germany, is being translated onto canvas and into marble. Not Nature in its beauty and purity, but—I must say—they try to paint dirt as dirt![54]

Jäger continued by paraphrasing Daller's speech of 1880, saying that in an exhibition like the Genossenschaft's first annual it was necessary not only to close one's eyes, but to hold one's nose as well. Concluding by indicting nudity in art and equating Natu-

ralism and *plein air* painting with socialism, Jäger effectively made his point that, for the Bavarian Center Party, art that did not beautify and ennoble life was not merely aesthetically inferior, but politically subversive as well.

Ultimately, though, Berlin's increasingly vital art community and the possibility that Prussia might also now supersede Bavaria as the German art center outweighed even the Center Party's detestation of the kind of art that dominated the first annual. In an impassioned speech pleading for approval of the budget submitted by the cabinet, Minister of Foreign Affairs Krafft von Crailsheim paraphrased Genossenschaft president Eugen von Stieler on this issue. "If, in the course of our political development," he remarked,

we have had to relinquish certain political privileges, we nevertheless do not want to let ourselves be supplanted in the domain of art. . . . It is of the utmost importance that Munich's longtime reputation as an art city of the first order be defended. If it is demoted to a

second-rate art center, its significance is diminished not merely by half, but by much, much more. Indeed, the defence of Munich's position as the German art center is not just Munich's concern; rather, it is a matter for all of Bavaria.[55]

In fact, when the negotiations ended Parliament had approved an annual purchasing grant of 100,000 DM, nine-tenths of which was to be spent exclusively on contemporary works of art.[56] The Genossenschaft had indeed won an important victory.

The Second Munich Annual in 1890

When Genossenschaft members began to plan for the second annual in 1890, they did so with remarkable equanimity. The conflict over jury bias at the 1889 exhibition had been defused, not only by the lively sales of Munich art at that show and the considerable profits reaped by the Genossenschaft from entrance fees and catalogue sales, but also by the passage of the acquisition budget for contemporary art. Genossenschaft members expected that most of the 90,000 DM would be used to purchase works

by Munich artists for the state collections, and felt confident that local sales at the second annual would equal if not substantially surpass those of its predecessor. Spring of 1890 thus found Munich artists hard at work both on the upcoming exhibition and on their own works for that salon. Yet the widely held assumption that 1890 would be a watershed year proved unjustified. Shortly after the opening of the exhibition it became clear that the successes of the first annual would not easily be repeated, and Munich artists quarreled again about holding yearly salons. As in 1889, these conflicts were ultimately reconciled, yet not before tensions grew to an intensity that suggested the Genossenschaft was moving ever closer to an irreparable rupture.

The first major task facing the Genossenschaft in preparation for the second annual was the election of jurors, and in light of the accusations of the modernist bias at the first annual it is not surprising that slightly older and considerably more moderate artists than those who had juried the 1889 salon won seats on the committee. Significantly, while ten out of the fifteen painting

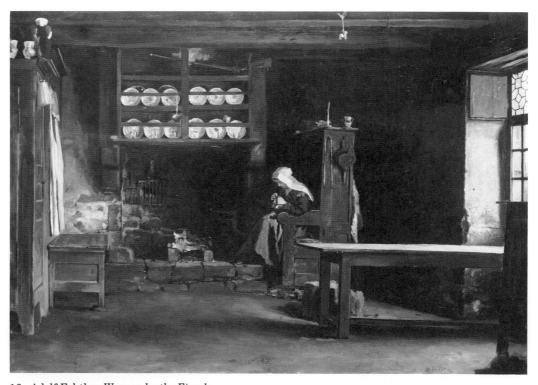

16. Adolf Echtler, *Woman by the Fireplace*

Fritz von Uhde, *Difficult Path*, ca. 1890

jurors of 1889 were to be among the founding secessionists, no one in the 1890 painting section would join that splinter group.[57] Moreover, the chair of the painting section—the most influential position on the jury—was held by the moderate Adolf Echtler (b. 1843), a painter of considerable talent who specialized in genre scenes of rural life in Brittany and Venice. As his picture *The Accident* (fig. 15) illustrates, Echt-

ler was fond of the dramatic anecdote generally avoided by the most innovative Munich artists. Yet he never became insipid, as did so many of the Munich narrative painters, and he was equally capable of rendering the quiet, intimate moments of daily life. His *Woman by the Fireplace* (fig. 16), for example, simply and soberly portrays a Breton woman knitting by a fire. Furthermore, while he generally adhered to the academic

18. Max Liebermann, *The Netmenders*, 1887–89

conventions of strong local color and
detailed rendition of figures and objects, he
often gave his pictures an atmospheric qual-
ity similar to the work of *plein air* painters
such as Uhde. Because Echtler's work thus
united tradition with innovation, many
Genossenschaft members felt that as chair-
man of the painting committee he would
ensure equitable treatment for artists of all
artistic temperaments.

If by electing such a moderate jury the
Genossenschaft hoped to prevent the bias of
the first annual, this did not mean that the
association also wished to relax the strict
standards it had adopted in 1889. On the
contrary, the lively market for Munich art
at the 1889 salon seemed to convince mem-
bers that encouragement of quality might
in fact be beneficial. Consequently, the asso-
ciation approved two new measures that
further eroded the egalitarian tradition of
the Genossenschaft. One permitted the
jurors to disregard the three-work limit in

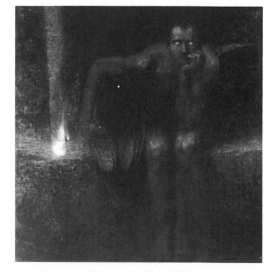

19. Franz von Stuck, *Lucifer*, 1890

Chapter 2

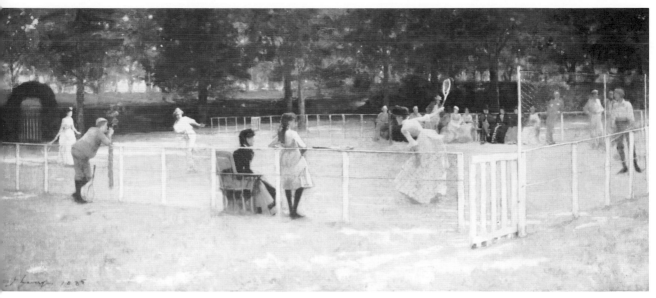

John Lavery, *The Tennis Party*, 1885

exceptional cases, thereby providing yet another mechanism for distinguishing talented from less gifted artists.[58] The other established a medal of honor that could be awarded each year to any artist, regardless of the number of times he or she had previously been recognized. While it is difficult to assess whether these measures significantly improved the quality of the Munich exhibitions, there are indications that the jury succeeded in eliminating many of the less accomplished artists from the second annual. Over half the submitted works were rejected, including some by faculty of the academy.[59]

But if the jurors of the second annual were no less rigorous than their predecessors, their choices were far more heterogeneous. As in 1889, many of the most innovative German artists were allowed to participate in the show. Fritz von Uhde, for example, exhibited his *Difficult Path*, ca. 1890 (fig. 17), which had outraged Catholics when exhibited in a Munich gallery earlier that spring. Originally entitled *The Trip to Bethlehem*, the anachronistic image portrays Joseph and the pregnant Mary as impoverished contemporary Bavarians trudging wearily along a muddy path at dusk.[60] Max Liebermann (1847–1935) was represented by *The Netmenders* (fig. 18), a sober image of communal work in which Dutch women mend fishing nets on a flat

expanse of coastal landscape. Unlike Uhde's picture, which was admired for its accomplished technical execution but criticized for its thematic interpretation, Liebermann's painting was attacked for its roughly scumbled and allegedly unfinished surface. Even some of the German Symbolists were admitted to the salon. Franz von Stuck, for example, exhibited three works, one of which, *Lucifer*, 1890 (fig. 19), portrays a winged male nude staring dementedly at the viewer.

But perhaps the most innovative pictures at the second annual were by painters collectively known as the Glasgow Boys, who were making their Munich debut in 1890 and decisively influenced the evolution of progressive Munich art.[61] This loose-knit group had existed informally since the late 1870s, when a number of Glasgow artists, repelled by the shallow sentimentality of the works of their colleagues, replaced anecdote in their own paintings with more matter-of-fact subjects executed primarily *en plein air*. Taking their cue from the Hague School and Jules Bastien-Lepage, these Scottish renegades—who included James Guthrie, E. A. Walton, James Paterson, W. Y. Macgregor, John Lavery, William Kennedy, Alexander Roche, and Thomas Millie Dow—developed a kind of rustic Naturalism, the main focus of which was figures in rural landscapes. But in the

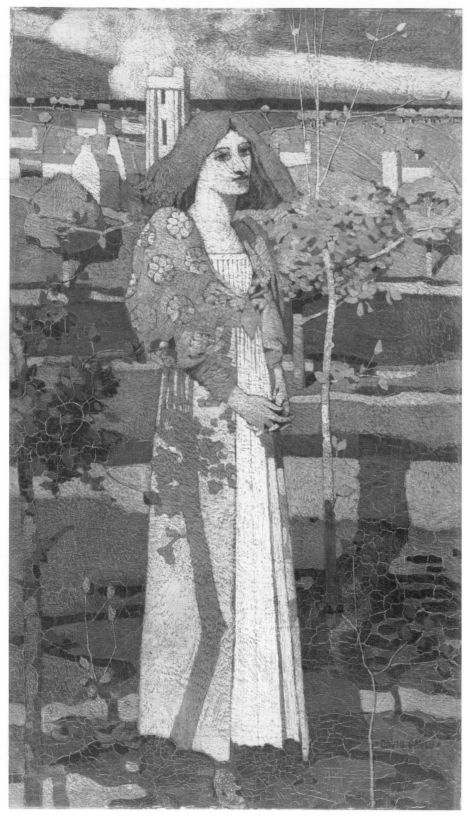

21. David Gauld,
St. Agnes, 1889

mid- to late 1880s painters more concerned with decorative effects and symbolic meaning came to the fore. Working south of Glasgow in the county of Galloway, a region still very much involved with Celtic myth and tradition, George Henry and Edward Hornel produced a body of work not dissimilar in style, content, and sensibility to the esoteric, mystical paintings of the contemporaneous Nabis Paul-Élie Ranson and Maurice Denis. With David Gauld, Stuart Park, and a number of others, they initiated the movement away from Naturalism in Scottish painting.

Seventeen of the "Boys" showed at the second annual, and a number of their most important works were among the sixty paintings and drawings exhibited. The group's *plein air* Naturalist phase, as typified by Lavery's *The Tennis Party*, 1885 (fig. 20), was represented, as was its Symbolist period. David Gauld exhibited his *St. Agnes* of 1889 (fig. 21), in which the world of medieval legend comes to life. Here a young woman gazes longingly into the distance, her figure silhouetted against a landscape whose tesserae-like shapes derive from stained glass, which the artist also designed and produced. Henry and Hornel's joint contribution to the exhibition, *The Druids* of 1890 (fig. 22), was also inspired by legend, in this instance by the mysterious race of men believed to have inhabited the county of Galloway. Priests in procession, their richly patterned vestments highlighted with areas of incised gesso overlaid with gleaming gold leaf, regally descend a hill so precipitous that it is nearly parallel to the picture plane. Similarly, George Henry's *Galloway Landscape* of 1889 (fig. 23) is an antithesis of the Naturalistic landscape painting that had been the Boys' credo five years earlier. Perspective and sizes are here ignored, with Henry compressing foreground, middleground, and background into a single landscape vista with trees and cattle scattered across it in profile. The creek, which snakes its way down from between two hills and then disappears off the bottom of the canvas like a decorative ribbon, underscores the picture's resolute flatness. The *cause célèbre* of the exhibition, the picture was both ruthlessly parodied by hostile critics and celebrated by progressive Munich painters.

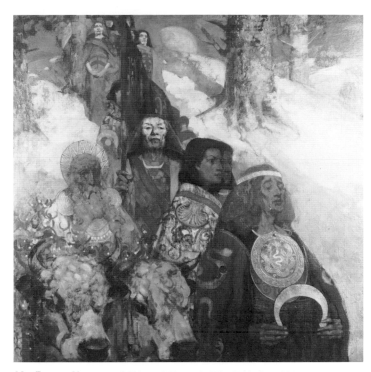

22. George Henry and Edward Hornel, *The Druids*, 1890

The art historian Richard Muther later described the characteristics of these works that most impressed forward-looking local artists. Just when the world was "under the spell of Manet, and recognised the highest aim of art in faithful and objective reproduction of an impression of Nature," he wrote, there burst forth from Scotland

a style of painting which took its origin altogether from decorative harmony, and the rhythm of forms and masses of colour. Some there were who rendered audacious and sonorous fantasies of colour, whilst others interpreted the poetic dreams of a wild world of legend which they had conjured up. But it was all the expression of a powerfully excited mood of feeling through the medium of hues, a mood such as the lyric poet reveals by the rhythmical dance of words or the musician by tones. None of them followed Bastien-Lepage in the sharpness of his "bright painting." The chords of colour which they struck were full, swelling, deep and round, like the sound of an organ surging through a church at the close of a service. They cared most to seek Nature in the hours when distinct forms vanish out of sight, and the landscape becomes a vision of colour,— above all in the hours when the clouds, crimson with the sunken sun, cast a purple veil

over everything, softening all contrasts and awakening reveries.[62]

Indeed, those Munich artists just beginning to search for an escape from the confines of Naturalism learned a great deal from the Glasgow Boys, whose suppression of detail in favor of a broader, more decorative rendering of form, use of deep tonalities that somehow seemed to convey the mysteries of nature, flattening of space, and eschewal of modern subject matter in favor of myth and legend all played an important role in the evolution of Symbolism and Jugendstil in Munich.

Yet if the jurors of the second annual welcomed painters as innovative as the Glasgow Boys, they also embraced far more traditional artists. Those who could not appreciate Henry's stylistically challenging *Galloway Landscape* might thus turn instead to the lyrical illusionism of the considerably more picturesque *Moonlit Night at the Dam Near Besigheim*, 1890 (fig. 24), by

Gustav Schönleber (1851–1917), just as viewers who were offended by the social commentary of Uhde's biblical stories could find solace in the many conventional religious pictures of the Passion of Christ. Similarly, those visitors bored by the prosaic realism of Liebermann or Lavery had the option at the second annual of finding entertainment in the many well-painted but melodramatic or saccharine anecdotal scenes of destitute young widows, jilted lovers, and Tyrolean peasants. Even history paintings, which had been almost entirely absent from the first annual, were a conspicuous presence at the 1890 exhibition. Arthur Kampf (b. 1864) exhibited a scene from the solemn funeral of Wilhelm I, *The Lying-in-State of Kaiser Wilhelm I in the Berlin Cathedral* (fig. 25), while many other artists showed works whose subjects were drawn from Germany's more distant past.

By thus balancing the daring and innovative with more conventional styles and subjects, the jury satisfied the majority of the

23. George Henry, *A Galloway Landscape*, 1889

Chapter 2

24. Gustav Schönleber, *Moonlit Night at the Dam Near Besigheim*, 1890

Genossenschaft, whose members had hoped that the second annual, unlike its predecessor, would accommodate a variety of artistic tastes. One measure of how well the jurors fulfilled their mandate is the virtual absence of hostile criticism of the show. Even Friedrich Pecht, the gadfly opponent of modernism and foreign influence, adopted a moderate tone in his discussion of the second annual.[63] Although he could still complain that contemporary artists rarely dealt with the "exalted" and the "beautiful," his remarks were less acerbic and his attitude less strident. Fritz von Ostini, critic for the *Münchener Neueste Nachrichten*, even saw the diversity of the show as evidence that Munich artists were again developing an interest in idealism after a period of excessive concern with Realism.[64] In short,

those artists and critics who had been disturbed by the modernity of the first annual were placated by the more comprehensive stylistic and thematic range of the 1890 exhibition. Even the fact that only 35 percent of the exhibitors were resident in Munich did not initially disturb Genossenschaft members, who seemed at least temporarily to have forgotten their original intent to focus the annuals on local work.[65] Indeed, Fritz von Ostini proudly flaunted the internationality of the exhibition. "What distinguishes the second Munich annual in the Glaspalast from most other recent exhibitions on the continent, even the Paris Salons," he wrote shortly after the show opened, "is the strong emphasis on its international character."[66] There was not even an outcry when the jury awarded 59 percent

of the medals that year to non-Germans.[67] Thus, while the first annual was beset with controversy from its outset, in its early stages the 1890 salon was relatively conflict-free.

Yet this congenial and complacent mood was short-lived, for Munich artists soon had pressing economic reasons for adopting a more chauvinistic attitude. All too soon it became apparent that, for the first time in the history of the Genossenschaft salons, not only were foreign exhibitors outselling Munich artists by a wide margin, but their work was now commanding higher prices as well.[68] Not surprisingly, within weeks of the exhibition's opening complaints thus began to multiply that many of the foreign works were mediocre and would not have been accepted had they originated in Munich. The system of personal invitations, whereby a juror requested specific works from artists without first securing confirmation from the entire jury, came under attack, since it was used almost exclusively to entice foreigners to exhibit with the association.[69] The conflict was further exacerbated when the exhi-

bition closed with a profit of less than 3,000 DM, in contrast to revenues of over 20,000 DM the previous year. Foreign exhibitors were held responsible for this as well, since the Genossenschaft assumed the costs of the works of foreign *invités*, and these constituted the bulk of the exhibition's expenses.[70]

The foreigners were thus blamed both for the depleted Genossenschaft treasury and for the sluggish sales of Munich work, and members of the association began again to lobby for the exclusion of non-Germans from the salons. One thoughtful observer agreed that future juries needed to be stricter with the foreign submissions, yet he also noted that it was not at all certain whether the elimination of foreign work from the annuals would actually result in increased sales of local work.[71] But such isolated voices of moderation were barely audible in the cacophony of dissension that grew with each sale of a foreign work of art. Indeed, Genossenschaft members, tolerant of the foreign presence as long as it was unthreatening, became decidedly antagonistic when their own livelihood was endangered.

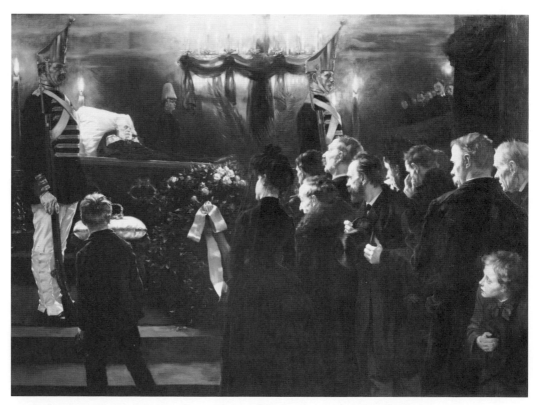

25. Arthur Kampf, *The Lying-in-State of Kaiser Wilhelm I in the Berlin Cathedral*

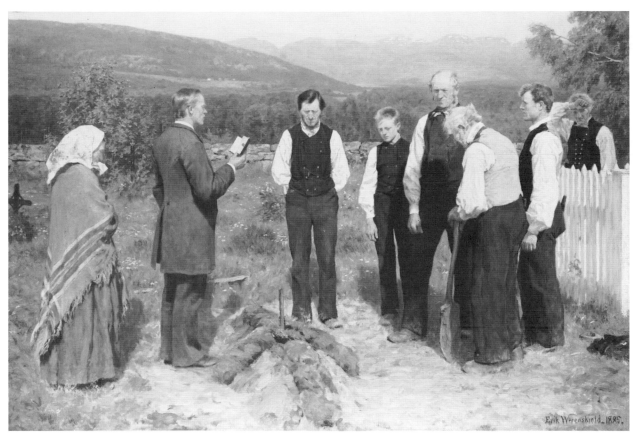

26. Erik Werenskiold, *A Country Funeral*, 1883–85

As the meeting to discuss these various issues approached in mid-December 1890, the atmosphere in the Munich art community was tense and acrimonious. Hans Eduard von Berlepsch, critic for the *Allgemeine Zeitung*, compared the collective Genossenschaft membership to a loaded pistol,[72] and sweeping changes in both the management and nature of the annual exhibitions were expected. Yet despite the discontent in the Munich art community and the widespread assumption that the Genossenschaft annuals were about to be revamped, the meeting proceeded peacefully and without a single dissenting voice.[73] No major statutory revisions were instituted, and within a month members of the association were enthusiastically working on the 1891 exhibition, which promised to be the most comprehensive and spectacular yet. The explanation behind this sudden and rather curious change of heart lay outside Munich, in Berlin, the city that Bavarians loved to hate.

The Third Munich Annual in 1891

For months preceding the December meeting of the Genossenschaft, Munich newspapers closely followed a story about the Verein Berliner Künstler, the Prussian chapter of the Allgemeine Deutsche Kunstgenossenschaft. The Berlin Verein would be celebrating its fiftieth anniversary in 1891, and the association wished to honor the occasion with a large international exhibition in the German capital. By mid-November the plans were complete. The Royal Academy of Arts had agreed to forgo its annual exhibition so that the Verein might, with considerable financial assistance from the state, mount a major exhibition in the summer of 1891.[74]

The news was received in Munich with apprehension. For one thing, it would be more difficult for the Genossenschaft to secure important foreign works for its third annual if another major exhibition was to be mounted in Germany concurrently. But

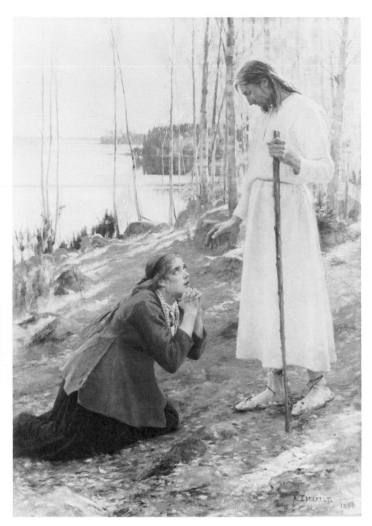

27. Albert Edelfelt, *Christ and the Magdalene*, 1890

annual salon.[75] Such a fusion of academic and independent artists had previously been the unique and salient characteristic of the Munich Genossenschaft, which for years had been the only major artists' association in Germany to unite all members of an art community in an effectively functioning unit. It was this solidarity that had enabled the association to accomplish considerably more than most other European exhibition societies, which were forced to compete, most often unsuccessfully, with local academies for space, funding, and prestige. Anton von Werner's consolidation of the Berlin artists, however, signified that the Berlin art community could now vie effectively with Munich in the organization of exhibitions, and for many Bavarians this implied a threat to their state's hegemony of the arts.

The sensitivity of this issue for Genossenschaft members became apparent shortly before their mid-December meeting. At that time the Verein Berliner Künstler suggested that the Genossenschaft forgo its annual exhibition in 1891 so that the Verein might mount its anniversary salon without competition from a show in Munich. In return, the Verein agreed not to mount an international exhibition in 1892, and argued that henceforth the annual shows should alternate between Berlin and Munich.[76] Had any other organization proposed an arrangement that would permit Munich artists to exhibit annually while lightening their bureaucratic responsibilities, it almost certainly would have received strong support from Genossenschaft members, many of whom were displeased with the current state of affairs in Munich. Yet coming from Berlin the proposal was inevitably taken as a challenge. As one observer sarcastically noted, the Verein's suggestions were considered "unspeakably naive. Just for the sake of the good Berliners, Munich should give up claim to an enterprise that it brought about only with infinite difficulty, but also with splendid success, and as equivalent for that Berlin will renounce something that so far it has not yet even achieved."[77]

By thus antagonizing the Genossenschaft with its proposal, the Verein Berliner Künstler unwittingly defused the tensions

of even greater concern were the implications of such a show. In the past, the Verein Berliner Künstler had commanded little respect in Berlin, possessing only minimal representation on the official commissions and juries traditionally dominated by members and faculty of the academy. It was due to the efforts of Anton von Werner, director of the Institute for the Fine Arts and chairman of the Verein, that the association increased its stature in the early 1890s. Astutely recognizing that unless the academy shared some of its authority artists would increasingly oppose it, Werner successfully argued for greater Verein influence. In 1892 the association even became an equal partner with the academy in the management of the

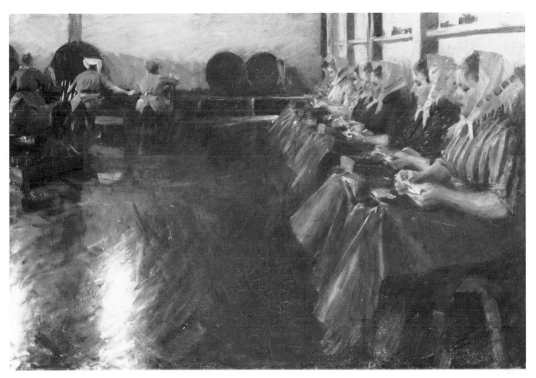

28. Anders Zorn, *The Large Brewery*, 1890

in the Munich art community following the 1890 exhibition. Genossenschaft members now saw the annual salons as a matter of Bavarian honor, and there was unanimous agreement to mount a more spectacular exhibition than Berlin. Since the Verein planned to include a great deal of foreign art in its show, Genossenschaft members even swallowed their bitterness at having been outsold by foreign artists at the second annual and agreed that significant participation of foreigners was necessary to ensure that the next Munich exhibition surpassed Berlin's. Indeed, past conflicts were momentarily forgotten, and a new spirit of cooperative solidarity pervaded the Genossenschaft. As one observer noted, "we must indeed work with all our strength, and everyone to whom Munich's artistic hegemony matters—the general art community, the exhibition committee, the authorities, the press, and the public—can do his part. We must show with our next exhibition what we can accomplish."[78]

In early February the membership at large demonstrated its new commitment to foreign participation by electing to the jury some of the most vociferous advocates of a foreign presence at the Genossenschaft shows. Of the fifteen members of the painting section, which included Franz von Stuck, Wilhelm Trübner, and Fritz von Uhde, eight would soon join the Secession, which from the outset defined itself as an international exhibition society.[79] Uhde, an ardent supporter of foreign participation and one of the few Munich artists to have been trained in Paris, was elected by his fellow jurors to chair both the influential painting section and the entire jury.

Not surprisingly, perhaps, those jurors with extensive foreign contacts were also among the most progressive artists in Munich, and the exhibition they mounted reflected their vanguard tastes. Works that might loosely be termed Realist and/or Impressionist dominated the salon. Many of these were by Scandinavian artists, who were exhibiting in significant numbers for the first time in Munich. Ironically, the Norwegian contingent had been slated to show in Berlin, but twenty-nine of the participants withdrew their works at the last minute in protest at Anton von Werner's

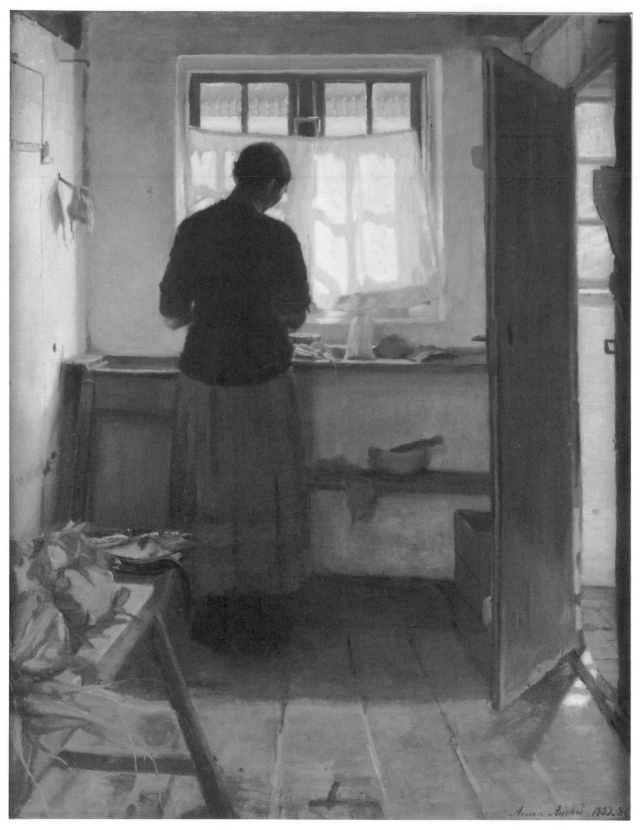

29. Anna Ancher, *The Maid
in the Kitchen*, 1883–86

autocratic handling of that exhibition.[80] The jury of the third annual in Munich was delighted, of course, to accept these works, not only because their presence at the Genossenschaft show constituted a triumph of sorts over Berlin, but also because they reflected the taste of the jury. Among his five pictures, Erik Werenskiold (1855–1938) exhibited *A Country Funeral*, 1883–85 (fig. 26), a sober Realist rendition of a burial attended by taciturn Norwegian peasants. The Finnish painter Albert Edelfelt (1854–1905) was represented with six pictures, one of which, *Christ and the Magdalene*, 1890 (fig. 27), must have particularly appealed to the jury for its thematic similarity to Uhde's pictures. Crisply rendered in a manner like that of Bastien-Lepage, the scene portrays a contemporary Mary Magdalene kneeling before Christ in an anachronistic northern landscape setting. More impressionistic than the detailed Realism of either Werenskiold or Edelfelt were the works of Anders Zorn (1860–1920) and Anna Ancher (1859–1935). Zorn's bravura brushwork was ideal for rendering the hectic ambience of *The Large Brewery*, 1890, (fig. 28),[81] while Ancher's broader handling of paint suppresses details and imparts a quiet, meditative atmosphere wholly appropriate to her entry, *The Maid in the Kitchen*, 1883–86 (fig. 29).

If the Scandinavian Realists and Impressionists were a powerful force at the third annual, so too were their French counterparts. Jules Bastien-Lepage (1848–84), for example, exhibited his *Love in the Village*, 1882 (fig. 30), an image of two young peasants in a landscape that characteristically equivocates between the illusionistic and the flat. Such ambiguous spatial relationships also typified the work of Edouard Manet (1832–83), whose *Dead Toreador* of 1863 and Impressionist *Departure from Boulogne Harbor*, 1864–65 (fig. 31), were posthumously exhibited.[82] Sisley was represented by three works, and both Monet and the Anglo-French painter Tissot participated with four each.[83] Artists from other European countries tended to be less daring stylistically than the French, but their subjects were aggressively Realist. Friedrich Pecht, in fact, was so distraught by the widespread representation of lower-class misery in the Dutch and Belgian pictures

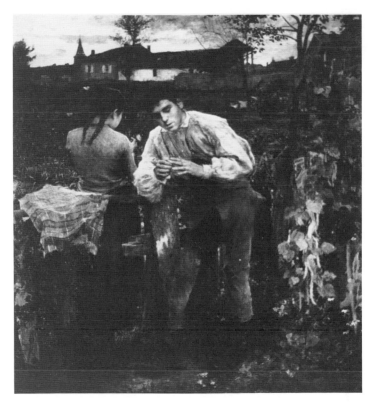

30. Jules Bastien-Lepage, *Love in the Village*, 1882

that year that his comments took on an unusually hysterical tone:

One sees . . . only greasy beggars, such as Israels paints, or insensible, stupefied peasants, as Neuhuys and Artz show, then very dishonorable men and greedy lackeys, as Boks from Brussels represents, or proletarians who have been enraged by ruthless exploitation, as Luyten and Struys present![84]

Indeed, the Realist orientation of the 1891 salon was so striking that even popular journals normally indifferent to art exhibitions took note of it. The *Fliegende Blätter*, for example, published a number of poems and cartoons parodying the show, one of which is set in the house of a Realist painter whose pictures of laborers and peasants lean against a wall. In the first frame a common thief, barefoot and in patched and ragged clothes, hears the approaching footsteps of a constable as he purloins a pocketwatch (fig. 32). By the time the policeman arrives, however, he has stepped behind the only empty picture frame in the room, thus managing to hide from the officer, who finds

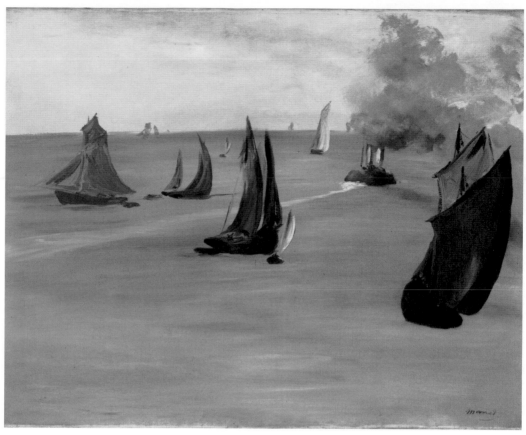

31. Edouard Manet, *Departure from Boulogne Harbor*, 1864–65

it impossible to distinguish the robber from the paintings (fig. 33).[85]

But if Realist and Impressionist canvases thus dominated the third annual, a somewhat smaller yet significant group of Symbolist works was also included in the show. Varying widely in tone and sentiment, these pictures constituted an important foil to the more prosaic images at the 1891 exhibition. One variant was represented by the Scandinavian Neo-Romantic mood painters, who typically combined relatively naturalistic scenes with brooding overtones in their work. The Norwegian Eilif Peterssen (1852–1928), for example, exhibited a view of the landscape near Christiania in his *Summer Night*, 1886 (fig. 34), which, despite its obsessive detail, exudes a melancholy typical of less descriptive Symbolist pictures. Edvard Munch (1863–1944) magnified this inflection tenfold in two of the three works he exhibited at the third annual. Stylistic differences

notwithstanding, both *Night in St. Cloud* of 1890 (now in Oslo's Nasjonalgalleriet) and *Summer Night: Inger at the Seashore* of 1889 (now in Bergen in the collection of Rasmus Meyers Samlinger) translate Peterssen's gentle melancholy into the more urgent, pervasive despair that would come to be Munch's trademark.

Another form of Symbolism at the third annual was both less anguished and more literary in character. Pierre Puvis de Chavannes (1824–98), for example, exhibited his *Game for the Fatherland* (*Pro Patria Ludus*), 1883 (fig. 35), a portrayal of idealized nudes leading a harmonious existence in a remote Arcadian setting.[86] Notably, Puvis's German counterpart, Hans von Marées (1837–87), was given a posthumous retrospective exhibition at the third annual. His thirty pictures—with their simplified designs, compressed space, decorative contours, and reduction of detail—drove home the lessons learned by progressive Munich

artists from the works of the Glasgow Boys in 1890. The triptych *The Hesperides*, 1884–87 (fig. 36), was among the most important of his exhibited works.

Yet another Symbolist current infused the chaste idealism of a Puvis or a Marées with sensual overtones inimical to their Arcadian pastorals. These varied in intensity, from the languid eroticism of *The Blue Hour*, 1890 (fig. 37), by Max Klinger (1857–1920) to the more urgent passion of Franz von Stuck's nymphs, satyrs, and fauns. Even such decorous figures as the Christian saints and martyrs were charged with undercurrents decidedly more sexual than heavenly.[87]

Simply stated, then, the third annual was dominated by variants of Naturalism and Symbolism. Yet unlike the 1890 exhibition, which was characterized by a marked heterogeneity of style and content, the salon of 1891 included very few conventional works of art. Indeed, Philipp Röth, a landscape painter now acknowledged to be among the most important representatives of the German *paysage intime*, and one of the oldest artists elected to the jury that year, bitterly complained that his fellow jurors merely ridiculed works that did not reflect the premises of the most contemporary trends in art. "Since Monday, 25 May, at the jury deliberations in the Glaspalast," he wrote in his diary. "Have attended all the meetings and unfortunately could not prevent the works of virtually all my friends from being rejected. . . . Almost all the jury members have no sense of form or composition, [to which] even the older members pay no heed." When the meetings concluded two weeks later, Röth expressed relief that he had at least managed to get a few works by older artists like Ludwig Willroider and Josef Wenglein through, but noted that "all along I had to listen to comments like 'It's an outrage for our exhibition that such a picture should be accepted.' " Röth ended his commentary by predicting that the jurying would "cause considerable bad blood" in the Munich art community.[88]

And indeed it did. Though the works themselves elicited varied responses from critics and artists, reactions to the bias of the exhibition were remarkably consistent. Virtually all the major newspapers and art journals published articles censuring the

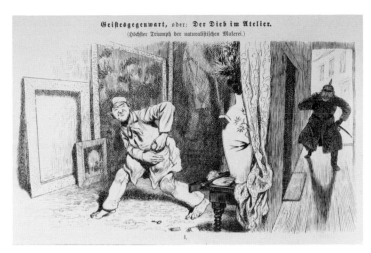

32. The Spirit of the Times, or: The Thief in the Studio, Part I (from *Fliegende Blätter*, 94 [1891])

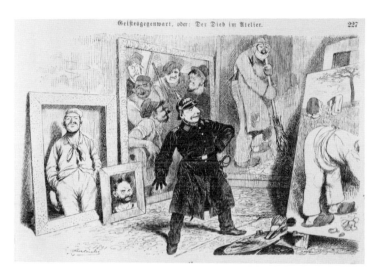

33. The Spirit of the Times, or: The Thief in the Studio, Part II (from *Fliegende Blätter*, 94 [1891])

jury's partiality to the most contemporary trends in art, and the most hostile of these accused the jurors of blatant partisanship.[89] Even those who generally supported avant-garde enterprises questioned the bias of the third annual. Georg Hirth, the co-owner of the *Münchener Neueste Nachrichten* and a staunch defender both of the annuals and of Naturalism and Realism, admitted obliquely that the jury had indeed overstepped its bounds.[90] The most reasonable criticisms came from the pen of the moderate Friedrich Avenarius, owner and chief editor of the Dresden-based art journal *Der Kunstwart*:

It is clear to the outside observer that some things in the management of the annual exhibitions could be different. Perhaps because we consider Uhde's artistic personality extraordinarily vigorous, it even seems doubtful to us that he would be the right man to head the administration—perhaps he is too biased. In any case, it can and should be articulated: even those [in the art community] who are impartial believe that in many cases not always only the quality but also the "direction" of the artist determined the acceptance or rejection, and the good or bad placement, of the pictures. Partiality on the part of those in power for their like-minded colleagues is not necessarily nepotism; it is explicable simply on the grounds of artistic conviction. Nevertheless, it cannot continue for long without damaging the the entire enterprise.[91]

Avenarius' diplomatic reference to Uhde discloses another source of friction in the Genossenschaft. As we have seen, Uhde was elected by his fellow jurors as chairman of the jury for the third annual. This post was exceedingly important in the dynamics of any exhibition, for its occupant was the ultimate arbiter and could thus influence the other jurors by both his aesthetic preferences and his personal style. In 1890 the position had been held by the painter Adolf Echtler, whose moderate views and accommodating personality played an important role in the final outcome of the exhibition, which was more diverse in style and subject than both its predecessor and its successor. Uhde, however, was not only a more radical painter, he was considerably more opinionated and abrasive personally than Echtler.

Uhde had begun his formal career as an artist in the Dresden Academy in 1867, where, however, he remained only three months, ultimately abandoning his studies to launch what would be a ten-year career

34. Eilif Peterssen, *Summer Night*, 1886

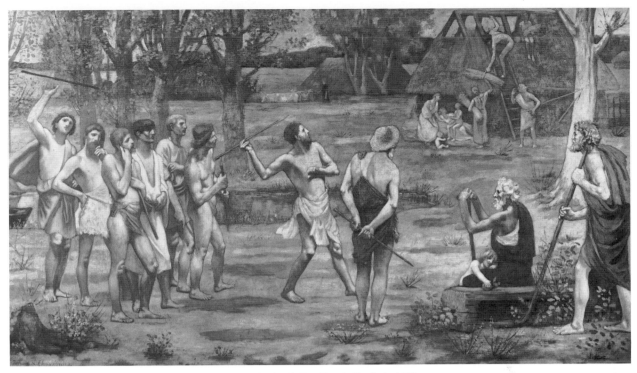

35. Pierre Puvis de Chavannes, *Game for the Fatherland (Pro Patria Ludus)*, 1883

in the military. There he was fortunate in receiving an officer's commission and being assigned to a cavalry regiment, the most prestigious branch of the army. No doubt he also enjoyed the pronounced respect that his dual position as aristocrat and army officer just then commanded in Germany.[92] As a noble Saxon lieutenant in the 1870s Uhde would have received adulation from all sides, and, if the assessments of his painter colleagues are any indication, he emerged from his military years arrogant and self-centered. Hermann Kaulbach saw Uhde as a "very characteristic personality of the military state that was Germany. He symbolizes that brute force to which nothing . . . was holy and which did not hesitate to attack even the most pitiable performance with insolent barrack-room jokes."[93]

Yet if Uhde was indeed proud and egocentric, he was nevertheless very unsure of his own artistic abilities. When he decided to leave the army to resume his career as an artist, he applied to and was rejected by Makart in Vienna and Piloty, Diez, and Lindenschmit in Munich. Uhde finally went to Paris for his schooling, where he entered the private atelier of Michael Munkácsy. As

his correspondence suggests, these multiple rejections and the fact that he found himself a student at the relatively late age of thirty seem to have induced a profound sense of insecurity that was curiously at odds with his arrogant nature. Alfred Lichtwark would later wonder about Uhde's lack of self-confidence, and, in describing what he termed a "persecution complex,"[94] he spoke of the artist's fragile ego in these terms: "Every censure distresses him now. He reads everything negative that is written about him, stays at home and grieves about it, goes to bed and ponders it over and over. No one in the world can remain healthy in such a state."[95]

Not surprisingly, the easily threatened yet opinionated Uhde was extraordinarily intolerant of artistic styles unlike his own, and he was particularly jealous of commercially successful artists. When the acclaimed genre painter Ludwig Knaus submitted his work to the third annual for consideration, Uhde was quoted as calling him "a hindrance to the development of art," a remark that prompted a local journal to suggest that the blustery, bullying jury chairman needed a straitjacket.[96] Indeed,

36. Hans von Marées, *The Hesperides*, 1884–87

Uhde's assessments of the work of his colleagues were often unnecessarily personal, and his example gave the jury deliberations a cutting, unprofessional edge that his predecessors had always managed to avoid. The membership at large quite naturally resented this, and although some could excuse Uhde's behavior on the grounds of "artistic temperament," the painter's numerous detractors found his strident partisanship and doctrinaire attitudes unforgivable.

The modernist bias of the exhibition and Uhde's abrasive personality were not, however, the only sources of friction. Equally irritating to many Genossenschaft members was that the jurors of the third annual included far more foreign art than even the competition with the Verein Berliner Künstler seemed to necessitate—more, in fact, than any jury in the history of the association.[97] Moreover, the foreigners were accorded considerably more space than other exhibitors. Of the eighty-six painters permitted to exceed the three-work limit, for example, seventy-two were foreign, and most of these exhibited a great many

works.[98] Adolf Artz (Holland) and Arnold Böcklin (Switzerland) each showed fifteen paintings, J.H.L. de Haas (Belgium) was represented with sixteen, Mortimer Menpes (England) exhibited twenty-five, and John Reid (England) showed a total of thirty-three paintings. Not surprisingly, because many of the foreigners were *invités* of the association and thus were not responsible for the shipping costs of their own work, the income from entrance fees and catalogue sales did not cover the expenses of the salon. For the first time in the history of the Genossenschaft, the association was faced with a large deficit.[99]

But of all the things that disturbed Genossenschaft members about the third annual, most distressing was the lukewarm reception of local art at that exhibition. As in 1890, foreign artists not only outsold their Munich colleagues by a wide margin, but their work also commanded substantially higher prices.[100] That this was beginning to take its toll on the local art community is evident from the fact that a year later, in 1892, authorities confiscated and auctioned off an unprecedented 4,500 oil

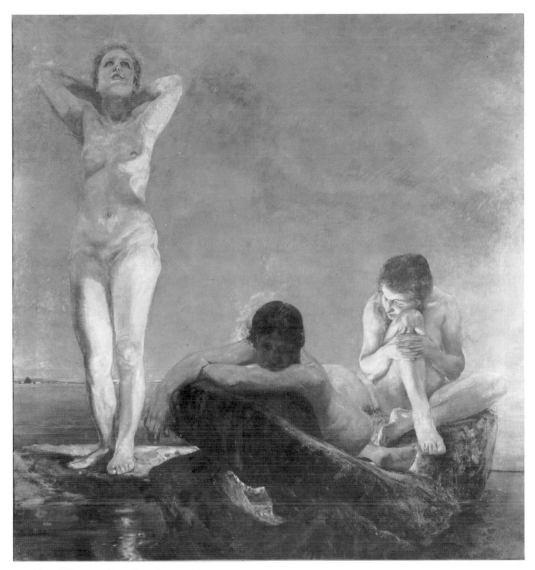

37. Max Klinger, *The Blue Hour*, 1890

paintings from Munich artists unable to pay their bills, in addition to hundreds of prints, drawings, sculpture, and applied-art objects. "The depressing fact of the matter," wrote Michael George Conrad, editor of Munich's avant-garde literary journal *Die Gesellschaft*, "is that the contemporary [Munich] artist has no support, and his career ends, if all goes well, [not in suicide but] in bankruptcy court."[101] Indeed, by 1891 Munich's art community seems finally to have outgrown its means of support, and an increasing number of artists were forced to abandon their profession for more profitable work.

Within this context it is hardly surprising that the foreigners were resented. By the time the exhibition closed in October many Genossenschaft members had forgotten their initial mandate to outdo the Verein Berliner Künstler at all costs, and were now blaming the jury and the foreign artists for their poor sales.[102] One local artist was particularly succinct:

The idea of annual international exhibitions in Munich is an excellent one, provided the good foreign artists always send good pictures. But when mediocre foreign artists send bad pictures, which are then given the best positions and are even purchased by the state; when our

committees and juries take expensive trips to foreign countries in order to bring white elephants to the Glaspalast; when our talented local artists are, with few exceptions, assigned bad positions, or rejected because of "lack of space"; where, then, is the promotion of Munich art?[103]

Significantly, this outburst of chauvinism within the Genossenschaft coincided with the rise to prominence of Julius Langbehn, a cultural critic whose ideas appealed to many in the Munich art community. In 1890 Langbehn made headlines with *Rembrandt als Erzieher* (*Rembrandt as Educator*), a diatribe against modern Germany and its alleged spiritual and cultural malaise.[104] Celebrating Rembrandt as a German, Langbehn cast him as a teacher of a new and final German reformation, in which art, not science or religion, would be the highest good, the true source of knowledge and virtue. This new art would have its roots not—like Naturalism—in objective empiricism, but in the subjective, elemental passions of men. Spontaneous, primitive, and populistic, it would be based in the peasantry, whose virtues and virility could inspire the moral reform of Germany if only a few artistic heroes would point the way, mythically restoring the proper, non-material view of life to the nation and enabling Germany to take its place as the *magister mundi*.

Langbehn's celebration of the peasant as the truly authentic German was among the first public expressions of the anti-urban sentiment that swept Germany during the decade of the 1890s and, as we shall presently see, led many secessionists to take up agrarian themes in their work. But Langbehn's emphasis on the necessity of returning to one's roots, of being true to one's native heritage, also played an important role in the debate about the third annual. Munich artists who opposed the foreign presence at the Genossenschaft salons on the grounds that the local art community was losing sales to the outsiders found in *Rembrandt as Educator* a moral justification of their stance. By invoking Langbehn's model of a rejuvenating, indigenous artistic tradition, untainted by alien influences, they could safely demand that the foreign presence be reduced at the Genossenschaft exhibitions without appearing to be moti-

vated by gain. Indeed, *Rembrandt as Educator* was an instantaneous success with both the general public and the intellectual and artistic elite. Despite its cumbersome style, its disjointedness, and its pretentiousness, it went through forty printings within two years of its publication and was favorably reviewed in almost every major cultural journal and daily newspaper.

Not everyone, of course, agreed with Langbehn's ideas, and there was considerable tension between the cosmopolitan minority and the more chauvinistic majority of the Genossenschaft. In mid-July, just two weeks after the third annual opened, the internecine bickering grew so intense that it spilled over into the public arena. Attendance during the first weeks of the exhibition had been considerably lower than normal, and in response to this Georg Hirth wrote a series of controversial articles for his own *Münchener Neueste Nachrichten*. Hirth accused the Genossenschaft's executive committee, whose responsibilities included publicizing the association's exhibitions, of deliberately trying to undermine the annual exhibitions by failing to publicize the 1891 salon. Citing the association's president, Eugen von Stieler, and secretary, Karl Albert Baur, by name, Hirth stated that both men "were from the beginning opponents of the annual exhibitions, because they feared that the glorious, decoration-rich quadrennial exhibitions would be eclipsed [by them]."[105] These articles, which included other equally serious allegations, assumed an unnecessarily personal tone, at times even degenerating into outright derision. Consequently Baur sued Hirth and his chief editor Ernst Francke for libel and brought them to court in a highly publicized jury trial that was the talk of the town for weeks.[106]

While Hirth's allegations unquestionably arose from a genuine commitment both to art in Munich and to the annual Genossenschaft exhibitions, they nevertheless were largely unfounded. No doubt Stieler, as president of an association dedicated to furthering the interests and well-being of Munich artists, expressed some concern over the abnormally large foreign contingent at the third annual. Yet from the outset Stieler had supported the annuals, and it was primarily through his dedicated

efforts on their behalf that the state had budgeted an annual purchasing grant for contemporary art. Moreover, his correspondence with the state administration demonstrates that he advocated not only the significant participation of foreigners at the annuals, but the state purchase of their works as well.[107] Indeed, Hirth eventually apologized publicly to both Stieler and Baur and admitted that his allegations were unfounded, yet not before he was considerably embarrassed by his trial, at which both he and Francke were found guilty of libel.[108]

The most significant aspect of the affair is that Hirth, though he called no witness who corroborated his allegations, consistently maintained throughout the trial that his information about Stieler and Baur derived from reliable sources within the Genossenschaft whom he did not wish to incriminate. There is little doubt that Fritz von Uhde was involved in this.[109] As chairman of the jury he was more responsible than anyone for the modernist and international tone of the exhibition, and Stieler must have spoken with him at some point about his own and the members' reservations concerning the third annual. Uhde was, however, incapable of responding constructively to criticism, and it is probable that he either misinterpreted or deliberately distorted Stieler's comments.[110] Yet whether Uhde genuinely believed that Stieler was opposed to the annuals, or simply used this as a smokescreen to obscure the widespread discontent with the exhibition he had chaired, is somewhat beside the point. More pertinent to the coming controversy is that the incident reflected the current mood in the Genossenschaft, which had evolved to the point where reasonable discussion of problems was impossible. A pattern of accusation and counter-accusation had been established during the course of Hirth's highly publicized trial, and, as will become evident, compromise would henceforth be virtually impossible for Genossenschaft members. Within several months the association would be permanently ruptured by a secession of its most prominent artists.

3. The Founding of the Munich Secession

 When the third annual closed in late October 1891, the collective mood of the Genossenschaft had rarely been so low. Profoundly depressed by the poor sales at the last exhibition, angered by that show's modernist and foreign bias, and disillusioned by the abrasive personality and intolerance of its jury chairman, Genossenschaft members were determined to revamp their annual salons. To do this, however, it was first necessary to unite the membership behind a platform of reforms, and the first general assembly of the association to follow the third annual was thus preceded by meetings of much smaller groups of Genossenschaft members working to develop an acceptable program. The most influential of these was the so-called "Achtundvierziger" ("the Forty-Eight"), a body of forty-eight artists whose motto "Equal rights for all" summarized their stance on exhibition policy. Notably, numerous jurors of the stylistically and thematically diverse second annual figured prominently in the group. Among them was Adolf Echtler, the moderate and accomodating chairman of the 1890 jury, the landscapist Ludwig Willroider (whose submissions to the third annual had passed the jury only with great difficulty), and the historical and religious painter Karl Marr. Other artists of some renown included Franz von Lenbach and Franz von Defregger.[1]

Two of the Forty-Eight's proposed reforms were particularly significant. The first would confine the duties of the jury to the acceptance or rejection of the submitted works, their subsequent installation in the Glaspalast, and the distribution of awards. The invitation of artists to exhibit at Genossenschaft shows, a responsibility the jury had also assumed in the past, would now fall to the executive committee. This decep-tively innocuous reform meant that jurors would no longer influence the selection of non-German works of art, as foreigners generally submitted works to the Genossenschaft exhibitions only by special invitation. In addition, it would enable the executive committee to invite artists whose orientation was undervalued by the jurors. Indeed, the executive committee might even countermand negative jury decisions by subsequently inviting artists to exhibit rejected works. In effect, such a reform would establish a system of checks and balances in the jurying system, a mechanism for counteracting any possible jury bias.

The second reform proposed by the Forty-Eight would not only reimpose the three-work limit on the juried artists; it would prohibit even Genossenschaft *invités* from exhibiting more than three works within a single category. This had been a particularly controversial issue at the third annual, as of the eighty-six exhibitors who had exceeded the three-work limit in 1891 seventy-two were foreign *invités* of the jury. As the Forty-Eight reiterated time and again, the change was intended not to eliminate the foreign presence entirely from the exhibitions, but merely to give foreign and Munich artists equal opportunities.

The thrust of these proposed changes was to restore to the Genossenschaft annuals a democratic foundation that would guarantee equitable treatment for artists of all ages, stylistic orientations, and nationalities. Although that had been the Genossenschaft's trademark through 1888, the changes instituted with the annuals of 1889 and 1890 had effected a movement away from this egalitarian approach. The division of power between the jury and the executive committee, along with the reinstitution of the three-work limit, would effectively return Genossenschaft policy to its populist origins.

The general assembly of the Genossenschaft met in early December 1891 to discuss the suggestions of the Forty-Eight as well as those of other concerned artists. Though such meetings were generally attended by only 150 to 250 members, this assembly drew the exceedingly large turnout of some five hundred artists, most of whom enthusiastically received the Forty-Eight's egalitarian platform. There were, of course, a number of opponents. Fritz von Uhde, understandably, denounced the group while defending the actions of the 1891 jury. Yet when the issue came to a vote an overwhelming majority of the Genossenschaft rebuffed Uhde and elected to amend the exhibition statutes according to the guidelines proposed by the Forty-Eight.[2]

Adolf Paulus was among those most immediately affected by these reforms. There is little doubt that the business manager—an impassioned advocate of foreign art—would have continued to lobby for increased international participation at the Genossenschaft exhibitions despite the statutory changes, and Eugen von Stieler was among the first to realize this. Although Stieler himself was not opposed to a significant foreign presence at the Genossenschaft shows, as president of the association he nevertheless considered it his duty to implement the new policies as defined by the membership at large. Thus, Stieler simply excluded Paulus from the evolving plans for the upcoming exhibition. The business manager, however, responded by demanding the same rights he had previously held, and Stieler, plainly wishing to replace him with someone more attuned to the wishes of the majority, used this as a pretext for dismissal. By mid-February all ties between Paulus and the Genossenschaft had been severed.[3]

If the executive committee and those Genossenschaft members who opposed significant foreign participation at the exhibitions felt considerable relief at Paulus' departure, advocates of an international presence did not. The statutory changes rendered it useless for supporters of foreign art to band together and elect a pro-international jury; furthermore, Paulus could no longer personally ensure that foreign artists would be included in the exhibitions.[4] Consequently, almost immediately after Paulus'

contract had been terminated the most vocal advocates of international exhibitions in Munich began to consider alternatives to the Genossenschaft.[5] Though it is not entirely clear who actually initiated these informal discussions, most likely Georg Hirth was the moving force behind the separatists. As early as 1890 he had suggested in the *Neueste Nachrichten* that another exhibition society be founded in Munich for the purpose of mounting annual international salons, and he subsequently guaranteed that he could raise the necessary funds to support such an association.[6] But if Hirth originated the concept, it was Paulus who actually implemented it. Initially he coordinated the efforts of a small group of dissidents, which included Bruno Piglhein, Ludwig Dill, Josef Block, Gotthard Kuehl, and Heinrich Zügel, and he soon persuaded several other artists, among them Victor Weishaupt and Franz von Stuck, to join the opposition as well. Indeed, the artists clearly regarded Paulus as the keystone of the movement and relied on his organizational talents and political acumen to guide them through the initial arrangements.[7]

On 29 February eleven artists—Josef Block, Ludwig Dill, Hugo von Habermann, Otto Hierl-Deronco, Paul Hoecker, Gotthard Kuehl, Bruno Piglhein, Franz von Stuck, Fritz von Uhde, Victor Weishaupt, and Heinrich Zügel—announced that they had established an informal club in which they would pursue their goals outside the confines of the Genossenschaft.[8] At this point neither resignation from the Genossenschaft nor the formal creation of a new exhibition society was mentioned, but the positive response this initial measure engendered—nine other Genossenschaft members, including Bernhard Buttersack, Ludwig Herterich, Leopold von Kalckreuth, Paul Wilhelm Keller-Reutlingen, Hugo König, Arthur Langhammer, Guido von Maffei, Robert Poetzelberger, and Fritz Voellmy now joined the dissidents—seemed to convince the artists that they would receive enough support from the Munich art community to guarantee the success of a breakaway group. In mid-March a statement composed by Paulus and Dill and signed by all twenty of the artists just named was circulated among Genossen-

schaft members. The document (given in full as Appendix I below) described the formation of an alternative exhibition society dedicated to the organization of annual international exhibitions, and lobbied for artist support.[9]

The impact of this statement on the Munich art community was astonishing. Over a hundred local artists attended the first meeting of the dissidents in the Kunstgewerbehaus on 4 April 1892, at which time a name for the new association was chosen—the Verein Bildender Künstler Münchens (Munich Society of Visual Artists)—and a fourteen-member executive committee, chaired by Bruno Piglhein and consisting of thirteen of the original twenty founders, was elected.[10] By the end of June the organization had grown to include 107 regular and 67 corresponding members (listed in Appendix III),[11] whose support had been secured by Paulus, Kuehl, and Habermann.[12] In the remarkably short span of four months, then, the number of Munich dissidents had multiplied nearly tenfold. Dubbed by the public and press the "Münchener Secession"—a title which the new association did not formally adopt until October 1892—the artists were now ready for action.[13]

Two documents, both composed by Paulus and Dill, provide insights into the program of the new association. The first announcement of the founding of the exhibition society (Appendix I) was short and concise, designed to attract support among Genossenschaft members already familiar with the events of the past three years. A lengthier statement, published in the *Neueste Nachrichten* on 21 June (Appendix II) and thereafter in numerous German art journals, introduced the members of the group to the public and explained the reasons for their secession.[14] Above all, the secessionists protested the extraordinary size of the Genossenschaft and its domination by mediocre artists, many of whom exhibited only infrequently but nevertheless controlled the association through their electoral majority. Working in an outdated manner geared toward the market, these artists had allegedly ignored the development of art outside Germany and were now hopelessly provincial. The secessionists intended to transcend such provincialism by mounting small

annual exhibitions that would be international in scope and elite in character. Indeed, the new association repudiated the democratic ethic of the Genossenschaft, frankly stating that fairness and equality for all were not its governing principles.[15] Rather, the Secession would limit its membership to "true" or "genuine" artists and its exhibitions to the "absolutely artistic."

That such public statements did not precisely define these terms is not surprising, for the Secession wished to avoid controversy while it sought public and official support during this formative period. Indeed, the executive committee went out of its way to stress that all artists—young and old, innovative and traditional, progressive and conservative—would be welcomed in the new organization as both members and exhibitors, provided their work was of a high level of quality. But quality in art—allegedly the sole criterion for admission to the group's exhibitions—was frequently assessed then, as now, precisely on the basis of style and content, and despite its disingenuous assurances to the contrary the Secession had a specific aesthetic agenda that it hoped to implement.[16] It is in the theoretical writings of Wilhelm Trübner, himself a secessionist, that we find evidence of what this agenda entailed.

Trübner (1851–1917) was born in Heidelberg and studied at the School of Art in Karlsruhe before moving to the Bavarian capital in 1869 to attend the Munich Academy.[17] Here he made the acquaintance of the Realist painter Wilhelm Leibl, under whose influence in the 1870s he painted his most successful works. Like other members of the *Leibl-Kreis*, Trübner was initially convinced that conveying the sensuousness of material things—the juiciness of the pulp of fruit, for example, or the dull gleam of a pewter mug—was the paramount goal of art and could be achieved only through careful observation and meticulous transcription of tone. Indeed, his portraits and landscapes of the 1870s reflect the group's preoccupation with capturing the exact quality of light and shade within even the smallest of areas. With time, however, Trübner ceased to believe that this working method could convey the "soul" of the portrayed object, and he began to advocate distilling details into essences. By the 1890s his compositions

were no longer minutely observed and meticulously transcribed, but were broadly and hurriedly brushed impressions of people and landscapes.

Trübner outlined both his own aesthetic assumptions and those of the Secession in a small but exceedingly important pamphlet published shortly after the founding of the new exhibition society. Indeed, though "Das Kunstverständnis von Heute" ("Art Appreciation Today") refers neither to the Secession nor to the Genossenschaft by name, it uses virtually the same rhetorical terminology adopted by Paulus and Dill in the Secession memoranda, while clarifying it considerably. In this treatise Trübner described two types of artists who are best understood as personifications of the Genossenschaft and the Secession. On the one hand there is the "popular" artist, whose anecdotal subject matter and accessible style are determined by pedestrian taste, and on the other the pure or *reinkünstlerisch* painter, who disdains the use of anecdote because it obstructs the search for a "genuine" and vital painterly style. Faced with an uncomprehending public accustomed to narrative pictures, such an artist defiantly proclaims:

I don't need to paint a beautiful face, I don't need an interesting event as a subject, and I also don't need to pose the depicted objects theatrically or to hide in velvet, silk, and satin what is in itself a beautiful material. Instead I simply choose an unpretentious subject with no overt action, no beautiful exterior, and no decorative effect, with the figures in a natural, unforced attitude, in the most common of everyday clothes. For all beauty must lie not in the natural beauty of the depicted object, but in the . . . manner of representation (itself).[18]

These are the words of the Realist in Trübner, who still believed that what mattered in art was the careful transcription of figures and objects in their natural settings. Yet, as we know, by the 1890s Trubner had already modified this approach to painting, and his Symbolist predilections found expression in the pamphlet as well. In numerous passages, for example, he criticizes artists who use photography as an aid in their work for their slavish dependence on visible reality. In Trübner's estimation, "genuine" art begins only when the momentary and specific in nature are distilled into essences and ideas. Thus the "true" artist strives not to produce an accurate, objective transcription of contemporary reality but, rather, to render visible its intrinsic properties that are at once timeless and universal.[19]

In short, like many other progressive artists of the 1890s Trübner sought to bridge the gap between Naturalism and Symbolism, each of which he identified in "Art Appreciation Today" as representative of the "true" and "genuine" in art. Together with the 1889 and 1891 Genossenschaft exhibitions—which were juried by many of the founding secessionists and were dominated by Naturalism and Symbolism—Trübner's pamphlet provided eloquent testimony to the Secession's aesthetic assumptions.

It is nevertheless important to distinguish the views of the dedicated executive committee and those of the rank-and-file membership, many of whom were only partially committed to the causes of artistic modernity and cosmopolitan internationalism. Trübner himself favored the promotion of the most contemporary aesthetic trends, but he had serious reservations about annually importing large quantities of foreign works of art to Munich, and he was quite vocal about this both before and after he joined the Secession.[20] Others were even less dedicated to the program of the Secession, joining merely to capitalize on the many advantages that membership in that association would bring. For the radical act of secession served to call attention to the dissidents and their art; in addition, the relatively small size of the new association guaranteed its members more exhibition opportunities than were possible in the unwieldy Genossenschaft—a particularly important benefit given the state of the local art market in the early 1890s. As one Secession member later noted, "the main concern of most was: Will you do better here, will you be better hung? There were only a few idealists who thought of the whole, of something lofty, of progress."[21]

Nonetheless, the enthusiasm and determination of the few dedicated "idealists," all of whom had won seats on the Secession's decision-making executive committee, were initially enough to forge a coherent policy.

Indeed, the founders of the group had already defined the goals of the association, acquired the necessary support within the art community, and won some public backing. But perhaps the most important ingredient for success—an exhibition space—was still lacking. Consequently, on 17 June 1892 the group petitioned the newly appointed Minister of Church and School Affairs, August Ludwig von Müller, for permission to use either all or part of the Glaspalast, or another state structure, to hold annual salons.[22]

Despite the rosy predictions of the *Neueste Nachrichten*, there was little likelihood that this request would be granted. On the one hand, the current mood of Parliament was such that the royal cabinet could hardly have risked supporting the secessionists even if it had wished to do so. Müller was not, of course, required to obtain permission from Parliament to give the Secession a state building in which to hold its exhibitions. But parliamentary approval was necessary to renew the annual purchasing grant for contemporary art, and in its session of 7 March 1892, at which this grant was reviewed, Center representatives had attacked the third annual of 1891 for its modernity and international scope. Particularly controversial was Uhde's *Flight into Egypt* of 1891 (now lost), which characteristically represented the Holy Family as contemporary impoverished Bavarians. Citing this as an example of the pernicious influence of foreign art on Munich painters, the speakers linked what they saw as a French-inspired Naturalism with socialism.[23] Given that Uhde was one of the founding secessionists, and that the new exhibition society was controlled by like-minded vanguard artists who intended to exhibit a great deal of foreign art at their salons, it is hardly surprising that the royal cabinet would not wish to endanger the art purchasing grant by giving the secessionists a gallery space and thus antagonizing the Catholic-dominated Parliament.

Yet the cabinet itself also had serious reservations about the Secession, albeit of a somewhat different nature from those of the Bavarian Center Party. Although Müller opposed neither foreign art nor the most contemporary aesthetic trends,[24] he was concerned about the ramifications of a divided

art community. Both he and the Prince Regent had in fact already tried to persuade Paulus and the dissident artists to rejoin the Genossenschaft.[25] His negative reply to the secessionists on 21 June 1892 focused on Munich's reputation as an art center, and the harm that a rupture in the art community would do to that reputation. "The [cultural] ministry," he wrote,

does not expect that a lasting division among the Munich artists and the consequences this would have on Munich exhibitions will have the beneficial effect that the Verein der Bildenden Künstler anticipates. It is largely due to the undivided collaboration of the entire art community that Munich's art is in the dominant position [in Germany], one that it has occupied since the powerful efforts of his late majesty King Ludwig I. A permanent corporate division into groups is only too well suited to confuse circles both far and wide and to weaken the reputation of Munich, which has been in the past so alluring. . . . [It] follows that, given the current state of affairs, the royal state ministry is not in the position to supply the association, one that is organically segregated from the whole, with the backing it requests.[26]

With one avenue of support now closed to them, the secessionists turned to the Munich city government, which, in contrast to the increasingly conservative state Parliament, remained a bastion of liberalism throughout the 1890s. In response to the group's request for the use of municipal land on which it might build an exhibition gallery, the Magistrat (or city council), under the leadership of Mayor Wilhelm von Borscht, formed a committee to explore the question. After careful consideration, its members unanimously concluded at the end of July that the program of the Munich Secession would be detrimental to Munich and its art:[27]

Munich owes its outstanding importance among German cities to *art and artists*, however highly one may rate other factors in its development. . . . We have therefore followed with careful attention the spirited movement that has taken place in circles of the Künstlergenossenschaft during and after the exhibitions of the last years. . . . We believe that the organization of a second international exhibition in addition to the annual international salon of the Künstlergenossenschaft would constitute a great financial and artistic danger for

the Munich exhibitions, and that the city of Munich . . . cannot reach out its hand at this time to help establish a second exhibition gallery that would be a lasting tribute to the splintering of the artistic strength of the city.[28]

It is significant that neither the aesthetics of the Secession's leading members nor the projected international scope of the group's exhibitions was at issue for the state and city administrations. Instead, the overriding concern of both governments was that the Secession and its program would destroy the unity of the Munich art community. This unity, they correctly felt, had been essential in the development of Munich's exhibition system, which was considered central to the city's reputation in the German Empire. In short, the source of their initial opposition to the Secession was the unusually intense cultural pride that marked the attitudes of so many late-nineteenth-century Bavarians.

For the moment, then, the Secession found itself with no backing from the city and state authorities. Unable to locate a suitable exhibition space in Munich, the executive committee thus began to look elsewhere for a home. It did not have to search far, as delegations from both Dresden and Frankfurt, anxious to strengthen their cities' cultural life, had already expressed interest in providing a base for the secessionists.[29] In Dresden, the construction of a municipal exhibition gallery had been under consideration for some time, and local officials seemed willing to implement this if the Secession would guarantee that it would exhibit in the city for five years. The Frankfurt delegation, organized by the city's mayor, offered the Secession the considerable fund of 500,000 DM and promised also to assume financial liability for the group's exhibitions. Negotiations with the two cities took place during the month of August, and by early September the Secession had actually begun to conclude a contract with Frankfurt.[30]

It was then that the executive committee first demonstrated the political perspicacity that came to characterize the early years of the Secession. Sensing that the Munich authorities would intervene if they perceived a real danger that the Secession would leave the city, the executive commit-

tee did not keep these negotiations secret but instead publicized in the *Neueste Nachrichten* its apparently successful attempts to locate outside of Munich. This did indeed effectively galvanize the municipal and state administrations, for whom the prospect of the emigration of Munich's most talented artists was too much to bear. In late September Mayor Wilhelm von Borscht and Minister of Church and School Affairs August Ludwig von Müller together began joint negotiations with the Secession and the Genossenschaft to facilitate a compromise. As city council members noted in a letter to the Genossenschaft pleading for its cooperation, art was such an important cultural component of the city that Munich authorities could ignore the situation no longer. "Munich," they wrote,

has grown great through art. Its outward appearance, its enterprises, its social life have all been beautified and ennobled by the influence of art, and it is thanks to art that its festivals have a singular magic that is unparalleled elsewhere. . . . We wish to cling to this fundamental fact and return to it when it threatens to be forgotten in the battles and bitter words of the moment.[31]

Four possibilities were considered by the negotiating parties. The first provided for the exhibition of 1893 to be jointly organized by the Genossenschaft and the Secession; the second, for that salon to be mounted by the state, which would call on members of both associations to serve on the central committee that determined exhibition policy; the third, for annual exhibitions to be sponsored by the Genossenschaft and the Secession in alternation; and the fourth, for the state administration to give the Secession a building in which to arrange its own exhibitions.[32] Each of these options granted the Secession significant concessions, an indication of just how effective the group's tactics had been in winning community support. Ultimately, though, Müller ruled out the last two possibilities,[33] and on 7 October 1892 he notified both the Secession and the Genossenschaft that they had exactly three weeks in which to finalize the details of a jointly sponsored exhibition for 1893. If they were unable to reach an agreement by the end of October, the government would itself begin preparations for a state exhibition.[34]

There was little likelihood, of course, that the two associations would come to an agreement, and this was made clear by the conditions each society set for its participation in a state exhibition.[35] Whereas the Genossenschaft asked that the salon be installed in a unified fashion, the Secession stipulated that each society be granted exactly half of the Glaspalast for distinct exhibitions juried and installed by separate committees. And while the Genossenschaft felt that the central committee should have three Genossenschaft members for every Secession representative, the Secession demanded equal representation on the committee. In addition, the Genossenschaft wanted Paulus' successor to hold the post of business manager, whereas the Secession sought an independent business manager with no affiliation to either association.

Müller did his best to accommodate the demands of both associations, and the parameters he set for a state exhibition represented a fair compromise.[36] Though the state did not wish to organize the exhibition in such a way that the split in the art community would be apparent, it agreed that each association could have its own jury and installation committee. In addition, the members of each organization might exhibit together in separate rooms, provided they did not specifically distinguish themselves from their counterparts. The central committee would consist of six or seven Genossenschaft members, three Secession members, one or two representatives of the municipality, and one state appointee. Since the city council was an aggressively liberal body whose representatives would no doubt support the secessionists, this distribution in effect guaranteed six or seven votes to the Genossenschaft and four or five to the Secession, with a state representative as the ultimate arbiter. As the Genossenschaft had roughly eight times as many members as its offshoot,[37] such an arrangement actually could be said to favor the Secession. Moreover, Müller acceded to the Secession's demands that an impartial business manager be appointed by the state.

These major concessions were not enough for the Secession, however. In an unusually lengthy meeting on 26 November 1892 the members considered the government's proposals, and then voted not to participate in a state exhibition under the proposed conditions.[38] No doubt their earlier success in locating alternative exhibition sites and the conciliatory response that such attempts had initially elicited from the Munich authorities convinced the secessionists that they could do still better. Their confidence was not unwarranted.

Philip Eulenburg, the Prussian ambassador in Munich, had followed the negotiations between the two art associations and the Bavarian government with great interest. Shortly after their collapse, and unbeknownst to the Bavarian state ministries, he approached Emperor William II with the suggestion that the secessionists might be won for Berlin. Though the Prussian ministries could enter into negotiations with the Secession only at the risk of souring relations with Luitpold, the Berlin city government—over which, as Eulenburg disingenuously claimed when questioned by the Bavarian Prime Minister Crailsheim, the Prussian state had no control—might arrange for a Secession exhibition without serious political repercussions. Eulenburg was given permission to act as an intermediary, and, apparently on his advice, the Secession then petitioned the Berlin municipality for an exhibition space. Though no venue was immediately available, the city council made it clear that it would do all it could to facilitate an exhibition of the Munich Secession in Berlin in 1893.[39]

In fact, when Dill, Piglhein, and Paulus initiated negotiations with the executive committee of that year's Grosse Berliner Kunst-Ausstellung, they were warmly welcomed. Not only did the committee promise the secessionists one of the prime locations in the state exhibition hall for their show, it also agreed that they could have their own jury and installation personnel. Moreover, of the 2,452 objects exhibited at the salon, the secessionists were allowed approximately 450 works, or nearly 20 percent of the total number. The association could hardly spurn such courtesy, and thus, ironically, the first exhibition of regular and corresponding members of the Munich Secession was held in Berlin from 14 May through 17 September 1893.[40]

There was, however, almost no chance that the secessionists would find a permanent home in Berlin, so the executive com-

mittee continued its search for an exhibition site in Munich. Its perseverance paid off. On 3 March 1893 the committee announced at a general meeting of the Secession that a member of the city's board of works, Franz von Brandl, had agreed to give the Secession a vacant plot of his own land for a five-year term.[41] A contract signed at the end of March formalized the arrangement,[42] and the Secession could now move forward with the financing and construction of a gallery space.

The piece of land donated by Brandl could hardly have been more desirable. It encompassed roughly 36,000 square feet at the intersection of the Pilotystrasse and the Prinzregentenstrasse, the latter of which was known for its refined tone and expensive real estate. As one foreign visitor noted, "few streets possess an individual character more distinctly defined, or a charm more readily felt. It is spacious, dignified, and—if for the sake of the connotation the term may be permitted—princely."[43] In addition, Brandl's plot was just opposite the Bavarian Residence and Court Garden as well as the vast English Garden, and it was but a short walk from what is still Munich's most elegant street, the Maximilianstrasse. As contemporary guidebooks noted, the neighborhood was extremely fashionable,[44] frequented by the affluent of Munich who shopped in the expensive boutiques, strolled in the court garden, and took their afternoon tea in the local cafes. The Secession's executive committee must have been delighted with its good fortune, for there was no locale that could better underscore the association's self-avowed elitism.

Within one month of procuring the land, construction of the Secession's exhibition gallery began. This was possible only because the executive committee had asked Munich architects to submit their plans for a possible design as early as July of 1892. After Brandl offered the land, Paul Pfann, professor of architecture at the Münchner Polytechnikum, was asked to adapt his proposal to the specific site.[45] In addition, the normally complicated process of financing the costs of construction was expedited by the Secession's wealthy benefactors. Thomas Knorr and Georg Hirth, co-owners of the *Neueste Nachrichten*, underwrote

loans from local banks to be repaid by the Secession in five annual installments of 25,000 DM each.[46] By the scheduled opening date of 15 July 1893 the structure was indeed complete (fig. 38). In less than three months, a gallery consisting of a main central hall and twelve smaller rooms with skylights had been constructed. The entrance, approached by steps and framed by two pairs of Ionic columns, was visible from both the Pilotystrasse and the Prinzregentenstrasse. Interior and exterior were simple and functional, the outside walls articulated only by slightly recessed rectangular panels punctuated by windows. Capped by an octagonal cupola, the Secession's understated home suited its elegant surroundings admirably.

Meanwhile, members of the executive committee were working to organize the exhibition itself, and their efforts were marked by the same shrewdness that had characterized their negotiations with the Munich authorities. Two major tasks remained before the association could hold its first Munich show. First, foreign artists had to be persuaded to exhibit with the Secession rather than with the Genossenschaft. This was of particular importance, as the secessionists had made the participation of non-Germans a central issue in their fight with the Genossenschaft. Fortunately, the second prerequisite—procuring public and/or private promissory notes to cover the unlikely possibility that the exhibition might be a financial failure—would easily be met if the cooperation of the foreigners could be arranged.

This was no simple task, however. Though German artists were acquainted with both the events of the past years and the program of the Secession, foreigners were generally unfamiliar with the new exhibition society. Moreover, even the Genossenschaft had difficulty securing the cooperation of foreign artists, particularly the French, who had ample exhibition opportunities within their own country. One way the Secession dealt with this was to enlist the help of its German members who had studied or worked abroad. Max Liebermann, for example, visited Holland regularly and had extensive contact with painters of the progressive Hague School. He was asked by the executive committee to per-

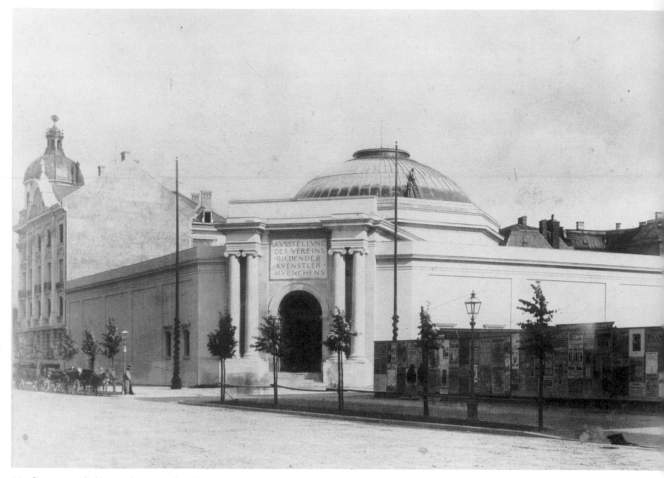

38. Secession Gallery, photograph of 1893

suade his Dutch colleagues to exhibit not with the Genossenschaft but with the Secession. Liebermann willingly complied, writing the painter Jan Veth:

My best friend, you must certainly know that a *Sezession* took place among the German artists last year, comparable with that in Paris. All the foreign artists—you just as much as Israels, Mesdag, etc.—form part of our *Sezession* and everything would be fine if only the Bavarian government in Munich, which is in the hands of the clerics, wasn't against us. We don't care a fig for the government, but what is very important is that the palace in Munich where the exhibitions are held (the Glaspalast) has been given to the opposition. They . . . are putting on their usual exhibition and they'll be sending a certain Bartels to invite you to take part. Piglhein, the president of the *Sezession*, has just asked me to make sure that you come in with us . . . and I hope the Hollanders won't join in with those old fogies.[47]

Such personal appeals were generally very successful. As described below, most members of the Hague School did in fact exhibit with the Secession, although they had shown with the Genossenschaft in past years. But the executive committee did not have such valuable and influential contacts everywhere, and thus another method of publicizing the exhibition was needed. It was Ludwig Dill who came up with a solution. In a letter to foreign artists describing the new association and its goals, Dill not only deceptively implied that the Genossenschaft would no longer include foreign work in its shows, but he also cited Adolf Paulus' name *and* his title of Royal Privy Councillor—without the knowledge of the business manager and to the considerable consternation of Luitpold and the royal cabinet. This created the false impression, of course, that the Secession was backed by the govern-

ment, which no doubt seemed to the letter's recipients a guarantee of the exhibition's importance.[48] Consequently, a great many foreign artists accepted the group's invitation to participate in its exhibition, with many agreeing to join the Secession as corresponding members—all of which was publicized in detail in the *Neueste Nachrichten*. Given that paper's enormous circulation, it is not surprising that the public was quickly convinced that the Secession had superseded the Genossenschaft in importance.[49] By late April 1893 the association had already collected promissory notes in the amount of 136,000 DM, an impressive display of support which only grew in magnitude in subsequent weeks.[50]

Still more promising was the city council's change of heart. Once the Secession had procured the land on which to build a gallery, Ludwig Dill again requested the municipal support that the group had been denied nine months earlier. Noting that the Secession's status had improved drastically, Dill slyly threatened the council with the emigration of the Secession should it not receive the desired financial support.[51] Though it was in fact highly unlikely that the secessionists would now leave Munich, the wound caused by their participation in the Berlin exhibition was deep, and the specter of Prussia usurping Bavaria's cultural dominance of Germany irritated it still further. Moreover, the municipal government could do nothing further to prevent the Secession from occurring; it was now an accomplished and irreversible fact. Consequently, the Munich city council voted at the end of April to provide the Secession with some of the support it requested. By May that sum was defined as collateral against financial failure and was fixed at 20,000 DM, which was to be divided into equal annual installments and distributed over the subsequent five years.[52] Though the figure was not large, amounting to only 4,000 DM annually, municipal support constituted an important psychological victory for the Secession.

In addition, the antagonism of the royal government had also dissipated considerably by the time the Secession's first exhibition opened. While the Ministry of Church and School Affairs would not use any of the art purchasing grant to buy works directly

from the Secession show, in at least one instance Müller worked through an intermediary to obtain for the Neue Pinakothek a painting that was exhibited there.[53] Moreover, though Prince Luitpold—still angry because the art community had been splintered[54]—refused the Secession's invitation to inaugurate the show,[55] he nevertheless visited the salon with Paulus before its formal opening on 15 July 1893, ultimately acquiring four paintings from the exhibition.[56] Though these purchases in no way corresponded to the Secession's rather inflated expectations of state and royal backing, they were still significant, if unofficial, gestures of goodwill, as well as an important harbinger of the future. In 1894 the state began to divide its purchases from the annual art acquisition budget between the Secession and the Genossenschaft, and in 1896, one year before Franz von Brandl was to reassume ownership of the Secession's land on Prinzregentenstrasse, the state even provided the association with new business offices and a permanent gallery space in the Kunst- und Industrieausstellungsgebäude (fig. 1). In return the Secession agreed to participate in the quadrennial "international" exhibitions in the Glaspalast, which it did from 1897 on.[57]

Indeed, the association had achieved a remarkable degree of success in the fifteen months since its founding. Not only had it constructed an exhibition gallery in an astonishingly short time and persuaded many foreign artists to exhibit there instead of with the Genossenschaft, it had also won considerable public and private support. But if the Secession had established itself as a powerful presence in the Munich art community even before its first exhibition opened, that position was still more secure when its show closed in late October. For this salon introduced the Munich public to an entirely new concept in exhibitions, one which, while controversial, breathed life into what many believed was a moribund system.

The Secession's First Munich Exhibition

Just three days after the Secession salon opened in the new gallery on Prinzregentenstrasse, the young August Endell (1871–

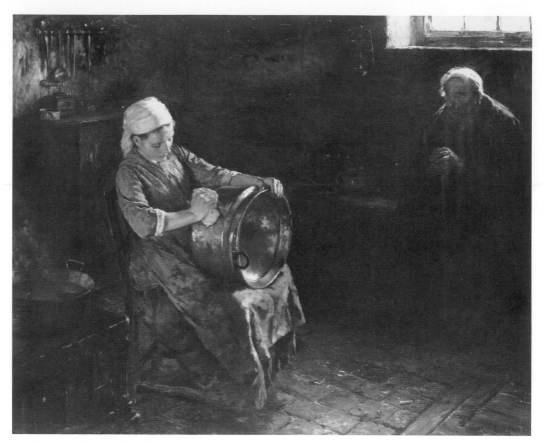

39. Max von Schmädel, *His Everything*

1925) wrote a cousin in Berlin that it was stunningly successful. "There," he noted, "one can truly learn to understand what modern painting is and what it attempts to be, and I can only advise you to come here."[58] Three years later Endell would scandalize Munich with his designs for the revolutionary Studio Elvira, one of the first and most striking architectural manifestations of Jugendstil in Germany. Indeed, this building heralded a new era in Munich art, one that saw the emergence of the journals *Simplicissimus* and *Jugend* as well as the maturation of Wassily Kandinsky, Paul Klee, Franz Marc, and Alexei von Jawlensky. Endell is thus a particularly significant witness to the Secession exhibition, and his description of it as especially "modern" assumes considerable importance in the context of turn-of-the-century German art.

But if Endell was one of the more prominent contemporaries to so characterize the first Munich exhibition of the Secession, he was by no means the only one. While many of Endell's colleagues did not share his enthusiasm for the Secession's modernity, nearly everyone agreed that the exhibition on Prinzregentenstrasse was exceptionally progressive. From the conservative Friedrich Pecht to the liberal editor of the *Zeitschrift für bildende Kunst*, Carl von Lützow, contemporaries who saw both Munich shows invariably commented on the vanguard tone of the Secession salon and the more traditional character of the Genossenschaft show.[59] Careful comparison of the two exhibitions does in fact sustain such descriptions, though not without qualification. As will become evident, the actual situation was more complex than many contemporary accounts suggest.

An integral factor in the perceived modernity of the Secession salon was its installation. Curiously, there are few, if any, pictures of the group's early exhibitions, but contemporary descriptions abound, providing ample testimony of the Secession's inno-

vations.[60] Whereas the Genossenschaft mounted its 1893 exhibition in the Glaspalast as it had in past years, constructing elaborate architectural decorations of cardboard and plaster while hanging pictures in multiple tiers on boldly patterned wallpaper and tapestries, the Secession departed radically from this arrangement. In addition to abandoning the complex interiors, the association also replaced the obtrusive wall hangings with delicate, light-colored wallpaper that did not compete with the works of art. The small Secession Gallery thus appeared more open and spacious than the large Glaspalast, an effect further intensified by the superb lighting of the building, whose twelve exhibition rooms were each equipped with a skylight draped by a white cloth designed to mute untoward glare. As one appreciative visitor put it, there were "no dark, heavy draperies, no wood carvings or panels, no deep, warm saturated colors, nothing of the traditional heavy, dignified, ostentatious splendor. Everything is new, fresh, modern, everything glitters and sparkles . . . in light, clear tones."[61]

Perhaps the most significant departure from tradition, though, was the exhibition's comparatively small size. While the Genossenschaft showed approximately 2,800 works, the Secession exhibited only about 900 objects, 650 of which were paintings hung in a single horizontal row.[62] This arrangement simplified the viewing of the exhibition considerably, for it reduced the commotion caused by visitors moving back and forth to view the pictures above and below eye level in the tiered installation of the Glaspalast.

The sum effect of these innovations was striking. Whereas the crowded and noisy Genossenschaft salon had an element of spectacle and popular entertainment similar to a street fair or carnival, the Secession exhibition was intimate and discreet, providing few distractions for serious viewers and offering ideal conditions for personal interaction with the works of art. As the critic Alfred Freihofer noted,

the great advantage that the Secession has over the Glaspalast . . . is the reduction of the space and number of pictures to an amount that a normal visitor is capable of enjoying. But even this would not be fully utilized if there were not something else that the Seces-

40. Jacob Maris, *Allotments Near the Hague*

sion has over the Glaspalast: the artistic atmosphere that embraces us the moment we enter and that does not let go, that tells us: here we are dealing with noble affairs of the human spirit and not with an annual fair.[63]

If the arrangement of the Secession salon thus seemed strikingly modern to contemporaries, so too did the works of art. In fact, the Secession exhibition was very similar to the third annual in its focus on some of the most contemporary movements in European art. Like the 1891 show, the modernity of which had in part precipitated the founding of the Secession, the exhibition on Prinzregentenstrasse was dominated by Naturalism, but now Symbolism in its many different guises played a greater role.

Typical of the painters working in a Naturalist style was Max von Schmädel (b. 1856), who that year showed the picture *His Everything* (fig. 39). An intimate scene of lower-class domestic life, this image represents an elderly man observing a young woman scrubbing the sides of a washtub.

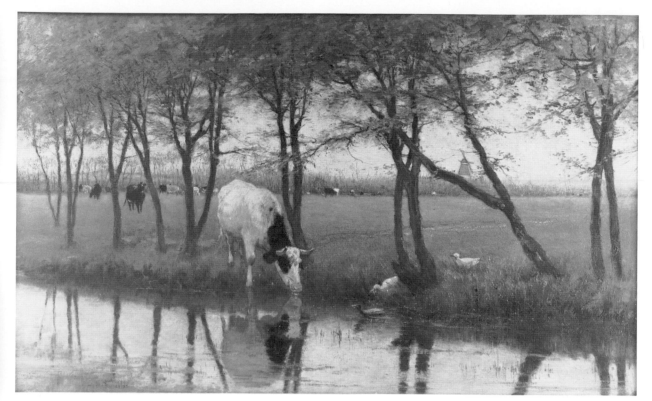

41. Willem Maris, *Drinking Cow*

42. Eilif Peterssen, *Mother Utne*, 1888

terizes the work of the Naturalist painters of the Hague School, who participated in the Secession salon at the urging of Max Liebermann. From Jacob Maris (1837–99), who exhibited three pictures like *Allotments Near the Hague* (fig. 40), to his brother Willem (1844–1910), who participated with two paintings similar to *Drinking Cow* (fig. 41),[64] the artists of the Hague School drew their unpretentious, ordinary subjects from the everyday lives of the peasant and fishing communities of the Netherlands. Such works neither dramatize nor criticize these lives, but simply present them prosaically, or with a tinge of lyricism. Indeed, despite their disparate subjects and styles and their varying countries of origin, *Mother Utne*, 1888 (fig. 42), by Eilif Peterssen, *Haying*, 1882 (fig. 43), by George Clausen (1852–1944), and *Landscape Near Cloister Seeon, with Telegraph Pole*, 1891 (fig. 44), by Wilhelm Trübner (1851–1917), all share a certain sobriety of sentiment alien to the anecdotal paintings of the popular *Lederhosen* painters exhibiting in the Glaspalast.[65]

This relatively objective, detached vision was even applied to subjects traditionally

Apart from the title, the artist avoided any trace of sentimental anecdote or overt social commentary, preferring merely to record the simple visual presence of figures and objects in a room gently illuminated by patches of light. Such prosaism also charac-

treated with reverence, as illustrated by one of the most controversial pictures in the exhibition, Max Liebermann's 1891 portrait of Carl Friedrich Petersen (fig. 45).[66] Born in 1809 and elected mayor of Hamburg twelve times between 1876 and 1892, Petersen was a popular and respected statesman. But though Liebermann emphasized his status by portraying him in his official mayoral vestments, the artist made no attempt to conceal the effects of age on the elderly subject. Head bowed, shoulders somewhat stooped, the eighty-two-year-old Petersen appears frail and unsteady, almost shrinking from the public eye as he hesitantly turns to the side. Though Wilhelm Trübner, who advocated such objectivity in "Art Appreciation Today," no doubt applauded Liebermann's dispassionate vision, most contemporaries were appalled that the artist would treat Petersen so irreverently.[67] The painter Franz von Lenbach best summarized widespread hostility to the picture when he critized the seces-

43. George Clausen, *Haying*, 1882

44. Wilhelm Trübner, *Landscape Near Cloister Seeon, with Telegraph Pole*, 1891

45. Max Liebermann,
*Mayor Carl Friedrich
Petersen*, 1891

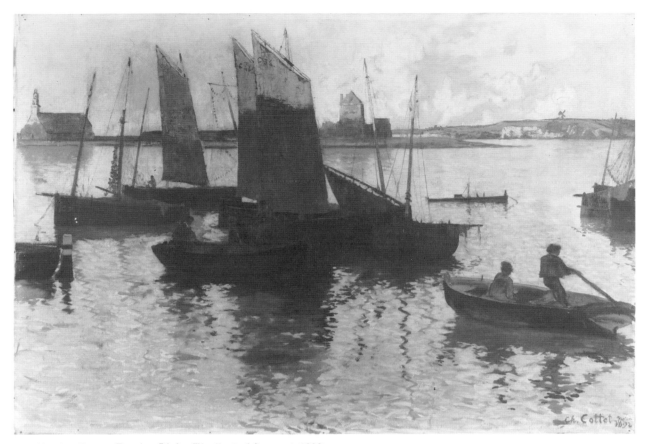

46. Charles Cottet, *Evening Light: The Port of Camaret*, 1892

sionists' "dilettantish fuss about truth [to nature]," stating unequivocally "there is no Truth without Beauty."[68]

If the Secession's first Munich exhibition was dominated by pictures that—despite their diversity of style and subject—rendered specific, everyday experience fairly objectively, a great many paintings nevertheless slighted the particular to emphasize instead the subjective and the general. As in 1891, these Symbolist works were heterogeneous in character, ranging in style from the illusionistic to the quasi-abstract and in sentiment from the chaste to the sensual. Yet all take us from a world of external facts to a less immediate, more universal realm of feelings and sensations.

One subgroup of Symbolist pictures, almost as large as the Naturalist contingent of the exhibition, might best be defined as Neo-Romanticism, or mood painting. Artists working in this manner typically transcended objective description in their

pictures by charging rather ordinary, illusionistically rendered subjects with psychological or emotional currents alien to more mundane Naturalist images. Frequently, such works have as their subjects early morning or evening landscapes, or figures in such landscapes, as the light conditions peculiar to these times are particularly well suited to investing the commonplace with preternatural overtones. The French artist Charles Cottet (1863–1924), for example, exhibited a painting similar to *Evening Light: The Port of Camaret*, 1892 (fig. 46), a scene that is rooted in the specific, identifiable reality of a Breton harbor at twilight.[69] Yet the image—with its deep, sonorous tonalities and stark contrasts of light and dark—exudes a brooding melancholy absent in the more matter-of-fact Naturalist landscapes. Peder Severin Kroyer (1851–1909), one of many Scandinavians working in this manner and exhibiting with the Secession, showed a portrait of his wife on the beach

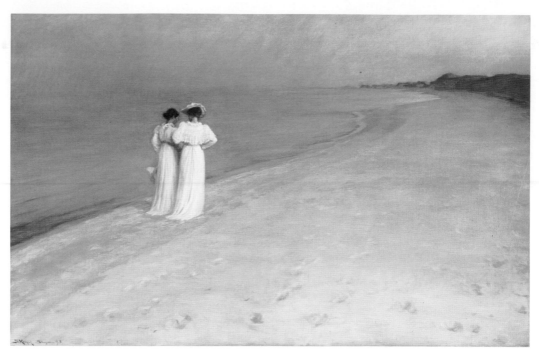

47. Peder Severin Kroyer, *Summer Evening on the South Beach at Skagen*, 1893

that was very similar to his *Summer Evening on the South Beach at Skagen*, 1893 (fig. 47).[70] Like Cottet, Kroyer suppressed detail in favor of a broader rendering of flowing form, while simultaneously adopting a pervasive mauve-blue palette that undermines the specificity of the subject and establishes a quiet, contemplative mood. Similarly, in the allegorical *Spring* (fig. 48) the German painter Otto Eckmann (1865–1902) interpreted landscape not as a place to play or work, but as a place to dream. Indeed, Eckmann's youthful woman seems an entranced, hieratic presence, floating through the blooming flowers of a spring meadow. With its flattened compositional space, geometric disposition of objects, and emphasis on contour and pattern, this image reflects the artist's interest in Jugendstil, though like the paintings of Cottet and Kroyer it is still essentially rooted in the illusionistic tradition. The aesthetic represented by these three pictures, which unite Realist style with Symbolist sentiment, embodies the two predominant movements within the Secession—Naturalism and Symbolism.

Another variant of Symbolism takes as its subject illusionistically rendered figures and objects in unreal situations or settings that mirror not objective reality but intangible feelings, dreams, and sensations. A particularly noteworthy example of such an approach is Franz von Stuck's *Sin*, 1893 (fig. 49), one of nine paintings he exhibited at the Secession salon. Perhaps the most notorious work of art to have been produced in *fin-de-siècle* Munich, the picture portrays a femme fatale whose seductive gaze is paired with the piercing stare of the serpent curling languorously around her bare shoulders. With its softly brushed forms and inky shadows, the image transported contemporary viewers from the world of substantive objects to a more immaterial realm of fantasy and desire.

Stuck's picture, set as it is between the golden classical columns of the artist's handmade frame, is apt introduction to yet another type of Symbolism that was represented at the Secession exhibition. Artists working in this manner were equally interested in exploring the realm of subjective experience divorced from contemporary reality, but they did so through a less representational style. One of the eight watercolors Carl Strathmann (1866–1939) exhibited, for example, depicts a medieval princess crown-

ing the victor of an athletic competition (fig. 50). Yet the subject is almost completely obscured by the tangled interplay of lines and forms that assume a life of their own, independent of the figures and objects they delineate. Carlos Schwabe (1866–1926), best known for his design of the poster advertising the first Rose + Croix exhibition, participated in the Secession salon with three watercolors, two of which were illustrations to Emile Zola's neo-mystical novel *Le Rêve* (The Dream). *Angélique on Her Deathbed* of 1892 (fig. 51), in which detail is downplayed in favor of generalized shapes that evocatively suggest the timelessness and universality of death, was one of these.[71] Similarly, Gerhard Munthe (1849–1929), who was inspired by the ornamental patterns of ancient Norwegian arts and crafts, employed an abstracted formal vocabulary in the suite of eleven watercolors that he exhibited. The flattened space, areas of pure color, and firm outlines of works like *The Suitors* (fig. 52) and *Horse of Hades* (fig. 53) were so well suited to the decorative arts that Munthe later used these watercolors as cartoons for tapestries.[72] Despite their obvious differences,

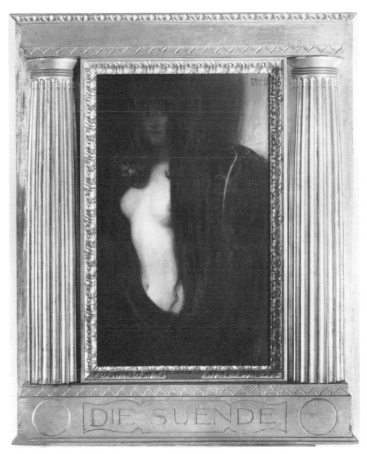

49. Franz von Stuck, *Sin*, 1893

works by artists like Strathmann, Schwabe, and Munthe share certain characteristics that distinguish them from more prosaic Naturalist images, including flattened compositional space, sinuous line, pure color, and decorative patterning, as well a thematic heritage in myth, literature, and the imagination.

The first Secession exhibition in Munich thus integrated the dispassionate, *plein air* pictures of the Naturalists with the more evocative images of the Symbolists, thereby juxtaposing the work of moderately progressive artists with that of some of the most innovative painters of the early 1890s. But so, too, did the Genossenschaft salon. Visitors to the Glaspalast could see, for instance, *Knucklebones*, ca. 1888–89, an Impressionist rendition of four children playing on a rocky beach by the English painter P. Wilson Steer (1860–1921). The Symbolist Fernand Khnopff (1858–1921)

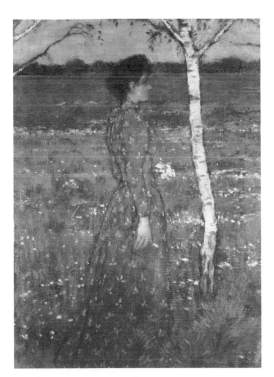

48. Otto Eckmann, *Spring*

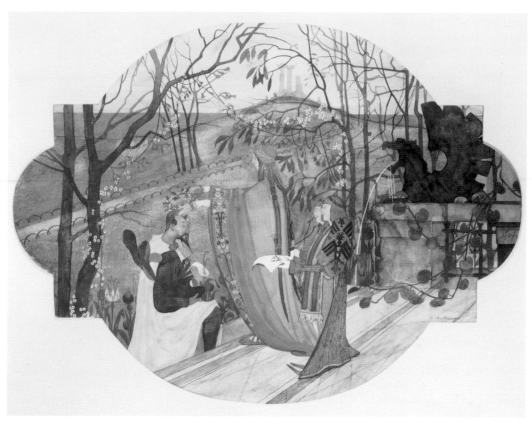

50. Carl Strathmann, *Victor*, ca. 1893

exhibited his seminal painting *I Lock My Door upon Myself*, 1891, which was purchased from the show by the Bavarian government and still ranks today as one of the strongest pictures in the state collection. Henry van de Velde (1863–1957) participated with his Neo-Impressionist *Woman at the Window*, 1889; and, significantly, the most radical painter to exhibit in Munich that year and the *cause célèbre* of the season was Jan Toorop (1858–1928), who showed seventeen pictures not with the Secession, but with the Genossenschaft. These works, which included his celebrated *The New Generation*, 1892, provoked a flood of hostile criticism ridiculing Toorop for his strange style and unintelligible combinations of disparate symbols.[73]

But if the Genossenschaft also included a number of vanguard artists in its show, why did contemporaries feel that the Secession salon on Prinzregentenstrasse was so much more radical? Paradoxically, the answer to this lies in the very impulse that prompted

the Genossenschaft to invite artists like van de Velde and Toorop at all. As we know, from its founding the Genossenschaft was committed to supporting artists of diverse orientations, and it consistently backed the concept of heterogeneous exhibitions incorporating the spectrum of contemporary art, from the innovative and progressive to the traditional and popular. Though such democratic policies were undermined in 1889 and 1891 when the future secessionists gained control of the jury, by 1893 the Genossenschaft had reasserted its egalitarian principles. Thus, despite the fact that some of the works in the Glaspalast were indeed aggressively modern, their impact was weakened by the far more numerous pedestrian pictures which the Genossenschaft felt obliged to include as well. In effect, the innovative works were the proverbial needles in a haystack of dated history paintings and insipid anecdotal pictures ranging in subject from flirtatious peasants to affluent city folk and in sentiment from the cloying to the melo-

dramatic. By contrast, the Secession felt no such obligation to support art of all orientations, preferrring instead to exhibit only the work of moderately progressive artists. Indeed, it is noteworthy that most of the painters showing with the Secession were between the ages of twenty-nine and forty-three, while a great many of the painters who exhibited with the Genossenschaft were either considerably older or significantly younger than this.[74] In short, whereas the Genossenschaft exhibition reflected the diversity of contemporary European art produced by painters, sculptors, and graphic artists ranging in age from the very young to the very old, the Secession exhibition was more narrowly focused on the work of forward-looking German and foreign artists primarily in their thirties. The most notable achievement of the first Secession salon in Munich, and the reason it seemed so much more modern than the Genossenschaft exhibition, was its undistilled presentation of moderately progressive contemporary art.

This had grave implications, of course, for casual audiences. Accustomed to the accessible styles and subjects of the routine, pedestrian works of art that dominated the Genossenschaft exhibitions, the unsophisticated visitor to the Secession exhibition was baffled. Alfred Freihofer, critic for the *Allgemeine Zeitung*, even suggested that a well-rounded education was insufficient to appreciate the Secession salon. In his estimation, it was necessary to possess the educated eye, commitment, and passion of a connoisseur to begin to understand the show at all.[75] Though Freihofer did not reject the exhibition on this basis, many other contemporaries did. Friedrich Pecht, for example, believed that anecdotal painting gave casual, unsophisticated audiences access to the world of art, and to neglect anecdote as the secessionists had done was to neglect the needs of everyone but connoisseurs.[76] "We need an art for the nation," he asserted,

and not just for royalty or monied, aristocratic dilettantes, as a good number of the secessionists believe. It is completely false when artists think they should produce only for connoisseurs. No, they must express what lives subconsciously in the heart and soul of their people.[77]

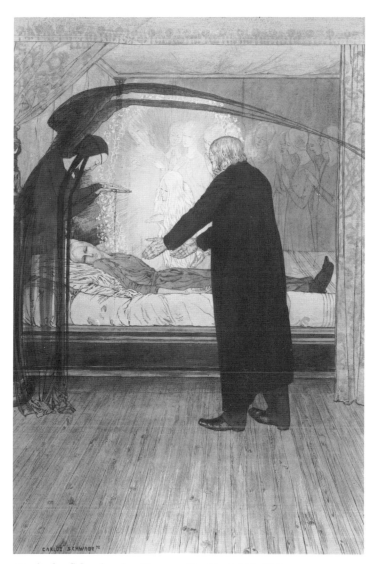

51. Carlos Schwabe, *Angélique on Her Deathbed*, 1892

Indeed, while the founders of the Genossenschaft had been genuinely committed to educating the public and gradually improving popular taste through exhibitions that a heterogeneous audience might identify with, the secessionists felt no such missionary zeal, believing it a grave error to make concessions to a casual art audience.

Notably, such self-conscious elitism was not confined to the Secession, but was an important element in Germany's socio-political climate of the 1890s. Indeed, by the last decade of the century liberalism—the movement that had initially spawned the Genossenschaft's populist principles—had suffered

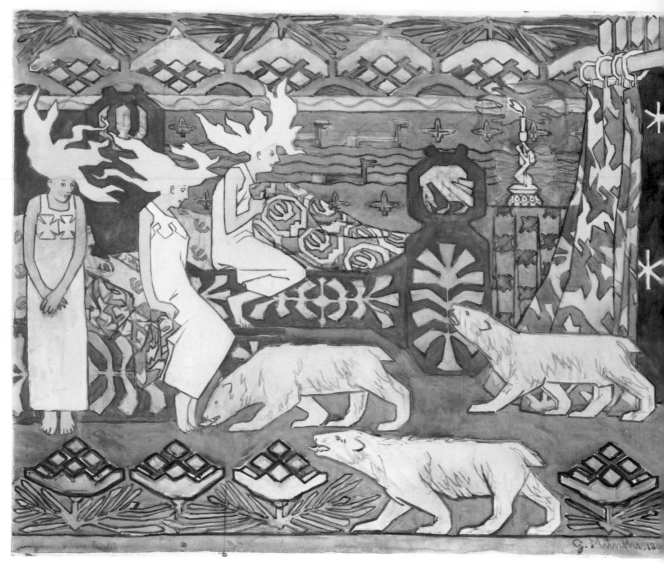

52. Gerhard Munthe, *The Suitors*, 1892

severe setbacks. Not only were its free-market policies undermined by protectionist tariffs and taxes in the late 1870s and 1880s, but the movement's measured *style*, with its emphasis on dignity, egalitarianism and rationality, was replaced in the 1890s by a very different type of political discourse. Despite the differences in their ideologies, Georg von Schönerer, Karl Lueger, and Theodor Herzl in Austria and Paul Lagarde and Julius Langbehn in Germany all adopted aristocratic posturing, high-keyed emotionalism and vituperative verbal rhetoric to mobilize a mass of followers dissatisfied with the rational argument and empirical evidence traditionally used by liberals.[78] Lagarde, for example, called both for a *Führer* who would mystically unite the German people in a culture of intuitive subjectivism and for a new nobility that would serve as a model for every other class in German society. Similarly, Langbehn—whose *Rembrandt as Educator* was, as the contemporary art historian Cornelius Gurlitt noted, the first book in decades that German artists avidly read[79]—longed for a leader who could inspire a Germanic rebirth, a reintegration of the *Volk* into one cohesive people governed by its aristocratic leaders. The Secession's dis-

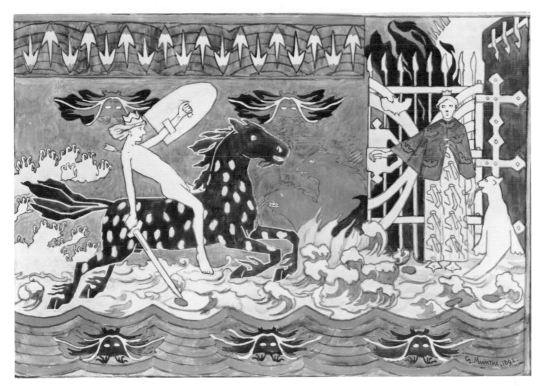

53. Gerhard Munthe, *Horse of Hades*, 1892

dain for the lay public, its belief that its members were the elite of the art world deserving of special treatment, and its aggressive, uncompromising, even manipulative mode of behavior must all be seen as part and parcel of this new political landscape. To be sure, many of the secessionists undoubtedly rejected the reactionary aspects of such ideology, but consciously or unconsciously they nevertheless adopted the style and the less ominous rhetoric of cultural critics like Lagarde and Langbehn. Indeed, just as the Genossenschaft's populist program was inextricably linked to 1860s liberalism, so too were the Secession's elitist policies bound up with the sociopolitical discourse of the 1890s.

In fact, the association's new tact seems to have had tremendous appeal. When the show closed at the end of October, both attendance and sales lagged somewhat behind those of the Genossenschaft salon, but not by much.[80] Even those contemporaries who did not agree with the exhibition's premise had to admit that the Secession's first Munich show made a considerable impact on the art community, and that henceforth the once-dominant Genossenschaft would have to contend with an aggressive and innovative competitor. Though it remained to be seen whether the new organization could maintain its momentum, at the end of 1893 it did in fact seem as if, in the words of Carl von Lützow, "the future belongs to the Munich secessionists."[81]

4. The Lyric Tradition: The Secession in the 1890s

 The art criticism of the 1890s, and subsequent memoirs and histories of the period by contemporaries who witnessed these years, fairly consistently describe the Secession salons during this period as exceptionally "modern." To be sure, there are frequent qualifications in such accounts, and almost everyone admits that after the turn of the century the association lost its initial vigor, mounting exhibitions that differed from those of the Genossenschaft only in size. Yet there was general consensus among contemporaries that at least during the 1890s the Secession was on the cutting edge, introducing to both the art community and the public the best of what was new in European painting, sculpture, architecture, and design.

But a close look at what the Secession did and did not exhibit in the 1890s reveals some interesting facts about the specific nature of the association's alleged modernity. Not only was it rather different from what we might expect, but its defining characteristics have certain parallels with the work of progressive artists living in Munich after 1900. These subtle but important affinities might best be illustrated by focusing on five secessionists—Max Liebermann, Fritz von Uhde, Leopold von Kalckreuth,

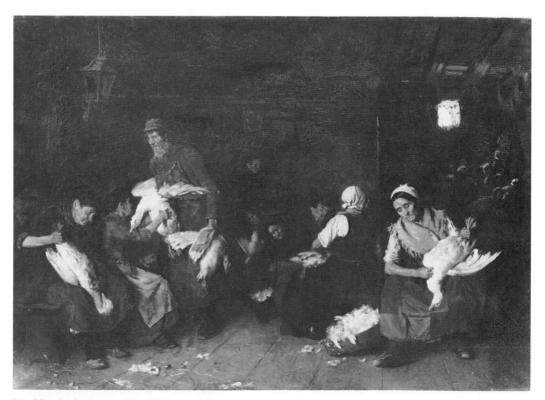

54. Max Liebermann, *The Goosepluckers*, 1871–72

Franz von Stuck, and Richard Riemerschmid—whose particular variants of Naturalism and Symbolism represented general tendencies within the Secession. Diverse though these tendencies were, together they defined what might broadly be termed a lyric tradition that ultimately reached its most brilliant expression a decade later in the work of certain early-twentieth-century Munich modernists.

Max Liebermann

Max Liebermann, one of four children of a wealthy Jewish family, was born in Berlin in 1847.[1] His grandfather had emigrated to the Prussian capital in the 1820s, making his fortune there in the manufacture of cotton, and his father and uncle maintained the business. Some indication of the family's continued success was its purchase in 1859 of a house directly beside the Brandenburg Gate on Pariser Platz, one of the most prestigious addresses in Berlin. The front windows of this building overlooked Unter den Linden, where military parades and state ceremonies were held regularly, and where the king and, later, the emperor rode en route to the Tiergarten. That Liebermann, who remained in the family home when his parents died, never used these events as subject matter for his work reflected his distaste for all that was pompous and ostentatious.

This personal and aesthetic aversion to pretension had its roots in the artist's childhood, when, despite the family's great wealth, he was taught to value simplicity, frugality, and hard work. Until her death in 1864, Liebermann's grandmother—a thrifty and energetic woman who, for all her wealth, never shunned physical toil herself—managed the household. Liebermann's father, Louis, was equally industrious, and though he harbored deep affection for his family he was strict and undemonstrative, tolerating few childish whims. He never had a great deal of sympathy for his son's artistic aspirations, and when Max, after completing the *Abitur* with some difficulty, wished to leave Berlin to study art elsewhere, he encountered considerable paternal opposition. Though Liebermann's father ultimately acquiesced, allowing his son to enroll in the Weimar Academy in 1868, he

neither supported Max's chosen career nor acknowledged his son's considerable talent. In fact, the elder Liebermann believed until the day he died that Max would be the *Sorgenkind* of the family, eventually becoming financially dependent on his brothers.

But if Louis Liebermann could not convince his son of the folly of the artist's profession, he nevertheless exercised considerable influence over Max, shaping the painter's attitudes and outlook in important ways. Unlike many artists, for example, Max never rebelled against his bourgeois heritage. Like his father, he valued success, frankly admitting his longing for traditional accolades and honors. To his mind these could best be obtained by hard work, and until his death in 1935 Liebermann adhered to a strict, disciplined schedule, working regular hours and rejecting everything that smacked of the bohemian. His lifestyle was so like that of his businessman-father that Gerhard Hauptmann once impatiently exclaimed: "How is it possible for such a philistine to paint such [beautiful] pictures!"[2] Perhaps more important, though, the artist inherited something of his father's cool reserve. As Karl Scheffler once noted,

it was easy to approach Max Liebermann, but impossible to get close to him. His house was full of visitors, and he was in touch with many renowned contemporaries, not just artists and literary figures, but also museum directors, collectors, and intellectuals. But though he needed stimulation and discussion, not one of [his acquaintances] could call himself an intimate friend. He was born with a sense of distance, which extended even to his family. . . . Even his love was characterized by reserve.[3]

The cool detachment that was an essential element of Liebermann's personality was also integral to his art. He first attracted attention with *The Goosepluckers* (fig. 54), a large canvas of women plucking goose feathers. Liebermann painted the work while still a student in Weimar, and he exhibited it in Hamburg in 1872. The picture (before being purchased by a private collector) provoked a flood of hostile criticism from contemporaries who interpreted it as a statement about the exploitation of the lower classes, here plucking feathers for down comforters to warm the affluent. Yet the critical reception of the piece said more

about the state of contemporary art and politics in Germany than it did about the work itself. For these women, though their working conditions are less than ideal, are neither dejected nor downtrodden. To the contrary, Liebermann has portrayed them as wiry, energetic, and strong, perhaps hardened by their years of labor but apparently not embittered by them. We are reminded of the artist's grandmother, the tough matriarch who, even in her wealthy old age, actively participated in doing the family laundry. These pluckers accept their lot matter-of-factly and with dignity, just as Liebermann, without romanticizing or engaging in social commentary, portrayed them. Though his impartiality was not then acknowledged by a public that saw in this work the seeds of social revolution, in retrospect the painting is like Liebermann himself—sympathetic, yet detached.

Twenty years and a world of experience lay between this early picture and those that Liebermann exhibited with the Secession during the 1890s. He took his first trip to Holland in 1871 and was so impressed by the people, the contemporary art, and the Dutch way of life that he returned almost annually until 1914, drawing much of his subject matter from both the rural communities and the cities of Holland. In 1873 he moved to Paris, where he was taken not with the work of the French Impressionists but with that of Troyon, Daubigny, Corot, and above all Millet. By 1878 he felt ready to return to Germany, and at the urging of Franz von Lenbach he took up residence in Munich, where he remained for six years. It was here that he first made contact with many of the future Munich secessionists, who would later call upon him to secure the cooperation of the Dutch for their first exhibition in 1893. Finally, in 1884, Liebermann settled with his new wife in Berlin, where he was one of the moving forces behind the founding of the Berlin Secession and was its first and arguably most effective president.

Meanwhile, the style of *The Goosepluckers*—a relatively tightly executed and

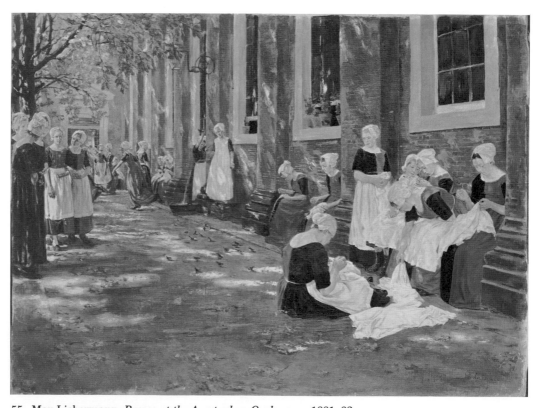

55. Max Liebermann, *Recess at the Amsterdam Orphanage*, 1881–82

Max Liebermann, *Garden of the Retirement Home for Men in Amsterdam*, 1880

finely detailed canvas of studied contrasts in light and dark—evolved into one characterized by broader brushwork and lighter tonality. He became preoccupied with the look of figures and objects in light and air, increasingly delineating their shapes not with a brush but with a palette knife. By degrees he left behind the smooth, finished surface with which he had begun, opting instead for scumbled passages that only suggest reality. Yet throughout his career Liebermann retained the dispassionate vision and objectivity that characterized his first major work. Indeed, it is this detachment that defines his entire oeuvre, from the pictures of the 1870s and 1880s, whose motifs were taken predominantly from the world of common people, to those around the turn of the century and later, whose themes were drawn from the lives of the middle and upper classes.

This is above all evident in Liebermann's images of the Amsterdam orphanage for girls (fig. 55) and of the city's retirement home for men (fig. 56), which date from the early 1880s. Even at this time Holland's social policies were quite advanced, providing humane environments for the old and infirm as well as for underage orphans. Liebermann, whose uncle was a representative of the Fortschrittsspartei (Progressive Party) and whose father was a city councilman whose duties consisted primarily of caring for the poor and homeless, placed great value on such social policies, believing them to be the basis of a truly just society.

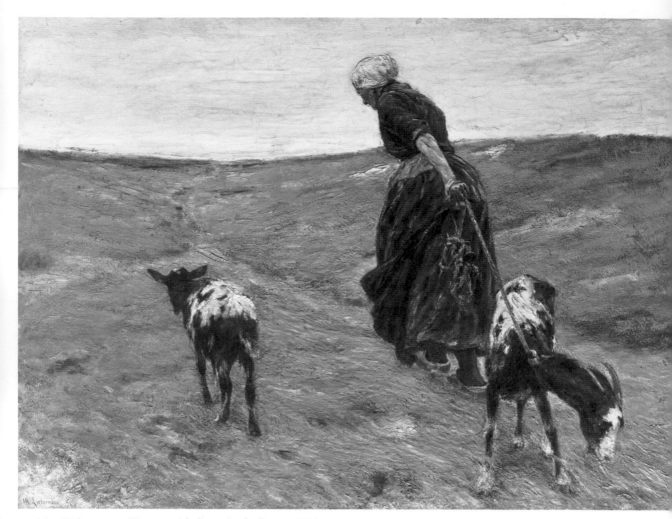

57. Max Liebermann, *Woman with Goats in the Dunes*, 1890

Impressed by these Dutch institutions, the artist painted them and their residents on several occasions. Resting or quietly working in sunny and clean indoor and outdoor environments, the orphans and elderly men who inhabit these paintings seem at first glance supremely content in their sheltered settings. On closer inspection, however, we note both the sad, pensive look of the young girl standing in the right foreground of the orphanage courtyard and the essential isolation of many of the men in the retirement home garden. Scarcely speaking with each other, they are lost in deep, introspective, and apparently lonely thought. Despite the great value that Liebermann placed on such institutions, then, he did not idealize the pensioners' lives, but rendered them with

the impartial eye of one who, by virtue of his own perpetual reserve, always maintained a large measure of objectivity.

This frequently caused problems for the artist. Though the images of the Dutch social institutions won him fame in Paris, they received a lukewarm reception at best in Germany, where the public and critics were accustomed to and appreciated the sentimentality of a Knaus, Defregger, or Grützner. And when in 1891 Liebermann exhibited *Woman with Goats in the Dunes*, 1890 (fig. 57), at the third annual salon of the Munich Genossenschaft, his reputation as the "apostle of ugliness" (as he was frequently called) was secure. Though the work was purchased by the state for the Neue Pinakothek, most critics decried the

lifesize picture of an elderly woman pulling one recalcitrant goat up a gently sloping dune in Holland while a second trots beside her. Contemporaries not only questioned Liebermann's elevation of this work-worn yet still vital and energetic peasant woman to monumental stature; they also criticized her allegedly unflattering pose and attacked the painting's thick, unblended layers of pigment, obviously applied with a palette knife. Liebermann further provoked hostile critics when he exhibited his portrait of Carl Friedrich Petersen, 1891 (fig. 45), at the first Secession exhibition. As we have seen, this painting unleashed a torrent of negative comments from contemporaries appalled that Liebermann would apply his probing vision to such a highly respected city official. Yet just as *The Goosepluckers* was hardly meant as a political statement, the Petersen portrait was not intended as a criticism of Hamburg's mayor. Both pictures sought merely to render unrhetorically aspects of contemporary reality.

Under the influence of the French Impressionists, whose work Liebermann avidly began to collect in the 1890s,[4] the artist's subdued, grayish palette of the 1870s and 1880s was replaced by brighter, more sun-drenched tones, and his brushwork became more hurried and feathery, rendering subjects as if viewed at a glance by passers-by. This technical shift was accompanied by a thematic one: the Dutch orphans and peasants gradually gave way in the 1890s to equestrians riding on the beach, elegant bourgeois families strolling through zoos (fig. 58), tennis players, and open-air restaurants and beer gardens (fig. 59), until finally images of the middle and upper classes came to dominate the artist's output completely. Liebermann never discussed this stylistic and thematic *volte-face*, but it is notable that it coincided with the rise to prominence in Germany of Julius Langbehn, who, like Liebermann, celebrated both Holland and the peasant as paradigms of virtue in his *Rembrandt as Educator*. Langbehn, however, also called for a mystical regeneration of the German people through membership in a creative, unscientific *Volk*, whose purity, he maintained, was tainted by the Jews in Germany, particularly by assimilated Jews. Liebermann—the Jewish liberal republican—must have been

58. Max Liebermann, *Parrot Way*, 1902

appalled not only that the Dutch peasant themes so dear to his heart had been co-opted and subverted by a reactionary, nationalist anti-Semite, but also that Germans everywhere were responding enthusiastically to the message of *Rembrandt as Educator*.[5] Rather than adopt aggressive, sententious themes as a counter to the ideology of a Langbehn, however, Liebermann simply gradually abandoned his Dutch peasant subject matter—which must now have seemed tainted to him—and looked to the French Impressionists to provide him with a model of another kind.

"I have never meddled in politics," Liebermann once said of himself. "Politics are an art like any other, and require serious study. . . . I detest dilettantism in politics just as much as in art."[6] Indeed, Liebermann's paintings and prints expressed a firm social and cultural outlook—one typical of the established, affluent, and liberal Berlin bourgeoisie—but it was never con-

59. Max Liebermann, *The Beer Garden "Oude Vinck,"* 1905

sciously political. Throughout his career the artist consistently avoided sharpening the declamatory edge of his pictures, preferring instead to remain at arm's length from his subjects. Ultimately, it is the calm, unrhetorical character of his work that has endured.

Though Liebermann was unquestionably the most talented exponent of this dispassionate variant of Naturalism, numerous other artists exhibiting with the Secession evolved similar sensibilities. The young Adolf Hölzel (1853–1934), whose abstract drawings of the late 1890s and early 1900s actually presaged Kandinsky's nonobjective art, was living in Dachau in the last two decades of the nineteenth century, painting pictures of the landscape and residents of that rural suburb of Munich. His *Devotions at Home* of 1890–91 (fig. 60), an early work, portrays an elderly woman sitting on a bed while reading a bible. Though the devout faith of this picturesque, work-worn peasant

might have been romanticized, Hölzel presented it with a calm, detached objectivity that precludes both sentimentality and social commentary. Similarly, Wilhelm Trübner (1851–1917), whose "Art Appreciation Today" outlined the major aesthetic premises of the Secession, was painting pictures in the 1890s that are characterized by the same matter-of-fact sobriety found in Liebermann's work of the period. His portrait of Luitpold (fig. 61), for example, is remarkable for its candor. Unlike most paintings of the elderly Regent, which present Luitpold as a vigorous, commanding presence standing in full military regalia, this picture shows him in hunting clothes, smoking a pipe and casually relaxing in a chair. Though Trübner's monarch is perhaps less feeble than Liebermann's Petersen, neither is he the stereotypical robust and energetic ruler of a powerful German state. Indeed, these and numerous other artists who exhibited with the Seces-

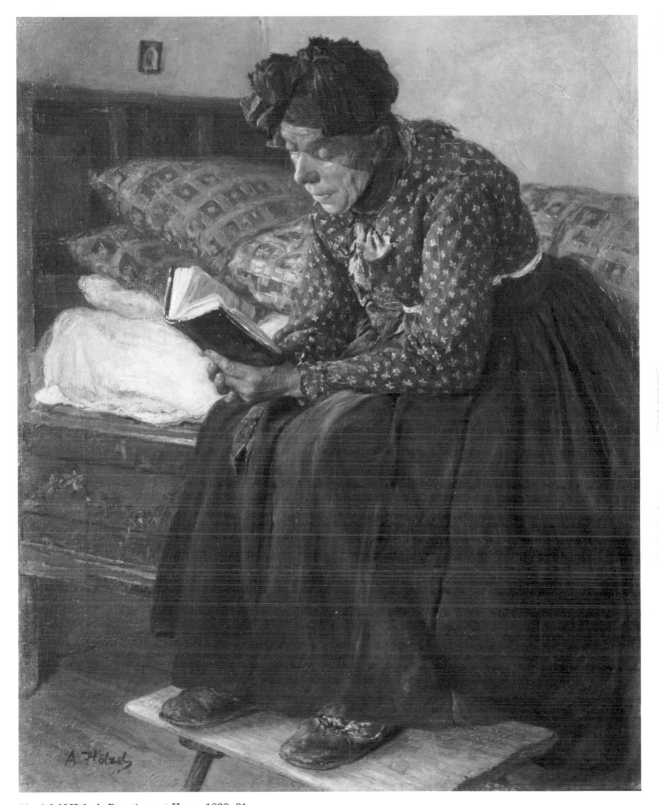

60. Adolf Hölzel, *Devotions at Home*, 1890–91

61. Wilhelm Trübner, *Prince Regent Luitpold of Bavaria*

sion consistently rendered their subjects, whether aristocrats or workers, with a straightforward veracity that neither romantically idealized nor overtly politicized them.

Fritz von Uhde

If Max Liebermann represented one pole of the Naturalist contingent in the Secession, Fritz von Uhde typified the other. Uhde was born in 1848 in Wolkenburg in Saxony.[7] His father, president of the Lutheran Church Council of that province, was by all accounts a strict and deeply religious man, who, like Louis Liebermann, tolerated few childish whims. Yet unlike Liebermann's father, Bernhard von Uhde supported his son's interest in art. Not only did he paint himself, but he engaged a drawing instructor for his wife, the daughter of the general director of the royal museums in Dresden, and their children. When Fritz expressed an interest in becoming an artist, he brought his son's drawings to Wilhelm von Kaulbach, who acknowledged the boy's talent. Despite his hopes that Fritz would follow in his footsteps and study law, he thus agreed to let his son enter the Dresden Academy upon completion of the *Abitur*. At the age of eighteen, then, Fritz von Uhde began his formal artistic training with his father's blessing.

As we have seen, his studies were destined to be brief. Uhde, with characteristic impatience, left the academy after only three months to embark on a military career.[8] Nevertheless, during the subsequent ten years he continued to draw and paint, and quite naturally his subjects were taken mostly from military life. He had a particular fondness for multi-figured battle scenes which, though far too complex for his unschooled talent, won him considerable adulation from his comrades in arms, who were proud to have an artist in their ranks. Perhaps as a result of this encouragement, Uhde opted in 1877 to abandon the military and try his hand again at becoming an artist, ultimately finding a position in Paris in the private painting school of the Hungarian Michael Munkácsy. It was here that his career began in 1878.[9]

Uhde's first success was *The Singer*, 1880 (fig. 62), a competent if conventional studio piece that portrays Dutch figures in seventeenth-century costume, lounging at a dining table in a neighborhood tavern. The witty anecdotal subject and quotations from Old Master paintings won him favorable notice in the Parisian press, and the work was purchased by a French collector. But Uhde chafed at this manner of representation, longing instead to paint directly in front of his subjects—"from nature," as he put it.[10] Indeed, that the depiction of unposed figures and objects in nonstudio settings was his true métier is apparent in a number of works he painted during and after a study trip to Holland in the summer of 1882. Like Liebermann, who was living in Munich at the time and who encouraged Uhde to learn about *plein air* painting through first-hand experience of Holland's remarkable atmospheric conditions, Uhde was taken with the simplicity and honesty of the rural Dutch communities. Thus, not only did he lighten his palette, loosen his brushwork, and introduce natural light into his pictures as a result of the Holland trip—all of which is evident in *The Playroom*, 1889 (fig. 9), an image of his children at play in their nursery—Uhde also began to focus on the lives of common people. *The Big Sister*, ca. 1885 (fig. 63), for example, shows two young children, whose coarse clothes and shoes identify them as members of a poor, probably rural family, playing in an uncarpeted, unpainted, and almost bare room. Similarly, *The Gleaners*, 1889 (fig. 64), portrays peasant women and children gathering stalks of cut grain, a common scene in nineteenth-century art.

But if Uhde increasingly depicted the lives of the lower classes in the 1880s, he did not politicize these images. The two children in *The Big Sister* are happy and content despite their obvious poverty, and the harvesters in *The Gleaners*, though hard at work, gather the grain on a sunny autumn day that is made to seem quite idyllic. Like their more renowned ancestors in Millet's 1857 painting, these gleaners undoubtedly belonged to the lowest level of peasant society permitted to gather the scant leftovers in the fields after the crops had been harvested. This is not apparent in Uhde's painting, however, for the artist did not juxtapose the impoverished peasants scrounging for bits of grain with large haystacks,

62. Fritz von Uhde, *The Singer*, 1880

nor did he portray the gleaners' economic subservience to the wealthy landowners, whose presence is signified in Millet's painting by the overseer on his horse. Rather, Uhde avoided any reference to the peasants' actual social position, presenting instead a harmonious view of rural life.

Like Liebermann, then, Uhde avoided portraying lower-class experience as wholly negative. Yet if the two artists were similar in this regard, their sensibilities were nevertheless subtly distinct. This is best illustrated by comparing Uhde's *The Gleaners* with a similar composition by Liebermann, *The Potato Harvest*, 1875 (fig. 65). Liebermann also avoided any reference in this painting to the actual social position of these field workers, but it is his interpretation of these workers—specifically, that of the child who is the focal point of the composition—that reveals his rather different orientation. Whereas the boy in Uhde's picture works diligently, apparently perfectly

content to spend his time gathering stalks of grain in the warm autumn sun, the girl in Liebermann's painting pauses in her work to gaze wistfully into the distance. Such a single melancholy note is typical of Liebermann's work, which evenhandedly emphasizes both the positive and the negative in all situations, good and bad alike. By contrast, Uhde's social realism is slightly more optimistic, presenting the poor as if they were not at all displeased with their difficult lot in life. Though he never went as far as Defregger, who completely masked the social and economic reality of nineteenth-century rural life in his saccharine genre pictures, Uhde nevertheless keyed his work to a more upbeat tone than did Liebermann. His subjects may be indigent, but only rarely are they unhappy.

This is also true of the poor rural peasants in Uhde's anachronistic religious paintings. It is difficult to know exactly what triggered the artist's fifteen-year preoccupa-

63. Fritz von Uhde, *The Big Sister*, 1885

64. Fritz von Uhde, *The Gleaners*, 1889

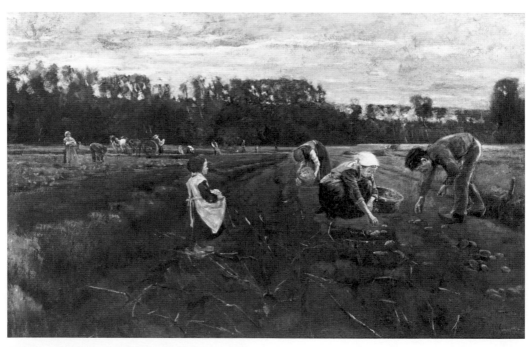

65. Max Liebermann, *The Potato Harvest*, 1875

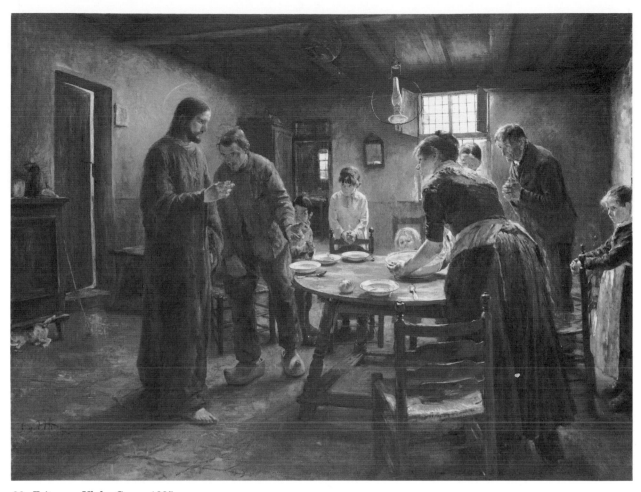

66. Fritz von Uhde, *Grace*, 1885

tion with rendering biblical stories in contemporary terms, but it is possible that the death of his deeply religious father in 1883 played a role. In that year Uhde began the first version of the painting *Suffer Little Children to Come unto Me*, which he completed in 1884 and exhibited five years later at the first annual of the Genossenschaft (fig. 10). In this image of desperate poverty, a group of poorly clothed children, some without shoes, gather around Christ in a sparsely furnished room, while behind adults wait patiently to pay homage to the Savior. Uhde later said that he had been inspired to paint the picture when he witnessed the new students of a local parish school being presented to the pastor for blessing. The biblical passage "Suffer little children to come unto me, and forbid them not: for of such is the kingdom of God" prob-

ably occurred to him even as he watched the children's hesitant approach toward the seated clergyman in that Bavarian schoolroom, and by substituting Christ for the pastor he effectively transformed what would have been a straightforward genre scene into an anachronistic illustration of the gospel.

This formulation so impressed the artist that he subsequently cast dozens of biblical stories in contemporary settings. In *Grace* of 1885 (fig. 66), for example, the artist rendered a working-class family about to sit down to dinner. As they recite the traditional Protestant grace, which begins with the words "Komm, Herr Jesus, sei unser Gast" ("Come, Lord Jesus, be our guest"), Christ himself literally walks into their dingy, uncarpeted dining room, blessing them and their meager meal of bread and

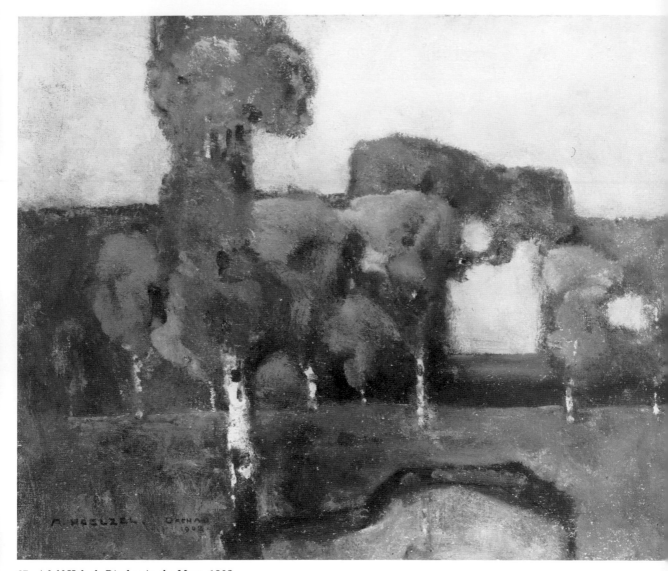

67. Adolf Hölzel, *Birches in the Moor*, 1902

soup with his presence. Other pictures portray contemporary Bavarians with Christ at the Sermon on the Mount, at the Last Supper, and at the Nativity. Most are turgid and melodramatic set pieces, but some, like *Difficult Path* of 1890 (fig. 17), are striking successes. Previously titled *The Journey to Bethlehem*, this atmospheric *tour de force* portrays Joseph and the pregnant Mary as contemporary Bavarians, seen from behind as they trudge through fog on a muddy road that critics immediately identified as the main entrance into Dachau.

Located in the moorlands just northwest of Munich, Dachau had a long tradition as a German Barbizon before it became tragically linked to the atrocities of the Third Reich. From the early nineteenth century the village served as a rural retreat for Munich painters fascinated by both the colorful local residents and the marshy topography of the area, whose watery atmosphere frequently enshrouded the town and its streets with gauzy mists. It was in this damp and foggy climate, which softens edges and blurs details, that the secessionists Ludwig Dill (1848–1940) and Adolf

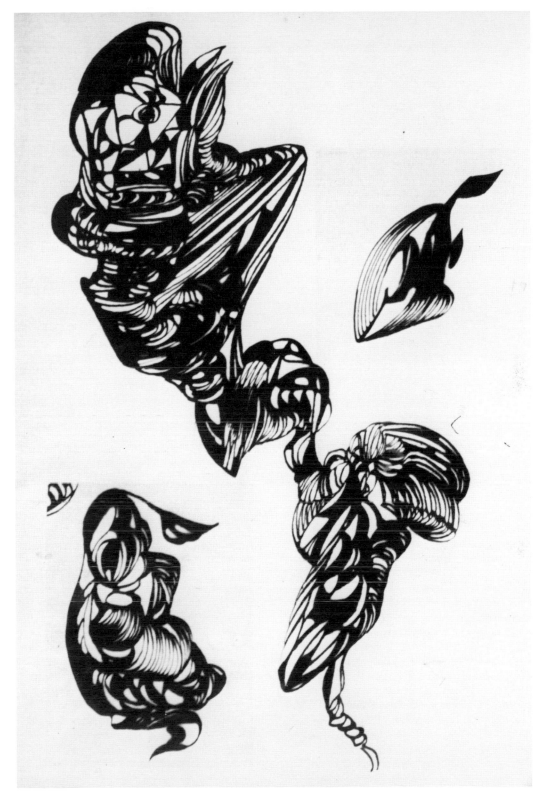

68. Adolf Hölzel, *Black Ornaments on Brown Ground*, ca. 1898

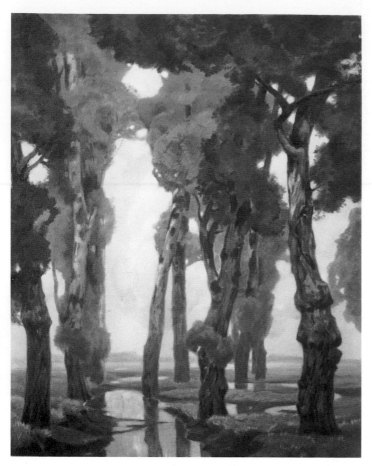

69. Ludwig Dill, *Poplar Forest*, ca. 1900

Hölzel made important strides in the evolution toward an abstract art. Here Hölzel's early Realist style, as represented by *Devotions at Home* (fig. 60), evolved into a more structured and decorative aesthetic. *Birches in the Moor* of 1902 (fig. 67), for example, compresses the mist-shrouded Dachau marshlands into two-dimensional, architectonic friezes of quasi-abstract shapes and patterns. Although he never entirely eliminated subject matter from his paintings, even before the turn of the century Hölzel was making completely abstract drawings (fig. 68) that foreshadowed Kandinsky's nonobjective experiments by more than a decade. Dill, who became the second president of the Secession in 1894, was less daring, but even his brush imparted an abstract rhythm and decorative formal effect to the birches and poplars of the region that were his subjects (fig. 69).[11]

Uhde too had worked in Dachau regularly since the summer of 1888, using its peculiar climate not as a springboard for formal experimentation like Dill and Hölzel, but as a backdrop for his atmospheric *plein air* pictures. In *Difficult Path*, for example, the damp and fog render more pitiable the predicament of Mary and Joseph the carpenter, forced to leave home and hearth just before the birth of their child. This particular story must have had special significance in Bavaria in 1889, when almost one-third of all Munich woodworkers were unemployed. In the latter half of the year, precisely when Uhde began work on *Difficult Path*, local carpenters staged their first strike since 1873, lobbying for more secure jobs and better working conditions.[12] Uhde can hardly have been unaware of the unrest, and he very probably intended his picture—in which Joseph is clearly identified as a carpenter by the saw slung over his shoulder—as a metaphor for the plight of the Bavarian woodworkers.

Uhde never discussed his political sympathies, but it is likely that he supported the contemporary Christian social movement, whose leaders held that the Church must minister to both the spiritual and the physical needs of its congregation. The first notable Protestant preachers in Germany of the social gospel were V. A. Huber, who advanced the idea in the late 1840s of Christian workers' associations or co-operatives as a means of combating poverty, and Johann H. Wichern, who in the 1850s gave practical form to the concept of "inner mission" by instituting a program to build homes for the indigent. This pioneer work was continued by Adolf Stoecker, an Evangelical pastor who lobbied vigorously for the reform of labor conditions and in 1878 founded the Christian Social Workers' Party. Friedrich Naumann, the outstanding Christian social reformer of the next generation, got his start with Stoecker and ultimately went on to found his own political party in 1896, which also emphasized the necessity of reducing the gulf that existed between the working classes and bourgeois society. The Lutheran Church in Saxony, of which Uhde's father was an important functionary, played a particularly distinguished role in Germany in the care of the poor, sick, and orphaned,[13] and one of Uhde's

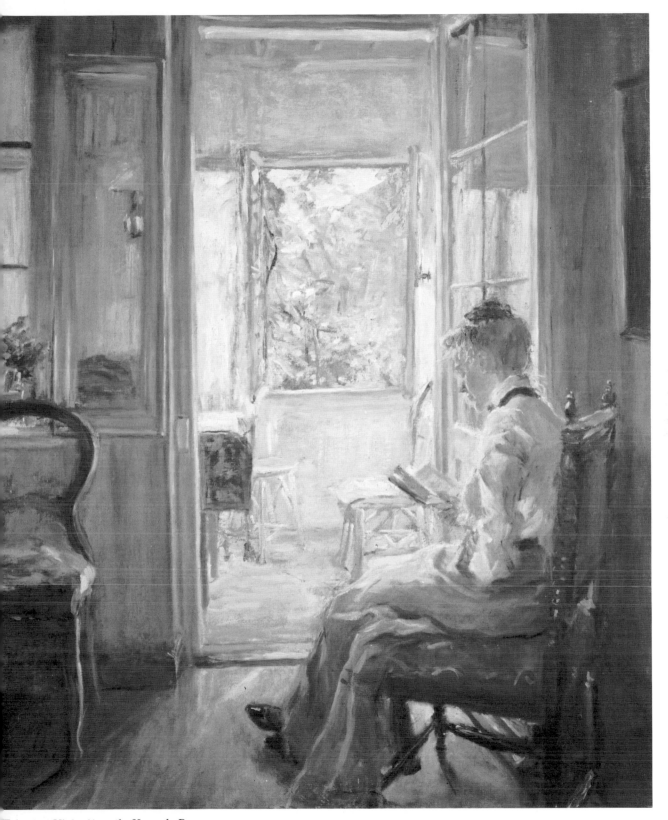

Fritz von Uhde, *Near the Veranda Door*

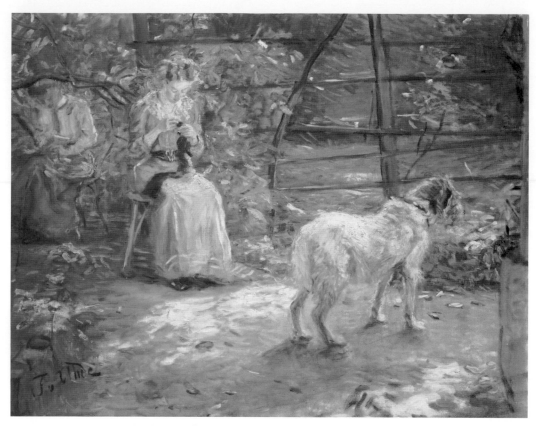

71. Fritz von Uhde, *In the Autumn Sun*

childhood friends and fellow cavalry officers during the Franco-Prussian War, Moritz von Egidy, even went on to found a prominent Christian mission organization that sponsored annual conventions in Berlin to win middle- and upper-class support for working-class causes.[14]

But however enlightened, none of these reformers advocated a radical restructuring of society. Stoecker, for example, was the son of a low-ranking government official, and he grew up respecting the traditional order in Prussia. Though there is no doubt that he had a compassionate understanding of the needs of the masses, he most certainly did not intend to eliminate class differences entirely. Quite the reverse: he was deeply mistrustful of socialism, and his reformist efforts were largely motivated by the fear that workers would reject the monarchy and Christianity in favor of the Social Democratic Party if their most basic economic and social needs were not met.

Similarly, Uhde demonstrated considerable sympathy for Germany's working class, but he never advocated in his art social or economic revolution. To the contrary, whether he portrayed the special camaraderie that develops between children forced by poverty to entertain each other without toys, or the close identification with Christ that was the particular prerogative of the destitute, Uhde consistently emphasized the few positive aspects in the lives of the needy while alluding to the rich rewards they would reap in heaven. Ultimately his hand was guided not by the detached objectivity that motivated Liebermann, but by deeply instilled religious doctrines intended not only to comfort the underprivileged with the hope of a better life in the hereafter, but also to counsel patience with the injustices of this life. Not surprisingly, those contemporaries who were aesthetically or politically more radical than Uhde disliked his Pollyanna-ish

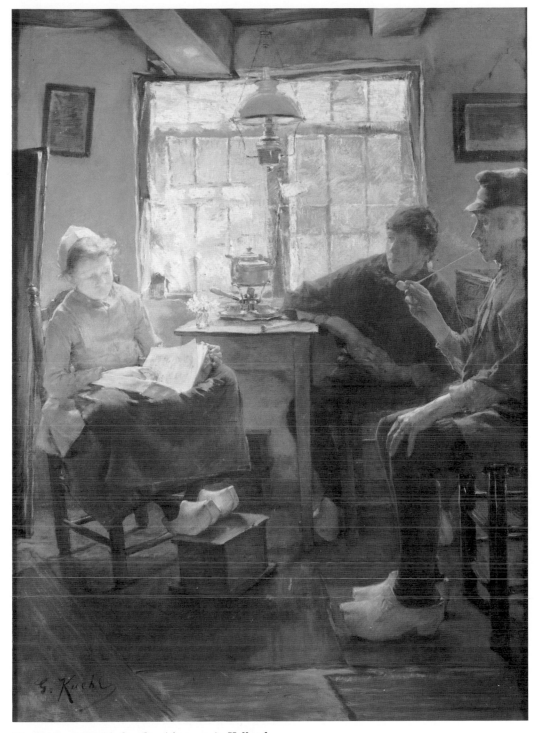

72. Gotthard Kuehl, *Sunday Afternoon in Holland*

optimism. Vincent van Gogh, for example, described the Christ in *Suffer Little Children to Come unto Me* as a "Santa Klaus" that did not belong in this otherwise moving rendition of peasant children in a schoolhouse.[15]

Even when Uhde abandoned such religious imagery around 1900, focusing his talents almost entirely on subjects drawn from his immediate environment, he invariably cast them in a rosy light. Most frequently he represented the activities of his daughters, who sit quietly, bathed in gentle sunlight, either reading, sewing, or knitting in the house (fig. 70) or out of doors (fig. 71). These unpretentious, introspective images suggest what Uhde might have attained had he concentrated his energy throughout his career on the *plein air* representation of unposed figures and objects in natural settings. More intimate than Liebermann's comparatively dispassionate genre paintings, these pictures of quiet domesticity bespeak in Uhde the sentimentalist that was absent from the temperament of the more detached Liebermann.

Few of the secessionists shared Uhde's interest in religion, but a great many evolved a similarly lyrical variant of Naturalism. Gotthard Kuehl (1850–1915), the artist who was instrumental in organizing the French section of the controversial third Genossenschaft annual, painted unpretentious images of the interiors of churches (fig. 5) and Dutch homes (fig. 72), the prosaism of which is gently modulated by soft, evocative lighting. Such an understated Romanticism also characterized the commonplace subjects of Max von Schmädel (b. 1856), whose *His Everything* (fig. 39) was exhibited at the first Secession salon in Munich. Though the painting merely represents an elderly man observing a young woman scrubbing the sides of a washtub, the patch of light falling from the window above quite literally softens the hard edges of their mundane existence. Likewise, the *plein air* animal painter Heinrich von Zügel (1850–1941) consistently rendered the experience of peasants tending cattle and sheep as a pleasant rural idyll, far removed from a more taxing urban existence (fig. 4). Though none of these artists fell prey to the insipid sentimentality of the *Lederhosen* painters, they nevertheless all shared a

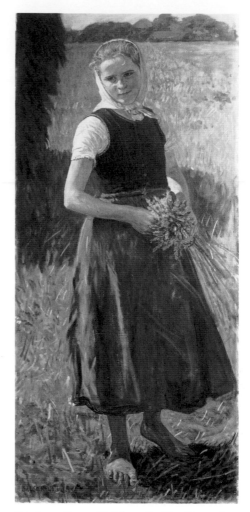

73. Leopold von Kalckreuth, *The Days of Our Years Are Threescore Years and Ten*, 1898

more idealized, Romantic world view than that of the artists around Liebermann, and together they formed an important contingent at the Secession exhibitions.

Leopold von Kalckreuth

With the work of Count Leopold von Kalckreuth (1855–1928) we leave the largely optimistic domain of the German Naturalists and enter the brooding sphere of one of the three major Symbolist contingents in the Secession. Kalckreuth's most famous painting, *The Days of Our Years Are Threescore Years and Ten* of 1898 (fig. 73), provides an apt introduction to this rather different sensibility. The work consists of three individ-

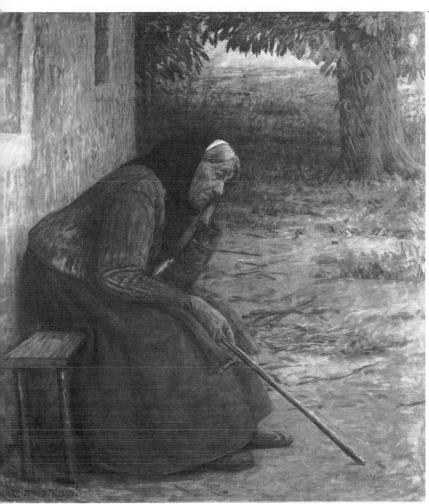
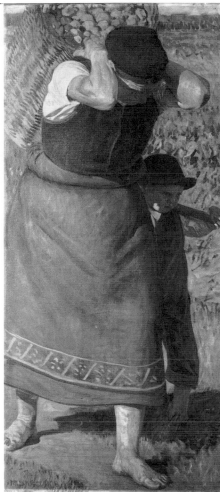

ual pictures representing stages in the life of a poor peasant woman. On the left she is but a young child, gathering stalks of cut grain after a harvest, and on the right she has matured into a barefoot middle-aged mother, carrying a heavy basket of potatoes and followed by her small son. In the center panel she has become an old woman, her face lined with worry and her back bent by decades of physical labor. Gazing sadly at the ground, she absentmindedly traces patterns in the dirt with her cane, apparently waiting for nothing but death. Unlike Uhde, who invariably illustrated uplifting biblical stories, Kalckreuth represented here the tenth verse of Psalm 90, one of the most pessimistic passages in the entire

Bible. "The days of our years are threescore years and ten; and if by reason of strength they be fourscore years, yet is their strength labor and sorrow; for it is soon cut off, and we fly away." Indeed, there is not a trace of optimism in this overwhelmingly melancholic image, which functions as a timeless, symbolic allegory of the life cyle.

There is little doubt that Kalckreuth's childhood predisposed the artist to this rather somber world view.[16] His father, Count Stanislaus von Kalckreuth, was a talented landscape painter whose pictures of the Alps rank among the best of the Düsseldorf Romantic school. Yet he was also a morose man subject to deep depressions that profoundly affected the tenor of the Kalck-

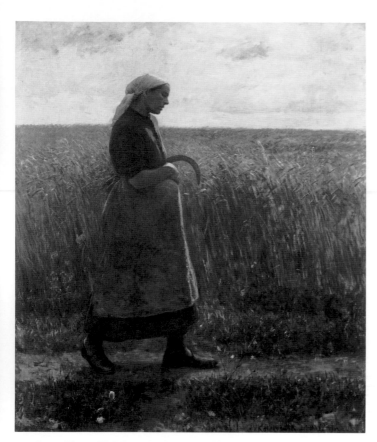

74. Leopold von Kalckreuth, *Summer*, 1890

reuth household. According to one of his grandchildren, Stanislaus was "from birth sickly, pessimistic, and at odds with himself, demanding from life a cure [for his ill will] as his unconditional right."[17] He fought continually with his colleagues at the art school that he directed in Weimar, bringing the battles home with him and rehashing them in detail over dinner. Years later the Kalckreuth family was still so joyless that when Leopold, who had been sent away for part of his schooling, arrived home after completion of the *Abitur*, one of his sisters felt it advisable to take him aside even before he entered the house and warn him that he still must try his hardest to "overlook the darker moments [of family life], for example when Papa gets too involved in your own affairs, or when you hear things about the [art] school that infuriate you."[18]

It would be difficult to exaggerate the effect that this apparently dismal childhood had on Kalckreuth, who as a mature artist almost always introduced a melancholic note of brooding into even the most pleasant of subjects. Kalckreuth knew as a boy that he wanted to become a painter, and he chafed at his parents' insistence that he first complete the *Abitur*. He entered the Weimar Academy just months after passing his exams, remaining there from 1875 through 1878. After one year in the military, Kalckreuth went in 1879 to Munich, where he worked independently for six years. There he met and became friends with Max Liebermann, who later would disapprove of the Symbolist inflection that came to characterize his work. It was during this time that Kalckreuth, like so many other secessionists, both discovered Holland as an artistic source and became a *plein air* painter, working outdoors in order to capture the effects of light and air on his subjects. By 1885 he was so proficient at his craft that he was recalled to Weimar to serve as instructor at the Kunstschule.

Among Kalckreuth's first successes was his 1889 *Summer* (fig. 74), in which a female harvester in the last stages of pregnancy walks by a wheat field that itself is ripe with grain. Superficially it is a pleasant allegory of fertility that emphasizes the intimate connection between simple, earthy peasants and the land from which they make their living. On a deeper level, however, the image has somber, if not sinister, overtones. Despite the sunny autumn weather, the woman is obviously exceedingly weary, traversing the homeward path only with considerable difficulty. In addition, she carries a scythe in her hand, a reference not only to the harvesting work from which she is returning, but also to the figurative death of both the grain and, ultimately, herself and her unborn child. To be sure, Kalckreuth's pictures were not always so mournful. *On Sunday Afternoon*, 1893 (fig. 75), which the artist exhibited at the first Secession exhibition in Berlin, captures the contented, contemplative mood of a rural couple strolling in fertile cornfields on a Sunday afternoon. Nevertheless, the sentiment of this picture is atypical in Kalckreuth's oeuvre, which for the most part is tinged with melancholy. Even *The Rainbow*, 1896 (fig. 76), evokes a poignant sadness, a subconscious yearning for unnameable feelings and sensations that, in *Storm Clouds*, 1899 (fig. 77), becomes so over-

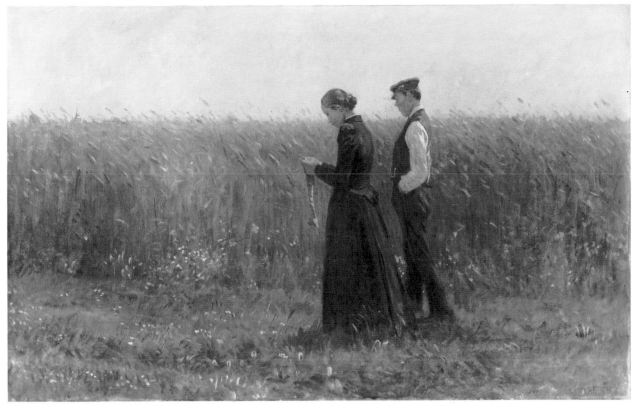

75. Leopold von Kalckreuth, *On Sunday Afternoon*, 1893

whelming that it blinds the man returning home from the fields on horseback to the danger of the threatening storm clouds gathering above him. Lost in somber thought, he rides slowly onward, a symbol of the disconsolateness of the human condition.

As is evident in all these images, Kalckreuth worked in an essentially Realist style, but he consistently downplayed detail in favor of generalized shapes that he arranged within a geometric compositional structure of verticals and horizontals. The resulting formal, abstracted quality evokes a timelessness most appropriate to expressing universal themes, feelings, and sensations. Indeed, Kalckreuth's style and his fondness for moody, evocatively lit landscapes elevate his subjects from the sphere of specific experience to a more general realm of universalities. As one of the first German artists of the late nineteenth century to employ a Realist style in the evocation of Symbolist sentiment, Kalckreuth was an important figure in the evolution of German Neo-Romanticism, his position can-

onized in 1902 when the Vienna Secession gave him a retrospective exhibition.

The melancholic tone of Kalckreuth's Symbolism, as well its timeless character, typifies the work of other very different artists exhibiting with the Munich Secession in the 1890s. The meticulously rendered and rigorously structured landscapes (fig. 78) of Karl Haider (1846–1912), for example, are less specific representations of the upper Bavarian countryside than generalized, evocative mood paintings with brooding overtones. Similarly, the Berlin artist Walter Leistikow (1865–1908), who participated annually in the Secession salons with works like *Schlachtensee* (fig. 79), evoked a kind of mournful poignancy in his calm landscapes of the lakes and parks in and around Berlin. Seemingly far removed from the hubbub of the city, these tranquil bits of nature appear frozen in time, their life becalmed by some preternatural unseen force. Likewise, Ludwig Dill, the Secession's second president, and his friend and colleague Adolf Hölzel captured above all the

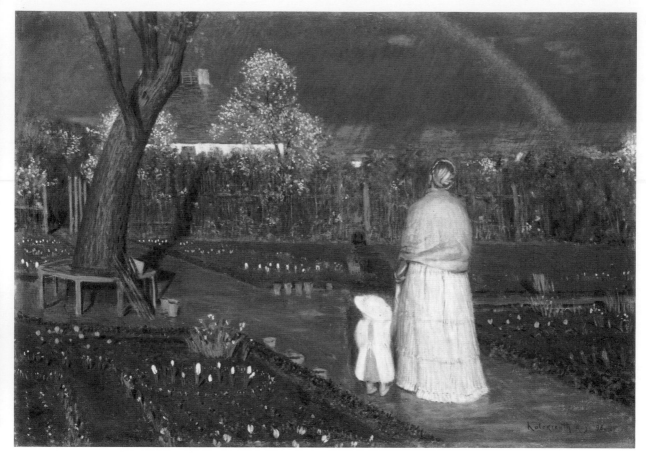

76. Leopold von Kalckreuth, *The Rainbow*, 1896

eerie quiet of the misty moorland around Dachau in their tonal, stylized paintings of birches and poplars growing in isolated, swampy bogs (figs. 67, 69).

Franz von Stuck

If the brooding work of Leopold von Kalckreuth represents one variant of the Symbolist aesthetic within the Secession, the sensual subjects of Franz von Stuck typify another. Born in 1863 in Tettenweis, a small village in lower Bavaria, Stuck demonstrated considerable talent as a child, acquiring a reputation in the village for his drawings and caricatures of the local townspeople.[19] However, his father was a miller with little artistic inclination, and he expected his son to carry on the family trade. It was only at his mother's insistence that the aspiring artist was allowed to con-

tinue school after completing his elementary education, and, significantly, he attended not a *Gymnasium* but the local trade school in Passau. Ultimately Stuck's father accepted his son's reluctance to run the family business, but he was adamant that at the very least Franz would become a competent craftsman. Accordingly, Stuck went to the Kunstgewerbeschule in Munich, where he remained from 1878 through 1881, learning primarily the principles and techniques of design and architectural drawing. This early exposure to the applied arts undoubtedly sparked Stuck's later interest in designing his own frames for his paintings as well as his home on Prinzregentenstrasse, and it was also probably one of the main reasons why the Secession, in which Stuck was a dominant force, initially supported the decorative arts movement at the end of the 1890s.

In 1881 Stuck entered the Academy of the Fine Arts in Munich, where he remained until 1885, studying under both Wilhelm Lindenschmit and Ludwig Löfftz. Though he apparently attended classes only sporadically, this was nevertheless a decisive period in his career, for it exposed him to the fine arts for the first time. The extensive training he had received at the Kunstgewerbeschule, however, served him well, for he supported himself both by designing decorative and applied art objects and by providing the Viennese publishing firm of Gerlach and Schenk with designs for various projects, including vignettes for menus and invitations as well as drawings for a series of zincographs the company published between 1882 and 1884.[20] These prints, collectively entitled "Allegorien und Embleme," were designed by numerous German and Austrian artists, including Nikolaus Gysis, Max Klinger, and the young Gustav Klimt. *The Hunt*, 1883 (fig.

77. Leopold von Kalckreuth, *Storm Clouds*, 1899

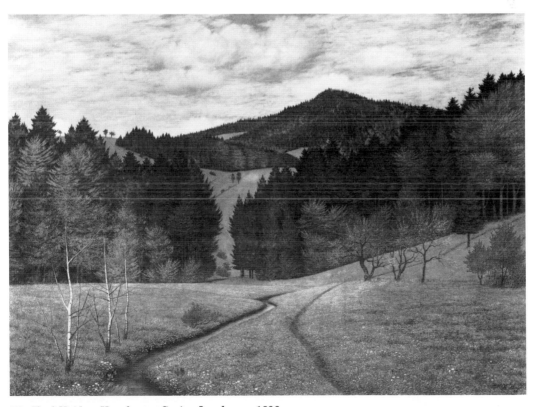

78. Karl Haider, *Haushamer Spring Landscape*, 1896

80), one of Stuck's earliest surviving designs for this series, already contains the seeds of his mature work. The model for the image was Rudolf Henneberg's 1868 *The Hunt for Good Fortune (Die Jagd nach dem Glück)*, now in the Nationalgalerie in East Berlin, in which a Junker on horseback pursues the elusive Fortuna, goddess of luck. Stuck, however, replaced Henneberg's Junker with a horned skeleton wielding a long whip and accompanied by a variety of vicious creatures, while simultaneously supplanting the fleeing Fortuna with a reclining nude poised precariously under the hoofs of Death's rearing steed. In thereby alluding to the rich tradition of the recumbent Venus, the goddess of love, Stuck converted an essentially pleasant tale about the pursuit of fortune into a diabolical allegory of love's demise.

Such sinister and erotic alterations of traditional iconography were common in Stuck's work, as is evident in his first major success, *The Guardian of Paradise*, 1889 (fig. 12). The artist exhibited this picture at the first Genossenschaft annual in 1889, winning both a small gold medal and 60,000 DM at the remarkably young age of twenty-six. The "guardian," of course, is the lone figure in the composition. Endowed with powerful wings, this angel protects the background "paradise" of high-keyed color and starburst shapes with a flaming staff. But despite his traditional attributes, the androgynous male figure represented here is no more angelic than the *femme fatale* Stuck would later favor. Wearing a gauzy gown that exposes his shoulders and reveals the shadowy outline of his legs, he stands with one hand resting provocatively on his hip, his pouty, ruby-red lips and dark, heavy-lidded eyes not warning us from but inviting us to enter his sensual paradise.

Innocence of 1889 (fig. 81) similarly conflates the erotic and the religious. The critic Hans Eduard von Berlepsch wrote about the

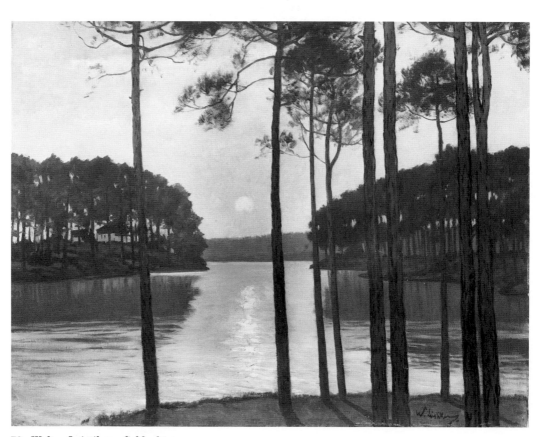

79. Walter Leistikow, *Schlachtensee*

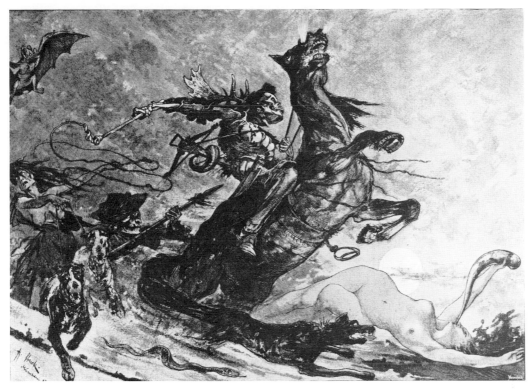

80. Franz von Stuck, *The Hunt*, 1883

picture when it was exhibited with *The Guardian* at the first annual, and identified the figure as the young Joseph.[21] Significantly, though, Stuck cast both Joseph and the lily, traditional symbol of purity, in wholly new roles in this painting. Firmly grasping with his left hand the bottom of the lily stem, which intersects his body at the level of his genitals, Stuck's Joseph fondles with his right hand the top of the shaft, just below the bursting shapes of the white petals. Lips parted, eyes slightly glazed, this boy seems not the chaste Joseph of biblical fame, but an adolescent youth just discovering his own sexuality.

Sin, 1893 (fig. 49), which was shown at the first Secession salon in Munich, expresses the suggestive sensuality of *The Guardian* and *Innocence* far more directly. Under the influence of the Glasgow Boys, who exhibited regularly in Munich from 1890, Stuck rejected the sun-filled palette he had initially favored for deeper, sonorous colors more appropriate to conveying both the sinister and the sexual. Here, shrouded in inky darkness, robe parted to expose glowing breasts and midriff, a sexy tempt-

81. Franz von Stuck, *Innocence*, 1889

ress wordlessly invites us with a seductive glance to submit to her charms. As if to preclude any doubt about his vamp's inherently evil nature, Stuck draped an orange-eyed snake around her shoulders and

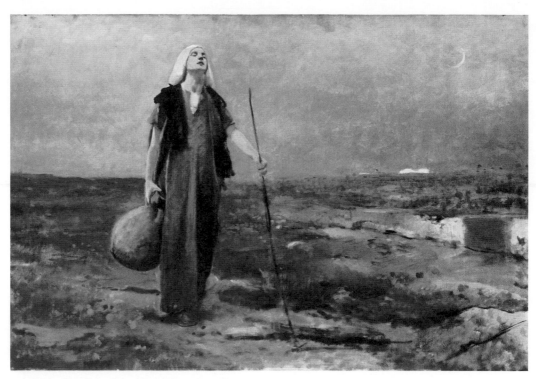

82. Bruno Piglhein, *The Blind Woman*, 1889

inscribed the title of the painting on his handmade gilded frame. Certainly no innocent Eve tricked by the serpent into betraying God, this mother of mankind is salacious and diabolical, in full sympathy with the Satan who caused the fall of man.

An astounding three-fourths of Stuck's paintings involve the erotic.[22] But if Stuck was unusually preoccupied with the libido, he was just one of many turn-of-the-century European artists who began to express visually their pent-up frustrations with the repressions of a "civilized" society. From Fernand Khnopff to Paul Gauguin, and from Jan Toorop to Ferdinand Hodler, avant-garde painters everywhere depicted either simpler, more "primitive" cultures or distant, mythical climes where the expression of elemental feelings and emotions like sexual need and desire was not taboo. This trend seems to have been particularly prevalent among the Munich secessionists. Some, like Arthur Langhammer, merely invested mundane subjects with sensual undertones. It is the barren fields in his *Peasant Girls from Dachau*, ca. 1900 (fig. 83), for example, that lead us to believe that

these pubescent teenagers are preoccupied not with thoughts of a better life but with adolescent dreams of erotic fulfillment. Bruno Piglhein, who served as the first president of the Secession until his death in 1894, occasionally cast his subjects in a similar light. His 1889 oil sketch *The Blind Woman* (fig. 82), for instance, is, despite its academic subject, charged with voluptuous undercurrents. On one level, of course, the woman's heavenward gaze can be read merely as a plea for divine guidance. But more subtly the pose conveys an air of tense expectancy, as if at this very moment this vulnerable woman is having a premonition of what might befall her as she makes her way alone through the isolated meadow. More overtly sensual is Max Klinger's *The Blue Hour*, 1890 (fig. 37), which was exhibited first at the Genossenschaft's third annual and then at the Secession's first exhibition in Berlin. Its pervasive blue tonality sets the stage for the languid, eroticized mood of the three adolescents lounging nude by the water at dusk. In the works of the secessionists Paul Hoecker, Ludwig Herterich, and Albert von Keller, even

religious figures like nuns and saints were cast in a sensual light. Indeed, although Stuck was probably the most obsessive about giving visual expression to the libido, he was just one of many secessionists who time and again turned to the erotic as a source of inspiration in the late 1880s and, particularly, the 1890s.

The reasons for this were many and diverse, but among them was the strength of the Catholic Church in Bavaria and of its political arm in Parliament, the Center Party, which together created a puritanical climate in Munich of the 1890s against which artists and writers alike reacted. As we know, the events of 1886 strengthened the Bavarian Center Party considerably. When the prestige of the crown and confidence in the liberal cabinet were both severely shaken by the scandal of King Ludwig II's death, the clerics who dominated Parliament were able to exert greater influence on a range of political and cultural issues. As well as lobbying to intensify those paragraphs of the Criminal Code dealing with *lèse-majesté*, incitement, and so-called 'gross mischief', they also advocated strengthening the passages on blasphemy and the distribution of obscene material. The Bavarian government did little to resist such efforts and between 1889 and 1900 supported a series of repressive proposals.

The most notorious of these was the Lex Heinze, so named because it was drafted in response to the murder of a Berlin night-watchman by a criminal and pimp named Heinze.[23] Initially the law was aimed at urban vice, but it was gradually broadened—primarily under the influence of the Bavarian Center Party, whose reformers claimed that Germany was in a state of moral decline and put the blame squarely on the weakening of religion and the devastating effect of pornography—to include a very flexible extension of the ruling on obscenity. Artists who publicly displayed pictures that, "without being obscene, tend to cause annoyance by grossly offending feelings of modesty and morality" would run the risk of six months' imprisonment or steep fines. Playwrights were also targeted, and a similar clause was thus inserted for theatrical productions.

Fortunately, by the time the Lex Heinze went into effect in June 1900, such ominous

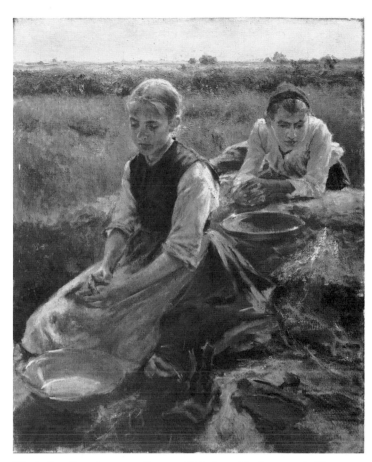

83. Arthur Langhammer, *Peasant Girls from Dachau*, ca. 1900

passages had been deleted from the law. But the Center Party continued to lobby for increased control over the arts, and it had particular success in censoring playwrights who overstepped the bounds of Catholic religious and sexual propriety.[24] Frank Wedekind, for example, completed his drama about adolescence and sexuality, *Frühlings Erwachen: Eine Kindertragödie* (*Spring Awakening: A Children's Tragedy*), in 1891, but Catholic authorities prevented the staging of the play in Bavaria until 1908, when a heavily censored version was finally cleared for performance. In August 1891 the playwright and journalist Hanns von Gumppenberg was sentenced to two months of fortress arrest for having publicly recited a poem by Karl Henckell which was interpreted as a libel of the emperor. Oscar Panizza was even more unfortunate. In 1894 he published *Das Liebeskonzil* (*The Council of Love*), a vicious satire on the

Holy Family and the papal court of Alexander VI in which God, Christ, Mary, and their emissaries on earth are all portrayed as weak, morally corrupt, and sexually depraved. Panizza was brought to trial on charges of blasphemy and in 1895 condemned to a year in jail.

To be sure, conditions in Bavaria were no worse than anywhere else in Germany at the time, and may even have been better. Notably, there was a rule in Bavaria and certain other states, but not in Prussia or Saxony, that offenses committed by means of the press had to be tried by jury.[25] This was a crucial safeguard, for the system made convictions much harder to obtain than in Dresden or Berlin, where press offenses were dealt with by tribunals of professional judges. Moreover, painters and sculptors were generally more immune to the kinds of censorship to which writers and dramatists were increasingly subjected in the 1890s.[26] Nevertheless, the atmosphere in Munich at the turn of the century was considerably more repressive than in the previous decades, when the liberal administration had usually managed to defend artistic freedom against attack from the Catholic Church and the Center Party. The change was keenly felt by everyone involved with the arts.

It is within this context that the increased incidence of eroticism in Munich painting of the 1890s assumes new implications. Either as a subconscious response to the Center's repressive policies or as a conscious nose-thumbing at prudish politicians, freethinking Munich artists of many different aesthetic persuasions introduced sexual motifs into their work. It was probably not mere coincidence, in fact, that many of Stuck's pictures conflated sensual and religious imagery, as did the Symbolist paintings of Paul Hoecker, Albert von Keller, and Gabriel Max. Indeed, like Panizza's *Council of Love*, Stuck's *Guardian of Paradise* and *Innocence* were very possibly intended as deliberate provocations of the clerical moralists who were exerting increasing influence over Munich's cultural life at the turn of the century.

Stuck—by all accounts a taciturn man who rarely discussed himself or his art—never openly declared his work a rebuttal of Catholic doctrine and policy, but his style

and choice of subjects incurred the clerics' public wrath on at least one occasion.[27] Moreover, another very important aspect of Stuck's output suggests that the artist's political and social sympathies were almost certainly directed against resurgent political Catholicism. Throughout his entire career Stuck maintained a lively interest in classical culture, which had been the strongest challenge to Catholic faith and values in Bavaria ever since the early 1800s. Indeed, nineteenth-century Bavarian monarchs consciously used classicism in their efforts to weaken the power of the clerics and nobility and to mold an educated and politically loyal middle class that would serve not the Church but the state.[28] Stuck's fascination with Antiquity and its anticlerical spirit of secular rationalism was first evident in the mythological subjects he chose for his early designs for Gerlach and Schenk, and it manifested itself throughout the artist's career. His 1893 poster for the first Secession exhibition (fig. 84), for example, features the helmeted Athena, Greek goddess of war. Centered within an octagon that alluded to the shape of the central hall and cupola of the Secession Gallery on Prinzregentenstrasse, her profiled visage personified the association's combative stance and avant-garde status, and was thus also used on the Secession's letterhead. In 1897 he frontalized the goddess for the poster of the first joint exhibition of the Secession and the Genossenschaft (fig. 85), a formulation that so impressed the young Gustav Klimt that he adopted it for his renowned painting *Pallas Athena* of 1898.[29] Stuck also used the poster as the basis of his own *Pallas Athena* of 1898 (fig. 86), which portrays the deity *en face*, wearing a helmet and the aegis on which the Gorgon's head is displayed.

However, Stuck was interested not just in the thematic heritage of Antiquity, but also in its formal characteristics. He claimed as his own the rectilinearity of the Archaic Period vase paintings in the Glyptothek, just as he appropriated the spatial ambiguity of the frieze fragments, on which three-dimensional sculptural figures are placed against resolutely flat, two-dimensional backgrounds. Indeed, dichotomy is the formal key to all of Stuck's most successful images, which, like ancient pottery and

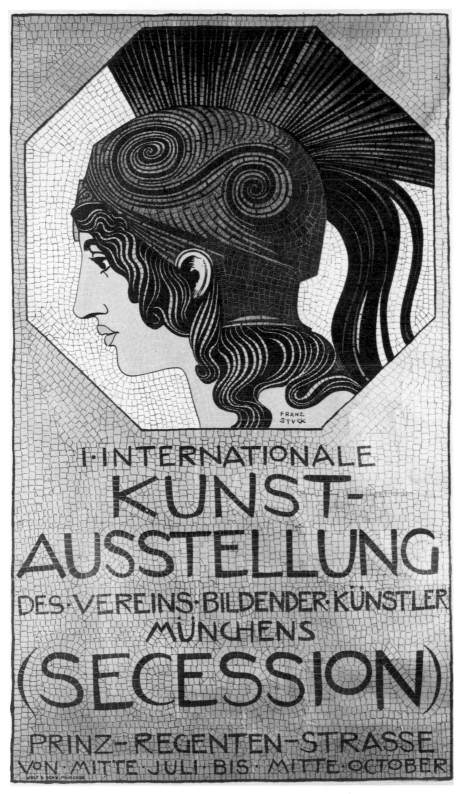

84. Franz von Stuck, Poster for the First Secession Salon of 1893

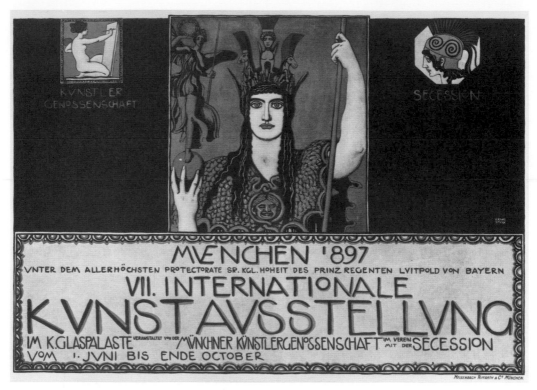

85. Franz von Stuck, Poster for the Seventh International Exhibition of 1897

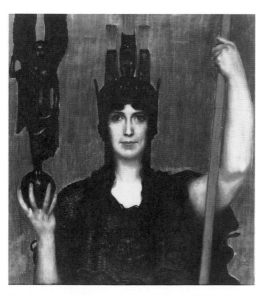

86. Franz von Stuck, *Pallas Athena*, 1898

sculpture, tend to be organized around sharp contrasts of line, form, and color. The horizontal is set against the vertical, the sculptural is paired with the two-dimensional, and light is juxtaposed to dark. The overall effect is highly decorative, and it was this that led the younger generation in Munich to adopt Stuck as a father figure who would point the way to an abstract-tending art in which form and color might play a greater role than subject in conveying psychological and emotive meaning. Not surprisingly, Kandinsky, who arrived in Munich in 1896, chose Stuck as his second teacher, working almost an entire year to improve his skills so that he might be accepted into Stuck's class. When he was finally admitted after one rejection, Kandinsky was advised to abandon color and work exclusively in black and white in order to learn the secrets of form. Stuck thereby effectively launched Kandinsky on his lifelong study of positive and negative space that proved so important in the evolution of modern art.[30]

Stuck's interest in Antiquity came to its fullest fruition in the home he designed for himself in 1897 and 1898. He modeled much of the interior after Pompeiian villas, using mosaics and fourth-style wall painting to create a Roman ambience, while on the

exterior Doric columns, sculptural friezes of battling gods, and plaster casts of Greek statues set a Neoclassical tone. In the 1890s Stuck had begun to make sculpture himself, and he installed his most important three-dimensional work—a monumental spear-throwing Amazon riding saddleless on the back of a spirited horse—on the grounds of the villa, and displayed a smaller version of the work (fig. 87) inside. Indeed, in addition to drafting the architectural plans himself, Stuck also designed all the villa's other ornament, from the furniture down to lighting fixtures. The Stuck villa still stands, an impressive if somewhat eccentric monument to the *Gesamtkunstwerk* aesthetic that swept Europe around the turn of the century.

Unfortunately, Stuck's output after 1900 was merely a hollow paraphrase of his powerful early statements, though this did not damage his remarkable career. Already in 1893 he was awarded the title of Royal Bavarian Professor, and in 1895, at the unusually young age of thirty-two, he replaced his erstwhile teacher Wilhelm Lindenschmit at the Munich Academy. By 1897 he was wealthy enough to build his electrically lit villa just down the block from the Secession Gallery, on Prinzregentenstrasse, one of the most exclusive streets in Munich. In 1905 Stuck was ennobled, and by 1914 the son of a humble miller was counted among Bavaria's millionaires.[31] Indeed, there is no doubt that the artist's preoccupation with erotica was shared by a good many turn-of-the-century Germans, who made Stuck's fortune with their patronage.

88. Richard Riemerschmid, *In the Open*, 1895

Richard Riemerschmid

Like Franz von Stuck, Richard Riemerschmid reacted to the sociopolitical climate of Munich in the 1890s, but his visual response, which typified a third variant of Symbolism at the Secession exhibitions, was quite different.[32] Born in 1868 in Munich, Riemerschmid was encouraged to pursue his interest in art by his maternal uncle, Victor Weishaupt, a *plein air* Impressionist painter who would later involve his nephew in the founding of the Secession. Riemerschmid studied painting at the Munich Academy from 1888 to 1890, and his earliest surviving pictures, which date from the early 1890s, are Naturalist landscapes executed in and around Munich. Like so many other

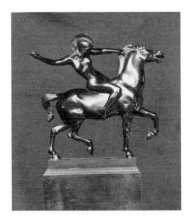

87. Franz von Stuck, *Riding Amazon*, 1897

89. Richard Riemerschmid, *In Arcadia*, 1897

artists at the turn of the century, however, he soon rejected the premises of Naturalism, and around 1893 he began to explore compositional motifs and inflections of mood wholly alien to works by artists like Liebermann. The space of *In the Open* (fig. 88) of 1895, for example, is so steeply uptilted that only a narrow strip of sky peeks over the flowering field, whose untouched purity, signified by the blooming wildflowers and the unregulated course of the brook, is contemplated by the young woman standing in the foreground of the picture. In isolated meditation, she gazes at the spring meadow within which she is embedded.

Over the next several years Riemerschmid focused his work on man's relationship to an unspoiled, pristine nature. *In Arcadia* of 1897 (fig. 89) replaces the proper young middle-class woman of *In the Open* with a tiny nude mother and child, who run

toward us, laughing, through a flowering meadow. Similarly, one of the designs Riemerschmid executed for *Jugend*, the art nouveau journal founded by Georg Hirth in 1896, portrays a recumbent nude holding a bouquet of flowers she has picked from the field in which she now lies (fig. 90). The esteem in which Riemerschmid held nature is evident in each of these compositions, but one painting above all, completed in 1896, made this explicit. (It was destroyed during World War II, but several preliminary studies (fig. 92) as well as a slightly different second version of 1900 (fig. 91) still exist.[33]) Titled *"And the Lord God Planted a Garden in Eden." Genesis 2:8*, the first version of the picture represented in triptych format an Arcadian landscape flanked on one side by the nude figure of a man and on the other by a woman, both of whom gaze with reverence toward the center of the composi-

90. Richard Riemerschmid, Title page
to *Jugend*, 19 June 1897

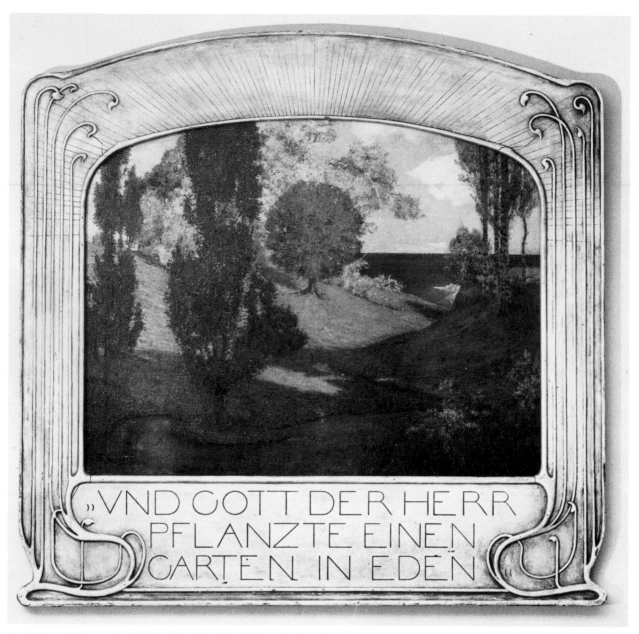

91. Richard Riemerschmid, *"And the Lord God Planted a Garden in Eden." Genesis 2:8*, 1900

tion, occupied by an apple tree encircled with a thin golden nimbus. By thus substituting nature for Christ within a format traditionally reserved for religious imagery, Riemerschmid defined his work as a kind of profane altar painting, in which nature, not God, was holy. Though he did away with both the triptych frame and the nudes in the 1900 rendition, Riemerschmid's essential message of the sanctity of nature was still unambiguously conveyed through the haloed tree of life. Such a radical statement was bound to cause considerable controversy, and after the first version was exhibited at the 1896 Secession salon and acquired in 1897 by the Dresdener Gemäldegalerie, conservatives in the Saxon Parliament attacked the museum for its purchase of this allegedly blasphemous deification of nature.

92. Richard Riemerschmid, Study for *"And the Lord God Planted a Garden in Eden." Genesis 2:8*, 1896

But if Riemerschmid was one of the most talented German painters to emphasize the importance of nature in his work, he was by no means the only one. To the contrary, a number of other turn-of-the-century artists, many of them secessionists, also re-created serene pastorals on canvas. The Berlin painter Ludwig von Hofmann, for example, participated annually in the Munich Secession salons with works such as *Spring Dance* (fig. 93), a Redon-like image of nudes floating within a luxuriant surface of colored textures that have no beginning, middle, or end. Though Otto Eckmann's *Spring* (fig. 48), which was exhibited at the first Secession exhibition in 1893, and *Grand Duchess Caroline von Sachsen-Weimar*, ca. 1903 (fig. 94), by the secessionist Hans Olde are both rooted more firmly in the real world, the youthful women who are the subjects of these paintings are nevertheless entranced, hieratic presences, gliding dreamily through their Arcadian settings. Similarly, in Olde's pointillist *Sleigh Ride*, ca. 1893 (fig. 95), a sleigh cuts quietly

93. Ludwig von Hofmann, *Spring Dance*

94. Hans Olde, *Grand Duchess Caroline von Sachsen-Weimar*, ca. 1903

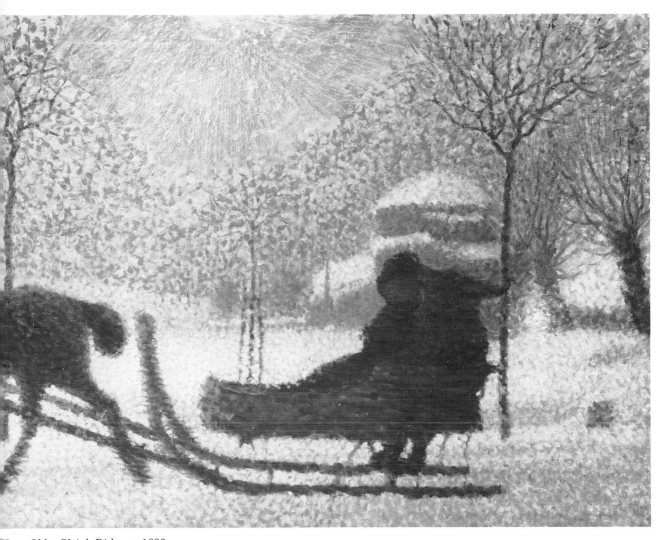

Hans Olde, *Sleigh Ride*, ca. 1893

through the snow of a landscape hermetically sealed from a world troubled by industry, poverty, and ugliness.

In 1895 Riemerschmid undertook a project that initially seemed to be, but actually was not, a departure from his interest in creating bucolic pastorals. That year he married the actress Ida Hofmann, and, after searching in vain to find suitable furniture for their new apartment, he designed it himself. Most of the pieces were fussy and overly dependent on the Gothic furniture in the Bavarian National Museum that he used as models, but by 1897, when Riemerschmid made his first public appearance as an applied artist, he had radically simpli-

fied his designs. That year he exhibited in Munich an elegant buffet (fig. 96), whose only ornament is a bit of decorative metalwork on the doors and some carving on the columns. Henceforth Riemerschmid worked increasingly with the decorative arts, designing single pieces as well as entire ensembles for patrons and exhibitions. In 1898, for example, the painter W. Otto in Bremen commissioned Riemerschmid to design a set of living room furniture, the overall simplicity and restraint of which are conveyed by the small table and two armchairs (fig. 97) that were part of a corner group in the ensemble. Another important commission came in 1898–99, when the

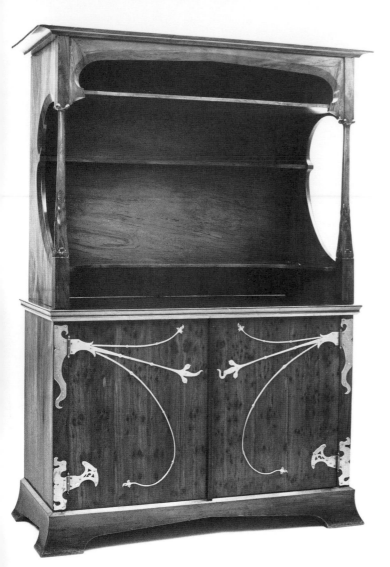

96. Richard Riemerschmid, Buffet, 1897

piano firm J. Mayer & Co. engaged Riemer-
schmid to create a music room for one of its
pianos. The result was displayed at the
1899 Deutsche Kunst-Ausstellung (German
Art Exhibition) in Dresden, in a room that
included a cabinet and music stands, as well
as chairs for the musicians (fig. 98). These
rank among the most beautiful and well-
crafted objects of the period, uniting ele-
gance with function in a design that
allowed the musicians to sit and play com-
fortably (fig. 99). The remarkable doorway
to his "Zimmer eines Kunstfreundes" (Room
for an Art-Lover) (fig. 100), which he cre-
ated for the 1900 World's Fair in Paris,

firmly established Riemerschmid's interna-
tional reputation as a designer, and he
henceforth abandoned painting altogether
to work exclusively in that field and in
architecture.

Of course, Riemerschmid was not alone in
embracing the applied arts. At first hesi-
tantly and then with increasing conviction
and assuredness, German painters, sculp-
tors, and architects like Otto Eckmann,
Bernhard Pankok, Hermann Obrist, August
Endell, and Bruno Paul expanded their
horizons in the mid- to late 1890s by design-
ing objects. Usually they had neither the
training nor the desire to execute the pieces
themselves, so they gave their drawings to
craftsmen who transformed them into fin-
ished products. Nothing was deemed too
small or unworthy of consideration, and fur-
niture, wall hangings, floor coverings,
eating utensils, light fixtures, wallpaper,
and even clothing now commanded the
attention of artists previously concerned
with only the "fine" arts. Initially the art-
ists lavished their attentions on the middle
and upper classes, but by the turn of the
century the more socially minded among
them were also designing well-made yet
affordable objects for workers. In 1900, for
example, when Riemerschmid exhibited his
lavish "Room for an Art-Lover" at the
World's Fair in Paris (fig. 100), he also won
a competition sponsored by the König-
Ludwig-Preisstiftung in Nürnberg for a set
of living room furniture to be produced for
under 350 DM.[34] Indeed, Riemerschmid
later made the needs of the working class a
central concern of his production: between
1907 and 1913 he designed the community
of Hellerau near Dresden, where workers
employed by the Deutsche Werkstätten
were provided homes in a garden city that
is still considered exemplary of its type.

Different as this widespread interest in
the decorative arts may seem from the con-
temporaneous enthusiasm for an unspoiled,
pristine nature, as reflected in the paintings
of Riemerschmid and others, each had its
origins in the frustration that many turn-of-
the-century Germans felt with modern
urban life.[35] Indeed, modernity had hit Ger-
many with particular force. The years
between unification and World War I saw
the country quickly evolve from a basically
rural nation into an urban one. Whereas

only 36.1 percent of the population lived in communities of over two thousand persons in 1871, by 1910 that figure had risen to 60 percent. The growth of the *Grossstädte*, defined in Germany at the time as cities numbering one hundred thousand persons or more, was especially striking. In 1871 there were only eight such cities, whereas in 1910 there were forty-eight.[36] Accompanying these rapid demographic changes were severe urban housing shortages and sharp increases in crime and vice. In Berlin alone about three thousand registered prostitutes were outnumbered by an approximated forty to fifty thousand illicit ones, who attracted business from all over North and Central Germany. Apart from questions of public order, this made venereal disease a major social problem. According to one estimate, in 1900 the number of recorded cases treated in German hospitals was exceeded only by those of tuberculosis.[37]

Even Munich—which in comparison to Berlin or the cities of the Ruhr remained largely unindustrialized—was beginning to look like an urban metropolis. Between 1868, when Riemerschmid was born, and 1896, when he completed his Eden picture, its population increased by more than two and a half times, from 154,000 to 415,500.[38] Most of this growth occurred in the 1880s and 1890s, when breweries, publishing houses, and the transporation and service industries expanded considerably, drawing the rural unemployed into the city as never before.[39] This growth was not only accompanied by the same social problems that vexed other cities but was also attended by a widening of the gap between the classes. As financiers and industrialists elsewhere in Germany had done in the 1860s and later, the upwardly mobile of Munich now adopted a more pretentious, indulgent lifestyle that clearly set them apart from the workers. As contemporaries noted, by the time Luitpold assumed the throne of Bavaria as Regent, the egalitarian atmosphere that had characterized Munich under Ludwig II was a thing of the past, and the contrasts between the rich and the poor, between the educated and the uneducated, became increasingly glaring as the century drew to a close.[40]

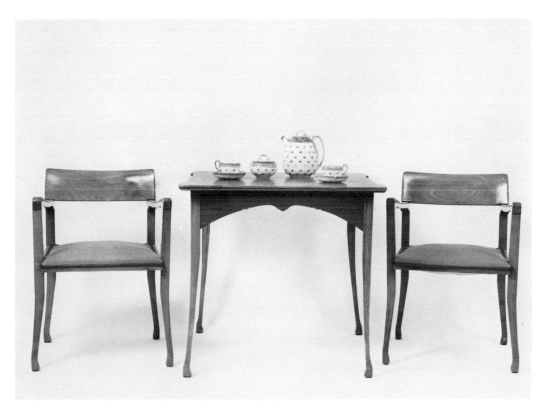

97. Richard Riemerschmid, Table and Two Armchairs, 1898

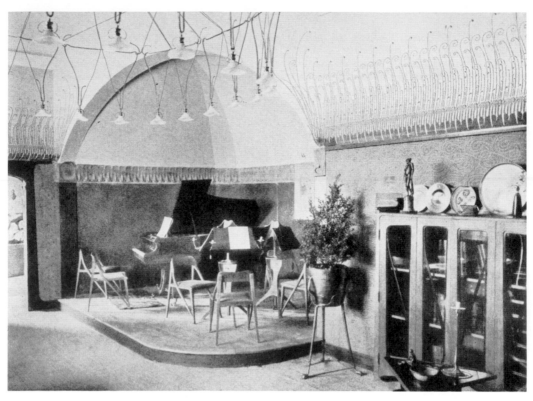

98. Richard Riemerschmid, Music Room at the Deutsche Kunst-Ausstellung, Dresden, 1899

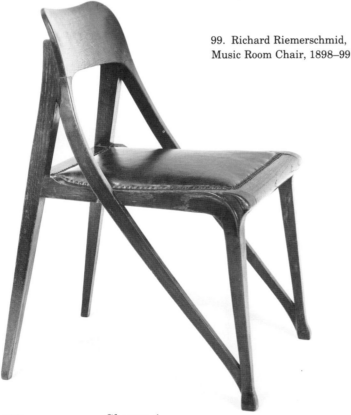

99. Richard Riemerschmid,
Music Room Chair, 1898–99

Responses to these changes were many and varied. Some contemporaries tried to implement change through political action. Riemerschmid, for example, joined Friedrich Naumann's National Social Association, a short-lived political party founded in 1896 and dedicated to reducing the gulf between the working classes and bourgeois society.[41] But by far the most common reaction was a kind of escapist, Neo-Romantic agrarianism that advocated leaving the city behind and returning to the land. Julius Langbehn's 1890 *Rembrandt as Educator*, for instance, was in part based on the notion that the best, the truly authentic German was the peasant, whose virtues and virility could inspire a moral reform of Germany that would restore the proper, nonmaterialistic view of life to the nation.[42] And, indeed, some took Langbehn's advice to heart, actually founding agrarian settlements free of capitalist entanglements. The colony of Eden, established in 1893, was one of the first. Land was common property here, and the inhabitants contributed a part

of their labor for the benefit of the whole community. Other Germans remained in the city, but sought regular spiritual renewal in the country. Members of the *Wandervögel*, the institutional affiliation of the German Youth Movement founded in 1901, quite literally fled the cities and suburbs during the hours they spent together in order to pursue fellowship in more "natural" settings.[43] Finally, the reformist *Gartenstadtbewegung* or Garden City Movement picked up steam shortly after 1900. A kind of synthesis of town and country in which single-family homes would be set amid greenery, the true garden city was completely self-sufficient, with a harmonious balance between small industry and agriculture.[44]

In the absence of comprehensive studies it is difficult to judge how many artists at the turn of the century embraced the underlying nationalism that pervaded many of these *völkisch* responses to the city. But there is no doubt that the same anti-urban sentiment that prompted German youth to flee the city for outings in the country and that led to the establishment of rural communes like Eden also induced artists to create on canvas serene utopian environments seemingly untouched by the evils of modern life. The designers were likewise motivated by an antipathy to the disagreeable aspects of modernity, and looked to the decorative arts as a possible means of rejuvenation. If only mankind could be surrounded with beautiful, well-crafted objects, artists reasoned, the ugliness and misery of modern life might be diminished. As Hermann Obrist, one of the most convincing apologists and theorists of the movement, wrote in 1901, the true mission of the decorative arts is to

anticipate how we are to refashion our dismal bourgeois reality in such a noble way that life in the future will be less toilsome than now.

Let us unite, O nation—citizens, sovereigns, critics, cities, scholars, women, and visual artists of all kinds—to fulfill this mission together.

As yet we are scattered like the spread fingers of a hand, each of which is powerless on its own. If we clench them into a fist, they could become a hammer that would smash the very prosaism of life.[45]

100. Richard Riemerschmid, Doorway to the Room for an Art-Lover at the Paris World's Fair, 1900

Not surprisingly, just as the Neo-Romantic painters took their subject matter from the country, so too did designers like Riemerschmid draw their formal vocabulary from nature. The appliqué ironwork on Riemerschmid's 1897 buffet (fig. 96), for example, meticulously renders the parts of a flowering plant, down to the nodes on the stem from which new buds will soon appear. The diagonal support of his music room chair (fig. 99) is more suggestive, recalling the sweeping curves of growing plants, yet not depicting them literally. But whether literal transcriptions or suggestive descriptions, all these objects share an undulating, seemingly organic flowing line, whose rootedness in nature might rejuvenate a people weary of modern city life, and reinvest them with the energy and enthusiasm of youth. Accordingly, the style was christened

101. Henry van de Velde, Study at the 1899 Secession Salon

"Jugendstil" after Georg Hirth's art nou-
veau journal, for which Riemerschmid and
many of his colleagues supplied designs.

At least initially the Secession played an
important role in the dissemination of both
Jugendstil and the reformist ideals of the
Gesamtkunstwerk movement. In 1896 it
mounted a retrospective of Walter Crane,
the English craftsman and apostle of Wil-
liam Morris, which was the first in a series
of Secession shows that devoted space to the
work of decorative artists. That winter, for
example, the Secession put together a large
exhibition of posters from around the world,
and the following year supported the inclu-
sion of the decorative arts in the seventh
international exhibition in the Glaspalast—
the first joint showing of the Genossenschaft
and the Secession since the split in 1892.
Only two of the seventy-five rooms in the

Glaspalast were devoted to contemporary
"Kleinkunst," but they were the main
attraction of the exhibition, entrancing both
the general public and the critics, who pro-
claimed the birth of a new national style.[46]
Arranged by Martin Dülfer and Theodor
Fischer, the rooms featured embroideries
by Hermann Obrist, woven wall hangings
by Otto Eckmann, stained-glass windows by
Carl Ule, vases by Emile Gallé and by the
Tiffany Glass and Decorating Company,
rugs by Georges Lemmen, and furniture by
Hans Eduard von Berlepsch, Bernhard
Pankok, and Richard Riemerschmid, who
made his first public appearance as a
designer with his 1897 buffet (fig. 96).

In 1898 the Secession continued to spon-
sor the decorative arts, exhibiting at its
summer salon illustrations made for
Jugend and objects mostly by foreign

124 *Chapter 4*

designers, including Emile Gallé, Paul Maurice Du Bois, Henry Nocq, V. Vallgren, Philippe Wolfers, and the Tiffany Company of New York. In the winter the association mounted its second show of posters and prints, with works by Beardsley, Mucha, Signac, Steinlen, Vuillard, and Felicien Rops.

But unquestionably the most spectacular exhibition came in the summer of 1899, when the Secession allowed the Ausschuss für Kunst im Handwerk (Committee for Art in Craft)—a Munich group devoted to mounting shows of the decorative arts within larger exhibitions of the "fine" arts—to put together a series of ensembles for its summer salon.[47] Henry van de Velde exhibited his furniture for the first time in Munich, showing a fully outfitted study (fig. 101), the centerpiece of which was an impressive oak desk whose sweeping Jugendstil curves were widely praised in the press. Fritz Erler designed a parlor (fig. 102), connected to a bedroom by Franz Mayr, while Bernhard Pankok created an entrance hall and Bruno Paul a dining room. Each was filled with furniture and objects executed by members of the Vereinigte Werkstätten für Kunst im Handwerk (United Workshops for Art in Craft), a limited liability company for the decorative arts founded in Munich in 1898 to facilitate links between artist-designers, executant-craftsmen, and the buying public.[48] Scotland was also represented at the exhibition by the Macdonald sisters and Mackintosh, as was France by Charpentier and Lalique, Russia by Fabergé, and the United States by Tiffany. A veritable feast of German and foreign decorative arts, the exhibition featured objects as diverse as electric, gas, and petroleum lamps, iridescent glass vases, jewelry, embroidered tablecloths, clocks, and framed mirrors.[49]

In the last years of the century, then, the Secession salons were an important outlet for the work of Riemerschmid and his German and foreign colleagues. To be sure, these shows were not the only Munich venue for the new arts and crafts movement, for the Genossenschaft also exhibited works by the young modernist designers. But the impact of Jugendstil was typically diluted in the Glaspalast, where works were also displayed by older, more traditional

102. Fritz Erler, Parlor at the 1899 Secession Salon

artists whose historicism was anathema to designers like Riemerschmid, Obrist, Pankok, and Eckmann.[50] By contrast the Secession presented in the late 1890s an undiluted version of the modern decorative arts, whose organic formal vocabulary and reformist ideals were to prove tremendously influential for the next generation of artists just coming of age in the Bavarian capital.

The Lyric Tradition

As I have suggested, the work of Liebermann, Uhde, Kalckreuth, Stuck, and Riemerschmid represented the major aesthetic trends of the Secession exhibitions in the 1890s—exhibitions that were consistently identified by contemporaries as especially "modern." Yet to note simply that the work of Naturalists like Liebermann and Uhde dominated the shows in the first half

of the decade and that the work of Symbolists and Jugendstil designers like Kalckreuth, Stuck, and Riemerschmid reigned in the second half does little to characterize the particular nature of the Secession's modernity, which was notably different from that of much other early modern European art. Simply stated, the Secession salons of the 1890s adumbrated a variant of modernism that generally eschewed direct expression of intense emotive content in favor of a more evocative and filtered nature lyricism.

This is evident above all in the subject matter of the Munich secessionists. Whereas many French Naturalists, Realists, and Impressionists of the 1880s and 1890s were concerned with the representation of contemporary urban life, the German Naturalists of the Munich Secession focused almost exclusively on rural themes. Even when they drew their subjects from the city, as Max Liebermann did in his paintings of the Amsterdam orphanage and retirement home, or Gotthard Kuehl in his pictures of churches in Hamburg, the Germans tended to avoid themes that were obviously urban in character. In itself, this is not surprising, as Munich—the city that shaped the sensibilities of most of these artists—was far more provincial than cosmopolitan Paris, remaining more a large village than a metropolitan center well into the twentieth century. Indeed, that a large number of the German Naturalists gravitated not to Paris but to Holland for their foreign study trips indicates that they simply felt most comfortable living in and drawing their subjects from rustic environments. Significantly, however, the Naturalists of the Munich Secession never developed a rural equivalent to Raffaëlli's urban vagabonds, Manet's ragpickers, or Degas' absinthe drinkers and laundresses. Almost invariably they shied away from the harsher realities of contemporary life in the country, preferring instead, like Liebermann, to present evenhandedly both the good and the bad or, like Uhde, to emphasize optimistically the positive over the negative.

Similarly, the themes preferred by the Symbolists exhibiting with the Munich Secession were almost always drawn from rural environments. Nor is this particularly surprising, as Symbolists all over Europe rejected the subject matter of the city in favor of non-urban themes more appropriate to the expression of subjective, interiorized experience. Yet what is striking about the Symbolists exhibiting with the Munich Secession is that they, like the Naturalists, tended to avoid the expression of anguish in their work, preferring instead to evoke less powerful emotions through an understated nature lyricism. Even the brooding character of Kalckreuth's art, which was more somber than that of almost any other Symbolist showing with the Secession, cannot compare to the tortured psychological tensions in the paintings of Munch, Hodler, and Ensor.

The secessionists' apparent aversion to modern-life themes and gripping emotive content, as well as their preference for subject matter rooted in nature and defined in a lyrical, evocative manner, was also reflected in the foreign art chosen for the Secession salons of the 1890s. It was not Munch but the mood painters Albert Edelfelt, Richard Bergh, Peter Ilsted, Bruno Liljefors, Gerhard Munthe, Eilif Peterssen, and Anders Zorn who represented Scandinavia at the Secession exhibitions.[51] Similarly, Albert Welti and Arnold Böcklin were enlisted from Switzerland, while Hodler was ignored.[52] And while the work of the evocative Belgian Symbolists Fernand Khnopff, Xavier Mellery, and Jean Delville was exhibited at the Secession salons during the 1890s, that of James Ensor, Vincent van Gogh, and Jan Toorop, which was more intense and directly expressive, was not. In its place were the pictures of the Naturalists of the Hague School, including George Hendrik Breitner, Paul Gabriel, Josef Israels, the Maris brothers, Hendrik Willem Mesdag, and Johannes Weissenbruch. Italy was represented by the Symbolist evocations of Giovanni Segantini, and from France came Edmond Aman-Jean, Paul Albert Besnard, Jacques-Emile Blanche, Eugène Carrière, Charles Cottet, Henri Gervex, Paul Helleu, Léon Lhermitte, Henry Martin, and Ary Renan. Significantly, when the Impressionists exhibited at all with the Secession they showed mostly landscapes,[53] and the French Post-Impressionists Gauguin, Toulouse-Lautrec, and Seurat did not participate at all in the Secession salons.

That the Munich Secession failed to exhibit works by those artists of the 1890s who today dominate our canon has led many to question the importance of this exhibition society. Indeed, even some contemporaries felt frustration with the association's aesthetic program of the 1890s. The painter and illustrator Hermann Schlittgen, for example, tried in the mid-1890s to bring to Munich the work of Gauguin, who was anxious to exhibit in the Bavarian capital, but he could not convince anyone, including the Secession, to sponsor this important artist. "A profound interest in modern art existed really only in North Germany," Schlittgen later complained, noting that in Munich even the progressive segments of the art community were "too bound to tradition, more conservative, and somewhat suspicious of the modern."[54] It was precisely this, in fact, that led Schlittgen and nine other artists to resign from the Secession in early 1894 to form the Freie Vereinigung (Free Association). The goal of this society, like that of the Secession, was to sponsor small exhibitions of international art, but from the outset its members wanted the shows to be more radical than those of the Secession. With no wealthy or influential benefactors like Georg Hirth, however, the Freie Vereinigung disintegrated after mounting only one small show in Berlin, and very soon most of its founders were back exhibiting with the Secession.[55]

But despite the Secession's indifference to many of the European artists who are today considered the masters of the 1890s, the association and its exhibitions nevertheless deserve consideration, for they shed light on the work of several seminal twentieth-century modernists who began their careers in Munich at the turn of the century. Wassily Kandinsky, having turned his back on a promising career as a university law professor, arrived in Munich from Russia in 1896 at the relatively mature age of thirty, determined to become an artist. He first enrolled in the private painting school of Anton Azbè, a Yugoslav whose atelier was among the most popular in Munich, and by 1900 he had gained admittance to Franz von Stuck's prestigious class at the Munich Academy. That same year the Swiss student Paul Klee was also admitted to Stuck's course, having spent the previous two years

in Munich learning the basics of draftsmanship in another local atelier, that of Heinrich Knirr. Franz Marc, son of a Munich landscape and genre painter, entered the academy in 1900 as well, attending the classes of Gabriel Hackl and Wilhelm Diez.

These artists received their formal training from their teachers at the academy, but the Munich Secession, together with the local museums and Munich journals like *Jugend* and *Simplicissimus*, was also an important component of their education. Indeed, each of these future innovators regularly attended the Secession salons of the late 1890s, which apparently impressed them all. Kandinsky wrote of the "brilliant debut" and energy of the early Secession, which he praised particularly for its support of foreign artists.[56] Klee was even more appreciative, filling his letters home to Switzerland with accounts of the association's salons. "I'm visiting the exhibition frequently," he wrote his parents in June 1899. "The Secession is especially grand this time. Herterich, Uhde, Zorn . . . as painters and Stuck and Hildebrand as sculptors [are] simply knockouts. It's not been as impressive in the Glaspalast for ages." Indeed, this particular exhibition—which Klee described with youthful enthusiasm in another letter home as "more magnificent than ever"—seems to have set the standard for him. When he came upon one picture that that he liked in the competing Genossenschaft salon, Klee noted tellingly that it was "worthy of the Secession."[57] Not surprisingly, both Kandinsky and Klee repeatedly submitted work to the Secession exhibitions, and the acceptance of a suite of Klee's etchings in 1906 was a source of great satisfaction and inspiration to the young artist.[58]

Each of these artists would later reject the Secession as provincial, but the parallels between their mature work and that exhibited at the Secession exhibitions in the 1890s are nonetheless striking. On the most superficial level, the increasing emphasis on pure line and form in the works that dominated the shows in the latter half of the decade foreshadowed Kandinsky's breakthrough to abstraction just before the war. Indeed, in at least one instance the Secession introduced Kandinsky to an important

103. Akseli Gallen-Kallela, *Defense of the Sampo*, 1896

contact. In May and June of 1898 it fea-
tured a show of Russian and Finnish Sym-
bolist painting put togther by Sergei
Diaghilev, who, before turning to ballet in
1909, organized art exhibitions and pro-
duced and edited Russia's avant-garde jour-
nal *Mir Iskusstva* (*World of Art*). Among the
most interesting participants—among
whom were the Russians Mikhail Vrubel,

Isaak Levitan, Valentin Serov, Alexandre
Benois, Lev Bakst, and Konstantin Somov—
was the Finnish artist Akseli Gallen-Kal-
lela, whose 1896 *Defense of the Sampo* (fig.
103) was a resounding success. Its curious
mixture of archaic stylization and realism
impressed many visitors to the exhibition,
one of whom was undoubtdly Kandinsky,
who subsequently featured Gallen-Kallela

104. Wassily Kandinsky, *Study for Composition II*, 1909–10

with thirty-six works in the fourth Phalanx exhibition of 1902.[59]

Similarly, the utopian ideals of Munich's arts and crafts movement, as represented at the Secession salons in the final years of the decade, unquestionably had considerable impact on this young Russian artist, whose work and theoretical writings were informed by the belief that art possessed a redemptive power that might reform contemporary life.[60] Indeed, the principal message of the *Blaue Reiter* almanac—that remarkable chronicle conceived by Kandinsky and Marc in 1911 and published by Piper Verlag in 1912—avowed the power of art to rejuvenate a mankind weary of the materialism of modern urban life and to initiate a new spiritual epoch. Combining illustrations of paintings, graphics, and sculpture—many of which alluded to healing and salvation—with essays on music, art, and theatre, the book itself, like the ensembles of Riemerschmid and his colleagues at the Secession exhibitions, was intended as a *Gesamtkunstwerk* whose syn-

thesis of the arts would ultimately ennoble mankind.[61]

Less obvious, perhaps, are the subtle affinities between the essentially nature-oriented, lyrical, and generally optimistic sensibility of the work exhibited at the Secession salons and that produced by Kandinsky, Marc, and others of the Blaue Reiter group. From the outset Kandinsky,

105. Franz Marc, *White Bull*, 1911

The Secession in the 1890s

106. Paul Klee, *Screen with Aare River Landscape Scenes*, 1900

for example, used medieval towns or unspoiled, pristine landscapes as the basis of his images of Russian fairy tales, and later, from about 1908 on, he employed landscapes as the setting for his omnipresent horse and rider motif (fig. 104), symbolic of mankind's salvation from materialism. Even his radically abstract paintings of 1912–13 have an organic character about

them. Though they are virtually devoid of identifiable objects, their sweeping curves and overlapping shapes nevertheless suggest a variety of landscape forms, from gently undulating hills and craggy mountains to subaqueous seascapes. Nature played a similarly important role in the work of Marc, whose paintings and prints were dominated by images of animals in

bucolic settings (fig. 105) not unlike Richard Riemerschmid's earlier pastoral Arcadias (fig. 90). At least until about 1912—when a new note of anxiety enters the compositions of both Kandinsky and Marc—the work of these artists is generally upbeat, its glowing colors and undulating lines conveying either joyful exuberance or quiet serenity.

Nature was of the utmost importance for Klee as well. Initially he intended to become a landscape painter, and a series of decorative panels dating from 1900, originally assembled as a screen and here reproduced in their original order (fig. 106), demonstrate his enthusiasm for the work of Neo-Romantic secessionists like Adolf Hölzel, Ludwig Dill, and Walter Leistikow

(figs. 67, 69, 79). Klee, however, found painting difficult in his formative years and was continually dissatisfied with his efforts on canvas. When he returned from Munich to Bern in 1901 he thus abandoned the decorative style adumbrated in the 1900 screen for biting caricatures that he executed as etchings.[62] It was not until his trip to Tunisia in 1914 that Klee transcended the cynicism of his early work and rediscovered painting and color, which made a joyful, sun-drenched appearance in his images of the African landscape and thereafter remained an important component of his mature style.

The work of these early Munich modernists is invariably more filtered than the paintings and graphics of the Expressionists in the north, which are generally characterized by an intensity and expressive directness foreign to their South German counterparts. This was a distinction keenly felt by the artists themselves. Kandinsky, in fact, rejected the Brücke artists' spontaneity and undiluted self-expression. "Such things have to be exhibited," he said in a discussion about whether to include illustrations of their work in the *Blaue Reiter* almanac, "but in my eyes it is not right to immortalize them in a documentation of today's art (which our book is to be) as a somewhat crucial and directing force."[63]

Is there not a certain symmetry between Kandinsky's aloofness toward the raw power of the art of Kirchner, Heckel, Pechstein, and Mueller and the Munich Secession's obvious uneasiness with the immediacy of works by artists like Ensor, Munch, van Gogh, and Toulouse-Lautrec? Was not the nature lyricism that dominated the Secession salons of the 1890s also an important element in the work of the early-twentieth-century Munich modernists? Indeed, rather than condemn the Munich Secession to historical obscurity for its indifference toward many of those early modern artists who are now considered seminal, it is more fruitful to consider the association and its exhibitions within the context of artistic developments in Munich. Simply stated, the secessionist preference for evocation as opposed to unmediated expression, and for rural subject matter as opposed to urban modern-life themes, was not simply a provincial refusal to embrace the most challenging stylistic and thematic aspects of a nascent modern art, but part of a tradition that would reach its most brilliant expression ten to fifteen years later in the nature-oriented lyricism of Kandinsky, Marc, Klee, and their colleagues.

5. Personalities, Politics, and Poverty: The Secession's Demise after 1900

 I went to the Secession not without a little nervous ness: but it wasn't completely unfamiliar to me after all. . . . Already in the first room I found the same bunglers, the same [Franz von] Stuck. Everything exactly where it used to be. . . . And only two new German artists, both insignificant. . . . In a half hour I was completely done with exhibition and gallery and didn't even get tired.
—Wassily Kandinsky to Gabriele Münter, 12 June 1907

With this description of the Munich Secession's 1907 summer salon, Wassily Kandinsky emphatically dismissed the association whose exhibitions of the late 1890s had made such an impact on him.[1] To be sure, his opinion was not entirely objective, for the Secession had repeatedly rejected the artist's work, most recently in 1906, when it turned down all nine of the paintings he had submitted for consideration.[2] But if Kandinsky's dismissal of the association was tinged with a trace of bitterness, it was nonetheless accurate. By 1907 the Munich Secession had long since fallen into decline, its shows more trifling than even those of the Genossenschaft.

This first became evident in the winter of 1899–1900, when the association mounted the first of three large historical exhibitions. During December and January visitors to the Kunst- und Industrieausstellungsgebäude saw not the products of the Vereinigte Werkstätten, but casts of sculpture by Donatello, a private collection of photographs of paintings by Velásquez, and contemporary copies of works by Spanish Masters.[3] The subsequent winter exhibition of 1900–1901 highlighted casts of sculpture by artists of the Italian Renaissance and Baroque—including Bernini, Bologna, Cel-

lini, Donatello, Jacopo della Quercia, and Verrocchio—and copies and photographs of paintings by Rembrandt and Frans Hals.[4] In the summer of 1901 the Secession mounted another large exhibition of Old Master works, including paintings by Cimabue, Bronzino, Giorgione, Titian, Velásquez, van der Weyden, Memling, Rubens, and others.[5] Finally, in 1905, the association sponsored a retrospective of the work of Franz von Lenbach, the Secession's erstwhile arch-enemy who had died in 1904.[6]

With these historical shows the Secession decisively rejected its founding principles, just as it did with its post-1900 exhibitions of contemporary art. Indeed, rather than reinvigorate its salons with innovators of the twentieth century like Cézanne, the Fauves, and Picasso, the association simply continued to feature those artists who had exhibited in the 1890s. Edmond Aman-Jean, Paul Albert Besnard, Jacques-Emile Blanche, Eugène Carrière, and Charles Cottet continued to represent France, while Frank Brangwyn, George Clausen, John Lavery, and Walter Sickert came from Great Britain, and the old standbys Michael Ancher, Peder Severin Kroyer, Carl Larsson, Christian Skredsvig, and Anders Zorn participated from Scandinavia.[7] True, in the early 1890s these artists had brought a breath of fresh air to the Munich art community, but by 1900, not to mention by 1910, their work seemed old-fashioned and academic. Moreover, the Secession also excluded some of the most interesting artists living in Germany. Most of the Jugendstil designers were barred from the post-1900 exhibitions, and the work of Kandinsky and Klee was repeatedly rejected.[8]

Some certainly found these changes in the Secession's program positive. Even Paul Klee visited the 1901 summer salon more

than once, describing it to his father in glowing terms:

Today I was again at the Secession's Renaissance show. Exhibited in incomparable taste are original works in private collections by Dürer, Holbein, Titian, etc. It is like going into the private chambers of an art-loving king. Everything authentic—pictures, frames, tapestries, chairs, jewelry cases—and for all that nothing pretentious, but rather free and natural in the rooms despite all the richness. The pictures themselves, for the most part exemplary portraits, are flawlessly preserved, so that after experiencing the Alte Pinakothek one is completely surprised about the modern freshness of the colors.[9]

But most progressive members of the art community indicted the Secession's historical excursions. The Berlin art critic Hans Rosenhagen wrote in 1901:

The "Secession" . . . appears to have utterly forgotten its essential objectives. For what is this so-called "Donatello and Renaissance Art Exhibition" which has already taken place twice in the Secession's house, if not propaganda for Lenbach's ideas about the single true Art and a commendation of Munich's imitation-industry? The reflection on the art historical value of the creations of the Florentine early Renaissance does not excuse anything. The Secession is not there to teach art history to the public.[10]

Rosenhagen went on to ask if the association would not have done better to mount a show of works produced by members of either the Vereinigte Werkstätten or the Vienna Secession. Even Munich secessionists questioned the association's new course. In Paris as a German juror for the World's Fair of 1900, Ludwig Dill bewailed the society's current indifference toward progressive contemporary art. *"The Viennese and Berliners are trying their hardest to get the best from here for their next exhibitions,"* he wrote his friend Hugo von Habermann, then vice-president of the society. "Only the Munich Secession is doing nothing. It will soon fall asleep. Someone should have been here *long ago* in this regard. . . . *Munich is in danger*, and no one will admit it."[11]

What changed the Munich Secession's direction around the turn of the century? Why, after having finally overcome the problems of the early 1890s, did the association's leaders suddenly depart from the pro-

gram they had fought so hard to develop? What prompted them to abandon the—at least for Munich—challenging exhibitions of the 1890s for safe but uninspiring shows of has-beens? In short, what led to the demise of the Munich Secession? Ironically, the very forces that had initially split the Genossenschaft in 1892 coalesced not ten years later to confound the Munich art community once again. This time it was not the Genossenschaft that succumbed to their onslaught, but the Secession.

Fritz von Uhde and the Munich Secession: Intolerance Takes Its Toll

Complain though he might about the Secession's lack of direction, Ludwig Dill himself was unwittingly partly responsible for the Secession's *volte-face* of 1900. Elected president of the association after Bruno Piglhein's death in 1894, Dill managed the Secession's affairs for most of the decade with enthusiasm and aptitude from his vantage point in Dachau. Although he did not himself experiment with the applied arts, Dill supported the *Gesamtkunstwerk* movement,[12] and it was undoubtedly his enthusiasm for both the decorative arts and an abstract-tending formal language that occasioned the Secession's innovative shows of 1898 and 1899. But in the autumn of 1899 Dill accepted a professorship at the academy in Karlsruhe and resigned as the Secession's president. His successor, Fritz von Uhde, was ill suited to replace him.

As we have seen, Uhde was not only personally abrasive and professionally insecure, he was also unwilling to acknowledge value in orientations other than those related to his own. When he was a progressive force in Munich in the early 1890s, this took its toll on the resident academic and popular painters, who were excluded from the 1891 exhibition that Uhde chaired. But when he assumed the presidency of the Secession in 1899 other artists had succeeded Uhde in the vanguard. Now *they* were the focus of his dogmatism, and this had unfortunate consequences for the Secession, for almost immediately Uhde changed the course charted by his predecessor and steered the association away from the most innovative trends in contemporary art.

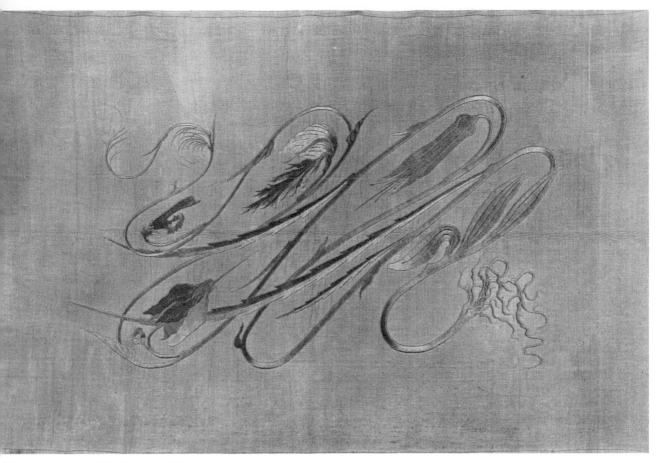

Hermann Obrist, *Whiplash*, ca. 1895

Symptomatic of Uhde's presidency and its impact on the Secession was an incident involving the Jugendstil artist Hermann Obrist, one of the founders of the Vereinigte Werkstätten and by 1900 an accomplished designer at the very heart of Germany's modern arts and crafts movement.[13] Obrist first attracted attention in 1889, when his pottery and furniture won a gold medal at the Paris World's Fair, and he solidified his reputation in 1896, when the Littauer Gallery in Munich exhibited thirty-five of his remarkable embroidered textiles. One of these, the *Whiplash* (fig. 107), is today considered a paradigm of Jugendstil art, its sinuous floral motif not an objective fragment of nature but a subjective expression, an abstract representation of nature's seething energy. Also a sculptor of tombs, funeral urns, monuments, and fountains, Obrist was a tireless and eloquent advocate of the

Gesamtkunstwerk movement as well, propagating its reformist message in frequent public lectures and essays. Indeed, Obrist's missionary strain was such that in 1902 he opened with Wilhelm von Debschitz the Lehr- und Versuch-Ateliers für Angewandte und Freie Kunst (Teaching and Experimental Studios for Applied and Fine Art), one of the first schools in Germany to emphasize the interdependence of the fine and applied arts.[14]

Uhde's predecessor, Ludwig Dill, was so convinced of Obrist's importance that he scheduled a retrospective of the artist's work for the winter of 1899–1900.[15] Following so closely on the heels of that year's summer salon, which had highlighted the products of the Vereinigte Werkstätten, such an exhibition would have underscored the Secession's commitment to Munich's new applied arts movement, while firmly

The Secession's Demise after 1900 135

establishing the association's position at the vanguard. But Dill departed for Karlsruhe in the autumn, and the shortsighted Uhde approved neither of the contemporary arts and crafts movement[16] nor of the tendencies toward the abstract that it had inspired in painting.[17] His sentiments were shared by committee member Franz von Stuck, who found the products of the Vereinigte Werkstätten too spare and unadorned, and termed them ugly, tasteless, and philistine.[18] So it is not surprising that Obrist's show was preempted by the Donatello-Velásquez exhibition. The artist, who justifiably expected the Secession to honor its commitment, politely suggested that he at least be granted the space after the other exhibition closed, and when Uhde curtly refused with no explanation he even offered to rent the rooms from the Secession himself. Again rebuffed by Uhde, Obrist resigned from the association, promising to publicize the Secession's breach of contract.

The artist apparently reconsidered this threat, for the affair remained under wraps. But a year later Obrist avenged himself with a widely read article that was, among other things, an incisive attack on the Secession's conservatism. Bitterly complaining about the lack of support for members of the Vereinigte Werkstätten, of which he was a founding member, Obrist wrote in the pages of the *Neueste Nachrichten*:

As long as the new [movement] was still in its infancy, the officially sanctioned representatives of high art admitted it to the rooms of . . . the Secession through the side doors. But ever since it seemed to be maturing into manhood [*seit es aber ein grosser Junge zu werden verspricht*], they have closed the gates. [The applied arts] alarm them, and seem to them unworthy. It has thus reached a point where the applied arts can find not a single place in Munich—this [once]-renowned *Kunststadt*—to present themselves in an artistic way except for their own sale rooms.[19]

Concluding that one could expect of Munich "no action, only reaction," Obrist predicted that unless government officials and Munich art organizations did a hasty about-face and embraced the new design movement, many of the city's best artists would abandon the Bavarian capital for other locations more responsive to the modern decorative arts.

Time proved his prophecy all too accurate. With Uhde at its head, the Secession continued to bar its doors to members of the Vereinigte Werkstätten, who, lacking official support of any other kind, left Munich one by one for greener pastures. Otto Eckmann departed for Berlin in 1897, to be followed by August Endell (1871–1925) in 1901 and by Bruno Paul (1874–1968) in 1907. By 1899 Peter Behrens (1868–1940) had abandoned Munich for Darmstadt, and by 1901 Bernhard Pankok (1872–1943) had left for Stuttgart. About the only major designers to remain in Munich were Richard Riemerschmid, who received many of his major commissions from and exhibited primarily outside the city, and Hans Eduard von Berlepsch (1849–1921), who died a spiritually and financially broken man.

To be sure, this mass exodus of Jugendstil designers may well have occurred even if the Secession had supported the modern applied arts, for Munich's art market, as we shall see, was in serious trouble around the turn of the century. At this time many artists, progressive and otherwise, left the Bavarian capital for other cities. But without an official exhibition venue, Munich designers like Eckmann, Paul, and Pankok had even less chance to establish a market for their work than did their colleagues who showed regularly with the Secession or the Genossenschaft. There can be no doubt that Fritz von Uhde and the association he presided over bore a great deal of responsibility for this drain of talent from Munich, which the city never fully recouped.

Uhde's intolerance was directly related to a deepseated sense of insecurity that frequently clouded his judgment. But this lack of professional confidence not only led him, and thus the Secession, to reject what was unquestionably the most vital and promising development in contemporary German art in recent years; it also exacerbated a conflict that ultimately further damaged the Secession's record of commitment to progressive art. Soon after the Obrist incident, Uhde, in a controversy over Munich's artistic hegemony in Germany, so angered the Berlin Secession that many of *its* members also resigned from the Munich Secession, never again to exhibit with their South German colleagues.

"Münchens Niedergang als Kunststadt": Cultural Chauvinism and Its Impact on the Secession

Shortly before the Munich Secession's exhibition of Old Masters in private collections opened to the public in 1901, two articles by the respected art critic Hans Rosenhagen appeared in the Berlin newspaper *Der Tag*. Titled "Münchens Niedergang als Kunststadt" ("Munich's Decline as an Art Center"), they described the city's alleged cultural demise and predicted that Berlin would soon assume Munich's leading role in the nation's artistic affairs.[20]

Rosenhagen did not identify a single individual or organization as the source of Munich's problem but, rather, took the entire community to task for its failure to nurture the city's reputation. He chided the Bavarian state government for not supporting the Secession immediately, thereby forcing its members to exhibit in 1893 in Berlin, where the public enthusiastically responded to its first undiluted taste of non-academic art. Indeed, Rosenhagen believed the Munich Secession's exhibition whetted the Berliners' appetite for progressive painting and sculpture, which in turn led to the formation of a lively art market that was gradually superseding Munich's. He also indicted the acquisitions for the Bavarian state collections, and attacked Munich critics for their apparent unwillingness to censure any artist or organization based in the Bavarian capital. Yet it was the artists themselves who bore the brunt of Rosenhagen's criticisms. Bemoaning what he called a "retrospective spirit" in Munich art, Rosenhagen rebuked all those painters, sculptors, designers, and architects who looked to the past for inspiration, simply rephrasing tradition in their work rather than creating anew. Franz von Lenbach and his followers were the primary target here, but Rosenhagen also roundly criticized the Secession's historical exhibitions, which, he believed, only encouraged such a retrogressive approach.[21]

By publicly expressing what many were saying privately, Rosenhagen hoped to shame the Secession into revamping its tired exhibition program. Uhde, however, was unabashed. In a letter to Rosenhagen he defended his recent accomplishments, proudly asserting that the association was "not a thoroughly modern one" and that even the most progressive artists could benefit from its historical shows.[22] Not surprisingly, the Secession's next exhibition was no more interesting than its immediate predecessors. As Kandinsky pointed out in a review of the association's 1902 summer salon for the Russian journal *Mir Iskusstva*, "hanging on the walls, it seems, are the 'same old things' we saw long ago, only somewhat faded—pictures that take as their point of departure the literal repetition of nature and thus forfeit the luster of the artist's intentions."[23]

But if Rosenhagen's essay did not have the desired impact on the Munich Secession, it most certainly did affect the association, sparking a controversy with the Berlin Secession that ultimately had disastrous results. Soon after the articles appeared, Uhde and the executive committee complained to Max Liebermann that the Munich secessionists had been slighted in the imperial capital in recent years, their work insufficiently represented and poorly installed at the Berlin Secession's exhibitions. Small wonder, they implied, that Berlin residents had the wrong impression about Munich and its most important exhibition society; and they threatened to exhibit with the Berlin Secession's arch-enemy, the state-supported Verein Berliner Künstler, if the situation were not remedied.[24]

Liebermann was justifiably horrified at this prospect. Since its inception the Berlin Secession had faced far more strident opposition than the Munich Secession ever encountered, primarily from the Prussian state and Emperor William II.[25] Infinitely more autocratic and intolerant than Prince Regent Luitpold of Bavaria, the emperor believed that there were absolute aesthetic truths from which artists should never deviate. These were above all evident in the art of classical Antiquity, which he held up as the model for contemporary German painters and sculptors.[26] Not surprisingly, William II waged continual battle with the Berlin Secession, whose members rejected his classical ideal as hopelessly reactionary. Liebermann feared that a split in the secessionist front would swing the fight decisively in the emperor's favor, and to fore-

stall this he thus promised the Munich secessionists that they could both jury and install their own work provided they continue to exhibit with the Berlin Secession. "In the end, fundamental principles cannot be entirely disregarded because of justified or unjustified anger," Liebermann argued in a reference to the resentment over the Rosenhagen articles, "otherwise the [secessionist] enterprise will perish."[27]

These concessions apparently mollified the Munich secessionists, for they did not exhibit that year with the Verein Berliner Künstler. Yet this was but a temporary truce, as anyone who knew Uhde and his feelings about Liebermann could have predicted. Indeed, by the late 1890s Uhde had built up considerable resentment toward his erstwhile friend and colleague, who had supplanted him as the *éminence grise* of Germany's modern movement. When *Kunst für Alle* published an article in 1897 proclaiming Liebermann the greater talent of the two, Uhde even wrote the editorial board to complain about the journal's "Semitic sympathies," stating that the essay would have been appropriate in a "Berliner Judenblatte" but not in a Munich magazine.[28] To Hans Rosenhagen he whiningly protested the recent trend in Berlin of honoring "others" at his expense,[29] and years later he was still grumbling about Liebermann, who, he said, had conspired with the Berlin art dealer Paul Cassirer in a sinister plot to fix the art market.[30]

As Alfred Lichtwark would later observe, the embittered Uhde had lost all sense of objectivity.[31] Nevertheless, as president of the Munich Secession his influence was considerable, and he was not about to compromise with Liebermann when his reputation and that of Munich were at stake. In the autumn of 1902 Uhde therefore continued to badger his Berlin colleagues. Not only did the executive committee request that the Munich group be granted its own jury and installation committee at the 1903 Berlin Secession exhibition; it also demanded enough space to show 150 to 200 works. Considering that the Berlin Secession's gallery on Kantstrasse was small, with only six rooms that could hold a total of some 380 works, the request was utterly unreasonable. Liebermann could not possibly promise more than half the space to

Munich, and the committee's demands were rejected. Uhde subsequently notified the Berlin Secession in December that his association would find another exhibition opportunity in the imperial capital, since, as he said in a reference to the Rosenhagen articles, "it is particularly important to us not to exhibit beneath our capabilities in Berlin, because the Munich Secession has not been kindly treated by the Berlin press."[32]

Uhde had finally gone too far. In a letter dated 29 December 1902, the Berlin Secession's executive committee notified the Munich secessionists that statutory regulations required them to resign if they exhibited elsewhere in the Reich capital; moreover, officers Max Liebermann, Walter Leistikow, Ludwig von Hofmann, and Max Slevogt renounced their affiliation with the Munich Secession.[33] In response, all the Munich members of the Berlin Secession resigned, provoking another round of resignations from the Munich Secession by more Berlin members.

Although Liebermann feared further repercussions, these events ultimately did not damage the Berlin Secession nearly as much as its sister organization in Munich. Indeed, by 1903 the Berlin Secession was generally considered the standard-bearer of modernism in Germany, its salons an important venue for many young European artists. The French Impressionists were a regular feature of its shows, as were numerous Post-Impressionists, including van Gogh, Gauguin, Toulouse-Lautrec, and Munch. Some of the young Expressionists also exhibited with the association, among them Kandinsky, Nolde, Käthe Kollwitz, and Max Beckmann. Thus, though Liebermann and the executive committee regretted the resignations of the Bavarians, ultimately they eliminated the most traditional wing of the Berlin Secession. By contrast, the Munich Secession had already lost much of its momentum by 1900, and the resignations of Berlin members in 1902 and early 1903 further impeded its progress. True, in 1904 the conflict over German participation at the St. Louis World Exposition momentarily reconciled the Secessions,[34] and in 1907—when Uhde was no longer president—Liebermann, Hofmann, Leistikow, and Slevogt even rejoined the association as

corresponding members. Yet resentment over the incident ran deep on both sides, and the Berlin secessionists hardly exhibited again with their South German colleagues.

Uhde's insecurity thus joined forces with Bavaria's omnipresent cultural chauvinism to confound the Munich Secession in the years around the turn of the century. But one other factor hastened the association's deterioration considerably. The market for Munich art, which had begun to weaken around 1890, collapsed shortly after 1900, in the process destroying what little vitality the Secession may have still had.

Money and Misery: The Secession and the Munich Art Market after 1900

As we have seen, during the latter half of the nineteenth century Munich's prestige as a German art center was sustained by its museums and its academy, by its frequent and vigorously supported exhibitions, and in a broader sense by its air of freedom and experimentation. Thus the Bavarian capital in the 1860s, 1870s, and 1880s drew not only artists but collectors and dealers as well, whose activities made Munich's art market the strongest in the country, with resident painters and sculptors as the primary beneficiaries.

Yet, ironically, it was the tremendous allure of Munich that ultimately caused the city's artistic demise, for the art community finally outgrew its own base. Already in 1890 and 1891 there was a sharp drop in the purchases of Munich art at the Glaspalast salon, prompting many Genossenschaft members to demand the exclusion of foreigners from the association's exhibitions. But rather than improve over the course of the 1890s, the situation steadily worsened. For one thing, the art community continued to grow in the years around the turn of the century, from 1,180 to 1,882 resident painters and sculptors between 1895 and 1907.[35] But despite their increased numbers, local artists sold significantly less as a group in Munich after 1900 than before, while other German and, in particular, foreign artists sold considerably more. In 1889, for example, 40 percent of the exhibitors at the Genossenschaft salon lived in Munich, and they accumulated 58 per-

cent of the total sales, while the 38 percent of the exhibitors who were foreign garnered only 33 percent of the sales. By 1903, however, Munich artists made up 45 percent of the exhibitors at the salon but brought in only 10 percent of the total sales, whereas the 21 percent of the participants who were foreign accumulated 42 percent of the sales.[36]

Under different circumstances either the crown or the state might have offset this sluggish market by augmenting their expenditures on art. Yet Luitpold's position as Regent—which restricted funds normally available to the sovereign—continued to limit the ruler's support of Munich painters and sculptors. Nor did the state alleviate the situation. In principle the liberal cabinet supported increased funding for the arts, but it was hampered by the opposition Center Party, which dominated parliamentary politics from the 1890s until the eve of World War I. As we have already seen, this had ominous implications for Munich's cultural life after the turn of the century. Indeed, not only did censorship increase, but financial support for all the arts languished.

One incident is symptomatic of the Center Party's economic impact on Munich's community of artists. In 1895 Robert von Landmann succeeded August Ludwig von Müller as Minister of Church and School Affairs in Bavaria. A moderate liberal who tried to compromise with the Center, Landmann was well liked by Catholics but opposed by anticlerical liberals in the cabinet, who finally succeeded in forcing him out of office in July 1902. The Center Party retaliated with a vengeance, slashing from the budget the 100,000 DM art acquisition fund, nine-tenths of which was earmarked for contemporary art. Fortunately, one of Luitpold's advisors personally donated funds to cover the budgetary cut, and in 1903 the legislature approved the allocation once again.[37] Nevertheless, the incident effectively demonstrates that art was not a priority for the Center Party—particularly when it threatened to undermine traditional Catholic values, as much contemporary theatre, painting, and sculpture did. Thus, the art budget either was used politically, as in the Landmann incident, or was allowed to languish. Despite continued expansion of the art community and infla-

tion in the cost of living and art prices, legislators increased the acquisition budget not at all between 1890 and 1913.[38]

In short, neither the crown nor the state helped alleviate the plight of Munich's art community, which writers, artists, and critics increasingly addressed after the turn of the century. Some, like the music and theater critic Theodor Goering, simply bemoaned the problem. "The number of artists is growing," he wrote in 1904, "and meanwhile the structure necessary for their support has not kept pace with this growth. As an art market Munich is far behind Berlin. There is much suffering for the artist here! The capacity, the capability, is there, but it does not find enough support."[39] Others offered concrete suggestions for narrowing the gap between the supply of Munich art and the demand for it. Many, for example, urged that even more Munich painters and sculptors branch out into the applied arts, giving industry an opportunity to assume the patronage functions that wealthy Bavarians had by and large neglected. One influential functionary even suggested that an association be formed to cultivate an international market for Munich art. This society—which he would call the Zentralstelle für Münchens Kunst und Kunstindustrie (Central Office for Munich's Art and Art Industry)—would, as well as mounting exhibitions, publishing catalogues, and advertising the work of local artists throughout Europe, also advise resident artists on legal and practical matters such as the most inexpensive and efficient procurement of materials.[40]

But the most ominous proposal came from an artist who had lived near Munich for a number of years. In 1911 Carl Vinnen, a landscape painter associated with the Worpsweder School who was then working in the North German town of Cuxhaven, published a polemical tract titled *Ein Protest deutscher Künstler* (*A Protest by German Artists*). Following a defensive preamble in which he disingenuously opposed "chauvinistic Teutomania" was a one-sentence paragraph that set the theme and tone of the whole: "In view of the great invasion of French art, which for the past few years occurred in the so-called progressive art centers of Germany, it seems to me a necessity for German artists to raise a

warning, without being deterred by the objection that their only motivation is envy." Vinnen subsequently went on to censure Germany's critics and journalists (who had recently become an irresponsible force, elevating theory above instinctive creativity and praising French art over all else), German collectors and museum directors (who paid enormous prices for studio remnants by Monet, Sisley, Pissarro, and the like while ignoring the masterpieces of their own countrymen), and all those native artists who slavishly emulated foreign models. "The *undignified disdain* for valuable national characteristics, today so widespread among our aesthetes, cannot lead to great achievements," he concluded in an appeal to patriotism and idealism:

A great, powerfully upward-striving culture and people like ours cannot forever tolerate spiritual usurpation by an alien force. And since this domination is being imposed on us by a large, well-financed international organization, a serious warning is in order: let us not continue on this path; let us recognize that we are in danger of losing nothing less than our own individuality and our tradition of solid achievement.[41]

It was no coincidence that of the 118 artists who "protested" with Vinnen by appending their names to the end of his essay, nearly half were from Munich, where the market could no longer support the disproportionately large resident community of painters, sculptors, and graphic artists. And many of the other signatories had, like Wilhelm Trübner, spent much of their careers in the Bavarian capital, leaving for other cities only when driven away by necessity. Sadly, almost all of the Munich artists who signed the document were secessionists.[42]

In fact, the Munich Secession had already taken practical steps to weaken the market for foreign art long before Vinnen's chauvinistic diatribe appeared in print. In 1900 the association voted to require its corresponding members—previously considered so integral to the secessionist enterprise that they were allowed to exhibit *hors concours*—to submit their work to a jury, just as resident artists were required to do.[43] This measure provided a safety valve for Secession jurors, who, in a misguided effort to shore up the market for Munich art, increasingly excluded their non-German

colleagues from the exhibitions. Whereas in 1893 more than half the exhibitors with the Munich Secession had lived in countries other than Germany, by 1908 a mere 17 percent of the exhibitors were foreign.[44] Indeed, the association's founding assumption that Munich artists "urgently need the foreigners for both material and idealistic reasons" was quickly forgotten in the lean years around the turn of the century. Long before the outbreak of World War I, market conditions had reshaped the Secession's refreshing cosmopolitanism of the early 1890s into a cultural parochialism that might easily be co-opted for more sinister political purposes.

In less than twenty years, then, the association had come full circle. Not only had it rejected the vanguard *Gesamtkunstwerk* advocates of the arts and crafts movement and alienated some of the most progressive painters in the Berlin Secession by 1903, but by 1908 it had also turned its back decisively on foreign artists, who initially formed the core of the secessionist enterprise. The competition with Berlin for artistic hegemony of Germany, economic uncertainty, and personal issues like Uhde's pathological insecurity together proved too much for the association, which ultimately fell prey to the very provincialism it had initially combated. In the end, the Munich Secession was unable to tame those forces out of which, in the early 1890s, it had emerged.

Appendixes

I. First Announcement of the Founding of the Verein Bildender Künstler Münchens

The following document lobbying for support was circulated within the Munich art community in mid-March 1892 by the twenty founders of the Munich Secession.

Colleagues! The recent events in the Munich Künstlergenossenschaft are no doubt familiar to you all, for they were such as to require that each member take a stand. The simmering pot has now boiled over and led to a rupture [within the art community] that was unavoidable and is also irreparable. The battle that had been waged secretly for years has now been publicly declared with bitterness. It is the battle of the discontented and offended mediocrity against artistic greatness, of the reactionary against the progressive. And if the majority of our members (including many renowned artists)—completely misconstruing the changes that have occurred in the art world—believe that the "good old days" can again be conjured up through inept measures, they are surpassed in their lack of insight only by the executive committee, which is incapable of protecting purely artistic interests and which adheres to the wishes and exists only through the support of that majority.

A corporation of approximately one thousand members—only two-fifths of whom, according to the statistics of the last three years, are exhibitors, and three-fifths of whom either hardly earn the title of "artist" or terrorize and paralyze all endeavors through their electoral majority—such a corporation is no longer capable of discharging the noble duty with which it is entrusted.

We, the artists, want to be masters in our own house! No longer do we wish to be controlled by painting lawyers and parliamentarians!

We do not want the concept and the nature of our exhibitions to be attacked and questioned each year.

And they have been questioned—indeed, endangered in the highest degree—by the recent statutory changes and the removal of our trustworthy business manager.

The annual exhibitions are not only dear to us, they have become the darlings of our noble Protector [Prince Regent Luitpold], of the city of Munich, and of the international public that appreciates art.

We, the undersigned, for the most part the founders of those same annual exhibitions, have united in order to save the annual exhibitions and our ideals; we are determined to dissociate ourselves from an association in which we have found neither understanding for nor cooperation with our ideas. In so doing we wish to lay the foundations for a new structure in which all Munich artists—that is, artists in the true sense of the word—will find a home, irrespective of their orientation, and we do not doubt that our German colleagues will join us.

We are founding an association of artists for the purpose of holding annual international exhibitions of a purely artistic nature, whereby we guarantee the individual artist the greatest possible latitude; we wish to support true art of all orientations; as far as possible we will strive for a strict but nonpartisan jury; through the most careful selection of our members, independent of the Genossenschaft, we wish to avoid the abuses of that association.

United we constitute a power that will be indestructible. We have reason to believe that we will have the sympathy of the highest authority, of the royal government, of the respectable press, of the knowledgeable public, and of many art-loving patrons!

Because it is not our intention to damage this year's international exhibition in any way, we request that you contribute to it, and we will delay our withdrawal from the Genossenschaft until after the exhibition opening.

Colleagues, artists, join us! Follow us in support of a good cause!

The provisional committee: Josef Block, Bernhard Buttersack, Ludwig Dill, Hugo Freiherr von Habermann, [Otto] Hierl-Deronco, Ludwig Herterich, Paul Hoecker, Gustav Leopold von Kalckreuth, Gotthard Kuehl, [Paul Wilhelm] Keller-Reutlingen, Hugo König, Albert Langhammer, Guido von Maffei, Bruno Piglhein, Robert Poetzelberger, Franz Stuck, Fritz von Uhde, Fritz Voellmy, Victor Weishaupt, Heinrich Zügel.

Collegen! Die letzten Vorgänge in der Münchener Künstlergenossenschaft dürften Ihnen im Allgemeinen bekannt sein—sie waren derart, dass sie gebieterisch die Stellungnahme jedes einzelnen Mitgliedes erfordern. Eine lange bestehende Gährung kam endlich ans Tageslicht und führte eine Spaltung herbei, die unvermeidlich war und auch nicht wieder auszugleichen ist. Der Kampf, der jahrelang geheim geführt wurde, ist nun mit Erbitterung an der Oberfläche entbrannt—es ist der Kampf der unzufriedenen und gekränkten Mittelmässigkeit gegen das Künstlertum, der Reaktion gegen den Fortschritt; und wenn die Mehrzahl unserer Mitglieder, darunter viele namhafte Künstler, in absoluter Verkennung der Wandlungen, die sich in der Kunstwelt vollzogen haben, glaubt, durch ungeschickte Massnahmen die "gute alte Zeit" wieder heraufbeschwören zu können, so werden sie in ihrem Mangel an Einsicht nur noch durch den Vorstand übertroffen, der, in seiner Majorität zur Wahrnehmung rein künstlerischer Interessen unfähig, sich seinerseits an jene Mehrheit hält und durch sie existiert.

Eine Körperschaft von etwa tausend Mitgliedern, von denen, wie die Statistik der letzten drei Jahre ergibt, nur etwa zwei Fünftel Aussteller sind, drei Fünftel derselben aber zum grossen Teile nicht nur kaum den Namen "Künstler" verdienen, sondern sogar diejenigen, die solche sind, durch ihre Stimmenmehrheit terrorisieren

und auf ihre Bestrebungen lähmend einwirken—eine solche Körperschaft ist der hohen Aufgabe, die ihr zukommt, nicht mehr gewachsen.

Wir, die Künstler, wollen Herren in unserem Hause sein! Wir wollen uns nicht länger von malenden Juristen und Parlamentariern bevormunden lassen!

Wir wollen nicht, dass jedes Jahr unsere Ausstellungen nach Idee und Art aufs Neue angefochten und in Frage gestellt werden.

Und in Frage gestellt, in hohem Grade gefährdet, sind sie worden durch die neuerlichen Statutenveränderungen, durch die Entfernung unseres erprobten Geschäftsführers.

Die Jahresausstellungen liegen nicht nur uns am Herzen, sie sind auch die Lieblinge unseres hohen Protektors, der Stadt München, des kunstsinnigen internationalen Publikums geworden.

Wir, Unterzeichnete, zum grössten Teile die Mitbegründer derselben, wir haben uns zur Rettung der Jahresausstellungen, zur Rettung unserer Ideale zusammengetan; wir sind entschlossen, uns von einer Gemeinschaft zu trennen, wo wir für unsere Ideen weder Verständnis noch Entgegenkommen gefunden haben. Wir wollen hiemit den Grundstein legen zu einem neuen Baue, der alle Münchener Künstler—Künstler im wahren Sinne des Wortes—einerlei von welcher Richtung, in sich aufnehmen soll und wir zweifeln nicht, dass sich uns unsere deutschen Kollegen anschliessen werden.

Wir gründen einen Verein von Künstlern behufs Abhaltung von jährlichen internationalen Ausstellungen rein künstlerischer Art, wobei wir dem einzelnen Künstler möglichsten Spielraum gewähren; wir wollen wahre Kunst von jeder Richtung pflegen; wir wollen mit allen Mitteln eine zwar strenge aber unparteiische Jury erstreben; wir wollen, unabhängig von der Genossenschaft, durch vorsichtigste Wahl unserer Mitglieder die Missstände dieser Corporation vermeiden.

Geschlossen bilden wir eine Macht, die unüberwindlich sein wird. Wir haben allen Grund zur Ueberzeugung, dass wir die Sympathie höchsten Ortes, der kgl. Regierung, der anständigen Presse, des gebildeten Publikums und vieler kunstbegeisterter Mäcene haben werden!

Da es uns ferne liegt, die diesjährige internationale Ausstellung in irgend einer Weise schädigen zu wollen, fordern wir Sie auf, dieselbe zu beschicken und verschieben unseren Austritt aus der Genossenschaft bis nach der Ausstellungseröffnung.

Collegen, Künstler, schliesst Euch uns an! Folgt uns im Dienste der guten Sache!!

Das vorläufige Comité: Josef Block, Bernh. Buttersack, Ludwig Dill, H. Frh. v. Habermann, Hierl-Deronco, Ludwig Herterich, Paul Hoecker, G. L. v. Kalckreuth, G. Kuehl, Keller-Reutlingen, Hugo König, A. Langhammer, Guido von Maffei, Bruno Piglhein, R. Poetzelberger, Franz Stuck, F. v. Uhde, F. Voellmy, V. Weishaupt, H. Zügel.

II. Memorandum of the Verein Bildender Künstler Münchens

The following statement—published in its entirety in the *Münchener Neueste Nachrichten* on 21 June 1892, and excerpted in other newspapers and art journals—announced and explained the issues behind the founding of the Munich Secession. The document also appeared as a circular that was distributed separately.

Exceptional changes have occurred in the last decade in the art world. Ceaseless production has replaced comfortable creation, and exhibitions, sporadic in bygone days, occur now in unbroken succession.

Munich has been the headquarters of German art since the time of Ludwig I. That annual exhibitions must continue to be held here thus seems only a fulfillment of the noble mission to which Ludwig I and his illustrious successors felt themselves called, and it is a fact whose accuracy has hitherto been doubted by no one. Yet the international character of these exhibitions has been challenged—indeed, passionately attacked from many quarters—either in principle or on the basis of the form that they have assumed in the last three years.

The criticism most often heard of the international character of the exhibitions is that it diminishes the earnings of the Munich art community. To put this question in perspective, some words about the expansion and contraction of the Munich art market are in order.

Early in the seventies the demand for Munich pictures increased in a way that was never anticipated. Both the talented and the less gifted had their hands full and were hardly able to keep pace with the great demand of the art dealers. These "golden days" lasted into the eighties, and the Munich art community lived by and large on American and English money. But meanwhile a powerful stimulus enlivened foreign art, and many artists of different nationalities suddenly surprised the world with exceptional originality and productivity. The Dutch, Belgians, Danish, Italians, even the Americans—all of whom had previously produced very little and almost never left the borders of their own countries—increasingly submitted pictures to the Paris Salon. In this way they entered the art market as powerful competitors. This competition was to become especially dangerous for us Munich artists. For while the majority of us—under the spell of the art market—remained artistically on the level of the sixties, these countries had joined the great modern currents that were then flooding all of Europe. It was not long before Munich art was deemed provincial in foreign countries. Simultaneously, the world art market was undergoing what was for us a painful but beneficial transformation. Namely, the Americans soon became weary of the old Munich pictures and turned to the rejuvenated art, cultivated mostly outside of Germany, that breathed light and air. This change of taste had long since occurred by the beginning of the first annual exhibition in 1889, and the accusation that these exhibitions damaged the Munich art market is thus completely untenable. The demise of the Munich art market in its prior state is a fact. If satisfactory results were nevertheless attained at the three annual exhibitions, any thinking person must realize that while an equally large portion of the sales fell to the foreigners, this is far more advantageous than if no sales were made in Munich at all. In any case, the belief that Munich artists would earn all the profits if the foreigners were excluded is unrealistic.

Just as untenable as the accusation that the foreigners cause considerable material damage is another contention heard frequently, that the modern spirit that has penetrated Munich art has destroyed and discredited it in foreign countries. To the contrary, if Munich art had awakened sooner from its slumber, if it had recognized our neighbors' progress earlier and had tried to keep pace with it, it would certainly have been spared some unfortunate experiences.

Only through progress does living art exist. If Munich assumed Düsseldorf's heritage in the art market at the end of the sixties, it was only because it was the first city in Germany to possess the technical achievements of the French and the Belgians. Similarly, it is possible to win back this importance in the competition with our foreign neighbors only if [Munich] recovers that much more quickly what it lost in the eighties. For what the opposition party so frequently labels "imitation of the French" is in fact only a free and healthy manifestation of the new spirit of the age. National differences have always existed only in so far as they originate in the temperamental differences of the individual peoples. Technical advances, like all newly discovered truths, belong to the entire world, and every isolationist program can lead only to a torpid art of dated formulas.

Like all new enterprises, the first annual exhibition of 1889 was the source of repeated complaints. After the close of the second it was generally agreed that the enterprise needed reform and that abuses had crept in whose elimination was desired by everyone. These reforms were postponed only because it was feared that untimely measures might play into the hands of threatening and competitive enterprises. It was unanimously decided to treat as exceptional the conditions in which the third annual exhibition of 1891 was formed. The jury of this show thus discharged admirably the duty it was assigned in regard to [the exhibition's] large size, but naturally the abuses also increased exponentially in this exceptional year.

The main problem that has begun to plague the annual exhibitions is their excessive expansion resulting from the acceptance of too many mediocrities. For the viewer it is tiring and antipathetic to work through a labyrinth of very disparate art products. If, as is willingly admitted, the number of foreigners should be reduced through the rejection of their inferior works, the same must apply equally, if not more so, to German and especially to Munich art. No doubt it is obvious to everyone that the more selective the admission of foreigners is, the more choosy we must be in reviewing our own ranks.

Although the jury of the last annual exhibition worked toward reform and insisted on the elimination of those abuses, one group of artists crassly twisted and exploited the exceptional conditions of 1891 that had been instigated, desired, and approved by the Genossenschaft. They won the support of many offended and discontented [artists], and because they, with the cooperation of the majority of the Genossenschaft, lost all objectivity—indeed, because they endangered the exceptional achievements of our exhibitions through overly hasty reforms—they made us realize that we could no longer remain part of the Genossenschaft.

The motto of the victorious majority was: "We Munich artists want to organize the exhibition. The foreigners should be 'admitted,' but 'Munich' art should be seen in Munich."

We are certainly the last to doubt the capabilities of the Munich art community. But we believe that it is overvaluing our talents to feel confident that *each year* a brilliant exhibition worthy of international interest can be mounted without the significant participation of the foreigners. For even if the Munich artists constitute a very respectable contingent in this annual parade of art, we still urgently need the foreigners for both material and idealistic reasons. And if Munich art is to prove itself equal to foreign art at the Munich exhibitions, if it is to win back the reputation that it once had but has now in part lost, then it must present itself completely differently than it has in the [recent] past. It is in the interest of the artists—precisely because it is in the interest of art—that the principle of accepting only the absolutely artistic must be implemented with total commitment and ruthlessness. We acknowledge this as the only means of fully harnessing the considerable power that is unquestion-

ably inherent in the art production of Munich, and of securing for this power the recognition and respect of our contemporaries.

Will the execution of this policy be possible within the Munich Künstlergenossenschaft? Will that [association] be equal to the noble task that it has been assigned? Can our intentions ever be realized, given the "three-picture-system," the nature of the jury elections, the voting method within the jury, the growing discontent on all sides, and the material distress of so many members? Will we ever be able even to approach an understanding of the artistic with the stifling majority? We cannot answer these questions in the affirmative today, nor is there even a remote possibility of being able to answer affirmatively in the foreseeable future.

Before our withdrawal, the Künstlergenossenschaft had grown in size to an association of roughly one thousand members of whom, according to the statistics of the last three years, roughly only two-fifths exhibit at the annual salon. In our opinion, this number must be greatly reduced through a more scrupulous selection [of members]! Under such conditions it is impossible for the Künstler-Genossenschaft to do justice both to the ideals of art and the personal interests of its members.

Every jury of these exhibitions will have the same experience: either it will—with the best intentions—do Munich art a great disservice by accommodating the immediate rather than the long-term needs [of the art community] and downgrading the Munich exhibition to the level of the local exhibition, or it will—keeping the big picture in mind—be forced to reject [the works of] many hundreds of members and thereby create a contingent that by its numerical majority will oppose anew each year the development of art and endanger the existence of these exhibitions by [instituting] measures dictated by passion.

To combat these hopeless conditions with petitions for changes in the statutes or with ultimatums to the Genossenschaft seemed to us, the disappearing minority, a bogus struggle as useless as it would be unworthy. We thus took the step that was, in our opinion, the only correct and possible one: we declared our withdrawal from the Genossenschaft.

The purpose of our new association is to form an energetic, right-thinking group of artists of all orientations who will mount annual international exhibitions and who, disregarding all personal benefit, will unreservedly embrace the principle that the representative Munich exhibitions must be elite exhibitions! The best interests of what is purely artistic may not be confused with or thwarted by any other interests. We can neither promise nor grant "equal rights for all," in the sense of the above-mentioned group of artists within the Genossenschaft. *Art* should be seen at our exhibitions, and every talent whose work can bring honor to Munich, whether of old or new orientation, should be able to prosper. We are prepared to make considerable sacrifices; everyone will do his best and submit himself to a jury, whose duties will be discharged by the executive committee serving at the time.

In order to maintain lively artistic activity and avoid the primary mistake that has damaged the Genossenschaft, any member who has not exhibited in three consecutive years will lose his vote, which can be regained only when the artist is again represented at our exhibitions. The affairs of our association will be managed in such a way that their artistic, legal, and commercial aspects will be kept fully and professionally separate.

It would be completely wrong to assume that we—the initiators of the proposed exhibitions, the representatives and advocates of the ideas expounded [here]—consider ourselves the only worthy representatives of Munich art, going our own way so that our own light might shine. No! If at first we must aspire to the new goal in small numbers, we are nevertheless certain of the support of all our spiritually and artistically like-minded colleagues who have Munich's art at heart, regardless of their orientation.

We must forgo the understanding of the large majority of the Künstlergenossenschaft, and refrain from responding to the defamations and insinuations with which we shall be overwhelmed. That we renounce our part of the Genossenschaft property, that we are laying ourselves open to malicious attacks, that we are assuming the burden of organizing the exhibitions: all this may serve as proof that for us the only means to save our ideals were those that we

have chosen—in cognizance of our artistic rights as well as of our artistic duties.

Ausserordentliche Wandlungen haben sich im letzten Jahrzehnt in der Kunstwelt vollzogen. An die Stelle behaglichen Schaffens ist ein rastloses Produciren getreten, und die früher vereinzelten Ausstellungen folgen sich jetzt in ununterbrochener Reihe.

München ist seit den Tagen Ludwigs I. der Vorort der deutschen Kunst. Dass gerade hier jährliche Ausstellungen abgehalten werden müssen, erscheint daher nur als eine Erfüllung der grossartigen Mission, zu der es durch Ludwig I. und dessen erlauchte Nachfolger berufen wurde, und ist eine Thatsache, deren Richtigkeit bisher von Niemand bezweifelt wurde. Angefochten, ja mit Leidenschaft bekämpft wurde dagegen von vielen Seiten der internationale Charakter dieser Ausstellungen— entweder im Princip oder in der Form, die sie im Laufe der letzten drei Jahre angenommen hatten.

Der am meisten gehörte Vorwurf, der gegen den internationalen Charakter der Ausstellungen erhoben wird, ist der der materiellen Schädigung der Münchener Künstlerschaft. Zur Richtigstellung dieser Frage mögen einige Worte über die Entwickelung und Rückentwickelung des Münchener Kunstmarktes gestattet sein.

Im Anfange der 70er Jahre hob sich die Nachfrage nach Münchener Bildern in ganz ungeahnter Weise. Grosse und kleine Meister hatten alle Hände voll zu thun und waren kaum im Stande, der grossen Nachfrage von Seiten der Kunsthändler nachzukommen. Diese "goldene Zeit" dauerte bis in die 80er Jahre hinein und die Münchener Künstlerschaft lebte zum weitaus grössten Theile von amerikanischem und englischem Gelde. Unterdessen hatte sich jedoch im Auslande ein mächtiger Aufschwung der Kunst vorbereitet und zahlreiche Künstler verschiedener Nationalitäten überraschten die Welt plötzlich durch eine ausserordentliche Originalität und Leistungsfähigkeit. Die Holländer, die Belgier, die Dänen, die Italiener, selbst die Amerikaner, die alle bisher nur in sehr engem Rahmen producirt und fast nie die Grenzen ihrer Heimath verlassen hatten, begannen von Jahr zu Jahr mehr den Pariser Salon mit ihren Bildern zu beschicken und traten auf diese Weise als mächtige Concurrenten in den Weltkunstmarkt ein. Ganz besonders gefährlich musste diese Concurrenz uns Münchenern werden. Denn während die Mehrzahl der Münchener—im Banne des Kunsthandels— künstlerisch auf dem Niveau der 60er Jahre stehen geblieben war, hatten diese Nationen sich schon der grossen modernen Strömung angeschlossen, die damals ganz Europa durchfluthete. Es dauerte nicht lange, so galt die Münchener Kunst im Auslande als veraltet. Eine für uns schmerzliche, aber heilsame Wandlung vollzog sich nun stetig im Weltkunstmarkt. Namentlich in Amerika wurde man der alten Münchener Bilder bald überdrüssig und wandte sich der verjüngten, Licht und Luft athmenden Kunst zu, die zumeist ausserhalb Deutschlands gepflegt wurde. Diese Wendung des Geschmackes war bei Beginn der ersten Jahresausstellung 1889 längst vollzogen—der Vorwurf, als hätten diese Ausstellungen den Münchener Kunstmarkt geschädigt, ist somit total hinfällig. Das Darniederliegen des Münchener Kunstmarktes in seiner früheren Art ist eine Thatsache; wenn nichts desto weniger bei den drei Jahresausstellungen recht befriedigende Resultate erzielt wurden, so wird sich jedem Denkenden die Ueberzeugung aufdrängen, dass, wenn auch ein noch so grosser Theil der Verkäufe den Fremden zu Gute kam, dieser Zustand weit vortheilhafter ist, als wenn in München überhaupt keine Geschäfte gemacht werden. Eine Utopie ist es jedenfalls, zu glauben, bei Weglassung der Fremden würde die ganze Verkaufssumme auf Münchener Künstler entfallen!

Ebenso hinfällig wie der Vorwurf der materiellen Schädigung durch die Fremden ist eine andere, oft gehörte Behauptung, als habe der moderne Geist, der in die Münchener Kunst eingedrungen ist, dieselbe zersetzt und im Auslande discreditirt— gerade im Gegentheil: hätte die Münchener Kunst sich früher aus ihrem Schlafe aufgerafft, hätte sie das Vorwärtsstürmen unserer Nachbarn früher begriffen und mit ihnen gleichen Schritt zu halten versucht, so wäre ihr gewiss manche traurige Erfahrung erspart geblieben.

Im Fortschritt allein ist lebendige Kunst. Wenn München Ende der 60er Jahre auf

dem Kunstmarkt die Erbschaft Düsseldorfs antrat, so verdankt es dies lediglich dem Umstande, dass es damals als die erste Stadt Deutschlands sich in den Besitz der technischen Errungenschaften der Franzosen und Belgier gesetzt hatte. Ebenso wird es heute—in der Concurrenz mit unsern ausländischen Nachbarn—diese Bedeutung nur dadurch wieder gewinnen können, dass es das in den 80er Jahren Versäumte um so schneller nachholt. Denn was von gegnerischer Seite so gern als "Nachahmung der Franzosen" hingestellt wird, ist im Grunde doch nur eine freie und gesunde Manifestation des neuen Zeitgeistes. Nationale Unterschiede hat es von jeher nur gegeben, insoweit sie aus den Temperamentsunterschieden der einzelnen Völker entsprangen. Die technischen Fortschritte gehören wie alle neuentdeckten Wahrheiten der ganzen Welt an, und jedes Isolirungssystem könnte nur zu einer in alten Formeln erstarrten Kunst führen.

Die erste Jahresausstellung 1889 gab nun, wie alle neuen Unternehmungen, schon zu mehrfachen Klagen Anlass; nach Schluss der zweiten war man allgemein zur Ueberzeugung gekommen, dass das Unternehmen reformbedürftig geworden sei, dass sich Missstände eingeschlichen hätten, deren Beseitigung von allen Seiten gewünscht wurde; verschoben wurde diese Reform nur deshalb, weil man angesichts drohender Concurrenzunternehmungen fürchtete, durch unzeitgemässe Massregeln jenen in die Hände zu arbeiten, man beschloss einstimmig, die Bedingungen, unter welchen die dritte Jahresausstellung 1891 zu entstehen habe, als ausnahmsweise zu betrachten. Die Jury dieser Ausstellung wurde denn auch der Aufgabe, die ihr in Bezug auf Reichhaltigkeit gestellt wurde, in vollem Masse gerecht,—aber selbstverständlich traten auch die Missstände in diesem Ausnahme-Jahr in potenzirte Weise hervor.

Der hauptsächlichste Missstand, an dem die Jahresausstellungen zu kranken begonnen haben, ist deren allzu grosse Ausdehnung, hervorgerufen durch die Aufnahme zu vieler Mittelmässigkeiten. Es wirkt für den Beschauer geradezu ermüdend und abstossend, sich durch ein Labyrinth von sehr ungleichwerthigen Kunstproducten durchzuarbeiten. Wenn nun gerne zugegeben werden soll, dass die Zahl der Fremden durch Zurückweisung des von ihnen etwa gelieferten Minderwerthigen zu reduziren ist, so trifft dies in gleichem, wenn nicht erhöhtem Masse, bei der deutschen und speciell bei der Münchener Kunst zu; und es ist wohl Jedermann einleuchtend, dass, je gewählter die Fremden bei uns auftreten, desto wählerischer wir selbst in der Musterung unserer Schaaren sein müssen.

Obschon nun die Jury der letzten Jahresausstellung dem Reformwerke näher trat und auf Abschaffung jener Missstände drang, sah sich eine Gruppe von Künstlern veranlasst, die von der Genossenschaft angeregten, vorausgewollten und vorauswussten Ausnahmezustände des Jahres 91 in krasser Weise auszumalen und auszubeuten; im Sturm eroberte sie den Beifall vieler Gekränkten und Unzufriedenen und indem sie, mit der Majorität Hand in Hand gehend, den Boden der Objektivität verliess, ja durch überhastete Neuerungen die ausserordentlichen Errungenschaften unserer Ausstellungen in Frage stellte, gab sie uns den Anstoss zu der Erkenntniss, dass in der Genossenschaft unseres Bleibens nicht mehr sein könne.

Die Parole der siegreichen Majorität war nun: "Wir Münchener wollen die Ausstellungen machen; die Fremden sollen 'zugelassen' werden—aber in München soll man 'Münchener' Kunst sehen."

Wir sind gewiss die Letzten, die an der Leistungsfähigkeit der Münchener Künstlerschaft zweifeln; aber, sich zu getrauen, *jedes Jahr* ohne ganz wesentliche Betheiligung der Fremden eine glänzende Ausstellung schaffen zu können, die geeignet ist, internationales Interesse zu erregen,—das halten wir für eine Selbstüberschätzung; denn, stellen auch die Münchener ein sehr respectables Contingent zu dieser jährlichen Heerschau der Kunst, so bedürfen wir doch der Fremden dringend, sowohl aus materiellen als ideellen Gründen,—und soll die Münchener Kunst sich auf Münchener Ausstellungen als der ausländischen ebenbürtig erweisen, soll sie den früheren, zum Theil verloren gegangenen Ruf wieder erobern, so muss sie künftig eine ganz andere Erscheinung bieten, als dies bisher der Fall war. Gerade im Interesse der Künstler—weil im Interesse der Kunst—

muss das Princip der Aufnahme nur des absolut Künstlerischen mit aller Energie und Rücksichtslosigkeit durchgeführt werden. Darin erkennen wir den einzigen Weg, die bedeutende Kraft, die im Kunstschaffen Münchens unstreitig enthalten ist, zu voller Entfaltung und Geltung zu bringen und ihr die Anerkennung und Achtung der Mitwelt zu sichern.

Wird nun die Durchführung dieses Princips in der Münchener Künstlergenossenschaft möglich,—wird letztere der hohen Aufgabe, die ihr zukommt, gewachsen sein, wird bei dem "Drei-Bilder-System", bei der Art der Jurywahl, bei dem Abstimmungsmodus in der Jury, bei der allgemein wachsenden Unzufriedenheit, bei der materiellen weitgreifenden Nothlage der Mitglieder—jemals eine Verwirklichung unserer Absichten erreichbar sein? Werden wir uns mit der erdrückenden Majorität jemals auch nur annähernd über die Frage verständigen können, was künstlerisch sei? Diese Fragen können wir weder heute bejahen, noch ist die geringste Aussicht vorhanden, sie in absehbarer Zeit bejahen zu können!

Die Künstlergenossenschaft war vor unserem Austritte zu einer Körperschaft von etwa tausend Mitgliedern angewachsen, von denen, wie die Statistik der letzten drei Jahre gezeigt hat, etwa nur zwei Fünftel als Aussteller bei den Jahresausstellungen in Betracht kommen,—eine Anzahl, die nach unserer Meinung, sich bei sorgfältigerer Auswahl noch ganz bedeutend verringern müsste! Es ist demnach für die Künstler-Genossenschaft ein Ding der Unmöglichkeit, zu gleicher Zeit den idealen Anforderungen der Kunst—und den persönlichen Interessen ihrer Mitglieder als solcher gerecht zu werden.

Jede Jury dieser Ausstellungen wird die gleiche Erfahrung machen: sie wird entweder—wohlwollend—der Münchener Kunst den allerschlechtesten Dienst leisten, indem sie, die kleinen Interessen vor den grossen betonend, die Münchener Ausstellung auf das Niveau der Localausstellung herabdrückt—oder sie wird,—das grosse Ganze im Auge habend,—viele Hunderte der Mitglieder zurückweisen müssen und dadurch eine Phalanx schaffen, die durch ihr numerisches Uebergewicht alle Jahre aufs Neue der Fortentwicklung der Kunst feindlich entgegentreten und durch von Lei-

denschaft diktirte Massnahmen die Existenz dieser Ausstellungen gefährden wird.

Gegen die dargelegten hoffnungslosen Zustände durch Anträge auf Statutenveränderung anzukämpfen, oder der Genossenschaft eine Art Ultimatum zu stellen, erschien uns, der verschwindenden Minorität, als ein ebenso nutzloses als unwürdiges Scheingefecht;—wir betraten daher den Weg, der nach unserer Ueberzeugung der allein richtige und mögliche war: wir erklärten unseren Austritt aus der Genossenschaft.

Der Zweck unserer neuen Vereinigung ist der, eine thatkräftige, gesinnungstüchtige Gruppe von Künstlern aller Richtungen zu bilden, welche jährliche internationale Ausstellungen abhalten und welche, absehend von persönlichen Vortheilen, sich rückhaltlos zu dem Principe bekennen: Die repräsentativen Münchener Ausstellungen müssen Eliteausstellungen sein! Die Interessen des rein Künstlerischen dürfen von keinerlei anderen Interessen alterirt oder gekreuzt werden. "Gleiches Recht für Alle" im Sinne der erwähnten Künstlergruppe der Genossenschaft können wir weder versprechen noch einräumen. Man soll auf unseren Ausstellungen *Kunst* sehen und jedes Talent, ob älterer oder neuerer Richtung, dessen Werke München zur Ehre gereichen, soll seine Blüthe reich entfalten können. Wir sind zu weitgehenden Opfern bereit; jeder wird nur sein Bestes geben und sich einer Jury unterwerfen, deren Amt der jeweilige Ausschuss der Vereinigung ausübt.

Um eine künstlerische Bethätigung auf die Dauer rege zu erhalten und den Hauptfehler, an dem die Künstlergenossenschaft krankt, zu vermeiden, wird jedes Mitglied, welches in drei sich folgenden Jahren nicht ausgestellt hat, bei Wahlen und bei Abstimmungen seiner Stimme verlustig gehen und solche erst wieder erwerben, sobald dasselbe auf unseren Ausstellungen wieder künstlerisch vertreten sein wird. Die Leitung unserer Vereinsangelegenheiten wird in ihrer künstlerischen, juridischen und kaufmännischen Funktion eine durchaus fachmännisch getrennte sein.

Die Annahme wäre eine durchaus irrige, als betrachteten wir, die wir die Unternehmer der gedachten Ausstellungen, die Träger und Vorkämpfer der entwickelten

Ideen sind, uns allein als die würdigen Repräsentanten der Münchener Kunst, um auf gesondertem Wege unser Licht leuchten zu lassen. Nein! wenn wir auch vorerst in kleiner Anzahl dem neuen Ziele zustreben, so rechnen wir doch bestimmt auf die Unterstützung aller uns geistig und künstlerisch verwandten Collegen, denen die Kunst Münchens am Herzen liegt, sie mögen sonst einer Partei angehören, welcher sie wollen.

Wir müssen darauf verzichten, von der grossen Majorität der Künstlergenossenschaft verstanden zu werden, ebenso auf die Schmähungen und Verdächtigungen zu entgegnen, mit denen wir überschüttet werden. Der Umstand, dass wir mit unserem Austritte auf unseren Antheil am Genossenschaftsvermögen verzichten, dass wir uns gehässigen Angriffen aussetzen, dass wir die Bürde der Gestaltung von Ausstellungen auf uns nehmen, mag als Beweis dafür dienen, dass für uns zur Rettung unserer Ideale kein anderer Weg mehr denkbar war, als der, den wir eingeschlagen haben—im Bewusstsein unseres künstlerischen Rechtes wie unserer künstlerischen Pflicht.

III. Membership Roster of the Verein Bildender Künstler Münchens

What follows is the Secession's membership roster of June 1892, which was appended to the printed "Memorandum" reproduced in Appendix II. First names have been added when the original gives only the family name, and titles have been translated. Otherwise the list, with its original orthography, is reproduced verbatim.

A. Regular Members

1. Amling, Franz
2. Ankarcrona, Gustav
3. von Aster, Martin
4. Becker-Gundahl, C. J.
5. Becker, Benno
6. Behrens, Peter
7. Bergen, Fritz
8. Berninger, Edmund
9. Block, Josef
10. Boller, Louis
11. Borchardt, Hans
12. Bredt, F. M.
13. Buchner, Georg
14. Buttersack, Bernhard
15. Corinth, Louis
16. Crodel, Paul
17. Dill, Ludwig
18. Eckenfelder, Friedrich
19. Eckmann, Otto
20. Eichfeld, Hermann
21. Exter, Julius
22. Fehr, Friedrich
23. Fellermeyer, Joseph
24. Flad, Georg
25. Flossmann, Joseph
26. Gabl, Alois, Professor
27. Graetz, Theodor
28. Grocholsky, Stanislaus
29. Baron von Habermann, Hugo
30. Hänisch, Alois
31. Halm, Peter
32. Hartwich, Hermann
33. Havenith, Hugo
34. Heim, Heinz
35. Heine, Theodor
36. Hengeler, Adolf
37. Herterich, Ludwig, Royal Professor
38. von Heyden, Hubert
39. Hierl-Deronco, Otto
40. Hinné, Charles, Copenhagen
41. Hoecker, Paul, Royal Professor
42. Hoelzel, Adolf
43. Hummel, Theodor
44. Kalckreuth, Count Leopold, Professor
45. Keller, Albert, Professor, Honorary Member of the Royal Academy of Fine Arts
46. Keller-Reutlingen, Paul Wilhelm
47. Kirchner, Eugen
48. Klinckenberg, Eugène
49. König, Hugo
50. Kuchel, Josef
51. Kuehl, Gotthard, Royal Professor, Honorary Member of the Royal Academy of Fine Arts
52. Kuschel, Max
53. Landenberger, Christian
54. Langhammer, Arthur
55. Laupheimer, Anton
56. Lepsius, Reinhold
57. Liebermann, Max, Berlin
58. Lipps, Richard
59. von Maffei, Guido

60. Maison, Rudolf, Professor, Sculptor
61. Meyer-Basel, Theodor
62. Müller, Peter Paul
63. Neuhaus, Hermann
64. Niemeyer, Adalbert
65. Olde, Hans
66. Oppler, Ernst
67. Peske, Geza
68. Piglhein, Bruno, Professor, Honorary Member of the Academy of Fine Arts
69. Piltz, Otto, Professor
70. Pötzelberger, Robert, Professor, Karlsruhe
71. Rabending, Fritz
72. Reinike, René
73. Räuber, Wilhelm
74. Samberger, Leo
75. Schachinger, Gabriel
76. Schlittgen, H.
77. von Schmädel, Max
78. Schmidt, Ludwig
79. Schmidt, Theodor
80. Schorn, Theobald
81. von Schroetter, Alfred
82. Szymanowsky, Waclaw
83. Selzam, Eduard
84. von Siebierz, Giebis
85. Simonson, Ernst
86. Speyer, Chr.
87. Stadler, Toni
88. von Stetten, Carl, Paris
89. Stremel, Max Arthur, Belgium
90. Strobentz, Fr.
91. Strützel, Otto
92. Stuck, Franz
93. Thomas, Victor
94. Trübner, Wilhelm
95. von Uhde, F., Royal Professor, Honorary Member of the Academy of Fine Arts
96. Ulrich, Charles Fred.
97. Velten, Wilhelm
98. Vetter, Karl
99. Völlmy, F.
100. Voltz, Wilhelm
101. Wahle, Fritz
102. Weishaupt, Victor
103. Wenban, S. L.
104. Werenskiold, Erik, Christiania
105. Winternitz, Richard
106. Zimmermann, Ernst, Professor, Honorary Member of the Academy of Fine Arts
107. Zügel, H., Professor, Honorary Member of the Academy of Fine Arts

B. Corresponding Members

1. Agache, Alfred, Painter, Paris
2. Aublet, Albert, Painter, Paris
3. Bareau, Emile, Painter, Paris
4. Besnard, Paul, Painter, Paris
5. de Beul, Franz, Painter, Paris
6. Billotte, René, Painter, Paris
7. Blanche, J. E., Painter, Paris
8. von Bochmann, G., Painter, Düsseldorf
9. Boldini, Jean, Painter, Paris
10. Breitner, G., Painter, Amsterdam
11. Carrière, Eugène, Painter, Paris
12. du Chattel, Fred. J., Painter, The Hague (Holland)
13. Clays, A. J., Painter, Brussels
14. Collin, R., Painter, Paris
15. Courtens, Franz, Painter, Brussels
16. Courtois, Gustave, Painter, Paris
17. Dagnan-Bouveret, P.A.J., Painter, Paris
18. Diez, Robert, Professor, Sculptor, Dresden
19. Ferragutti, Adolfo, Painter, Milan
20. Gay, Walter, Painter, currently in Paris
21. Gervex, Henry, Painter, Paris
22. Baron von Gleichen-Russwurm, Ludwig, Painter, Weimar
23. Gola, Emilio, Painter, Milan
24. Guthrie, James, Painter, Glasgow
25. Hagen, Theodor, Professor, Painter, Weimar
26. Hamilton, W., Painter, Heensburgh (England)
27. Haug, Robert, Professor, Painter, Stuttgart
28. Herrmann, Hans, Painter, Berlin
29. L'Hermitthe, Léon, Painter, Paris
30. Jerace, Francesco, Sculptor, Naples
31. Jerace, Vincenzo, Sculptor, Naples
32. Johannsen, V., Painter, Copenhagen
33. Israels, Joseph, Painter, The Hague (Holland)
34. Klinkenberg, K., Painter, Amsterdam
35. Kolstô, Frederik, Bergen (Norway)
36. Kroyer, P. S., Painter, Copenhagen
37. Laurenti, C., Painter, Venice
38. Lavery, John, Painter, currently in Madrid
39. Leemputten, Frans, Painter, Antwerp
40. Maris, Willem, Painter, Voorburg (Holland)
41. le Mayeur, A., Painter, Brussels
42. Melchers, Gari, Painter, Paris
43. Michetti, J., Painter, Francavilla al Mare, Italy

44. Monteverde, Giulio, Sculptor, Rome
45. Munthe, Gerhard, Painter, Paris
46. Myslbeck, J., Professor, Sculptor, Prague
47. Oyens, Pierre, Painter, Brussels
48. Peterssen, Eilif, Painter, Christiania
49. Reid, John R., Painter, London
50. Reiniger, Otto, Painter, Stuttgart
51. Rietti, Arturo, Trieste
52. Roche, Alexander, Painter, Glasgow
53. Roll, Alfred, Painter, Paris
54. Sartori, Giuseppe, Sculptor, Milan
55. Sartorio, Aristide, Painter, Rome
56. Skarbina, Franz, Painter, Berlin
57. Segantini, G., Painter, Milan
58. Sinding, Otto, Painter, Christiania (Norway)
59. Sinding, Stephen, Bildhauer, Copenhagen
60. Stott of Oldham, William, Painter, London
61. Strasser, Arthur, Sculptor, Vienna
62. Tegner, Hans, Painter, Copenhagen
63. Thaulow, Fritz, Painter, Paris
64. Thoma, Hans, Painter, Frankfurt a. M.
65. Tissot, James-Jacques-Joseph, Painter, Paris
66. Villegas, José, Painter, Rome
67. Zorn, Anders, Painter, Paris

Notes

Chapter 1

1. Thomas Mann, *Stories of a Lifetime* (London: Secker and Warburg, 1961), I, pp. 142–44.

2. Declaration of 26 July 1892, SAM, Kulturamt 119. I am indebted for this citation to Robin Lenman, whose articles "A Community in Transition: Painters in Munich, 1886–1924," *Central European History* 16 (March 1983), pp. 3–33, and "Politics and Culture: The State and the Avant-Garde in Munich 1886–1914," *Society and Politics in Wilhelmine Germany*, ed. Richard J. Evans (New York: Barnes and Noble, 1978), pp. 90–111, not only initially led me to valuable archival sources in the early stages of my research, but subsequently provided much of the raw material of this chapter.

3. On the collecting activities of the Wittelsbachs, see Wolf-Dieter Dube, intro., *Pinakothek. Munich* (Milan: Newsweek, Inc., and Arnoldo Mondadori Editore, 1969). Heinz Gollwitzer, "Kunst, Königtum und mäzenatische Politik," in his *Ludwig I. von Bayern. Königtum im Vormärz. Eine politische Biographie* (Munich: Süddeutscher Verlag, 1987), pp. 745–65, discusses Ludwig I as a patron of the arts.

4. Rudolf Reiser, *Die Wittelsbacher 1180–1918. Ihre Geschichte in Bildern* (Munich: Bruckmann, 1979), p. 128.

5. As one contemporary wrote on the occasion of the opening of the museum, the Neue Pinakothek was "a shining example for others, for princes and cities, to roll out the red carpet in the same way for contemporary art and to assemble eloquent testimony to its history." Werner Mittlmeier, *Die Neue Pinakothek in München 1843–1854*, Studien zur Kunst des neunzehnten Jahrhunderts, No. 16 (Munich: Prestel-Verlag, 1977), p. 123. On the early history of German museums in general, see Volker Plagemann, *Das deutsche Kunstmuseum 1790–1870*, Studien zur Kunst des neunzehnten Jahrhunderts, No. 3 (Munich: Prestel-Verlag, 1967).

6. On Ludwig's collection, see Christoph H. Heilmann, "Die Sammlung zeitgenössischer Malerei König Ludwigs I. in der Neuen Pinakothek," in Mittlmeier, *Die Neue Pinakothek*, pp. 121–38. J.H.W. Wagener's collection of contemporary art—probably the only one in Germany to rival that of Ludwig I—and what happened to it after it became the core of the Nationalgalerie in Berlin is discussed in Dieter Honisch, intro., *Verzeichnis der Gemälde und Skulpturen des 19. Jahrhunderts* (Berlin: Staatliche Museen Preussischer Kulturbesitz, 1976), pp. 3–4; Dieter Honisch, *Die National Galerie Berlin* (Recklinghausen: Verlag Aurel Bongers, 1979); and Paul Ortwin Rave, *Die Geschichte der National Galerie Berlin* (Berlin: Nationalgalerie der Staatlichen Museen Preussischer Kulturbesitz, Berlin, n.d.).

7. Although no comprehensive history of the Royal Academy of Fine Arts exists to date, the primary source is Eugen von Stieler, *Die königliche Akademie der bildenden Künste zu München: Festschrift zur Hundertjahrfeier* (Munich: Bruckmann, 1909), which outlines the academy's history through 1858. More recently, *Tradition und Widerspruch: 175 Jahre Kunstakademie München*, ed. Thomas Zacharias (Munich: Prestel-Verlag, 1985), both summarized Stieler's work and outlined subsequent issues in the academy's history. Of the numerous essays in this collection, I find Ekkehard Mai's contributions, "Problemgeschichte der Münchner Kunstakademie bis in die zwanziger Jahre," pp. 103–43, and "Akademie, Sezession und Avantgarde—München um 1900," pp. 145–77, particularly helpful. Other more readily available studies are Birgit Angerer, *Die Münchner Kunstakademie zwischen Aufklärung und Romantik: Ein Beitrag zur Kunsttheorie und Kunstpolitik unter Max I. Joseph*, Miscellanea Bavarica Monacensia, No. 123, ed. Karl Bosl and Richard Bauer (Munich: Stadtarchiv München, 1984); Esther Betz, "Kunstausstellungswesen und Tagespresse in München um die Wende des 19. Jahrhunderts: Ein Beitrag zum Kunst- und Kulturleben der Bayrischen Hauptstadt," Diss. Ludwig-Maximilians-Universität zu München, 1953; York Langenstein, *Der Münchner Kunstverein im 19. Jahrhundert: Ein Beitrag zur Entwicklung des Kunstmarkts und des Ausstellungswesens*, Miscellanea Bavarica Monacensia, No. 122, ed. Karl Bosl and Richard Bauer (Munich: Stadtarchiv München, 1983); and Nikolaus Pevsner, *Academies of Art, Past and Present* (Cambridge: Cambridge University Press, 1940).

8. Mai, "Problemgeschichte bis in die zwanziger Jahre," p. 129; see also p. 136, n. 3 for attendance figures during the 1870s, 1880s, and 1890s.

9. On the Kunstausstellungsgebäude, see Mittlmeier, *Die Neue Pinakothek*, pp. 12–13; and Langenstein, *Der Münchner Kunstverein*, pp. 159–61. The principal source on the Glaspalast is Munich, Münchner Stadtmuseum, *Der Münchner Glaspalast 1854–1931. Geschichte und Bedeutung*, 5 June – 30 August 1981.

10. Myrna Smoot, "The First International Art Exhibition in Munich 1869," *Salons, Galleries, Museums and Their Influence in the Development of 19th and 20th Century Art*, Proceedings of the 24th International Congress of the History of Art 1979 (Bologna: Cooperativa Libraria Universitaria Editrice, n.d.), VII, pp. 109–14; Georg Jacob Wolf, "Sechzig Jahre Münchner Künstlergenossenschaft," *Das Bayerland* 39 (1928), pp. 294–95; and *Katalog zur I. internationalen Kunstausstellung im Königlichen Glaspalaste zu München, 1869* (Munich: Verlag des Ausstellungscomités, 1869).

11. For example, until 1874 the comparatively small biennial exhibitions of the Berlin Academy had to be held in cramped quarters in its building on Unter den Linden; between 1876 and 1885 they were mounted in a provisional barrack-type building on the Museumsinsel. The rotating exhibitions of the Verein Berliner Künstler—the approximate equivalent of the Münchener Künstlergenossenschaft—were also small affairs, held from 1869 to 1892 in the group's clubrooms on the remote and somewhat shabby Kommandantenstrasse. As contemporaries frequently noted, none of these locations was suitable for major exhibitions. On the exhibitions of the academy and Verein Berliner Künstler, see Klaas Teeuwisse, "Berliner Kunstleben zur Zeit Max Liebermanns," *Max Liebermann in seiner Zeit*, Berlin, Nationalgalerie Berlin, 6 September – 4 November 1979, pp. 72–87; Klaas [Nicolaas] Teeuwisse, *Vom Salon zur Secession. Berliner Kunstleben zwischen Tradition und Aufbruch zur Moderne 1871–1900* (Berlin: Deutscher Verlag für Kunstwissenschaft, 1986); and Peter Paret, *The Berlin Secession. Modernism and Its Enemies in Imperial Germany* (Cambridge, Mass.: Harvard University Press, 1980).

12. The academy's charter, which was drafted by the institution's general secretary, the philosopher Friedrich Schelling, is reprinted in *Tradition und Widerspruch. 175 Jahre Kunstakademie München*, pp. 327–35, and discussed in some detail by Eberhard Simons, "Natur und Kunst. Zur Aktualität der Gründungsurkunde der Akademie der bildenden Künste in München von F. W. Schelling," ibid., pp. 59–74.

13. In 1811, for instance, approximately 60 students participated in the exhibition with 216 works out of a total of 427; in 1814, 80 students were represented with 403 works out of 692; in 1820, 119 students exhibited 410 of the 846 works. *AZ*, No. 249, Beilage, 6 September 1845, p. 1985.

14. Both Johann Peter Langer (director, 1808–24) and his successor, Peter von Cornelius (director, 1825–41), were notoriously poor administrators disliked by students and faculty alike. Their continued mismanagement of the salons and the faculty apathy this created made it difficult for their successors, Friedrich von Gärtner (director, 1841–47) and Wilhelm von Kaulbach (director, 1849–74), to transform the exhibitions into a successful artistic and financial enterprise. On Langer, see Langenstein, *Der Münchner Kunstverein*, pp. 52–54; Mai, "Problemgeschichte bis in die zwanziger Jahre," pp. 109–11; Rudolf Oldenbourg, *Die Münchner Malerei im 19. Jahrhundert*, I: *Die Epoche Max Josephs und Ludwigs I.*, ed. Eberhard Ruhmer (1923; rpt. Munich: Bruckmann, 1983), pp. 79–82; and Pevsner, *Academies of Art*, pp. 211–12. On Cornelius, see Mai, "Problemgeschichte," pp. 111–14, and Pevsner, pp. 214–15.

15. In 1845, for example, only twenty students with 45 works were included in the exhibition of 353 items from Germany, France, Holland, Belgium, and Italy. *AZ*, No. 249, Beilage, 6 September 1845, p. 1985. The increased foreign and non-student participation was possible not only because Ludwig gave the academy access to the Kunstausstellungsgebäude, but also because he granted permission to charge admission to the shows, thereby increasing the academy's revenues for the exhibitions. Criticisms of the salons are cited in Hermann Uhde-Bernays, *Die Münchner Malerei im 19. Jahrhundert*, II: *1850–1900*, ed. Eberhard Ruhmer (1927; rpt. Munich: Bruckmann, 1983), p. 13. Eugen von Stieler also discusses the problems of the academic exhibitions in *Die königliche Akademie der bildenden Künste zu München*, pp. 140–42.

16. Uhde-Bernays, *Die Münchner Malerei*, II, p. 13, and Stieler, *Die königliche Akademie der bildenden Künste zu München*, p. 142. Technically, the move to include the independents went against the academy's charter, which assigned the organization of the salons to the academicians. Despite some faculty dissent, however, the measure encountered little significant opposition.

17. Both Uhde-Bernays, *Die Münchner Malerei*, II, p. 13, and Stieler, *Die königliche Akademie der bildenden Künste zu München*, p. 142, imply that independent Munich artists were involved to some extent in the organization of the 1853 academic exhibition, which, though much improved over past salons, was nevertheless still a relatively modest affair. On the history of the Allgemeine Deutsche Kunstgenossenschaft, see

Heinrich Deiters, *Geschichte der Allgemeinen Deutschen Kunstgenossenschaft* (Düsseldorf: Bagel, 1906); the anonymous "Zur Geschichte der deutschen Kunstgenossenschaft," *Kunstchronik*, 3 (1868), pp. 185–86; and Paret, *The Berlin Secession*, p. 13.

18. The "Erste Historische Deutsche Kunstausstellung" in Munich in 1858 was followed by a second in Cologne (1861), a third in Vienna (1868), a fourth in Berlin (1872), a fifth in Berlin (1886), and a sixth in Munich (1892). Each was administered by the appropriate local chapter of the Allgemeine Deutsche Kunstgenossenschaft.

19. On Dietz, see R. Schill, "Nekrolog," *Kunstchronik*, 4 (1871), pp. 75–78; and F. Pecht's entry on Dietz in *Allgemeine Deutsche Biographie*, 2d ed. (1877; rpt. Berlin: Duncker & Humblot, 1968), 5, pp. 209–10.

20. Stieler, *Die königliche Akademie der bildenden Künste zu München*, pp. 146–47, details the events leading up to this transfer of responsibility.

21. Like the Verein Berliner Künstler, the Münchener Künstlergenossenschaft was the local chapter of the Allgemeine Deutsche Kunstgenossenschaft. This changed, however, when the Secession was founded in 1892, as many of the secessionists wished to continue their membership in the ADK. A new local association was thus formed, and it included members of both the Secession and the Genossenschaft. See *Anzeiger der Münchener Künstlergenossenschaft*, No. 29 (16 November 1892), pp. 1–2. No comprehensive history of the Münchener Künstlergenossenschaft exists to date, and the association's archives were presumably lost in World War II. Correspondence pertaining to the conferral of a royal charter and other documents on the goals and structure of the Genossenschaft are in BayHStA, MInn 73477. The SAM and the BSB also have some files pertaining to the Genossenschaft, but information about the association is otherwise best obtained through contemporary Munich newspapers, especially the *AZ* and *MNN*, which reported regularly and extensively on the activities of and controversies within the Genossenschaft. The most detailed secondary sources are Betz, "Kunstausstellungswesen und Tagespresse in München"; Deiters, *Geschichte der Allgemeinen Deutschen Kunstgenossenschaft*; and Wolf, "Sechzig Jahre Münchner Künstlergenossenschaft."

22. Statuten der Münchener Künstlergenossenschaft (1882), BayHStA, MInn 73477.

23. This procession is described in Ludwig Schrott, *Der Prinzregent. Ein Lebensbild aus Stimmen seiner Zeit* (Munich: Süddeutscher Verlag, 1962), pp. 127–28.

24. Georg Jacob Wolf, *Münchener Künstlergenossenschaft und Secession* (Munich: Drei Eulen-Verlag, n.d.), n.p.

25. Initially these exhibitions were referred to as the "Lokalausstellungen" or "Jahresausstellungen"; later, when they were open all year round, they were known as the "Permanentausstellungen" or the "Ständige Ausstellungen." On the early exhibitions, see *Kunstchronik*, 5, No. 17 (17 June 1870), pp. 146–47; *Kunstchronik*, 5, No. 19 (15 July 1870), p. 163; *Kunstchronik*, 8, No. 47 (5 September 1873), pp. 744–52; and Wolf, "Sechzig Jahre Münchner Künstlergenossenschaft," pp. 295–96.

26. The odd numbering of the series of international exhibitions has caused some confusion in essays on Munich art. Although the 1869 exhibition was international in scope, it was not counted by the Genossenschaft as one of the series. The 1879 show was considered the first international; the 1883 exhibition, the second; and the 1888 salon, the third. The large international in 1892 in Munich, while similar in form to the first, second, and third internationals, was not one of this series, but was the sixth in a series sponsored by the Allgemeine Deutsche Kunstgenossenschaft yet administered by the Munich Genossenschaft.

27. On the organization of the Genossenschaft exhibitions, see "Statut für die internationalen Kunst-Ausstellungen in München," "Internationale Kunstausstellungen in München: Geschäftsordnung für das Central-Comité," and "Die Preisjury und deren Geschäftsordnung," all in the collection of printed and handwritten documents pertaining to the third international exhibition of 1888, in BSB. See also the collection of documents pertaining to the sixth international exhibition of 1892, in BSB.

28. In 1879 a petition signed by Bastien, Duez, Roll, Worms, Butin, and Firmin-Giraud requested of the government that all artists who had exhibited previously in the Salon be allowed to elect juries. The administration accepted the idea, and the 1881 Salon was the first to be managed by the independent artists, who grouped together under the name Société des Artistes Français. Notably, this was the salon at which Manet first received a medal, against the wishes of the academic teachers at the École des Beaux-Arts, some of whom had also been elected to the jury. Albert Boime, *The Academy and French Painting in the Nineteenth Century* (London: Phaidon, 1971), p. 17; and John Rewald, *The History of Impressionism*, 4th rev. ed (New York: Museum of Modern Art, 1973), p. 452. On the Société des Artistes Français, and on the other French art associations that were founded in the last quarter of the century, see also Pierre Vaisse, "Salons, Expositions et Sociétés d'Artistes en France 1871–1914," *Salons, Galleries, Museums and Their Influence in the Development of 19th and 20th Century Art*, Proceedings of the 24th International Congress of the History of Art 1979 (Bologna: Cooperativa

Libraria Universitaria Editrice, n.d.), VII, pp. 141–55; and Germain Bazin, "Le Salon de 1830 à 1900," *Scritti di storia dell'arte in onore di Lionello Venturi* (Rome: De Luca, 1956), II, pp. 117–23.

29. In 1879 the reversals of the foreign juries' decisions were so numerous as to provoke a lengthy pamphlet attacking the actions of the central committee and citing written complaints from foreign corporations to the Genossenschaft. R.M., *Eine Muster-Jury. Beitrag zur Geschichte der internationalen Kunst-Ausstellung in München 1879* (Munich: Rudolf Fried, 1879).

30. I have obtained these approximate figures by comparing the handwritten lists "Persönlich Eingeladene," in the collection of documents pertaining to the third international exhibition of 1888, in BSB, with *Katalog der III. internationalen Kunstausstellung (Münchener Jubiläumsausstellung)*, 3d ed. (Munich: Verlagsanstalt für Kunst und Wissenschaft, mid-July 1888).

31. See, for example, the letter from the Minister of the Interior, Max von Feilitzsch, to Luitpold, 3 August 1888, BayHStA, MK 9269, in which Feilitzsch describes in detail the work of the jury for the Kunstgewerbe-Ausstellung in 1888. Marginal notations indicate that Luitpold saw and gave attention to this and other documents dealing with the arts.

32. See especially the correspondence between the royal cabinet and the horticultural society, November 1891 – April 1892, BayHStA, MK 14341, in which the administration eventually refused the society's request to use the exhibition hall so that the Genossenschaft might have access to the entire building. Although the agricultural exhibitions sponsored by the horticultural society and normally held in the Glaspalast were both popular and lucrative, in the last decade of the century the administration increasingly took the position that the salons sponsored by the Genossenschaft were crucial to Munich's reputation within the Reich and should therefore take precedence over all other exhibitions.

33. After the first international in 1879 and following considerable debate, the Bavarian Parliament approved an annual grant (subject to renewal) of 8,600 DM to support the Genossenschaft's international exhibitions. These funds were henceforth allocated for the exhibitions in each budget. Until 1890 Parliament also allocated funds for the support of the arts in the amount of 42,860 DM, part of which was used to purchase works for the state collections in the Alte and Neue Pinakothek. After extensive political lobbying in 1890, Parliament also approved an annual grant of 100,000 DM, nine-tenths of which was to be spent exclusively on contemporary works of art for the state's collection in the Neue Pinakothek (see also Chapter Two, note 56 below). Although

the Ministry of Church and School Affairs, which was responsible for administering the grant, purchased many works directly from artists, it also spent a great deal of this grant at the Genossenschaft exhibitions. For the evolution of these measures, see the *Stenographische Berichte über die Verhandlungen der bayerischen Kammer der Abgeordneten (VdKdAbg)* 1879–80, vol. 4 (15 January 1880), pp. 595–96; *VdKdAbg* 1889–90, vol. 5 (28 March 1890), pp. 588–606; *VdKdAbg* 1889–90, vol. 6 (30 April 1890), pp. 281–84; the *Stenographische Berichte über die Verhandlungen der bayerischen Kammer der Reichsräthe (VdKdAbg)* 1889–90, vol. 4 (Protokollen-Band), pp. 353–65; and Chapter Two below, pp. 32–36. Horst Ludwig, *Kunst, Geld und Politik um 1900 in München. Formen und Ziele der Kunstfinanzierung und Kunstpolitik während der Prinzregenten-Ära (1886–1912)*, Kunst, Kultur und Politik im deutschen Kaiserreich, No. 8, ed. Ekkehard Mai and Stephan Waetzoldt (Berlin: Gebr. Mann Verlag, 1986), reproduces some of these stenographic reports and presents a helpful year-by-year breakdown of the Bavarian state budget for the visual arts during the Regency.

34. The incident is related in R.M., *Eine Muster-Jury*, p. 13. The work in question was Max Liebermann's *Jesus in the Temple*, which I discuss in Chapter Two.

35. The primary and most controversial exception to this policy was the removal of Max Slevogt's *Danae* from the Secession exhibition in 1899. Notably, however, Slevogt was named royal professor only two years later, at the relatively young age of thirty-three. Hans-Jürgen Imiela, *Max Slevogt* (Karlsruhe: G. Braun, 1968), pp. 36–38, 355–56. Robin Lenman has shown that until the early 1900s artists normally ran far less risk of police interference than writers or, especially, dramatists. See Lenman, "Censorship and Society in Munich, 1890–1914," Diss. Oxford 1975; and Lenman, "Politics and Culture." Peter Jelavich, *Munich and Theatrical Modernism. Politics, Playwriting and Performance, 1890–1914* (Cambridge, Mass.: Harvard University Press, 1985), also treats at length Bavaria's censorship policies and their impact on art and artists, although he concentrates primarily on the theatre.

36. Paret, *The Berlin Secession*, pp. 9–28, discusses the interaction of the state with art organizations in imperial Berlin.

37. See, for example, Max von Feilitzsch to Luitpold, 3 August 1888, BayHStA, MK 9269.

38. On these Belgian exhibition societies and Les XX, their avant-garde successor, see Jane Block, *Les XX and Belgian Avant-Gardism 1868–1894*, Studies in the Fine Arts: The Avant-Garde, No. 41, ed. Stephen C. Foster (Ann Arbor: UMI Research Press, 1984).

39. See note 28 above. In Vienna, the academy relinquished control of exhibitions to the Genossenschaft der Bildenden Künstler Wiens—the local chapter of the Allgemeine Deutsche Kunstgenossenschaft and thus the approximate equivalent of the Münchener Künstlergenossenschaft—in 1868, only five years after the Munich Academy discontinued its sponsorship of exhibitions. See "Kunstvereine, Sammlungen und Ausstellungen," *Kunstchronik*, 4, No. 2 (6 November 1868), p. 12. Although the lack of sufficient research on the Vienna Genossenschaft hinders comparisons with the Munich society, it appears that the ties between the academy, government, and Genossenschaft in Vienna were much closer than those existing in Munich.

40. See the printed documents "Geschäftsordnung der Münchener Künstlergenossenschaft" from 1882 and "Statuten der Münchener Künstlergenossenschaft" from 1900, BayHStA, MInn 73477.

41. *AZ*, No. 86, Morgenblatt, 26 March 1892, p. 3.

42. In 1895 there were roughly 2,074 painters and sculptors in Bavaria who supported themselves solely by their profession, and 1,196 people working in other areas of the arts, such as engraving, calligraphy, and pattern-drawing. In comparison to this total of 3,270, there were 3,068 artists working in Bavaria in 1882. In 1892, then, there must have been approximately 3,100 practicing artists in Bavaria. The Genossenschaft's records list 1,020 members in 1892, 164 of whom lived outside of Bavaria. Hence, about 856 of the 3,100 practicing artists in Bavaria were members of the Genossenschaft. (However, many of the 3,100 were commercially employed and thus would not have belonged to the Genossenschaft anyway, so the meaningful percentage is actually higher.) These figures should be used with caution, however, since the classification of "artist" was not always clearly defined. In 1895, for instance, artists were defined as "Kunstmaler, Kunstbildhauer, Graveure, Steinschneider, Eiseleure, Modelleure, Musterzeichner, Kalligraphen" and those who practiced "sonstige künstlerische Berufe mit Ausnahme von Musik, Theater und Schaustellung." In 1882, by contrast, artists were merely defined as "Kunstmaler, Kunstbildhauer," and those who practiced "künstlerische Betriebe für gewerbliche Zwecke." Comparisons are therefore difficult, and the above should be regarded merely as rough approximations. *Statistik des deutschen Reiches*, 2 (1882), 105 (1895).

43. Although the elections took place at meetings of the Genossenschaft, they were generally preceded by intense lobbying and behind-the-scenes negotiations. Members of social societies of artists, such as Allotria and the Gesellige Vereinigung, worked together to elect their own candidates by voting en bloc. See, for instance, the ballots in the collection of documents on the third international exhibition of 1888, in BSB, and in SAM, Kulturamt 889, 901.

44. See the collection of documents pertaining to the third international exhibition of 1888, in BSB.

45. *AZ*, No. 117, 2. Beilage, 27 April 1888, p. 1, notes that about 1,800 works had been submitted to the jury of the German section by the deadline of 23 April. According to the *Katalog der III. internationalen Kunstausstellung (Münchener Jubiläumsausstellung) 1888*, 3d ed. (Munich: Verlagsanstalt für Kunst und Wissenschaft, mid-July 1888), 1,520 works by German artists were exhibited. We know from the list "Persönlich Eingeladene in Deutschland," in the collection of documents on the third international exhibition of 1888, in BSB, that of these 1,520 works 159 were unjuried. In short, about 1,361 of the some 1,800 works submitted to the jury for consideration, or 76 percent, were accepted. See *AZ*, No. 137, 2. Beilage, 17 May 1888, p. 2; and *AZ*, No. 142, 23 May 1888, p. 6, for reports of the Salon des Refusés.

46. Von Feilitzsch to Luitpold, 3 August 1888, BayHStA, MK 9269.

47. See, for instance, the lengthy description of the activities to take place in June of 1888 in the Glaspalast in *AZ*, No. 159, 9 June 1888, p. 6. In contrast to the avant-garde musical soirées at the salons sponsored by the Belgian exhibition society Les XX, described by Jane Block in *Les XX*, the concerts at the exhibitions of the Munich Genossenschaft were usually popular in character.

48. *AZ*, No. 190, Morgenblatt, 11 July 1889, p. 3; and Karl von Vincenti, "Die erste Jahresausstellung in München: Erste Eindrücke," *AZ*, No. 186, Beilage, 7 July 1889, p. 3.

49. The painter-turned-writer Gottfried Keller described this practice in his autobiographical novel *Green Henry*, trans. A. M. Holt (New York: Grove Press, 1960), pp. 424–25.

50. On the development of the German economy after 1850, see David Landes, *The Unbound Prometheus. Technical Change and Industrial Development in Western Europe from 1750 to the Present* (Cambridge: Cambridge University Press, 1969), especially the data on p. 194; and Knut Borchardt, "The Industrial Revolution in Germany," *The Fontana Economic History of Europe*, vol. IV, pt. 1: *The Emergence of Industrial Societies*, ed. Carlo M. Cipolla (London: Collins, 1973), pp. 76–160.

51. Among studies that discuss the new type of entrepreneur after 1850, see Friedrich Zunkel, *Der Rheinisch-Westfälische Unternehmer 1834–1879: Ein Beitrag zur Geschichte des deutschen Bürgertums im 19. Jahrhundert* (Cologne and Opladen: Westdeutscher Verlag, 1962), pp. 61–62,

99–132; Percy Ernst Schramm, *Hamburg, Deutschland und die Welt* (Munich: Georg D. W. Callwey, 1943), pp. 479–544, especially pp. 488–91; Hansjoachim Henning, *Das Bildungsbürgertum in den preussischen Westprovinzen*, vol. I of *Das westdeutsche Bürgertum in der Epoche der Hochindustrialisierung 1860–1914. Soziales Verhalten und soziale Strukturen*, Historische Forschungen, No. 6 (Wiesbaden: F. Steiner, 1972), pp. 40–41; and R. Engelsing, "Lebenshaltungen und Lebenshaltungskosten im 18. und 19. Jahrhundert in den Hansestädten Bremen und Hamburg," *International Review of Social History*, 11, No. 1 (1966), p. 87.

52. The art historian Karl Scheffler, for example, described the salon merely as a means of entertainment, and mocked "the fusion of art, beer music, and pickup joint, the profanation, proletarization, and theatricalization of art." K. Scheffler, *Berlin, ein Stadtschicksal* (Berlin, 1910), p. 177, quoted in Teeuwisse, "Berliner Kunstleben zur Zeit Max Liebermanns," p. 77. Scheffler's comments, though provoked by the salons in Berlin, succinctly summarize the complaints voiced about the Munich exhibitions.

53. Form letter from the central committee to offending Munich associations, 21 July 1888, SAM, Kulturamt 899.

54. *AZ*, No. 281, Morgenblatt, 10 October 1889, p. 3.

55. The principal source on German liberalism is James Sheehan, *German Liberalism in the Nineteenth Century* (Chicago: University of Chicago Press, 1978), of which the third section (chapters 6–8) describes the nature of the liberal movement during the 1850s and 1860s. On the history of Bavaria and its liberal movement, see Michael Doeberl, *Entwicklungsgeschichte Bayerns* (Munich and Berlin: Oldenbourg, 1931), vol. III; Hans-Michael Körner, *Staat und Kirche in Bayern 1886–1918* (Mainz: Matthias-Grünewald-Verlag, 1969); Leonard Lenk, "Katholizismus und Liberalismus: Zur Auseinandersetzung mit dem Zeitgeist in München, 1848–1918," in *Der Mönch im Wappen: Aus Geschichte und Gegenwart des katholischen München* (Munich: Schnell & Steiner, 1960), pp. 375–408; Karl Möckl, *Die Prinzregentenzeit: Gesellschaft und Politik während der Ära des Prinzregenten Luitpold in Bayern* (Munich and Vienna: R. Oldenbourg, 1972); and Dieter Albrecht, "Von der Reichsgründung bis zum Ende des Ersten Weltkrieges (1871–1918)," in Max Spindler, ed., *Handbuch der bayerischen Geschichte* (Munich: C. H. Beck, 1974), IV, pp. 283–386.

56. Lenk, "Katholizismus und Liberalismus," pp. 382, 384. On urban liberalism, see also James Sheehan, "Liberalism and the City in Nineteenth-Century Germany," *Past and Present*, 51 (May 1971), pp. 116–37.

57. For circulation figures of the *Neueste Nachrichten* and other dailies in Bavaria, see Lenk, "Katholizismus und Liberalismus," p. 403. The *Neueste Nachrichten* so dominated the newsstands that one cleric complained that "one can travel for weeks in Catholic Bavaria without ever seeing a Catholic newspaper" (ibid.).

58. Lenman, "A Community in Transition," pp. 5, 20–21, outlines such attractions in greater depth. See also Thomas E. Willey, "Thomas Mann's Munich," in *The Turn of the Century: German Literature and Art 1890–1915*, McMaster Colloquium on German Literature, II, ed. Gerald Chapple and Hans H. Schulte, foreword by Alvin A. Lee (Bonn: Bouvier, 1981), pp. 477–91; and Karl Bosl, "München, Deutschlands heimliche Hauptstadt. Bemerkungen zur Strukturanalyse des modernen Hauptstadt- und Grossstadt-Typus in Deutschland," *Zeitschrift für Bayerische Landesgeschichte*, 30 (1967), pp. 298–313.

59. *Statistik des deutschen Reiches*, 107 (1895); *Statistisches Jahrbuch für das deutsche Reich*, 20 (1895); and Paul Drey, *Die wirtschaftlichen Grundlagen der Malkunst. Versuch einer Kunstökonomie* (Stuttgart and Berlin: J. G. Cotta'sche Buchhandlung Nachfolger, 1910), p. 72.

60. See Theodor Schieder, *Das deutsche Kaisserreich von 1871 als Nationalstaat*, Wissenschaftliche Abhandlungen der Arbeitsgemeinschaft für Forschung des Landes Nordrhein-Westfalen, No. 20 (Cologne: Westdeutscher Verlag, 1961). Other works that stress the artificial nature of German unification rather than its supposed "predetermined" character or rootedness in any deeper cultural or historic unity are Robert Berdahl, "New Thoughts on German Nationalism," *American Historical Review*, 77 (1972), pp. 65–80, and J. J. Sheehan, "What is German History? Reflections on the Role of the *Nation* in German History and Historiography," *Journal of Modern History*, 53 (1981), pp. 1–23.

61. Endell to Breysig, 9 July 1892, Berlin, Staatsbibliothek Preussischer Kulturbesitz, Handschriftenabteilung, Nachlass Breysig, 5.

62. *VdKdAbg* 1889–90, vol. 5 (28 March 1890), p. 602.

63. John Lavery, *The Life of a Painter* (London: Cassel, 1940), p. 65. Lavery actually wrote that this was true of painters in "Germany," but this generalization was based almost entirely on his experiences in Munich, where, after first exhibiting in 1890 at the Genossenschaft salon, he was celebrated as one of the most significant talents to have emerged from Scotland. The Bavarian Government purchased Lavery's painting *The Tennis Party* from the 1890 salon for the Neue Pinakothek.

64. Theodor Goering, *Dreissig Jahre München. Kultur- und kunstgeschichtliche Betrachtungen* (Munich: C. H. Beck'sche Verlag, 1904), p. 112.

65. Ibid., p. 57.

66. On Wittelsbach patronage after Ludwig I, see Lenman, "A Community in Transition," pp. 15–16; Peter Jelavich, "Munich as Cultural Center: Politics and the Arts," in *Kandinsky in Munich: 1896–1914* (New York: Solomon R. Guggenheim Foundation, 1982), pp. 18–19; and Hans Riehl, *Märchenkönig und Bürgerkönige. Wittelsbacher Geschichte(n) 1806–1918* (Pfaffenhofen: Verlag W. Ludwig, 1979).

67. Lenman, "A Community in Transition," pp. 15–16.

68. In 1907 only 2 percent of the labor force was employed in enterprises with over a thousand workers. Peter Steinborn, *Grundlagen und Grundzüge Münchener Kommunalpolitik in den Jahren der Weimarer Republik. Zur Geschichte der bayerischen Landeshauptstadt im 20. Jahrhundert*, Miscellanea Bavarica Monacensia, No. 5, ed. Karl Bosl and Michael Schattenhofer (Munich: Stadtarchiv München, 1968), p. 27; as cited in Lenman, "A Community in Transition," p. 21. Also see Lenman, pp. 19–20, on Munich's resident art collectors.

69. Knorr favored Munich's avant-garde in his collection, which was formed during the 1880s and 1890s. Many of the secessionists—including Hugo von Habermann, T. T. Heine, Adolf Hölzel, Max Liebermann, Bernhard Pankok, Richard Riemerschmid, Max Slevogt, Carl Strathmann, Franz von Stuck, and Fritz von Uhde—were represented in it, as were a number of foreign artists whose work the Secession exhibited in its early salons, among them Felicien Rops and Giovanni Segantini. *Die Galerie Thomas Knorr in München*, ed. Fritz von Ostini (Munich: Knorr & Hirth, 1906).

70. Specifically, 37, 46, 29, 44, 46, 53, and 36 percent of the turnover at the 1879, 1883, 1888, 1889, 1890, 1891, and 1892 Genossenschaft salons, respectively, came from foreigners; 42, 30, 30, 23, and 39 percent of the turnover at the 1888, 1889, 1890, 1891, and 1892 exhibitions came from Germans not living in Munich. See the "Verkaufs-Statistik," in the collection of documents pertaining to the third international exhibition of 1888, in BSB; and the Genossenschaft annual reports, 1889–92.

71. For American patronage of the Genossenschaft salons, see the "Verkaufs-Statistik," in the documents on the third international exhibition, in BSB; and the Genossenschaft annual reports. On the art import tariff, and America's relationship to the Bavarian capital, see Lenman, "A Community in Transition," pp. 21–22.

72. See the "Verkaufs-Statistik," for the third international exhibition, in BSB.

73. In 1879, 21 percent of the objects for sale by Munich artists were purchased, while only 17 percent and 12 percent of the salable works by other German and foreign artists were purchased. In 1883, the figures were 28, 17, and 17 percent; and in 1888, 31, 22, and 22 percent. The average selling price for works of art originating in Munich was 2,433 DM in 1879, as compared to 1,838 DM for works originating elsewhere in Germany and 2,178 DM for foreign objects. In 1883, the figures were 2,279 DM, 1,477 DM, and 1,549 DM respectively; and in 1888, 2,295 DM, 2,012 DM, and 2,279 DM. "Verkaufs-Statistik" for the third international exhibition, in BSB.

74. See the letter from Ostini to Riemerschmid, 1 September 1896, Archiv für Bildende Kunst am Germanischen Nationalmuseum, Nachlass Riemerschmid, B172.

75. Just how damaging this lack of adequate exhibition space was for art markets outside Munich is indicated by sales figures. In 1879 the academic exhibition in Berlin netted sales of only 153,482 DM, as compared with the sales of 453,286 DM from the 1879 Genossenschaft show in Munich. *Verzeichniss der Werke lebender Künstler auf der LIV. Ausstellung der königlichen Akademie der Künste*, 29 August – 31 Oktober 1880 (Berlin: Verlag von Rudi Schuster, 1880), p. xxvii; and "Verkaufs-Statistik," in the documents on the third annual exhibition of 1888, in BSB. Indeed, Munich's hold on the market was so strong that even in 1887, after the Berlin Academy began to hold its exhibitions in the Landesausstellungspalast, sales of only 185,000 DM were recorded. By contrast, the Genossenschaft salon of 1889—which was larger than the 1887 Berlin show by only about 200 objects—netted sales of 479,250 DM. *Kunstchronik*, 23, No. 42 (23 August 1888), p. 677; and the Genossenschaft annual report, 1889. Alfred Lichtwark, director of the Hamburger Kunsthalle from 1886 to 1914, was among those contemporaries who recognized that the Munich art market owed its dominant position in Central Europe in the latter half of the century precisely to the Kunstausstellungsgebäude and the Glaspalast. See Alfred Lichtwark, "Aus München," *Pan*, 2 (1896), p. 254.

76. See Chapter Five.

77. R. Martin, *Jahrbuch des Vermögens und Einkommens der Millionäre in Bayern* (Berlin, 1914), pp. 36, 47, 50; as cited in Lenman, "A Community in Transition," pp. 9–10.

Chapter 2

1. "Eine Münchener Krise," *Kunst für Alle*, 22 (October 1906 – September 1907), p. 330.

2. 154 works by Munich artists were sold for 353,350 DM, or 33 percent of the total turnover of 1,070,540 DM. 112 works by other German artists were sold for 225,290 DM, or 21 percent of the total turnover; and 216 works by foreign artists were sold for 491,900 DM, or 46 percent of the

total turnover. The average price for a work of art originating in Munich was 2,295 DM; that for one originating elsewhere in Germany was 2,012 DM; and that for a foreign work of art was 2,277 DM. The exhibition made a profit of over 2,500 DM. "Verkaufsstatistik," in the collection of documents pertaining to the third annual exhibition of 1888, in BSB; and the Genossenschaft annual report, 1888.

3. Both Paulus and Eugen von Stieler, president of the Künstlergenossenschaft, later claimed to have originated the idea. See Adolf Paulus, "Zwanzig Jahre Münchner Secession 1893–1913," *Die Kunst*, 27 (October 1912 – September 1913), p. 326; and Eugen von Stieler, "Die Entstehung der Münchener Jahresausstellungen," *Das Bayerland*, 39 (1928), p. 308. However, as I shall argue, since Paulus stood to derive considerable personal benefits from annual exhibitions while Stieler did not, he is the more likely candidate.

4. Paulus' mother, Julie von Schönlin, descended from a long line of aristocrats who had played key political and military roles in the monarchy. Her family collected art, and as the only daughter she inherited a number of important pieces that were then housed in the Paulus home. Paulus' father, Adolf Karl Paulus, descended from a family whose most prominent member was the theologian Heinrich Eberhard Gottlob Paulus, one of the main representatives of Rationalism in German philosophy. Unless otherwise cited, my information on Paulus derives from interviews conducted in July 1983 and extensive correspondence with Paulus' grandson, Herbert Paulus, who maintains the family archive in Erlangen.

5. Paulus' wife, Anna Neupert-Watty, was the adopted daughter of Richard Watty, an influential politician in Hamburg whose ancestors had emigrated to Germany from Scotland and Ireland. Watty, who maintained his English citizenship, financed his art collecting through his business in the diamond trade. His and his daughter's correspondence with the British artists he supported still exists in the Paulus family archive.

6. Baron von Branca to Paulus, 4 July 1893, Paulus Family Archive, Erlangen. A copy of this letter, in which Branca requests Paulus' presence "as usual" when Luitpold visited the Secession exhibition before its opening, is in SAM, Secession No. 356. On Paulus' relationship with Luitpold, see Karl Alexander von Müller, *Aus Gärten der Vergangenheit* (Stuttgart: W. Kohlhammer, 1952), p. 15.

7. In 1898, for example, a certain C. Steinbart saw Richard Riemerschmid's painting "*And the Lord God Planted a Garden in Eden*" (see Chapter Four) in the Dresdener Gemäldegalerie and wanted a similar picture for his own collection. Rather than contact Riemerschmid directly, he wrote Paulus, asking him to get in touch with

Riemerschmid to see if the artist would be willing to undertake such a commission. Riemerschmid was pleased to do so. See the letter from Paulus to Riemerschmid, 3 August 1898, and the subsequent series of letters between Steinbart and Riemerschmid, Archiv für Bildende Kunst am Germanischen Nationalmuseum, Nürnberg, Riemerschmid Nachlass, B3.

8. One admiring contemporary, for example, described the difficulties that Paulus caused for organizers of exhibitions elsewhere in Germany: "When delegates from Berlin and Vienna went to the Netherlands, England, and France in the 1880s, most saw with horror that the best and newest works had been robbed from the studios, since Paulus had already been there and had procured the lion's share for Munich." "H.V.," "Hofrat Paulus," *Moderne Kunst*, 1901, p. 258.

9. Paulus, "Zwanzig Jahre Münchner Secession," p. 326.

10. *Kunst für Alle*, 4 (October 1888 – September 1889), p. 42.

11. Among the numerous articles printed in the *MNN* supporting the institution of annual salons, see especially *MNN*, No. 350, Vorabendblatt, 2 August 1888, p. 4; *MNN*, No. 413, Einzige-Tages-Ausgabe, 9 September 1888, p. 1; *MNN*, No. 473, Einzige-Tages-Ausgabe, 14 October 1888, pp. 1–2; *MNN*, No. 483, Vorabendblatt, 20 October 1888, p. 2; and *MNN*, No. 519, Einzige-Tages-Ausgabe, 11 November 1888, p. 3.

12. Petition from Eugen von Stieler to the royal cabinet, February 1890, BayHStA, MK 14163. In fact, it was widely acknowledged that the Genossenschaft exhibitions were lucrative for the city. Representative August Schels, for example, noted in a parliamentary speech supporting continued state subventions to the association's salons that "anyone who considers that several hundred thousand tourists came to Munich because of the [1883] salon, all of whom stayed here for a time . . . and naturally left a great deal of money behind, will recognize the advantages, the financial advantages, that the city of Munich and the entire state gained from the last art exhibition." *VdKdAbg* 1884, vol. 2 (9 February 1884), p. 413.

13. On Werner, see Paret, *The Berlin Secession*, especially pp. 14–20.

14. *MNN*, No. 528, Morgenblatt, 16 November 1888, p. 3.

15. On Hirth, see the entry by Leonhard Lenk, *Neue deutsche Biographie* (Berlin: Duncker & Humblot, 1972), 9, pp. 329–41; and Franz Carl Endres, *Georg Hirth: Ein deutscher Publizist* (Munich: Walter C. F. Hirth, 1921).

16. On the *Neueste Nachrichten* and the publishing company Knorr und Hirth, see Buch- und Kunstdruckerei Knorr und Hirth, Verlag der Münchener Neuesten Nachrichten, *Rückblicke*

und *Erinnerungen anlässlich ihres 25jährigen Jubiläums* (Munich: Knorr und Hirth, 1900).

17. In 1898 the strength of Hirth's collection was eighteenth-century porcelain figurines, of which he owned nearly 800 examples. His collection also included nearly 1,300 applied art objects, among which were weapons, armor, musical instruments, textiles, furniture, and books. See *Collection Georg Hirth*, 3 vols. (Munich and Leipzig: G. Hirth, 1898). Among Hirth's most important writings are *Das deutsche Zimmer* (1880), *Aufagaben der Kunstphysiologie* (1891), *Das plastische Sehen als Rindenzwang* (1892), and *Der Stil* (1898).

18. The proceedings and outcome of the meeting were published in *MNN*, No. 531, Einzige-Tages-Ausgabe, 18 November 1888, p. 4; and *AZ*, No. 323, 2. Beilage, 20 November 1888, p. 1. Reports on the Genossenschaft meetings that appeared in the local press were usually officially sanctioned by the association's executive committee and were therefore presumably accurate. See *MNN*, No. 559, Einzige-Tages-Ausgabe, 6 December 1891. At times the dailies speculated about the activities of the Genossenschaft, but it is always clear from the wording of a report whether it was an official or unofficial account.

19. To speed up the decision-making process, the association elected a fourteen-member council whose job was to explore the various possibilities with the executive board and then make recommendations to the members at large. Not surprisingly, the artists who had worked the hardest in support of the annual exhibitions were elected to this provisional council, which included Fritz Baer, Otto Fröhlicher, Hugo von Habermann, Paul Hoecker, Paul Wilhelm Keller-Reutlingen, G. Laverenz, Arthur Langhammer, Robert Poetzelberger, Victor Weishaupt, Ludwig Zumbusch, and the academicians Hugo König, Wilhelm Lindenschmit, Bruno Piglhein, and Fritz von Uhde. Significantly, all but five of the committee members would join the Secession three years hence, and many of the recommendations this council formulated for the annuals (see below) were later adopted at the Secession salons. This parallel was later noted by Otto Julius Bierbaum, who said that "the Munich Secession was instigated and realized mainly by those artists who had earlier instigated and realized the founding of the Munich Annual Exhibitions of Art Works of All Nations." Bierbaum, intro., *Secession. Eine Sammlung von Photogravuren nach Bildern und Studien von Mitgliedern des Vereins "Bildender Künstler Münchens"* (Berlin: Photographische Gesellschaft, 1893), p. v. For the committee's recommendations to the Genossenschaft, and the draft and final version of the statutes for the annual exhibitions, see SAM, Kulturamt 901.

20. *MNN*, No. 33, Einzige-Tages-Ausgabe, 20 January 1889, p. 4. This did not mean that the Genossenschaft intended to eliminate major international exhibitions from its program. To the contrary, members voted at this time to continue the series of large international exhibitions, which had already taken place in 1879, 1883, and 1888. The next one would occur in 1892, and the following in 1897. Now, however, so-called "annual" exhibitions would be held in the interim years, which would differ from the large "internationals" in size, scope, and organization. The resolution to limit non-Munich participation and the amendments listed below applied *only* to the annuals. By contrast, the large "internationals" were to be organized as they had been in past years. As I discuss below, however, while in theory the "annuals" were to differ significantly from the "internationals," in practice they were actually very similar.

21. The committee actually proposed that only one class of medals be distributed instead of the customary two, but members of the Genossenschaft did not approve the suggestion.

22. This practice was used very liberally. At the 1888 exhibition no less than 15 percent of the exhibitors were unjuried guests of the Genossenschaft. See Chapter One, p. 9.

23. The committee that drafted the new policies suggested that all submitted works be numbered according to quality. Artists whose work received a low rating would be given the opportunity to withdraw their pieces so as to avoid embarrassment; otherwise, all works with the same number would be installed together in the Glaspalast. Although there seems to have been considerable controversy about this method of installation, the Genossenschaft ultimately approved the proposal. It is not clear, however, whether artists were notified of their ratings and given the opportunity to withdraw their work should they wish to do so.

24. Among the other new measures designed to improve the efficiency and quality of the jurying process was the uniting of the numerous exhibition committees into one body. In the past, members of the Genossenschaft had elected four separate bodies to manage the shows. An acceptance jury chose which works would be admitted to the exhibitions, the executive committee of the Genossenschaft issued the *hors concours* invitations, a hanging committee controlled the installations, and an awards jury took charge of commendations. Not surprisingly, this system was problematic. The awards jury, for instance, might confer a first-class medal on a picture that the hanging committee had installed in an undesirable position. Official pronouncements on quality were thus understandably vague and did not have the desired impact. Henceforth all duties were

concentrated in a single body, which would control all aspects of the exhibition. One other important change in the jurying process was made. At past Munich exhibitions, committees from foreign countries had at times assisted in the selection of pictures and sculptures by non-German artists. Believing that mediocre work had thereby crept into the exhibitions, the association now stipulated that a single jury consisting only of Genossenschaft members would choose all works, German and foreign alike.

25. The Genossenschaft debated the proposed changes on 18 and 25 January and on 1, 15, and 22 February, and the proceedings of these meetings were widely published in the local press. See also the Genossenschaft annual reports, 1888 and 1889.

26. Besides Dill, Kuehl, Piglhein, and Weishaupt the painting section comprised Hugo von Habermann, Ludwig Herterich, Paul Hoecker, Paul Wilhelm Keller-Reutlingen, Alfred von Kowalski-Wierusz, Ernst Meisel, Peter Paul Müller, Wilhelm Räuber, and the academicians Nicolaus Gysis, Matthias Schmidt, and Ludwig Willroider. The sculpture section consisted of Joseph von Kramer, Otto Lang, and Rudolf Maison. The architectural jurors were Emanuel Seidl and the academicians Joseph Buehlmann and Leonhard Romeis. The print jury consisted of Johann Bankel, Michael Holzapfel, and Wilhelm Rohr.

27. Before 1889 the Bavarian state had allotted half of the Glaspalast to the Genossenschaft for its exhibitions, and the other half to the horticultural society, which mounted a very popular and lucrative flower exhibition each spring. In 1889, however, the state broke with tradition by granting the Genossenschaft the entire Glaspalast, which signified growing recognition of the importance for Bavaria of Munich's art community and its achievements. Henceforth the art association was given priority in the use of the state exhibition hall. For a particularly significant instance of the Genossenschaft's preferential treatment by the state, see the correspondence between the horticultural society and the Ministry of the Interior, November 1891 – April 1892, BayHStA, MK 14341. In contrast to the "internationals," which were generally held from June through October, the annuals were to be somewhat shorter in duration, spanning the months of July through October.

28. The proceedings of this meeting were published in *MNN*, No. 236, Vorabendblatt, 22 May 1889, p. 4.

29. Of the approximately 300 French artists who received such invitations, for example, roughly 150 sent works to the first annual. The jury further facilitated the participation of foreigners by permitting those who had shown works at the Paris Salon to exhibit the same works in

Munich. Since the Paris Salon did not even close until mid-July, the Genossenschaft's first annual exhibition was incomplete until a month after it had opened.

30. Roughly 40 percent of the exhibitors at the first annual were non-German, as compared to 42 percent at the show in 1888. Another 23 percent of the participants lived in German cities other than Munich, and only 37 percent of the exhibitors actually resided in the Bavarian capital. I have obtained these figures from the catalogues of the respective exhibitions, in each case using the latest, most complete edition of the catalogue available to me. The figures should be regarded only as rough approximations, however, since the Genossenschaft frequently added or removed pictures during the run of an exhibition.

31. Anonymous letter published in *MNN*, No. 260, Vorabendblatt, 6 June 1889, p. 4.

32. See, for instance, *MNN*, No. 260, Vorabendblatt, 6 June 1889, p. 4.

33. *AZ*, No. 186, Beilage, 7 July 1889, p. 3.

34. *MNN*, No. 459, Vorabendblatt, 5 October 1889, p. 1.

35. *AZ*, No. 286, Beilage, 15 October 1889, p. 1.

36. Zügel actually exhibited *Auf dem Heimwege (Homeward Bound)*, which differed from *Shepherdess at the Fence* in that it portrayed sheep slowly making their way toward the viewer over a flat expanse of sunny landscape. Gotthard Kuehl showed the oil painting *Kirchgang (Procession to the Church)*, which differed from the pastel *View of the St. Jacobikirche* in its medium, and in that it portrayed a small child next to and another figure behind the woman with the prayer book. Otherwise, the works that I illustrate were very similar in style and sensibility to the exhibited pictures, which I have not been able to locate.

37. *AZ*, No. 217, Beilage, 7 August 1889, p. 3.

38. For discussion of the controversy in Parliament over the first annual, see this chapter, pp. 32–36.

39. Boime, *The Academy and French Painting in the Nineteenth Century*, pp. 15–17.

40. Richard Muther, *The History of Modern Painting* (London: J. M. Dent, 1907), II, 210–13.

41. The art historian and critic Richard Muther addressed precisely this issue when he noted how difficult it was for a Munich audience of the 1880s to appreciate a straightforward Naturalism: "Since Oswald Achenbach and Eduard Grützner the public had seen so many views of Vesuvius and the Bay of Naples, and so many humorous *genre* episodes, that it was almost impossible to imagine simple regions and serious men after these showy landscapes and laughing faces. In addition to this an uncompromising study of nature offended eyes which could only tolerate her when trimmed and set in order. The fresh rendering of personal impressions seemed

brutal after that more glittering painting which made a dexterous use of the articulation of form and colour found in the old masters, adapting them for the expression of its own aims. The effort to express the values of tone with a renunciation of all narrative intention was looked upon as want of spirit. . . ." Muther, *The History of Modern Painting*, IV, 324.

42. *AZ*, No. 179, Morgenblatt, 30 June 1889, p. 2.

43. *AZ*, No. 200, Beilage, 21 July 1889, p. 2, notes that Max opposed the concept of annual salons but "surprised" the jury anyway with an entry at the last minute. The picture was not listed in the provisional catalogue distributed when the exhibition first opened, so it must not have been submitted until after the opening.

44. 151 works by Munich artists sold for 278,252 DM, or 58 percent of the total turnover of 479,250 DM; 48 works by other German artists sold for 43,135 DM, or 9 percent of the total turnover; and 112 works by foreign exhibitors sold for 157,863 DM, or 33 percent of the total turnover. These figures are particularly interesting when compared to the exhibitors' demographics. Only 40 percent of the exhibitors were from Munich, but they accumulated 58 percent of the sales, whereas the 38 percent of the exhibitors who were foreign accumulated only 33 percent of the sales. The average price for a work of art originating in Munich was 1,843 DM, that for one originating elsewhere in Germany was 899 DM; and that for a foreign work of art was 1,409 DM. For these figures, and accounts of the income from and expenses incurred by the first annual, see the Genossenschaft annual report, 1889.

45. Eugen von Stieler was the youngest son of the portraitist Josef Karl Stieler, best known as the creator of Ludwig I's "Schönheitengalerie," a collection of thirty-six portraits of beautiful women. But notwithstanding the elder Stieler's phenomenal success as a portraitist of and for the German aristocracy, he was one of the founders of the Kunstverein, an association dedicated to helping artists without a secure clientele find a market for their work. This democratic persuasion was an essential element of Stieler's character, and his son Eugen was probably elected president of the Genossenschaft at least in part because he had inherited his father's attitudes. After demonstrating some initial promise as a history painter, Eugen von Stieler turned to the tradition of humorous genre so popular in Bavaria, painting scenes of peasant life reminiscent in tone if not in quality of the works of Defregger and Grützner. On Eugen von Stieler, see *Die Kunst*, 53 (November 1925), Beiblatt, XVI; *Die Kunst*, 61 (October 1929), Beiblatt, XL; and Wolf, "Sechzig Jahre Münchner Künstlergenossenschaft."

46. BayHStA, MF 68364 and MK 14163 contain correspondence from Stieler and other documents pertaining to Stieler's conversations with Johann von Lutz and to the cabinet's position on the Genossenschaft petition. Stieler later summarized his dealings with Lutz in his article "Die Entstehung der Münchener Jahresausstellungen," pp. 308–10. The Genossenschaft's formal request for an increase in the art budget is reprinted in the Genossenschaft annual report, 1890, pp. 11–15.

47. Stieler to the royal cabinet, February 1890, BayHStA, MK 14163.

48. Lutz relating Stieler's arguments to Riedel, August 1889, BayHStA, MF 68364.

49. While both Lutz and Finance Minister Emil von Riedel felt that Stieler was exaggerating the seriousness of the situation and were mildly annoyed that, after initiating the annuals of its own accord, the Genossenschaft should now come to the state for financial assistance, they were nevertheless impressed by his arguments. See the series of letters between the two ministers from mid-August, BayHStA, MF 68364.

50. Jelavich, *Munich and Theatrical Modernism*, p. 14. Jelavich's study is, in part, a valuable and detailed account of the Bavarian Center Party and its changing fortunes in the latter half of the nineteenth century and the early twentieth. Friedrich Prinz, "Bayern und München am Ende der Prinzregentenzeit," in Munich, Haus der Kunst, *"München leuchtete." Karl Caspar und die Erneuerung christlicher Kunst in München um 1900*, 8 June – 22 July 1984, pp. 21–28, also provides a concise overview of Bavarian politics during the Regency.

51. Jelavich, *Munich and Theatrical Modernism*, pp. 37–38, and passim.

52. Paret, *The Berlin Secession*, pp. 44–45, discusses the picture and reactions to it in some detail.

53. *VdKdAbg* 1879–80, vol. 4 (15 January 1880), p. 595.

54. *VdKdAbg* 1889–90, vol. 5 (28 March 1890), pp. 592–93. The work that so disturbed Jäger was probably Fritz von Uhde's 1887 *Sermon on the Mount*, now in the Museum of Fine Arts in Budapest. Ironically, this painting was not exhibited at all at the Genossenschaft's first annual of 1889, but at the association's third international salon of 1888, which is undoubtedly where Jäger saw it.

55. *VdKdAbg* 1889–90, vol. 5 (28 March 1890), p. 602.

56. Initially the budget committee of the Lower House refused to recommend to Parliament the proposed increase in the purchasing grant. Although this action was primarily a political maneuver designed to force a favorable ruling on several unrelated Center motions, it was also an

expression of concern about the state of contemporary art as represented at the first annual. By the time the petition was introduced for discussion in the Lower House of Parliament, the government had in fact made some political concessions to the Center Party, and in return the budget committee recommended an annual purchasing grant of 60,000 DM, one-half of what the royal cabinet had requested. After considerable debate, this was in fact approved. Yet in response to a convincing speech by Prince Ludwig, who argued that the larger budget was needed, the Upper House of Parliament overturned the postulated 60,000 DM and proposed instead a compromise of 100,000 DM. The Center-dominated Lower House found this acceptable. For the complex and controversial evolution of this measure, see the sources cited in Chapter One, note 33. Möckl, *Die Prinzregentenzeit*, pp. 254–330, thoroughly outlines the political, social, and religious controversies that led to the committee's initial rejection of the petition, but in my opinion underestimates the aesthetic issues that affected Center policy. Moreover, I cannot agree entirely with Möckl's interpretation (pp. 329–30) of the Center's ultimate accommodation on the cultural budget as merely an instance of the party's support of Ludwig, who the Center hoped would succeed Luitpold. Undoubtedly, this was an important consideration for Center representatives; it is nevertheless clear from parliamentary speeches that anti-Prussian sentiment was equally significant in the Center's subsequent decision to approve the larger sum.

57. The artists elected to the painting section of the jury were Anton Braith, Adolf Echtler, Walter Firle, Edmund Harburger, Karl Marr, Georg Papperitz, Robert Schleich, Karl Frithjof Smith, Karl Stühlmuller, Joseph Weiser, Ludwig Willroider, and the academicians Joseph Brandt, August Fink, Gabriel Hackl, and Klaus Meyer. The sculpture section of the jury consisted of Rudolf Maison and the academicians Anton Hess and Wilhelm Rümann. Jakob Deininger, Wilhelm Rohr, and Albrecht Schultheiss were elected as jurors for graphic arts, and the academicians Leonhard Romeis, Albert Schmidt, and Friedrich von Thiersch won seats on the architecture section. The mean age of the jury was forty-three, as opposed to the mean age of forty in 1889. Of the entire twenty-four-member jury, only the sculptor Rudolf Maison later joined the Secession.

58. In 1889 the three-work limit had been repealed only because at first there were comparatively few submissions to the first annual, and the Genossenschaft wanted to ensure that the exhibition would have enough works. In 1890, however, the membership at large voted to amend the statutes of the annuals to the effect that jurors were explicitly given the right to exceed the limit in cases where the work was deemed exceptional.

The adoption of this new practice was reported in *MNN*, No. 590, Einzige-Tages-Ausgabe, 22 December 1889, p. 4, and incorporated into the exhibition statutes. See the "Satzungen der Münchener Jahres-Ausstellung 1891," in the collection of documents pertaining to the third annual exhibition of 1891, in BSB.

59. The local press protested both the number of rejections and the fact that the work of many renowned artists had been eliminated. See, for example, *AZ*, No. 25, Drittes Morgenblatt, 25 January 1891, p. 9. Out of consideration for those who were rejected, the journalists did not, as a rule, cite specific names. Since records of jury deliberations appear to have been destroyed, either by the jurors themselves or later, it is difficult to know exactly what was rejected and why. Artists' letters and diaries occasionally provide insights, yet I have located none which deals specifically with the 1890 exhibition.

60. See pp. 94–96 for a more detailed discussion of this work.

61. On the Glasgow Boys, see David Irwin and Francina Irwin, "The Glasgow School," chapter 20 in *Scottish Painters at Home and Abroad 1700–1900* (London: Faber and Faber, 1975), pp. 372–94; Glasgow, The Art Gallery and Museum, *The Glasgow Boys 1880–1900*, 2 vols. (Edinburgh: Scottish Arts Council, 1968 and 1971); and Roger Billcliffe, *The Glasgow Boys* (London: John Murray, 1985). It was Paulus who discovered the Boys for Munich. In the spring of 1890 he traveled to England as a delegate of the jury, and visited the Grosvenor Gallery in London, where he saw for the first time the work of the Glasgow Boys. Paulus then went immediately to Glasgow to meet the artists. As James Guthrie's biographer relates, Paulus made most of the arrangements for their participation in the upcoming Munich exhibition through Guthrie. See James Lewis Caw, *Sir James Guthrie*, Foreword by D. Y. Cameron (London: Macmillan, 1932), pp. 59–63; and the numerous letters to Paulus from the Glasgow artists in the Paulus Family Archive, Erlangen.

62. Muther, *The History of Modern Painting*, IV, 34–35.

63. Pecht's reviews of the exhibition were published in the journal he edited, *Kunst für Alle*.

64. *MNN*, No. 483, Morgenblatt, 21 October 1890, p. 1.

65. Of the 1,284 exhibitors, 445 (35 percent) were from Munich, 215 (17 percent) lived elsewhere in Germany, and 624 (48 percent) were foreign. Genossenschaft annual report, 1890.

66. *MNN*, No. 380, Morgenblatt, 21 August 1890, p. 1.

67. Of the 51 award winners, 12 (23 percent) were from Munich, 9 (18 percent) lived elsewhere in Germany, and 30 (59 percent) were foreign.

68. 84 works by Munich artists sold for 138,930 DM, or 36 percent of the total turnover of 389,475 DM; 24 works by other German artists sold for 30,020 DM, or 8 percent of the total turnover; and 124 works by foreign exhibitors sold for 220,525 DM, or 56 percent of the total turnover. Although only 48 percent of the exhibitors were foreign, they accumulated 56 percent of the sales, whereas the 35 percent of the exhibitors from Munich accumulated only 36 percent of the sales. The average price for a work of art originating in Munich was 1,654 DM; that for one originating elsewhere in Germany was 1,251 DM; and that for a foreign work of art was 1,778 DM. Genossenschaft annual report, 1890.

69. As one artist-critic put it, "those [foreigners] who wish to exhibit and sell here should also have to subject themselves to the judgment of the local artists." H. E. von Berlepsch, "Münchener Kunst-Bummeleien," *AZ*, No. 344, Morgenblatt, 12 December 1890, p. 1.

70. The statutes of both the large international exhibitions and the annuals stipulated that the Genossenschaft assume the shipping costs of the works of all the invited artists. This was not a minimal expense, as a large percentage of the *invités* were foreign. Whereas in 1889 these shipping costs had amounted to 11,300 DM, in 1890 they rose to 302,600 DM. *AZ*, No. 339, Zweites Abendblatt, 7 December 1891, p. 5. The Genossenschaft annual report, 1890, provides a final accounting of the exhibition's income and expenses.

71. Berlepsch, "Münchener Kunst-Bummeleien," p. 1.

72. Ibid.

73. The proceedings of this meeting were published in *AZ*, No. 349, Abendblatt, 17 December 1890, p. 1; and *MNN*, No. 578, Vorabendblatt, 17 December 1890, p. 4.

74 The earliest report regarding the Berlin exhibition appeared in *MNN*, No. 31, Einzige-Tages-Ausgabe, 20 January 1890, p. 3. In October the incidence of notices concerning the Berlin show increased dramatically in the various Munich periodicals, and on 18 November the *Neueste Nachrichten* announced that the question had been definitively decided. *MNN*, No. 529, Vorabendblatt, 18 November 1890, p. 4.

75. On the relationship of the Verein, the academy, and the state in imperial Berlin, see Paret, *The Berlin Secession*, pp. 9–28.

76. The proposal was publicized in both the Munich and the Berlin press. See, for example, the article lamenting the Genossenschaft's refusal in *National Zeitung*, No. 689, Abend-Ausgabe, 16 December 1890, p. 1. The Verein's proposal was discussed in the general meeting of the Genossenschaft that took place on 16 December 1890, the proceedings of which were published in *MNN*, No.

578, Vorabendblatt, 17 December 1890, p. 4. Notably, in 1879 the Genossenschaft, with the Munich Academy, had made a similar request of the Royal Academy in Berlin. That year the Genossenschaft mounted the first of its quadrennial international exhibitions, and the association wanted the Royal Academy of the Arts in Berlin to forgo its annual salon in consideration of the Munich show. The request was turned down, however, and this was no doubt a factor in the Genossenschaft's refusal to cooperate with Berlin in 1891. Committee for the 1879 Munich exhibition to the Prussian Kultusministerium, 4 February 1879, and Carl von Piloty (director of the Royal Academy of Fine Arts in Munich) to the Royal Academy of Arts in Berlin, undated, Akademie der Künste, West Berlin, Reg. 2. 323 Akte betr. die grosse akademische Kunstausstellung 1879. I am grateful to Robert Kunath for this citation.

77. *MNN*, No. 582, Vorabendblatt, 19 December 1890, p. 4.

78. *MNN*, No. 1, Einzige-Tages-Ausgabe, 1 January 1891, p. 4.

79. Elected to the painting section were Gustav Bauernfeind, J. F. Engel, Paul Wilhelm Keller-Reutlingen, Hugo König, Guido von Maffei, Wilhelm Marc, Joseph Munsch, Robert Poetzelberger, Emil Rau, Philipp Röth, Adolf Stäbli, Franz von Stuck, Wilhelm Trübner, Fritz von Uhde, and Wilhelm Velten. Of these painters, Keller-Reutlingen, König, Maffei, Poetzelberger, Stuck, Trübner, Uhde, and Velten later joined the Secession. Joseph von Kramer, Otto Lang, and Jakob Ungerer were elected to the sculpture committee, and the architects Joseph Bühlmann, Julius Hoffmann, and Heinrich von Schmidt won seats on the architecture section. Johann Bankel, Peter Halm, and Adolf Wagenmann were elected as jurors of the graphic arts.

80. Werner first appointed Otto Sinding, a painter of Nordic winter scenes, as the representative of Norway's artists, then arbitrarily withdrew his support and named instead Hans Dahl, a mediocre figure painter resident in Berlin, as chairman of the committee. Werner also privately sent twenty-two additional invitations to other artists, most of them born in Norway but living in Germany or England. The committee of Norwegian artists in Christiania considered his actions an affront and wired their decision not to participate in the Berlin exhibition. Reinhold Heller, *Munch, His Life and Work* (London: John Murray, 1984), p. 100.

81. Zorn executed a series of interior views of breweries during a stay in Stockholm in 1890, and the one he exhibited in Munich is identified in the catalogue simply as *Brauerei in Stockholm* (*Brewery in Stockholm*). Since the work is not illustrated in the catalogue, it is impossible to

identify which of the series was exhibited, but the example I illustrate can be considered typical.

82. It is not clearly documented whether the picture I illustrate is the one that was exhibited, but it is probable. Although the work was not illustrated in the catalogue, its title was listed as *Abfahrt von Boulogne*. The only example of Manet's numerous Boulogne harbor scenes that clearly represents boats *departing* from the port is the Chicago Art Institute's *Departure from Boulogne Harbor*, earlier titled *The Outlet of Boulogne Harbor*. On Manet's Boulogne scenes, see Anne Coffin Hanson, "A Group of Marine Paintings by Manet," *Art Bulletin*, 44 (1962), pp. 332–36.

83. Tissot exhibited his series *The Prodigal Son in Modern Life*, now in the Musée de Nantes. The anachronism of the works must have particularly appealed to Uhde, who, despite his vastly different artistic temperament, was also fond of translating biblical stories into contemporary conceits. It has proved impossible to identify the pictures that Sisley and Monet exhibited. Each of Sisley's three works was simply labeled *Landschaft (Landscape)*, and Monet's were cited as *Am Teich (By the Pond)*, *Seestück (Sea Piece)*, *Marine (Seestück) (Marine [Sea Piece])*, and *Landschaft (Landscape)*.

84. Friedrich Pecht, "Die Münchener Jahres-Ausstellung von 1891," *Kunst für Alle*, 6 (October 1890 – September 1891), p. 337.

85. *Fliegende Blätter*, 94 (1891), pp. 226–27. For other cartoons and one lengthy parody of the third annual in the form of a poem, see *Fliegende Blätter*, 95 (1891), pp. 62, 81–82, 215.

86. The work, now in the Walters Art Gallery, is a modified version of the mural on the same subject that Puvis executed for the north wall of the stairwell of the Musée de Picardie in Amiens. Commissioned by the French government in 1880 for the sum of 40,000 francs, it was completed in 1882, exhibited at the Salon of the same year, and—after some structural changes were made to the stairway of the museum—finally installed in 1888. Both the mural and the canvas Puvis exhibited in Munich include representations of young javelin-throwing Picardians who, as the title of both works indicates, are responsible for the defense of their homeland. The paintings can probably be considered a response to the defeat of France in the Franco-Prussian war.

87. See, for example, Ludwig Herterich's *St. George (Der Heilige Georg)*, which was purchased from the third annual by the state for the Neue Pinakothek.

88. Lebenserinnerungen Philipp Röth, Archiv für Bildende Kunst am Germanischen Nationalmuseum, Nürnberg. On Röth and other German representatives of the *paysage intime*, see Siegfried Wichmann, *Meister, Schülen, Themen*.

Münchner Landschaftsmaler im 19. Jahrhundert (Herrschung: Schuler Verlagsgesellschaft, 1981).

89. The most acerbic criticisms were published in the reactionary cultural journal *Sodom und Gomorrha oder Der Untergang des guten Geschmacks in Kunst, Literatur und Presse*, which ran a series of articles in its first three volumes reviewing the exhibition and the jury's work.

90. See, for example, Hirth's article "Die Zukunft des Münchner 'Salons,' " *MNN*, No. 492, Morgenblatt, 28 October 1891, pp. 1–2.

91. *Der Kunstwart*, 5 (1891–92), p. 44.

92. As Gordon Craig has noted, after 1871 military values permeated all walks of German life, from the world of business, where a breed of industrialists ran their enterprises as if they were fortress commanders, to the university community, where the student corporations adopted the ceremonials and the vices of garrison life and tried to emulate the style of the Prussian lieutenant. This respect for all things military in Germany coincided with the growing social insecurity of a once proud and self-reliant middle class, and what had once been a tolerant bourgeois contempt for the aristocracy now gave way to the slavish aping of feudal style. Gordon Craig, *The Germans* (New York: Meridian, 1983), p. 239, and *Germany, 1866–1945* (New York: Oxford University Press, 1978), pp. 99–100.

93. Hermann Kaulbach, "Katalog der Zwanglosen-Gemälde-Ausstellung vom 6. Januar 1892," p. 5, Monacensia Abteilung, Münchner Stadtbibliothek. Kaulbach's "Katalog" is a handwritten parody of the 1891 Genossenschaft show and of the controversies involved in its organization and aftermath. He does not cite Uhde by name, but it is clear from his description that he was describing the president of the jury. Kaulbach, as a member of the executive committee of the Genossenschaft that year, would have been privy to information about the jury's activities that might not have reached the membership at large.

94. On 1 October 1904, Lichtwark wrote that "he [Uhde] is very embittered and angry; it almost seems as if he has a persecution complex." Letter to the Kommission für die Verwaltung der Kunsthalle, as quoted in Bettina Brand, *Fritz von Uhde. Das religiöse Werk zwischen künstlerischer Intention und Öffentlichkeit*. Hefte des Kunstgeschichtlichen Instituts der Universität Mainz, No. 7, ed. Richard Hamann-MacLean (Mainz: Kunstgeschichtliches Institut der Universität Mainz, 1983), p. 166.

95. Lichtwark, letter from 13 June 1906, as quoted in Brand, *Fritz von Uhde*, p. 167.

96. "Einer Jury Zweck, Ziel und Ende," *Sodom und Gomorrha*, 2 (1891), p. 16.

97. Of the 1,425 exhibitors, 416 (29 percent) lived in Munich, 239 (17 percent) lived elsewhere

in Germany, and 770 (54 percent) were foreigners. Genossenschaft annual report, 1891.

98. See the *Illustrierte Katalog der Münchener Jahresausstellung von Kunstwerken aller Nationen im kgl. Glaspalaste 1891*, 4th ed. (Munich: Verlagsanstalt für Kunst und Wissenschaft, 1 September 1891).

99. From 1890 to 1891 the number of invited artists rose from 311 to 444 (not all of them accepted, of course). See the collection of documents pertaining to the second and third annual exhibitions of 1890 and 1891, in BSB. The profits from catalogue sales, entry fees, and commissions in 1891 were 14,000 DM higher than in 1890. Shipping costs, however, amounted to 38,000 DM in 1891, as opposed to 32,600 DM in 1890 and 11,300 DM in 1889. Moreover, the association incurred considerably greater installation expenses for the 1891 salon than for past shows. When all accounts were settled, the exhibition had accrued a deficit of roughly 14,000 DM. See *MNN*, No. 559, Einzige-Tages-Ausgabe, 6 December 1891, p. 4; *AZ*, No. 339, Zweites Abendblatt, 7 December 1891, p. 5; *AZ*, No. 75, 15 March 1892, p. 1; and the Genossenschaft annual report, 1891.

100. 119 works by Munich artists sold for 197,375 DM, or 32 percent of the total turnover of 612,960 DM; 44 works by other German artists sold for 72,820 DM, or 12 percent of the total turnover; and 156 works by foreign artists sold for 342,765 DM, or 56 percent of the total turnover. On this occasion 54 percent of the exhibitors were foreign, and they accumulated 56 percent of the sales, and the 29 percent of the exhibitors who were from Munich accumulated 32 percent of the sales. However, the average price for a work of art originating in Munich was only 1,659 DM; that for one originating elsewhere in Germany was 1,655 DM; whereas the average price for a foreign work of art was 2,197 DM. Genossenschaft annual report, 1891.

101. George Conrad, "Aus dem Münchener Kunstleben," *Die Gesellschaft*, 1893, p. 230.

102. The editors of the *Moderne Blätter*, in fact, noted that they had received so many letters protesting the foreign presence at the third annual and criticizing the jury that they felt obligated to print at least one article in support of the enterprise. See Otto Julius Bierbaum, "Die Zukunft der Münchener Jahres-Ausstellungen," *Moderne Blätter*, 7 November 1891, pp. 2–7. The journal also published a sampling of the correspondence that initially prompted Bierbaum's defensive article. See *Moderne Blätter*, 8 August 1891, pp. 6–7; 22 August 1891, p. 3; and 5 September 1891, p. 8.

103. Anonymous letter to the *Bayerische Vaterland*, No. 163, 23 July 1891, p. 1.

104. The most detailed treatment of Langbehn and his book is Fritz Stern, *The Politics of Cultural Despair: A Study in the Rise of Germanic*

Ideology (Berkeley: University of California Press, 1961, rpt. 1974). See also Chapter Three, note 79 below.

105. *MNN*, No. 317, Vorabendblatt, 17 July 1891, p. 4. Other such accusatory articles appeared in *MNN*, No. 311, Vorabendblatt, 14 July 1891, p. 4; *MNN*, No. 321, Einzige-Tages-Ausgabe, 19 July 1891, p. 4; *MNN*, No. 323, Vorabendblatt, 21 July 1891, p. 4; *MNN*, No. 325, Vorabendblatt, 22 July 1891, p. 4; *MNN*, No. 329, Vorabendblatt, 24 July 1891, p. 4; and *MNN*, No. 331, Vorabendblatt, 25 July 1891, p. 4.

106. To his credit, Hirth published a full transcript of his trial in *MNN*, No. 531, Vorabendblatt, 20 November 1891, pp. 3–4; *MNN*, No. 532, Morgenblatt, 20 November 1891, pp. 2–3; *MNN*, No. 533, Vorabendblatt, 21 November 1891, pp. 3–4; and *MNN*, No. 534, Morgenblatt, 21 November 1891, pp. 2–3.

107. See Stieler's petition to the royal cabinet, February 1890, BayHStA, MK 14163.

108. Hirth was sentenced to fourteen days in prison, and Francke received a fine of 50 DM. In February 1892 Hirth won an appeal against the verdict, and his prison sentence was commuted to a 500 DM fine. See *MNN*, No. 94, Morgenblatt, 27 February 1892, p. 2; *MNN*, No. 95, Einzige-Tages-Ausgabe, 28 February 1892, pp. 2–3; and *MNN*, No. 96, Einzige-Tages-Ausgabe, 29 February 1892, p. 3. See also Georg Hirth's brief to the appellate court of 15 February 1892, *Berufungsschrift an das k. Landgericht München* (Munich: Knorr & Hirth, 1892), now preserved in the BSB, and the executive committee's explanation of its handling of the publicity in the Genossenschaft annual report, 1891.

109. Paulus, "Zwanzig Jahre Münchner Secession," p. 329, intimates as much in stating that the "Vorstandschaft" of the 1891 jury did indeed have a close relationship to the *MNN*. The anonymous author of the article "Der Kampf um den Glaspalast," in the short-lived satirical journal *Sodom und Gomorrha*, 5 (1892), pp. 4, 8, was more explicit, linking Hirth and Uhde by name and referring to the affair as the "Hirth-Uhde'sche Hetze."

110. Indeed, Lovis Corinth later attested that Uhde interpreted all criticisms of the exhibition as personal insults (though he misdated the exhibition chaired by Uhde to 1892). Lovis Corinth, "Thomas Theodor Heine und Münchens Künstlerleben am Ende des vorigen Jahrhunderts," *Kunst und Künstler*, 4 (1905–1906), p. 152. That Uhde would in fact have had difficulty handling Stieler's criticisms is suggested by another incident in which the artist threatened to take revenge on Friedrich Pecht merely for publishing a negative review of Uhde's work. See Uhde to Hugo von Habermann, 8 August 1883, Städtische Galerie Würzburg, Nachlass Habermann.

Chapter 3

1. The group, which also included Hans von Bartels, Walter Firle, August Holmberg, Hermann Kaulbach, Albert von Keller, Gabriel Seidl, Otto Seitz, Wilhelm Trübner, Josef Wenglein, Alfred von Kowalski-Wierusz, and Joseph Wopfner, first met on 21 November 1891. The most concise statement of its platform, which was presented at two general meetings of the Genossenschaft in early December, was written by the group's spokesman, Hippolyte von Klenze, and printed in *AZ*, No. 75, Morgenblatt, 15 March 1892, pp. 1–3.

2. The meeting was held on 4 December, but because the business could not be finished at that time another assembly was called for 7 December. The proposal to limit the duties of the jury was apparently the most controversial, but all the suggestions of the Forty-Eight were ultimately adopted by the Genossenschaft. *AZ*, No. 75, Morgenblatt, 15 March 1892, p. 3, reported that of the roughly five hundred members in attendance at the first meeting, only about twenty voted against the proposed statutory changes. Notably, the membership at large also voted to censure publicly not only Georg Hirth and the *Neueste Nachrichten* for the attacks on Stieler and Bauer but also those Genossenschaft members who had gone to Hirth with their criticisms of the executive committee. The official reports of the proceedings of the two Genossenschaft meetings were published in *AZ*, No. 337, Zweites Abendblatt, 5 December 1891, p. 5; *AZ*, No. 339, Zweites Abendblatt, 7 December 1891, p. 5; *AZ*, No. 340, Abendblatt, 8 December 1891, pp. 2–3; *MNN*, No. 559, Einzige-Tages-Ausgabe, 6 December 1891, p. 4; and *MNN*, No. 564, Vorabendblatt, 10 December 1891, p. 4.

3. The executive committee did not invite Paulus to two organizational meetings for the 1892 salon, and asked him to attend only a part of a third. Since the business manager was contractually guaranteed a voice and a vote on the central committee of the quadrennial exhibitions, of which the upcoming salon was one, Paulus protested his exclusion from the meetings by refusing to attend at all. This presented the executive committee with grounds to give him notice, which it did on 2 February 1892. By the terms of his contract Paulus could have remained until the end of 1893, but he chose instead to leave immediately. On 12 February 1892 his contract was definitively terminated by mutual agreement. Letter from Herbert Paulus to the author, 25 August 1985; and Genossenschaft annual report, 1892.

4. The dismay that some artists felt at Paulus' departure was most poignantly expressed by Bruno Piglhein, who wrote the business manager shortly after the contract had been terminated.

Conveying his sadness about the entire affair, Piglhein described the dismissal as a great loss which even Paulus' enemies would eventually come to regret deeply. Letter from Bruno Piglhein to Adolf Paulus, 17 February 1892, Paulus Family Archive, Erlangen.

5. The initial meetings of this group took place on 13, 16, 18, 24, and February 1892. Calendar entries of Adolf Paulus, as summarized in the "Chronologie" compiled by Herbert Paulus, Paulus Family Archive, Erlangen.

6. *MNN*, No. 576, Vorabendblatt, 16 December 1890, p. 4; and *MNN*, No. 311, 14 July 1891, as cited in Betz, "Kunstausstellungswesen und Tagespresse in München," p. 88.

7. See especially the letter from Victor Weishaupt to Adolf Paulus, February 1892, Paulus Family Archive, Erlangen, in which Weishaupt not only accepted Paulus' invitation to attend a meeting of the small group of dissidents, but asked if Paulus would want to invite Weishaupt's nephew, Richard Riemerschmid, to attend as well. "Perhaps he is too young, but I'll leave it to you," wrote Weishaupt deferentially.

8. Uhde-Bernays, *Die Münchner Malerei im 19. Jahrhundert*, II, p. 234, says that these artists released a statement that read as follows: "Those who are gathered today have, independent of the Munich Künstlergenossenschaft, constituted themselves as a club in pursuit of those measures that in their opinion are in the interests of Munich art." This was not published in the Munich press, however, and I have not been able to locate such a document, though it presumably did indeed exist. The meeting was held in the studio of the Piglhein student Josef Block.

9. According to Paulus' daily calendar entries, as summarized by Herbert Paulus, "Chronologie," Paulus and Dill composed the document on 11 March 1892, so it was no doubt distributed to Genossenschaft members shortly thereafter. The statement is reprinted in Paulus, "Zwanzig Jahre Münchner Secession," pp. 329–30.

10. Both Uhde-Bernays, *Die Münchner Malerei im 19. Jahrhundert*, II, pp. 235–36, and Paulus, in his daily calendar, as summarized by Herbert Paulus, "Chronologie," commented on the impressive display of support at this meeting. Bruno Piglhein was elected as president with Hugo von Habermann as his alternate, and Paul Hoecker as secretary with Robert Poetzelberger as his alternate. Ludwig Dill, Albert von Keller, Gotthard Kuehl, Arthur Langhammer, Franz von Stuck, Fritz von Uhde, and Heinrich Zügel were elected as regular members of the executive committee, with Bernhard Buttersack, Ludwig Herterich, and Paul Wilhelm Keller-Reutlingen as their alternates. See the Secession's "Gründungsmemorandum," SAM, Secession 377 (Appendix II in this book), which cites the names of the group's execu-

tive committee. Albert Keller was the only artist elected to the executive committee who had not signed the first document lobbying for artist support.

11. Both the membership roster and the lengthy "Gründungsmemorandum" (Appendix II) were published in their entirety in *MNN*, No. 278, Vorabendblatt, 21 June 1892, p. 4. Other local newspapers and journals, such as *Der Kunstwart* and *Kunst für Alle*, published only portions of the documents. In addition, the Secession printed the memorandum and membership roster independently, and then appended them to any of their correspondence soliciting support. See, for example, the copies of these documents in SAM, Secession 377.

12. Again, Paulus' advice was considered essential in choosing the corresponding members. See the letter from Bruno Piglhein to Adolf Paulus, 25 March 1892, Paulus Family Archive, Erlangen, in which Piglhein respectfully asks for Paulus' help in drawing up a list of corresponding members, and requests that Paulus inform Kuehl and Habermann when it is convenient for him to meet with the two artists to do so.

13. Shortly after the dissidents resigned from the Genossenschaft, the public began to refer to them as the secessionists. It was Adolf Paulus who suggested in a general meeting of the association on 14 October 1892 that the group change its name from the Verein Bildender Künstler Münchens to the Münchener Secession, since the former designation might be too easily confused with the Münchener Künstlergenossenschaft. The assembly voted to table Paulus' motion temporarily, and there is no record of when the association formally assumed the shorter name. But by June 1893 at the latest the association was using a letterhead with both names. "Protokolle des Vereins Bildender Künstler Münchens, Secession, Generalversammlungen" (hereafter cited as "Protokolle"), 14 October 1892, SAM, Secession 1541; and circular on Secession letterhead publicizing the new association and its exhibition, June 1893, Paulus Family Archive, Erlangen.

14. According to Paulus' daily calendar, as summarized by Herbert Paulus, "Chronologie," Paulus and Dill composed the first announcement of the founding of the Secession on 11 March 1892. The second statement, titled "Memorandum des Vereins Bildender Künstler Münchens," was lengthier and more complicated, and thus required more work. A letter from Ludwig Dill to Adolf Paulus, 24 April 1892, Paulus Family Archive, Erlangen, documents their joint efforts to write the statement. Two versions were read at the meeting of the executive committee on 3 May 1892, which voted to combine them. Presumably Paulus and Dill also worked on this. "Protokolle," 3 May 1892, SAM, Secession 1541.

15. For example, rather than grant all members voting privileges, as the Genossenschaft did, the Secession stipulated that those members who had not exhibited for three consecutive years would lose their vote until they again participated in one of the Secession salons. See the "Statuten des Vereins Bildender Künstler Münchens," SAM, Secession 377.

16. See, for example, the important founding "Memorandum" (Appendix II), which on the one hand stresses the Secession's willingness to embrace artists of all orientations, while on the other it criticizes those artists who have not kept pace with the "modern spirit."

17. On Trübner, see Maria Makela, "Wilhelm Trübner: A Link Between Realism and Impressionism in Germany," Thesis Tulane University 1981; and Klaus Rohrandt, "Wilhelm Trübner. Kritischer und beschreibender Katalog sämtlicher Gemälde, Zeichnungen und Druckgraphik. Biographie und Studien zum Werk," Diss. Christian-Albrechts-Universität 1972.

18. "Das Kunstverständnis von Heute," in Wilhelm Trübner, *Personalien und Prinzipien* (Berlin: Bruno Cassirer, 1907), p. 130. Trübner's essay was originally published anonymously as a brochure in 1892.

19. See especially *Personalien und Prinzipien*, pp. 86–94.

20. Trübner belonged to the Forty-Eight, whose members all believed that foreign artists had unfairly received preferential treatment at the Genossenschaft annuals. Trübner's suppport of this group's platform in 1891, when the annuals were revamped, was no doubt the reason why he was not asked to be one of the twenty founding members of the Secession, an exclusion that he continued to resent for many years. Yet even when Trübner joined the Secession he did not change his stance on the matter of foreign art. "Art Appreciation Today" is, among other things, an attack on foreign domination of the German art market.

21. Hermann Schlittgen, *Erinnerungen* (Munich: Albert Langen, 1926), p. 274.

22. *Kunst für Alle*, 7 (October 1891 – September 1892), p. 315.

23. *VdKdAbg* 1891–92, vol. 8 (7 March 1892), pp. 619–33. The most bellicose speeches were delivered by representatives Beckh and Schädler. Despite their objections to the third annual, however, the purchasing grant was renewed for the coming year.

24. In fact, he even argued before an antagonistic Parliament in its session of 7 March 1892 that the inclusion of foreign works of art in the Genossenschaft exhibitions and the purchase of such works by the state were necessary. *VdKdAbg* 1891–92, vol. 8 (7 March 1892), p. 626. On Müller, see the memoirs of his son, Karl Alex-

ander von Müller, *Aus Gärten der Vergangenheit.*
Notably, Müller and Adolf Paulus were neighbors
on Arcisstrasse until 1887, when Müller became
Munich's Polizeidirektor (Assistant Chief of
Police). From 1888 until 1890 he held the office of
Polizeipräsident (Chief of Police), and in 1890 he
became the Bavarian cultural minister. In his
memoirs Müller's son revealed something of the
minister's untraditional taste when he said that
his father admired Defregger and Grützner, but
that he had a real passion for the painter Karl
Haider (ibid., p. 118).

25. Shortly after the founding of the Secession,
Müller expressed his negative feelings about a
rupture within the art community at a meeting
with Piglhein, the president of the association.
Letter from Bruno Piglhein to Adolf Paulus, 16
April 1892, Paulus Family Archive, Erlangen.
According to Paulus' daily calendar, as summa-
rized by Herbert Paulus' "Chronologie," the busi-
ness manager was called for a meeting with
Müller on 10 May, at which time the cultural
minister asked him not to prevent the dissident
artists from rejoining the Genossenschaft, should
it come to that. On 11 May Paulus had an audi-
ence with Luitpold, who asked the business man-
ager to resume his old position with the Genossen-
schaft.

26. *Kunst für Alle*, 7 (October 1891 – Septem-
ber 1892), p. 315.

27. The Secession submitted its request,
accompanied by the founding memorandum, a list
of members, and statutes, on 30 June 1892. The
Magistrat then formed a twenty-two-member
committee to review the Genossenschaft exhibi-
tion statutes from its founding to the present day
and investigate all the possible sites that might
be given to the Secession. On 26 July the commit-
tee made its unanimous recommendation to the
Magistrat not to approve the Secession's request,
and in turn the Magistrat, with only one dissent-
ing vote, elected not to support the Secession. See
the collection of documents, including a draft of
the rejection letter to the Secession, in SAM, Kul-
turamt 119.

28. Declaration of the Magistrat, 26 July 1892,
SAM, Kulturamt 119.

29. Rita Hummel, "Die Anfänge der Mün-
chener Secession: Eine kulturpolitische Studie,"
Thesis Ludwig-Maximilians-Universität zu Mün-
chen 1982, pp. 46–50, outlines these developments.

30. The parameters of a contract with Frank-
furt were discussed at an executive committee
meeting on 1 September 1892, and the Secession's
requirements were sent to the mayor of that city
on 5 September. Nothing was definitively settled,
however, for on 14 October the Secession was still
negotiating with both Frankfurt and Dresden.
"Protokolle," 1 September and 14 October 1892,
SAM, Secession 1541.

31. Copy of a letter from the Magistrat to the
Künstlergenossenschaft, 30 September 1892,
SAM, Kulturamt 119. At an open meeting of the
Magistrat on 30 September a declaration was
read that linked the negotiations to keep the
secessionists in Munich with the efforts of Frank-
furt and Dresden to lure the artists away. Decla-
ration of the Magistrat, 30 September 1892, SAM,
Kulturamt 119.

32. The first two options as well as the last
were specifically cited in the declaration of the
Magistrat, 30 September 1892, SAM, Kulturamt
119, as possible solutions to the problem of keep-
ing the secessionists in Munich. The third—that
is, the possibility of exhibitions being sponsored
by the Genossenschaft and the Secession in alter-
nate years—was cited in the *Anzeiger der Mün-
chener Künstlergenossenschaft*, No. 23, 5 October
1892, p. 2.

33. It seems as if in so doing he reneged on a
promise made early in the negotiations that the
Secession would be given either its own exhibition
building or at least half of the Glaspalast. Ludwig
Dill speaks bitterly of Müller's change of heart in
his unpublished "Lebenserinnerungen," Archiv
für Bildende Kunst am Germanischen National-
museum, Nürnberg, and Georg Fuchs, *Sturm und
Drang in München um die Jahrhundertwende*
(Munich: Georg D. W. Callwey, 1936), pp. 41–42,
relates an incident that indicates that at some
early point Luitpold had also come to support the
secessionists. Indeed, the Secession was so confi-
dent of the cabinet's support that it broke off
negotiations with Dresden. See Ludwig Dill's
letter, probably of early October, to Dresden's
architectural advisor Richter, as cited in
Hummel, "Die Anfänge der Münchener Seces-
sion," p. 59; and Richter to Dill, 12 October 1892,
as cited in *AZ*, No. 307, Abendblatt, 4 November
1892, p. 1. See also the exchange of acerbic letters
between the Secession and Müller, published in
AZ, No. 332, Morgenblatt, 29 November 1892,
p. 3, and *AZ*, No. 333, Abendblatt, 30 November
1892, p. 1.

34. *Kunst für Alle*, 8 (October 1892 – Septem-
ber 1893), p. 44.

35. The Genossenschaft discussed and voted on
the matter at a special general meeting on 19
October 1892, the results of which were reported
in various Munich newspapers and journals. See,
for example, *AZ*, No. 292, Morgenblatt, 20 Octo-
ber 1892, p. 3; and *Anzeiger der Münchener
Künstlergenossenschaft*, No. 26, 26 October 1892,
pp. 1–2. The *Anzeiger*, No. 27, 2 November 1892,
pp. 3–4, reported that the Secession considered
the same issues in its meeting of the 27 October
1892; however, the "Protokolle," SAM, Secession
1541, contains no record of this meeting.

36. On 19 November 1892 Müller notified the
two asssociations of his compromise offer, which

was cited in *Kunst für Alle*, 8 (October 1892 –September 1893), pp. 123–24; and *Anzeiger der Münchener Künstlergenossenschaft*, No. 30, 23 November 1892, pp. 1–2.

37. In late October the Genossenschaft had 863 regular members, as compared to the Secession's 107. *Anzeiger der Münchener Künstlergenossenschaft*, No. 26, 26 October 1892, p. 2.

38. That this meeting lasted over three hours—a fact noted in the brief "Protokolle," 26 November 1892, SAM, Secession 1541—is some indication that Müller's compromise proposal for a state exhibition was in fact fair enough to present the secessionists with a difficult choice. Since the Secession refused to participate in an exhibition organized by the state, the royal cabinet then notified the Genossenschaft that it could use the Glaspalast in 1893 for its salon. In an obvious reference to the secessionists, however, the ministers stressed the importance of accommodating at the exhibition artists who were not Genossenschaft members. Letter from Müller and Feilitzsch to the Genossenschaft, 4 December 1892, BayHStA, MK 14341.

39. The incident is related in Möckl, *Die Prinzregentenzeit*, p. 372; and in Hummel, "Die Anfänge der Münchener Secession," pp. 61–62. BayHStA, MA 78532 contains correspondence from February and March of 1893 about the Secession's possible emigration to the imperial capital. Significantly, the letters exchanged about this matter between the Bavarian ministries in Munich and the Bavarian ambassador in Berlin, Hugo Lerchenfeld-Köfering, which are preserved in this file, reveal that no one in the Bavarian state government suspected Eulenburg of duplicity. To the contrary, everyone involved believed that Eulenburg actually acted in the best interests of Bavaria by trying to *prevent* the Munich Secession from exhibiting in Berlin. For his part, Lerchenfeld-Köfering, at the instructions of his superiors in Munich, did everything in his power to stop the exhibition.

40. See the exhibition catalogue *Grosse Berliner Kunst-Ausstellung 1893*, 14 May – 17 September 1893, Landes-Ausstellungsgebäude am Lehrter Bahnhof. The secessionists were given the largest gallery in the exhibition hall and four adjacent side rooms. It was again Dill, Piglhein, and Paulus who made the arrangements with Berlin. See especially the undated letter from Ludwig Dill to Adolf Paulus, Paulus Family Archive, Erlangen, which discusses the Berlin exhibition.

41. "Protokolle," 3 March 1893, SAM, Secession 1541. Though I have not been able to trace the negotiations between Brandl and the Secession, Ludwig Dill noted in his memoirs, Archiv für Bildende Kunst am Germanischen Nationalmuseum, Nürnberg, that the publication of the

letters in November between the Secession and the Dresden committee on the one hand, and between the Secession and Müller on the other, won the association many supporters in the Munich community who believed that the cultural ministry had treated the Secession badly. No doubt Brandl was among them.

42. *AZ*, No. 88, Zweites Morgenblatt, 29 March 1893, p. 1, printed an announcement submitted by the Secession stating that the contracts had recently been signed. The delay during the month of March was apparently because Brandl left Munich briefly for health reasons.

43. Henry Rawle Wadleigh, *Munich: History, Monuments and Art* (New York: Frederick A. Stokes, 1910), p. 1899. It is noteworthy that building codes prohibited structures on the Prinzregentenstrasse from exceeding three stories in height, so that the quality of air and light on the boulevard would not be negatively affected. On the street and its significance for Munich, see *MNN*, No. 359, Vorabendblatt, 7 August 1889, p. 3; *MNN*, No. 373, Einzige-Tages-Ausgabe, 15 August 1889, p. 3; and, more recently, *Denkmäler in Bayern. Landeshauptstadt München*, ed. Michael Petzet (Munich: R. Oldenbourg, 1985), pp. 138–39.

44. Karl Baedeker, *Southern Germany (Wurtemberg and Bavaria): Handbook for Travellers*, 11th rev. ed. (Leipzig: Baedeker, 1910), p. 231.

45. The request for preliminary design plans was printed in *MNN*, No. 309, Einzige-Tages-Ausgabe, 10 July 1892, p. 4. Pfann's designs were unanimously approved by the municipal building commission by 2 April 1893, and by 20 April 1893 the Secession had been given the go-ahead from all quarters. The groundbreaking took place on 10 May 1893. *MNN*, No. 152, 2 April 1893, p. 3, and as cited in Hummel, "Die Anfänge der Münchener Secession," pp. 70–71.

46. In a letter to the Secession, 8 April 1893, SAM, Kulturamt 119, the Secession's technical advisors, Heilmann and Littmann, estimated the cost of construction of the building at ca. 120,000 DM. Ludwig Dill, in an undated letter to Bruno Piglhein, Paulus Family Archive, Erlangen, indicated that the necessary funds for the building were borrowed from local banks. These were probably the Bayerische Hypotheken- und Wechselbank München and the Bayerische Vereinsbank München, since the Secession's financial statement from 31 December 1894, SAM, Kulturamt 119, lists these particular lending institutions as creditors. That the loans were to be repaid in five annual installments of 25,000 DM each, amounting to the total of the 120,000 DM loan plus 5,000 DM in interest, is evident from another financial statement the Secession submitted to the Magistrat with a request for municipal support, 27 March 1893, SAM, Kulturamt 119. Dill, in his

memoirs, Archiv für Bildende Kunst am Germanischen Nationalmuseum, Nürnberg, noted that the construction of the gallery "was made financially possible by the generous help of our friends Knorr and Hirth!" It is not clear, however, how much of the loan was underwritten by Knorr and Hirth, though it was undoubtedly a great portion, if not all, of it.

47. Max Liebermann to Jan Veth, 1893, Rijksprentenkabinett, Rijksmuseum, Amsterdam, as cited in John Sillevis, "The Years of Fame (1885–1910)," *The Hague School: Dutch Masters of the Nineteenth Century*, ed. Ronald de Leeuw, John Sillevis, and Charles Dumas (London: Weidenfeld and Nicolson, 1983), p. 93. In an earlier letter to Veth, Liebermann expressed both his doubts about and his hopes for the new society: "Perhaps you have read that we Germans are going to break away from the older generation, now at this very moment. Piglhein of Munich is in Berlin to set up a federation of all the young, progressive elements among the German artists. Let us hope it will succeed, but fundamentally I believe that only talent can herald a new era in art. It has nothing to do with societies. However, struggle is obviously preferable to stagnation." Liebermann to Veth, 18 January 1893, as cited in Sillevis, "The Years of Fame," p. 93.

48. Dill, realizing that the vacationing Paulus would be reprimanded for this, wrote the business manager apologizing for what he termed this deplorable "oversight." When, on his return to Munich, Paulus was indeed immediately called to an audience with Luitpold, he could produce Dill's letter confirming that he had had nothing to do with the affair. As Dill then wrote with decided glee, "Paulus was absolved, and the goal achieved!!" The incident is related in Dill's memoirs, Archiv für Bildende Kunst am Germanischen Nationalmuseum, Nürnberg.

49. By 1892 the *Neueste Nachrichten* had reached a daily circulation of 80,000. Möckl, *Die Prinzregentenzeit*, p. 372. The executive committee and the *Neueste Nachrichten* also collaborated in publicizing the participation of well-known artists, often to their pronounced displeasure. The English artist Hubert von Herkomer, for example, was extremely irritated when the *Neueste Nachrichten* presented his decision to participate in the Secession exhibition as evidence of that association's artistic superiority to the Genossenschaft. This native Bavarian, who had become something of a celebrity in southern Germany as the "local boy made good" after his emigration to England, subsequently protested to Luitpold that he had agreed to participate in the Secession show only because Paulus was a friend "that always behaved well towards" him and not because he wished his name "to be used for or against any side." Hubert von Herkomer to Luitpold, 9 July

1893, BayHStA, Geheimes Hausarchiv, Abt. III, Nachlass Prinzregent Luitpold Nr. 272.

50. *MNN*, No. 193, Morgenblatt, 27 April 1893, p. 2.

51. Petition from the Secession to the Magistrat, 27 March 1893, SAM, Kulturamt 119. In this petition Dill requested that the Secession be granted the 50,000 DM that six months earlier, in a council declaration of 30 September 1892, SAM, Kulturamt 119, the municipality had allocated in the event that the 1893 exhibition were to be organized by the state. The Magistrat established a twenty-one-member committee to explore the Secession's renewed petition. Documents of 18 and 20 April 1893, SAM, Kulturamt 119.

52. The council's declaration of 26 April 1893, SAM, Kulturamt 119, gave the Secession the choice of either a one-time subsidy of 10,000 DM or a subsidy of 20,000 DM to be distributed over a period of five years. *MNN*, No. 238, Vorabendblatt, 26 May 1893, p. 4; and *MNN*, No. 241, Morgenblatt, 27 May 1893, p. 3, announced that the Secession had chosen the latter offer and explained the other terms of the grant.

53. The picture in question was Franz von Stuck's *Sin*, which was purchased for 4,000 DM, shortly after the Secession exhibition opened, by E. J. Haniel, a landowner in Haimshausen near Dachau who had earlier donated 40,000 DM to the state government for the explicit purpose of acquiring works of art. The day after he bought the painting, Haniel rather surprisingly offered it to the state for purchase, and Müller immediately recommended that the Prince Regent approve the use of Haniel's art fund for it. "It is highly desirable," he wrote in his note to Luitpold on 27 July 1893, "that this picture, which is characteristic of this highly talented artist who is not yet represented in the Neue Pinakothek, be incorporated into the state's painting collection." Luitpold approved the request, and the purchase was made. Both the peculiar circumstances and the unusual speed of the transaction suggest that Müller probably enlisted Haniel as a middleman so that the government could obtain the work but avoid the appearance of sanctioning the secessionist enterprise. On Haniel's art fund and the Stuck purchase, see BayHStA, MK 40863. Heinrich Voss, *Franz von Stuck 1863–1928. Werkkatalog der Gemälde mit einer Einführung in seinen Symbolismus*, Materialien zur Kunst des 19. Jahrhunderts, No. 1 (Munich: Prestel-Verlag, 1973), p. 268, states incorrectly that Haniel donated the painting to the state collection at the end of 1895.

54. Shortly before the opening of the Secession exhibition, Luitpold's general adjutant, Baron von Branca, wrote Paulus asking him to tell one of the artists involved in coordinating the participation of the Dutch, J.H.L. de Haas, that he should under no circumstances speak to Luitpold about

the new exhibition society, as it would only upset the Regent. Baron von Branca to Paulus, 4 July 1893, Paulus Family Archive, Erlangen. A copy of this letter is in SAM, Secession 356.

55. A member of Luitpold's staff with the initials "E.H." wrote Piglhein on behalf of the Prince Regent declining the Secession's invitation to inaugurate its show, explaining that at that time Luitpold would "probably" be out of town. Copy of a letter from E.H. to Piglhein, 1 July 1893, BayHStA, Geheimes Hausarchiv, Abt. IV, Luitpold 20.

56. Branca's letter to Paulus testifies that it was Luitpold's custom to attend the Genossenschaft exhibitions with Paulus before they opened, and Branca conveyed the Regent's wish that Paulus make himself available to do the same with the first Secession salon. *MNN*, No. 317, Vorabendblatt, 14 July 1893, p. 4, reported that the Prince Regent had purchased from the exhibition Otto Eckmann's *Winterabend* (*Winter Evening*). This painting and Heinz Heim's *Der Kugelspieler* (*The Marble-Player*), J. Leempoel's *Junge Sphinx* (*Young Sphinx*), and Carl von Stetten's *Apfelblüte* (*Apple Blossoms*) were also cited as having been purchased by the Prince Regent from the first Secession salon in Erwin Pixis, *Verzeichnis der von Weiland Seiner Königlichen Hoheit dem Prinzregenten Luitpold von Bayern aus privaten Mitteln erworbenen Werken der bildenden Kunst* (Munich: n.p., 1915). Presumably all were bought on Paulus' advice.

57. On the state's decision to acquire works from the Secession exhibitions and to give the Secession the Kunstausstellungsgebäude, see Maria Makela, "The Founding and Early Years of the Munich Secession," Diss. Stanford University 1986, pp. 167 73.

58. August Endell to Kurt Breysig, 18 July 1893, Berlin, Staatsbibliothek Preussischer Kulturbesitz, Handschriftenabteilung, Nachlass Breysig, 5. For this citation I am grateful to Tilmann Buddensieg, who first published Endell's valuable correspondence with Breysig in *Festschrift für Eduard Trier zum 60. Geburtstag*, ed. Justus Müller Hofstede and Werner Spies (Berlin: Gebr. Mann, 1981). A somewhat shortened and translated version of this suggestive article is "The Early Years of August Endell: Letters to Kurt Breysig from Munich," *Art Journal*, 43 (1983), pp. 41–49.

59. The newspapers *Allgemeine Zeitung*, *Das Bayerische Vaterland*, *General-Anzeiger*, *Münchener Neueste Nachrichten*, and *Über Land und Meer: Deutsche Illustrirte Zeitung* all published lengthy reviews of the exhibition, as did the journals *Die Gesellschaft*, *Kunst für Alle*, *Kunstchronik*, and *Zeitschrift für Bildende Kunst*. It is not my intention here to outline in detail the various reactions to the Secession's first Munich show,

though I do cite some critics when particularly appropriate.

60. See especially Hans Peters, "Ausstellungsgebäude der Sezessionisten in München," *Über Land und Meer: Deutsche Illustrirte Zeitung*, 70 (1893), p. 788; and the notices in *AZ*, No. 189, Morgenblatt, 10 July 1893, p. 1; *AZ*, No. 195, Morgenblatt, 16 July 1893, pp. 1–2; *AZ*, No. 242, Morgenblatt, 1 September 1893, pp. 1–2; and *General-Anzeiger*, No. 70, 18 July 1893, p. 2. The photograph of the interior of a Secession exhibition, published by Renate Heise in the exhibition catalogue Munich, Münchner Stadtmuseum, *Die Münchener Secession und ihre Galerie*, 10 July – 14 September 1975, p. 25, dates from between 1911 and 1914. Letter from Renate Heise to the author, 28 December 1985.

61. Peters, "Ausstellungsgebäude," p. 788.

62. Genossenschaft annual report, 1893; and *Offizieller Katalog der internationalen Kunst-Ausstellung des Vereins bildender Künstler Münchens "Secession" 1893*, 6th ed. (Munich: Bruckmann, 1893).

63. Alfred Freihofer, "Die erste internationale Kunstausstellung der Secession in München," *AZ*, No. 242, Morgenblatt, 1 September 1893, p. 1.

64. The sixth edition of the catalogue lists Jacob Maris as exhibiting *Landschaft beim Haag* (*Landscape near the Hague*: Cat. No. 359), *Die Brücke* (*The Bridge*: No. 360), and *Dordrecht, Winterabend* (*Dordrecht, Winter Evening*: No. 361). Willem Maris exhibited *Melkzeit* (*Milking Time*: No. 362) and *Auf der Wiese* (*In the Meadow*: No. 363).

65. The catalogue cites Trübner as exhibiting three pictures, one of which is simply listed as *Landschaft, Seeon* (*Landscape, Seeon: No. 583*). Fritz von Ostini, however, in his review of the exhibition in *MNN*, No. 497, Einzige-Tages-Ausgabe, 29 October 1893, pp. 1 2, favorably notes two Seeon landscapes by Trübner, which he unfortunately does not describe. Trübner painted a total of four landscapes near Seeon during 1891 and 1892, all of them similar in style and sentiment to the one I have chosen to illustrate. Eilif Petersson's picture is listed in the catalogue as *Meine Mutter* (*My Mother*: No. 427), and George Clausen's as *Die Mäher* (*The Reapers*: No. 86), both of which were probably the pictures I reproduce.

66. For reasons that are unclear, the picture was not listed in the catalogue, though critics discussed it at length in their exhibition reviews. It was commissioned early in 1890 by Alfred Lichtwark, director of the Hamburger Kunsthalle, as one of the "Sammlung von Bildern aus Hamburg" which he initiated in 1889.

67. Max Georg Zimmerman, in his article "Kritische Gänge," *Kunst für Alle*, 8 (October 1892 –September 1893), p. 376, complained that

anyone who knew Petersen and recognized in him the aristocrat, patrician, statesman, and man of the world that he was "would turn away insulted from this portrait . . . which depicts him as a feeble old man." Writing for the *General-Anzeiger*, No. 186, 5 August 1893, p. 3, Martin Feddersen noted that Petersen looked like an old supernumerary who had only been put in a mayor's costume to perform some unimportant role in a play. Significantly, Petersen, who died in the autumn following the completion of this picture in summer 1891, and his family were appalled by Liebermann's interpretation and prevented the public presentation of the picture to the Kunsthalle until 1902.

68. *MNN*, No. 451, Vorabendblatt, 3 October 1893, p. 4. Lenbach's remarks were delivered shortly before the Secession exhibition closed, in a convention on painting techniques, some of the proceedings of which were published in the *Neueste Nachrichten*.

69. The Secession catalogue listed two paintings exhibited by Cottet: *Der alte Kahn (Dämmerung) (The Old Skiff [Twilight]*: No. 95c) and *In der Brandung (Finterre) (In the Surf [Shoreline]*: No. 95d). Although I have not been able to locate either of these, Cottet did a number of port scenes at twilight around this time, all of which are painted in the somber, semi-realistic style of *Evening Light: The Port of Camaret*. Despite close contact with Gauguin and the Nabis, the artist seemed to prefer this style in portraying the most tragic moods of Brittany.

70. The painting Kroyer actually exhibited was listed and illustrated in the catalogue as *Porträt meiner Frau (Portrait of My Wife*: No. 308). The scene, acclaimed even by those critics hostile to the Secession exhibition, was a rear view of his wife standing on the beach, with a dog sitting next to her. Though *Summer Evening on the South Beach at Skagen* focuses more on the landscape than on the figures, it is similar to the portrait of Kroyer's wife in its generalized flowing forms, its pervasive blue tonality, and its introspective sentiment.

71. This watercolor, cited in the Secession catalogue as *Ich würde es Dir gegeben haben (I would have given it to you)*, was exhibited that year at the Société Nationale des Beaux Arts under the title *Je te l'aurais donné*. Another, slightly different version was included in the published edition of Zola's *Le Rêve*, also with the title *Je te l'aurais donné*. On Schwabe's illustrations for this novel, see Marla Hand, "The Symbolist Work of Carlos Schwabe," Diss. University of Chicago 1984, I, pp. 72–94. I am grateful to Marla Hand for her assistance in establishing which of these illustrations was exhibited with the Secession.

72. See the exhibition catalogue London, Hayward Gallery, *Dreams of a Summer Night. Scan-*

dinavian Painting at the Turn of the Century, 10 July – 5 October 1986, pp. 200–203, for a discussion of these watercolors and their place within Munthe's art.

73. P. Wilson Steer, *Knucklebones*, ca. 1888–89, oil on canvas, 61 × 76.2 cm., Ipswich, Ipswich Museum; Fernand Khnopff, *I Lock My Door upon Myself*, 1891, oil on canvas, 72 × 140 cm., Munich, Staatliche Gemäldesammlungen; Henry van de Velde, *Woman at the Window*, 1889, oil on canvas, 114 × 128 cm., Antwerp, Koninklijk Museum voor Schone Kunsten; Jan Toorop, *The New Generation*, 1892, oil on canvas, 107.8 × 123.2 cm., Rotterdam, Museum Boymans-van Beuningen.

74. Painters aged 14–18 constituted 1 percent and 0 percent of the exhibitors at the Genossenschaft and Secession salons respectively; 19–23, 2 and 1 percent; 24–28, 10 and 12 percent; 29–33, 18 and 25 percent; 34–38, 18 and 23 percent; 39–43, 15 and 20 percent; 44–48, 12 and 10 percent; 49–53, 10 and 4 percent; 54–58, 6 and 3 percent; 59–63, 2 and 0 percent; 64–68, 4 and 0 percent; 69–73, 1 and 1 percent; 74–78, 1 and 0 percent. In sum, 13 percent of the painters at both exhibitions were aged 28 and under; 51 percent of the painters at the Genossenschaft salon were between the ages of 29 and 43, whereas 68 percent of the painters at the Secession salon were in that age range; and 36 percent of the painters at the Genossenschaft salon were between the ages of 44 and 74, while only 19 percent of those at the Secession salon were in this age group. The mean age of painters exhibiting with the Genossenschaft was forty-one, as against thirty-eight for the Secession. These figures are based on the ages listed in Thieme-Becker for painters cited in the edition of the Genossenschaft catalogue printed on 12 August, and in the 6th edition of the Secession catalogue.

75. Alfred Freihofer, "Die erste internationale Kunstausstellung der Secession in München," *AZ*, No. 299, Morgenblatt, 28 October 1893, p. 2.

76. Pecht even believed that narrative painting was peculiarly German, and that to neglect it was to neglect the rich heritage that distinguished German art from that of other nations. In praising a Defregger painting exhibited that year in the Glaspalast, for example, he obliquely criticized the secessionists in commenting that "one finds such intimately observed moments more often in German art than in the art of any other nation . . . and it would be the greatest stupidity to give up this positive characteristic, which is so intimately bound to the now-despised anecdote, for the mere observation of light and air on figures." Friedrich Pecht, "Die Jahresausstellung 1893 der Künstlergenossenschaft zu München," *Kunst für Alle*, 8 (October 1892 – September 1893), p. 323.

77. Friedrich Pecht, "Die Münchener Jahres-ausstellung von 1893," *AZ*, No. 213, Morgenblatt, 3 August 1893, p. 2.

78. On the new style of politicians in the 1890s, see particularly Carl Schorske, "Politics in a New Key: An Austrian Trio," chapter 3 in *Fin-de-Siècle Vienna: Politics and Culture* (New York: Vintage, 1981), pp. 116–80; and Stern, *The Politics of Cultural Despair*, passim.

79. Cornelius Gurlitt, *Die deutsche Kunst des neunzehnten Jahrhunderts*, 3d ed. (Berlin: 1907), p. 470; as cited in Stern, *The Politics of Cultural Despair*, p. 156. Artists were probably alerted to *Rembrandt as Educator* by German art journals, many of which reviewed the book extensively. See, for example, Friedrich Pecht's glowing report in the Munich journal *Kunst für Alle*, which noted that the book, already in its third printing, was "so correct in its ideas that it should be read in its entirety." Friedrich Pecht, "Rembrandt als Erzieher," *Kunst für Alle*, 5 (October 1889 – September 1890), pp. 193–97.

80. According to *AZ*, No. 301, Abendblatt, 30 October 1893, p. 3, around 100,000 entry tickets of varying sorts were sold to the Genossenschaft exhibition, while roughly 60,000 tickets were sold to the Secession salon. The Genossenschaft annual report of 1893 recorded sales of 288 works, or about 11 percent of the total number exhibited, in the amount of 388,329 DM, at an average price of 1,348 DM per object. By contrast, 146 works, or about 16 percent of the total number exhibited, were purchased from the Secession show for 135,902 DM, at an average price of 931 DM per work. Drey, *Die wirtschaftlichen Grund-lagen der Malkunst*, p. 313. Drey maintains that only 876 works were exhibited, though the edition of the catalogue I have used lists about 900 objects.

81. Carl von Lützow, "Neue Bahnen in der Kunst," *Zeitschrift für bildende Kunst*, N.F. 5 (1893–94), p. 2.

Chapter 4

1. The principal sources for biographical infor-mation on Liebermann are Erich Hancke, *Max Liebermann. Sein Leben und seine Werke*, 2d ed. (Berlin: B. Cassirer, 1923); and Hans Ostwald, *Das Liebermann Buch* (Berlin: Paul Franke Verlag, 1930). The artist's life and work are also sensitively treated in the essays in the exhibition catalogue Berlin, Nationalgalerie Berlin, *Max Liebermann in seiner Zeit*, 6 September – 4 November 1979; of these I find Matthias Eberle's "Max Liebermann zwischen Tradition und Oppo-sition," pp. 11–41, particularly suggestive.

2. Quoted in Hancke, *Max Liebermann*, p. 20.

3. Karl Scheffler, *Die fetten und die mageren Jahre* (Leipzig and Munich: P. List, 1946), p. 70.

4. Liebermann first developed a taste for Impressionism in the mid–1880s, when he became acquainted with it through the extensive collec-tion of his friends and neighbors Carl and Felicie Bernstein. His first acquisition, however, was not made until 1892, when he traded a portrait that he had painted of Carl Bernstein for a Manet still life in the Bernstein collection. On Liebermann's Impressionist collection, which included seven-teen works by Manet, five by Degas, three by Monet, and one each by Pissarro and Renoir, see Peter Krieger, "Max Liebermanns Impression-isten-Sammlung und ihre Bedeutung für sein Werk," in *Max Liebermann in seiner Zeit*, pp. 60–71.

5. On the startling popularity and reception of the book, see Stern, *The Politics of Cultural Despair*, pp. 153–80 (and Chapter Two above). The connection between Langbehn and the shift in Liebermann's work was first suggested by Mat-thias Eberle, "Max Liebermann zwischen Tradi-tion und Opposition," pp. 36–37.

6. Interview with a French reporter in *B.Z. am Mittag*, 12 June 1919; as cited in Peter Paret, " 'The Enemy Within'—Max Liebermann as Presi-dent of the Prussian Academy of Arts," Leo Baeck Memorial Lecture 28, Leo Baeck Institute, New York, 1984, p. 8.

7. The two principal studies of Uhde's life and work are Anne Mochon, "Fritz von Uhde and Plein-Air Painting in Munich, 1880–1900," Diss. Yale University 1973; and Bettina Brand, *Fritz von Uhde*.

8. Uhde's decision to leave the academy is typi-cally presented by his early biographers as a result of the constraining atmosphere in which the allegedly sensitive artist could not function. Though this was undoubtedly true up to a point, far more pertinent was Uhde's marked inability to persist in courses of action that did not bring him immediate success. Brand convincingly argues, for example, that during the 1890s Uhde, against his better judgment, changed both his subjects and his painting style in order to please the critics and win widespread acclaim. Though she attributes this lack of inner resolve to his comparatively late start as an artist, maintaining that at the age of thirty Uhde did not have a chance to "become" a painter but had to "be" one, his youthful impatience with the academy sug-gests instead that this irresolution was an innate personality trait.

9. Again, Uhde's refusal to accept the unani-mous judgment that he was not yet ready to enter a master painting class and should begin instead with a more elementary drawing and composition course must be seen in the context of his unwill-ingness to persevere in actions that did not bring him immediate success. His rejection of a solid academic training had unfortunate consequences

for his oeuvre. For nearly twenty years Uhde's painting was deficient in precisely those areas in which he would have received extensive training at the academy: composition and draftsmanship.

10. As is evident from his letters to Amélie Endres, his fiancée in Munich, Uhde was characteristically unwilling to act on his better judgment until he had achieved a measure of success with his "Salon" paintings. "I think that I choose such subjects so that I can make a name for myself," he wrote, and "one day, when we have a cozy little household, I can paint everything from nature there." Uhde to Endres, 28 February 1880 and 21 December 1879, as cited in Brand, *Fritz von Uhde*, pp. 25, 23.

11. Wolfgang Venzmer, to whom I am deeply indebted for sharing with me in January 1988 information on Hölzel and Neu-Dachau, has written the sole monograph on this important and still undervalued artist: *Adolf Hölzel, Leben und Werk* (Stuttgart: Deutsche Verlags-Anstalt, 1982). On the "Neu-Dachau" style that Hölzel and Dill together with Arthur Langhammer forged at the turn of the century, see the classic study by Arthur Roessler, *Neu-Dachau: Ludwig Dill, Adolf Hölzel, Arthur Langhammer*, Knackfuss Künstler Monographien, No. 78 (Bielefeld and Leipzig: Velhagen & Klasing, 1905); Wolfgang Venzmer, *Neu-Dachau, 1895-1905. Ludwig Dill, Adolf Hölzel, Arthur Langhammer in der Künstlerkolonie Dachau* (Dachau: Kreis- und Stadtsparkasse Dachau-Indersdorf, 1984); and Eva Dix, "Die Künstlerkolonie Dachau und die Münchner Secession," Thesis Ludwig-Maximilians-Universität zu München 1985. Peg Weiss, in *Kandinsky in Munich. The Formative Jugendstil Years* (Princeton: Princeton University Press, 1979), pp. 40–47, discusses Hölzel's possible influence on Kandinsky.

12. Brand, *Fritz von Uhde*, p. 124.

13. Ulrich von Brück briefly outlines the "inner mission" work of Saxony's Evangelical Church in the nineteenth century in "Gestaltwandel der sächsischen Diakonie," *Verantwortung. Untersuchung über Fragen aus Theologie und Geschichte. Zum sechzigsten Geburtstag von Landesbischof D. Gottfried Noth DD.*, ed. Evangelisch-Lutherisches Landeskirchenamt Sachsens (Berlin: Evangelische Verlagsanstalt, 1964), pp. 24–28.

14. On Uhde's relationship to Egidy, see Mochon, "Fritz von Uhde and Plein-Air Painting in Munich," p. 165. Egidy's organization is discussed in Richard Hamann and Jost Hermand, *Naturalismus*, Deutsche Kunst und Kultur von der Gründerzeit bis zum Expressionismus, No. 2 (Berlin: Akademie-Verlag, 1959), p. 241.

15. Letter from Vincent van Gogh to his brother Theo, 6 July 1885, Letter 416, *The Letters of Vincent van Gogh to His Brother 1872–1886*, intro. J. van Gogh-Bonger (London: Constable, and Boston: Houghton Mifflin, 1927), II, pp. 513–14. Van Gogh first expressed his reservations about the picture in the undated Letter 414, pp. 508–9.

16. The major source of information on Kalckreuth is a biography by the artist's son, Johannes Kalckreuth, *Wesen und Werk meines Vaters: Lebensbild des Malers Graf Leopold von Kalckreuth* (Hamburg: Hans Christians Verlag, n.d.). The book is rich in biographical and anecdotal detail, but comparatively scanty on the genesis of specific paintings.

17. Kalckreuth, *Wesen und Werk meines Vaters*, p. 14.

18. Ibid., p. 93.

19. On Stuck, see the classic monographs by Otto Julius Bierbaum, *Stuck*, 2d ed., Künstler-Monographien, No. 42 (Bielefeld and Leipzig: Velhagen & Klasing, 1901); and Franz Hermann Meissner, *Franz von Stuck. Ein modernes Künstlerbildnis*, Die Kunst unserer Zeit, No. 9 (Munich: Franz Hanfstaengl, n.d.). More recent publications include Voss, *Franz von Stuck 1863–1928*; and the essays in the catalogue issued by the Museum Villa Stuck, *Franz von Stuck 1863–1928* (Munich: Karl M. Lipp Verlag, 1984).

20. These and other early works by and influences on Stuck are sensitively discussed in Horst Ludwig, "Franz von Stuck und seine Wegbereiter in München," in Museum Villa Stuck, *Franz von Stuck 1863–1928*, pp. 140–57.

21. H. E. von Berlepsch, *Die erste Münchener Jahres-Ausstellung*, Die Kunst unserer Zeit (Munich: Hanfstaengl Kunstverlag, 1889), p. 9. Probably Berlepsch meant the New Testament Joseph, who as an adult would be chosen as Mary's husband on account of his innocence and chastity, and whose iconographical association with the lily was traditional; but he may also have meant the Old Testament Joseph, who as a young man rejected the advances of Potiphar's wife. Stuck was inclined to treat standard iconography in just this deliberately ambiguous way. Even though others identified the figure more traditionally as a young girl, a number of commentators noted the underlying eroticism of the image. See, for example, Bierbaum, *Stuck*, p. 31.

22. As noted by Voss, *Franz von Stuck*, p. 11. I cannot agree with Voss' Marxist interpretation of this fact, which posits that the economic conditions of the late nineteenth century created a sexually repressed populace that found an outlet in the production and consumption of explicitly erotic art such as Stuck's; Voss' argument does not account for the unusually high incidence of erotica in Munich art. See below.

23. Robin Lenman discusses this law thoroughly in "Art, Society, and the Law in Wil-

helmine Germany: The Lex Heinze," *Oxford German Studies*, 8 (1973–74), pp. 86–113.

24. On the conservative cultural policies of the Center Party and their effects on playwriting in Munich, see Jelavich, *Munich and Theatrical Modernism*; the discussion of Wedekind and Panizza, pp. 53–99, is particularly suggestive. Jürgen Kolbe, "Ein 'kulturhemmender Faktor': Zensur gegen Panizza, 'Simplizissimus,' Wedekind," in his *Heller Zauber. Thomas Mann in München 1894–1933* (Berlin: Siedler Verlag, 1987), pp. 135–65, also discusses literary censorship in Munich.

25. On this aspect of the German federal system, see Lenman, "Politics and Culture," pp. 97–98.

26. Although pictures were occasionally removed from exhibitions, or—like Max Liebermann's *Jesus in the Temple* (fig. 14)—rehung, such instances were both rare and controversial. Though the reasons for this are unclear, it probably had something to do with the unusually high status of artists in Munich, and with Prince Regent Luitpold, a passionate art collector who counted numerous painters and sculptors among his closest friends and probably defended their interests against clerics whenever possible.

27. See Michael S. Cullen, "Das Minenfeld des Geschmacks: Des Künstlers perfide Politikerfalle Stucks Bild 'Die Jagd nach dem Glück' im Reichstag Berlin 1899," in the Villa Stuck catalogue *Franz von Stuck 1863–1928*, pp. 182–98.

28. Jelavich, *Munich and Theatrical Modernism*, pp. 12–21, discusses the use of classical culture in Bavaria for both state control and public depoliticization.

29. Gustav Klimt, *Pallas Athena*, 1898, oil on canvas, 75 × 75 cm., Vienna, Historisches Museum der Stadt Wien. On this painting, see Fritz Novotny and Johannes Dobai, *Gustav Klimt*, trans. Karen Olga Philippson (London: Thames and Hudson, 1968), p. 307.

30. On Kandinsky and Stuck, see Weiss, *Kandinsky in Munich*, pp. 48–53.

31. R. Martin, *Jahrbuch des Vermögens und Einkommens der Millionäre in Bayern* (Berlin, 1914), as cited in Lenman, "A Community in Transition," p. 10.

32. On Riemerschmid, see especially Winfried Nerdinger, "Richard Riemerschmid und der Jugendstil," *Die Weltkunst*, 52 (1982), pp. 894–97; and the exhibition catalogue Munich, Münchner Stadtmuseum, *Richard Riemerschmid. Vom Jugendstil zum Werkbund. Werke und Dokumente*, 26 November 1982 – 27 February 1983, ed. Winfried Nerdinger.

33. On the various versions of the composition, see Munich, Münchner Stadtmuseum, *Richard Riemerschmid. Vom Jugendstil zum Werkbund*, pp. 89–90.

34. Ibid., p. 155.

35. Klaus Bergmann, *Agrarromantik und Grossstadtfeindschaft* (Meisenheim am Glan: Verlag Anton Hain, 1970), and Andrew Lees, "Debates about the Big City in Germany, 1890–1914," *Societas*, 5 (1975), pp. 31–47, discuss the pervasive anti-urbanism in Germany around 1900.

36. Lees, "Debates about the Big City in Germany," p. 32.

37. Lenman, "Art, Society, and the Law in Wilhelmine Germany: The Lex Heinze," p. 89.

38. *1875–1975. 100 Jahre Städtestatistik in München. Statistisches Handbuch der Landeshauptstadt München* (Munich: Amt für Statistik und Datenanalyse der Landeshauptstadt München, 1974), p. 131.

39. Steinborn, *Grundlagen und Grundzüge Münchner Kommunalpolitik in den Jahren der Weimarer Republik*, pp. 24–28.

40. Theodor Goering, *Dreissig Jahre München*, p. 88; and Steinborn, *Grundlagen und Grundzüge*, pp. 31–32.

41. In a condolence letter on Riemerschmid's death, Theodor Heuss, Naumann's biographer, discussed the artist's affiliation with Naumann. The letter, now in a private collection, is cited by Winfried Nerdinger in Munich, Münchner Stadtmuseum, *Richard Riemerschmid. Vom Jugendstil zum Werkbund*, p. 21. The standard source on Naumann, who has attracted a great deal of scholarly attention, still remains Theodor Heuss, *Friedrich Naumann, der Mann, das Werk, die Zeit*, 2d ed. (Stuttgart: R. Wunderlich, 1949). More recent studies include Ingrid Engel, *Gottesverständnis und sozialpolitisches Handeln; eine Untersuchung zur Friedrich Naumann*, Studien zur Theologie und Geistesgeschichte, No. 4 (Göttingen: Vandenhoeck & Ruprecht, 1972), and Peter Theiner, *Sozialer Liberalismus und deutsche Weltpolitik: Friedrich Naumann im Wilhelminischen Deutschland*, Schriften der Friedrich-Naumann Stiftung, Wissenschaftliche Reihe (Baden-Baden: Nomos Verlagsgesellschaft, 1983).

42. On Langbehn, see Stern, *The Politics of Cultural Despair*, pp. 97–180; and above, pp. 56 and 78, and Chapter Three, note 79.

43. George L. Mosse, *The Crisis of German Ideology. Intellectual Origins of the Third Reich* (New York: Grosset & Dunlap, 1964), pp. 111–12, 171–89, discusses Eden and Germany's Youth Movement.

44. On the Garden City Movement, see Bergmann, *Agrarromantik und Grossstadtfeindschaft*, pp. 135–63; and Kristiana Hartmann, *Deutsche Gartenstadtbewegung* (Munich: H. Moos, 1976).

45. From the lecture "Neue Möglichkeiten in der bildenden Kunst," delivered on 27 November 1901 in the Berliner Kunsthaus; reprinted in Her-

mann Obrist, *Neue Möglichkeiten in der bildenden Kunst. Aufsätze* (Leipzig: Eugen Diederichs, 1903), pp. 167–68.

46. Peg Weiss, in *Kandinsky in Munich*, pp. 24–25, was probably the first to call attention to the importance of this exhibition for the history of German Jugendstil, and Winfried Nerdinger, in his article "Richard Riemerschmid und der Jugendstil," discussed the show and the exhibited works in some detail. For contemporary reactions see Hans Eduard von Berlepsch, "Endlich ein Umschwung," *Deutsche Kunst und Dekoration*, 1 (October 1897 – March 1898), pp. 6–12; Paul Schultze-Naumburg, "Die Kleinkunst," *Kunst für Alle*, 12 (October 1896 – September 1897), pp. 378–79; and G. Keyssner, "The Munich International Art Exhibition," *Studio*, 11 (1897), p. 193.

47. Members of the executive committee of the Ausschuss für Kunst im Handwerk included Martin Dülfer, Theodor Fischer, Hermann Obrist, Richard Riemerschmid and Friedrich Wilhelm Rolfs. Some documents on the Ausschuss and its activities are in the Archiv für Bildende Kunst am Germanischen Nationalmuseum, Nürnberg, Nachlass Riemerschmid, B130 and B150.

48. On the Vereinigte Werkstätten, see Sonja Günther, *Interieurs um 1900. Bernhard Pankok, Bruno Paul und Richard Riemerschmid als Mitarbeiter der Vereinigten Werkstätten für Kunst im Handwerk* (Munich: Wilhelm Fink Verlag, 1971).

49. For contemporary reactions to the applied art section at this exhibition, see G.F. [Georg Fuchs], "Angewandte Kunst in der Secession zu München 1899," *Deutsche Kunst und Dekoration*, 5 (October 1899 – March 1900), pp. 1–23; G. Keyssner, "The Exhibition of the Munich 'Secession,' 1899," *Studio*, 17 (1899), p. 185; Karl Voll, "Die VII. internationale Kunstausstellung der Münchener Secession," *Kunst für Alle*, 14 (October 1898 – September 1899), p. 325. Henry van de Velde discussed his participation in the show in *Geschichte meines Lebens* (Munich: R. Piper & Co. Verlag, 1962), pp. 145–51, although he mistakenly cited the date of the exhibition as 1898.

50. In 1898, for example, the Genossenschaft devoted eight rooms in the Glaspalast to the decorative arts; but next to ensembles by Martin Dülfer, Theodor Fischer, Hans Eduard von Berlepsch, and Karl Hocheder, filled with objects by the Vereinigte Werkstätten and by foreign Jugendstil designers, were historicist rooms arranged by Emanuel Seidl and Friedrich von Thiersch in styles harking back to Antiquity and the German Renaissance.

51. Munch did exhibit in Munich at the joint exhibition of the Secession and the Genossenschaft in 1901, but in all probability it was not at the instigation of the Secession, which consistently bypassed the Norwegian artist during the 1890s, despite the fact that he was a logical candidate for the Secession salons. Indeed, in 1892 Munch was severely censured by the Verein Berliner Künstler, which invited him to mount an exhibition of his works but unceremoniously retracted the offer once the pictures were installed. By including some of these paintings in its first exhibition the Secession might have made a strong statement against the narrow-minded provincialism that (it maintained) destroyed organizations like the Verein Berliner Künstler and the Genossenschaft. Apparently, however, Munch's work was too acerbic for the Secession to take up his cause. Paret, *The Berlin Secession*, pp. 50–53, describes the Munch incident and its ramifications in detail.

52. Although Hodler participated in the joint exhibitions of the Secession and the Genossenschaft in 1897 and 1901, it was not until 1903, when his work was considerably less controversial, that he exhibited with the Secession.

53. In 1895 Sisley and Pissarro each exhibited one landscape at the Secession salon. Not until 1899 did one of the French Impressionists again exhibit with the Secession, and then Monet showed two landscapes and Degas, two paintings of dancers. In 1900 Sisley exhibited one landscape, and Monet showed two, one of which was a haystack painting.

54. Schlittgen, *Erinnerungen*, pp. 280–82.

55. Others seceding with Schlittgen were Peter Behrens, Lovis Corinth, Otto Eckmann, Julius Exter, Thomas Theodor Heine, Hans Olde, Max Slevogt, Carl Strathmann, and Wilhelm Trübner. Documentation about the formation of the Freie Vereinigung is scanty at best, but Lovis Corinth's letters to Hans Olde and to his close friend Schlittgen, in *Lovis Corinth. Eine Dokumentation* (Tübingen: Verlag Ernst Wasmuth, 1979), pp. 41–43, and a draft of a letter to a certain "H.E.," reproduced ibid., p. 44, suggest that the main point of contention with the Secession was the jury and executive committee, which Corinth and the others considered biased. The Freie Vereinigung intended to eliminate this problem by mounting jury-free exhibitions to which particular artists would be invited.

56. Kandinsky made these comments about the Secession exhibitions of the 1890s in a largely negative review of the 1902 summer exhibitions in Munich for Sergei Diaghilev's journal *Mir Iskusstva* (*World of Art*). The review is translated and reprinted as "Correspondence from Munich," in *Kandinsky. Complete Writings on Art*, ed. Kenneth C. Lindsay and Peter Vergo (Boston: G. K. Hall, 1982), I, pp. 45–51.

57. Paul Klee to his parents, 20 June 1899 and 26 October 1899, in *Paul Klee: Briefe an die Familie 1893–1940*, ed. Felix Klee (Cologne: DuMont Buchverlag, 1979), I, pp. 56, 60. Other

letters reveal that Klee went to the Secession exhibitions whenever possible, even after he had left Munich to return to Bern in 1901, and that he solicited information about the shows when he could not attend. See, for example, Klee to his fiancée Lily Stumpf, 30 July 1902, 25 July 1904, and 10 May 1905, *Briefe an die Familie*, I, pp. 257, 437, and 503. See also the numerous entries about the Secession in *The Diaries of Paul Klee 1898–1918*, ed. and intro. Felix Klee (Berkeley: University of California Press, 1968).

58. By his own account Kandinsky sent work to the Secession three times, and was rejected on each occasion. Will Grohmann, *Wassily Kandinsky. Life and Work*, trans. Norbert Guterman (New York: Harry N. Abrams, 1958), p. 42. Paul Klee wrote of his thwarted attempts to exhibit with the Secession in his diary, entry nos. 786 (1907), 787 (1907), and 818 (1908), in *The Diaries of Paul Klee*, pp. 212, 225. The young artist's mounting hopes and excitement about the etchings that were in fact accepted by the Secession in 1906 are charmingly conveyed in numerous letters to Lily Stumpf during April, May, and June 1906, and reprinted in *Briefe an die Familie*, I.

59. Peg Weiss, in *Kandinsky in Munich*, pp. 66–67, was the first to point out the connection between Gallen-Kallela's exhibition at the Secession and its probable impact on Kandinsky. On Gallen-Kallela's *The Defense of the Sampo*, see London, Hayward Gallery, *Dreams of a Summer Night*, 10 July – 5 October, pp. 110–11. On the exhibition as a whole, see John E. Bowlt, *The Silver Age: Russian Art of the Early Twentieth Century and the "World of Art" Group* (Newtonville, Mass.: Oriental Research Partners, 1979), pp. 89–93; and the review by G. Keyssner, "Russische Bilder," *Kunst für Alle*, 14 (October 1898 – September 1899), pp. 70–73. Bowlt, passim, and Charles Spenser, Philip Dyer, and Martin Battersby, *The World of Serge Diaghilev* (New York: Penguin Books, 1979), pp. 15–40, discuss Diaghilev's exhibition and publishing activities.

60. The importance of Munich and its arts and crafts movement for the evolution of Kandinsky's art and theory was first and most conclusively demonstrated in Weiss, *Kandinsky in Munich*, passim.

61. Klaus Lankheit provides a thorough history and analysis of the almanac in the reprint *The "Blaue Reiter" Almanac*, ed. and intro. Klaus Lankheit (New York: Viking, 1974), pp. 11–48.

62. Marcel Franciscono, "Paul Klee um die Jahrhundertwende," in the exhibition catalogue Munich, Städtische Galerie im Lenbachhaus, *Paul Klee. Das Frühwerk 1883–1922*, 12 December 1979 – 2 March 1980, pp. 34–59, analyzes Klee's multifaceted debt to Munich's artistic culture at the turn of the century, while Charles Werner Haxthausen's essay "Klees künstlerisches

Verhältnis zu Kandinsky während der Münchner Jahre," ibid., pp. 98–130, succinctly differentiates between Kandinsky's optimism and Klee's thoroughgoing pessimism, as reflected in his etchings of these years.

63. Cited in Paul Vogt, "The Blaue Reiter," *Expressionism. A German Intuition 1905–1920* (New York: Solomon R. Guggenheim Foundation, 1980), p. 197.

Chapter 5

1. Kandinsky to Münter, 12 June 1907, Städtische Galerie im Lenbachhaus, Munich, Gabriele Münter- und Johannes Eichner-Stiftung.

2. Kandinsky protested these rejections in a letter to the executive committee of the Secession, pointing out that each of the nine pictures had already been exhibited at either the Salon d'Automne, the Berlin Secession, or the Deutscher Künstlerbund. This proved to him that "in the Munich Secession not my works but my personality is juried." Kandinsky to the executive committee of the Munich Secession, 1 June 1906, Städtische Galerie Würzburg, Nachlass Habermann. I am grateful to Robin Lenman for bringing this letter to my attention, and to Ingrid Schmitt-Götzner of the Städtische Galerie for her tireless and ultimately successful efforts to facilitate my access to the Habermann estate.

3. For notices of this exhibition, for which I have not been able to locate a catalogue, see *Die Kunst*, 1 (1899–1900), pp. 188, 213.

4. *Offizieller Katalog der Ausstellung von Abgüssen nach Werken des Pisano, Quercia, Civitali, Verrocchio, Mino da Fiesole, Della Robbia und Anderer, und von Reproduktionen nach Werken des Rembrandt und Frans Hals, veranstaltet vom Verein bildender Künstler Münchens (e.V.) "Secession" 1900–01* (Munich: Verlagsanstalt F. Bruckmann, 1900). A total of 392 works were exhibited, of which 132 were casts and 259 were reproductions of paintings. See also Ph. M. Halm's review of the show, "Die Plastik des Quattrocento in der Ausstellung der Sezession," *Monatsberichte über Kunstwissenschaft und Kunsthandel*, 1 (1900–1901), pp. 145–46.

5. *Offizieller Katalog der Ausstellung von Meisterwerken der Renaissance aus Privatbesitz, veranstaltet vom Verein bildender Künstlers "Secession" (e.V.)*, 1st ed. (Munich: Verlagsanstalt F. Bruckmann, 1901). Because 1901 was a quadrennial year in which the Secession was required to exhibit together with the Genossenschaft in the Glaspalast, the Kunstaustellungsgebäude was free from June through October. The Renaissance exhibition—which comprised 776 works, including 158 paintings, 48 large-scale bronzes and many decorative art objects—was thus held there. Among the collec-

tions represented were those of Prince Regent Luitpold, Prince Arnulf, and the Grand Duke Ludwig von Hessen.

6. As in 1901, the Secession exhibited with the Genossenschaft in the Glaspalast in the summer of 1905, and the Kunstausstellungsgebäude was used to house the Lenbach retrospective.

7. Certainly the Secession could rise to the occasion, particularly with its spring exhibitions, which usually were more challenging than the summer or winter shows. In the spring of 1908, for example, the association exhibited works by Vuillard, Bonnard, Roussel, and Vallotton, and in the spring of 1909 it included thirteen pictures by Cézanne. Even the summer shows could hold some surprises. George Minne exhibited three sculptures at the 1906 summer salon, at which Paul Klee was also represented with ten etchings. But these were isolated instances, far more the exception than the rule at the post-1900 Secession exhibitions.

8. See Chapter Four, note 58 above.

9. Paul Klee to Hans Klee, 21 June 1901, in *Paul Klee: Briefe an die Familie*, I, p. 128.

10. Hans Rosenhagen, "Münchens Niedergang als Kunststadt II," *Der Tag*, No. 145, 14 April 1901, p. 1. On Rosenhagen, see also note 20 below.

11. Dill to Habermann, 7 June 1900, Städtische Galerie Würzburg, Nachlass Habermann.

12. See, for example, Dill's letter to Hugo von Habermann, 15 November 1903, Städtische Galerie Würzburg, Nachlass Habermann, in which he stressed the overwhelming importance both for the Secession and for Munich of initiating and supporting collaboration among artists in all fields.

13. On Obrist, see *Hermann Obrist. Wegbereiter der Moderne*, ed. Siegfried Wichmann (Munich: Stuck-Jugendstil Verein, 1968); Silvie Lampe-von Bennigsen, *Hermann Obrist. Erinnerungen* (Munich: Verlag Herbert Post Presse, 1970); and, more recently and in relation to Kandinsky, Weiss, *Kandinsky in Munich*, pp. 28–34.

14. On the Obrist-Debschitz school, see Wilhelm von Debschitz, "Eine Methode des Kunstunterrichts"; Hermann Obrist, "Die Lehr- und Versuch-Ateliers für angewandte und freie Kunst"; and the anonymous article "Die erste öffentliche Ausstellung der Lehr- und Versuch-Ateliers für angewandte und freie Kunst", all in *Dekorative Kunst*, 7 (1903–1904), pp. 209–27, 228–32, 232–37. For a more recent analysis of the school, see Helga Schmoll gen. Eisenwerth, "Die Münchner Debschitz-Schule," in *Kunstschul-Reform 1900–1933. Fünf Beispiele ihrer Verwirklichung*, ed. H. M. Wingler (Berlin: Gebr. Mann, 1977), pp. 68–82.

15. Obrist outlined the ensuing sequence of events in letters to Hugo von Habermann, 12 and 27 December 1899, and 30 May 1900, Städtische Galerie Würzburg, Nachlass Habermann.

16. See, for example, Uhde's letter to Hans Rosenhagen, 15 May 1901, BSBHSmlg, in which he unequivocally stated: "To be sure, we [at the Secession] have little taste and even less space for the modern applied arts."

17. In 1902 Uhde even defined Naturalism as the quintessential Germanic style: "Personally I would have hoped that painters had not so quickly abandoned efforts oriented toward an accurate study of nature. I have the impression that we became independent too soon. We should have done many more years of such thoroughly studied work, as in the days of Naturalism. It also seems to me as if, after this renunciation, an un-Germanic element has crept into painting. We could have such a magnificent German art if, instead of taking foreign models as our point of departure, we had continued to build on the tradition of Albrecht Dürer!" Fritz von Uhde in response to Eduard Engels, *Münchens "Niedergang als Kunststadt." Eine Rundfrage* (Munich: Verlagsanstalt F. Bruckmann, 1902), pp. 42–43.

18. "I do not think that the Vereinigte Werkstätten has accomplished such outstanding things," Stuck wrote in 1902. "In fact, I find most of their furniture ugly. Irrespective of the tastelessness and artificiality of the details, as a whole the furnishings have such a shabby, prosaic, and philistine effect! Try just once to hang in such a room a picture with a strong colorful effect, like a Böcklin: it just does not work, it kills the entire room, because only very delicate things go with such furniture, like lithographs, etchings, or maps. The only person I could possibly imagine living in such quarters would be a court clerk." Franz von Stuck in response to Engels, *Eine Rundfrage*, p. 39.

19. Hermann Obrist, "Die Antwort durch die That," *MNN*, No. 213, Morgenblatt, 7 May 1901, p. 2. See also the second half of this article in *MNN*, No. 214, Vorabendblatt, 8 May 1901, p. 3. Both essays were in response to Hans Rosenhagen's "Niedergang" articles, discussed below.

20. Hans Rosenhagen, "Münchens Niedergang als Kunststadt," *Der Tag*, No. 143, 13 April 1901, pp. 1–3, and No. 145, 14 April 1901, pp. 1–2. Rosenhagen was not only the Berlin art correspondent for several newspapers, including the *Tägliche Rundschau*, the *Münchener Neueste Nachrichten*, and the *Gazette des Beaux-Arts*; he also published the art journal *Atelier* and by 1900 had written a monograph on Max Liebermann. In the following two decades he wrote at least ten more major books, including studies on Wilhelm Trübner and Fritz von Uhde.

21. Apart from its impact on the Secession, the essays had an explosive effect in Munich. Most local newspapers and journals immediately pub-

lished rebuttals—some of which, it should be noted, the cultural ministry clipped and filed with Rosenhagen's original articles. The art publicist Eduard Engels circulated a questionnaire to artists, historians, critics, and collectors asking if Munich had indeed lost its cultural preeminence: the comments of thirty-three respondents were published in 1902, touching off the controversy once again. See Engels, *Eine Rundfrage*; and BayHStA, MK 14163.

22. Uhde to Rosenhagen, 15 May 1901, BSBHSmlg.

23. Kandinsky, "Correspondence from Munich," in *Kandinsky. Complete Writings on Art*, I, p. 46.

24. For Max Liebermann's response to the Munich Secession's expression of dissatisfaction, see his letters to Hugo von Habermann, 3 and 26 December 1901, and 26 February 1902, Städtische Galerie Würzburg, Nachlass Habermann.

25. In *The Berlin Secession*, Peter Paret outlines the kinds of battles that Liebermann and his colleagues fought with the emperor and his allies in the bureaucracy, whose treatment of the association he regards as symptomatic of some features of German public life before the First World War, including the reckless politicizing of what might have been nonpolitical issues, the unnecessary driving into opposition of groups that might otherwise have strengthened the status quo, and an intolerance that eventually damaged its own cause.

26. In his most important statement on the function of art in German society—his address celebrating the completion of the double row of monuments lining the Siegesallee—William II compared art to nature, which exists "according to eternal laws that the creator himself observes, and which can never be transgressed or broken without threatening the development of the universe. It is the same with art. Before the magnificent remnants of classical antiquity we are overcome with the same emotion; here, too, an eternal, unchanging law is dominant: the law of beauty and harmony, the law of aesthetics. This law was expressed by the ancients in such a surprising and overwhelming manner, with such perfection, that despite all our modern feelings and knowledge we are proud when a particularly fine achievement is praised with the words: 'That is nearly as good as the art of 1900 years ago.'" Speech of 18 December 1901, in *Die Reden Kaiser Wilhelms II*, ed. Johannes Penzler (Leipzig, 1907), III, p. 60; as translated in Paret, *The Berlin Secession*, p. 25. Notably, Liebermann cited this particular speech as one of the reasons why the Munich Secession should not exhibit with the state-supported Verein Berliner Künstler. "Perhaps the emperor's most recent speech about art," he wrote to his friend Hugo von Habermann, "has

shown your colleagues what they might expect from the official exhibition." Liebermann to Habermann, 26 December 1901.

27. Liebermann to Habermann, 26 December 1901.

28. Uhde to the editors of *Kunst für Alle*, 10 and 16 June 1897, Berlin, Staatsbibliothek Preussischer Kulturbesitz, Handschriftenabteilung, Dokumenten-Sammlung Darmstaedter 2n 1884, Fritz von Uhde. The article that so upset the artist began with a long comparison of Uhde and Liebermann: "More and more it is recognized that despite Uhde's refined talent, and the spiritual mood with which he permeated his works, Liebermann far surpasses him in temperament—and temperament is everything! In vigor, in nobility, in individuality, Liebermann was always superior to Uhde. It's just that we were blinded by Uhde's interesting choice of subjects; also, we were negatively influenced by the [technical] clumsiness that Liebermann displayed at the beginning, and not just at the beginning. But now we see more clearly how much more valuable Liebermann is than Uhde, as a character in art, as a natural talent [*Naturerscheinung*] in German painting. This is not said to offend Herr von Uhde; but it can no longer be suppressed, for it is only fair that we now explicitly grant the man—who so frequently has been accorded, almost with pity, the spot "beside" Uhde—the place that he really deserves. . . . He alone of the two deserves to be treated as one of the greats who have influenced the painterly culture." Hermann Helferich, "Studie über den Naturalismus und Max Liebermann," pp. 225–28.

29. Uhde to Rosenhagen, 25 July 1900, BSBHSmlg.

30. Alfred Lichtwark to the Kommission für die Verwaltung der Kunsthalle, 1 October 1904, as cited in Brand, *Fritz von Uhde*, p. 166.

31. Lichtwark to the Kommission für die Verwaltung der Kunsthalle, 1 October 1904.

32. Letter from Uhde and Benno Becker to the executive committee of the Berlin Secession, 27 December 1902, as cited in *MNN*, No. 25, Vorabendblatt, 17 January 1903, p. 2.

33. Max Liebermann, Ludwig von Hofmann, Walter Leistikow, and Max Slevogt to the Munich Secession, 29 December 1902, as cited in *MNN*, No. 25, Vorabendblatt, 17 January 1903, p. 2. For other reports on the controversy and on the spate of resignations it precipitated, see also *MNN*, No. 7, Einzige-Tages-Ausgabe, 6 January 1903, pp. 3–4; *MNN*, No. 37, Vorabendblatt, 24 January 1903, pp. 1, 3; *MNN*, No. 40, Einzige-Tages-Ausgabe, 26 January 1903, p. 3; *AZ*, No. 3, Abendblatt, 3 January 1903, p. 1; *AZ*, No. 5, Abendblatt, 5 January 1903, pp. 1–2; and *Kunst für Alle*, 18 (September 1902 – September 1903), p. 224.

34. In 1901 the United States invited Germany

to mount an exhibition of German art at the forthcoming St. Louis International Exposition, a celebration of the centennial of the Louisiana Purchase. Conflict over Germany's participation in this show erupted when Emperor William II learned that the art section was being organized by a government-appointed group of artists, museum directors, and art dealers that included many secessionists. He set in motion a complete reversal of government policy that ultimately took the power away from this representative committee and gave full responsibility for the art show in St. Louis to the conservative Allgemeine Deutsche Kunstgenossenschaft. With one exception the secessionist chapters of that organization then refused to participate in the exhibition, and they underscored their outrage at the emperor's unilateral action by resigning from the Kunstgenossenschaft and forming at the end of 1903 a new national organization, the Deutsche Künstlerbund (German Federation of Artists). Paret outlines these events, and their significance for German history, in *The Berlin Secession*, pp. 112–55. Ironically, it fell to the Munich Secession to host the Künstlerbund's first exhibition in 1904, which—because of the Bund's composition of and control by all the German and Austrian secessionist groups—included work that the Munich Secession itself would probably not have considered. The Vereinigte Werkstätten, for example, was granted six rooms, which were then designed as ensembles filled with furniture and objects by the group's members. *Offizieller Katalog der X. Ausstellung der Münchener Sezession: Der Deutsche Künstlerbund (in Verbindung mit einer Ausstellung erlesener Erzeugnisse der Kunst im Handwerk)*, 4th ed. (Munich: Verlagsanstalt F. Bruckmann, 1904).

35. In comparison to this growth rate of 60 percent, Berlin's art community—the only other in Germany even to approach the size of that in Munich—grew by only 27 percent during that same time period, from 1,159 to 1,475 resident painters and sculptors. The only other urban art community in Germany to grow faster than Munich's was that in Frankfurt, which expanded by 68 percent. But here the total number of resident painters and sculptors—142 in 1895, and 238 in 1907—was much lower. *Statistik des deutschen Reiches*, 107 (1895), 207 (1907).

36. In 1889, of the 1,075 exhibitors 430 (40 percent) were from Munich, 234 (22 percent) were from elsewhere in Germany, and 411 (38 percent) were non-German. Of the 311 works purchased at the exhibition for a total of 479,250 DM, 151 works by Munich artists were purchased for 278,252 DM (58 percent); 48 works by artists living elsewhere in Germany were purchased for 43,135 DM (9 percent); and 112 works by foreign artists were purchased for 157,863 DM (33 per-

cent). In 1903, of the 1,284 exhibitors 575 (45 percent) were from Munich, 442 (34 percent) were from elsewhere in Germany, and 267 (21 percent) were non-German. Of the 440 works purchased at the exhibition for a total of 396,770 DM, 55 works by Munich artists were purchased for 39,086 DM (10 percent); 270 works by other German artists were purchased for 191,730 DM (48 percent); and 115 works by foreign artists were purchased for 165,954 DM (42 percent). Sales figures from the other Genossenschaft exhibitions also indicate that sometime around the turn of the century art produced in Munich seems to have lost its cachet. For the above figures, see the Genossenschaft annual report, 1889, pp. 2–3; *Offizieller Katalog der Münchener Jahres-Ausstellung 1903 im kgl. Glaspalast*, 2d ed. (Munich: Verlag der Münchener Künstlergenossenschaft, 1903); and Drey, *Die wirtschaftlichen Grundlagen der Malkunst*, Table X, p. 312.

37. It was this incident that provoked the notorious "Swinemünde Telegram" affair, when Emperor William II sent Luitpold a wire in which he not only personally offered to give the Regent the necessary funds to cover the budgetary cut but also conveyed his "indignation" about the "despicable ingratitude" of the legislature. The telegram was the subject of considerable debate in almost all the German newspapers, with most unbiased and Bavarian dailies sharply censuring the emperor's meddling in Bavarian affairs. Ultimately, the incident led to the downfall of the staunchly liberal prime minister Crailsheim, who was replaced in spring 1903 by Clemens von Podewils, a conservative liberal who strove to reconcile the moderate factions of the liberal and Catholic parties. See Möckl, *Die Prinzregentenzeit*, pp. 520–28.

38. For a concise overview of the Bavarian state art budget, see Ludwig, *Kunst, Geld und Politik um 1900 in München*, pp. 13–18.

39. Goering, *Dreissig Jahre München*, p. 237. Other solicitous essays include Adolf Brougier, *Gedanken über die fernere Entwickelung Münchens als Kunst- und Industrie-Stadt* (Munich: n.p., 1905); and Paul Kutter, *Das materielle Elend der jungen münchener Maler* (Munich: Max Engl, 1912).

40. Brougier, *Gedanken*, pp. 34–37.

41. Carl Vinnen, *Ein Protest deutscher Künstler* (Jena: Eugen Diederichs, 1911), pp. 1, 2, 16, as translated by Paret, *The Berlin Secession*, pp. 183–84, 185. Prior to the publication of his "protest" Vinnen had written two articles on the alleged manipulation of the German art market, which he circulated among members of the German secessions and of the Künstlerbund. After receiving comments from his readers he combined and revised the articles into a manifesto with the Ciceronian title "Quousque tandem,"

which he published together with the names of his supporters and extracts from their letters under the general title *Ein Protest deutscher Künstler*. On Vinnen's tract and its implications as a political statement, see Paret, pp. 182–99.

42. Fifty-two of the 118 signatories lived in Munich, whereas only eleven resided in Berlin, where the art market was considerably more buoyant.

43. See the "Satzungen des Vereins bildender Künstler Münchens (Secession) e.V." (Munich: C. Wolf & Sohn, 1900), p. 4, where, for the first time, corresponding members are no longer guaranteed the "juryfrei" status.

44. I have derived these figures from the latest editions available to me of the Secession exhibi-tion catalogues. Walter Riezler, director of the museum in Stettin, put his finger on the existen-tial angst of the Munich Secession when he noted in 1913 that nothing could be more antithetical to the association than "endangering the existence of its members; who would ever be so uncollegial in Munich! It guarantees their existence as much as possible, moreover, each individual member of the group attends to the fame of the others. Woe to him who dares to cast doubt on the absolute perfection of one member in favor of another, not to mention in favor of a Berliner or a Frenchman: he is a traitor, a servant of Cassirer, a puppet of Tschudi—and one can no longer be seen with him." Walter Riezler, "Rundschau. Berlin und München," *Süddeutsche Monatshefte*, October 1913, pp. 112–13.

Select Bibliography

Many works cited in the text have not been included in this bibliography, in particular, newspaper and journal notices about Künstlergenossenschaft and Secession business, individual catalogues and reviews of the Künstlergenossenschaft and Secession exhibitions, and works of tangential interest. Readers should refer to the general heading "Serials and Ephemeral Publications" for the most important sources of information on the Munich exhibition societies and on reviews, and to the endnotes for full references.

Manuscripts

AKADEMIE DER KÜNSTE, WEST BERLIN

Akte betr. die grosse akademische Kunstausstellung 1879, Reg. 2. 323

ARCHIV FÜR BILDENDE KUNST AM GERMANISCHEN NATIONALMUSEUM, NÜRNBERG

Lebenserinnerungen Ludwig Dill
Lebenserinnerungen Philipp Röth
Nachlass Richard Riemerschmid

BAYERISCHES HAUPTSTAATSARCHIV (BAYHSTA), ALLGEMEINE ABTEILUNG, MUNICH

Aussenministerium
MA 78527 Die Jahresausstellungen von Kunstwerken aller Nationen in München
MA 78532 Die Kunstausstellungen der Secession

Finanzministerium
MF 68364 Pflege und Förderungen der Kunst, Generalia 1888–1949

Kultusministerium
MK 9269 Kunstgewerbe-Ausstellung 1888
MK 14163 Kunstanglegenheiten im Allgemeinen, Kunst und Kunstgewerbe
MK 14341 Glaspalast in München, Benutzung
MK 14356 Kunstausstellungs-Gebäude
MK 40863 James Haniel (Stiftungen)

Ministerium des Innern
MInn 73477 Genossenschaft der bildenden Künstler

BAYERISCHES HAUPTSTAATSARCHIV (BAYHSTA), GEHEIMES HAUSARCHIV, MUNICH

Abt. III, Kabinettsakten Luitpold
Nr. 19 Jahresausstellungen im Münchener Glaspalast, 1896–1918
Nr. 20 Die Ausstellungen der Secessionisten, 1893–1907
Nr. 22 Internationale Kunstausstellungen in München, 1892, 1897, 1901, 1905, 1909, 1913

Abt. III, Nachlass Luitpold
Nr. 272 Hubert Herkomer, 1893–1895

Abt. IV
Luitpold 20

BAYERISCHE STAATSBIBLIOTHEK (BSB), MUNICH

Schriften, welche die deutsche Kunst- und Kunst-industrie-Ausstellung in München im Jahre 1876 betreffen
Münchener Jahresausstellung . . . im kgl. Glaspalaste 1889 [1890, 1891, 1893, 1894, 1895, 1896, 1898, 1899, 1900, 1902, 1903, 1904]. Sammlung darauf bezüglicher Schriften [the separate catalogue headings for documents that pertain to the annual exhibitions for these years differ in minor details of wording]
Internationale Kunstausstellungen im kgl. Glaspalaste . . . 1879 [1883, 1888, 1892, 1897, 1901]. Sammlung darauf bezüglicher Schriften [the separate catalogue headings for documents that pertain to the quadrennial exhibitions of these years are variously worded]

BAYERISCHE STAATSBIBLIOTHEK HANDSCHRIFTENSAMMLUNG (BSBHSMLG), MUNICH

Rosenhageniana, II, 1 Fritz von Uhde (21B)

MÜNCHNER STADTBIBLIOTHEK, MONACENSIA ABTEILUNG, MUNICH

Hermann Kaulbach, "Katalog der Zwanglosen-Gemälde-Ausstellung vom 6. Januar 1892"

PAULUS FAMILY ARCHIVE, ERLANGEN
Nachlass Adolph Paulus

STAATSBIBLIOTEK PREUSSISCHER
KULTURBESITZ, HANDSCHRIFTEN-
ABTEILUNG, WEST BERLIN
 Nachlass Kurt Breysig
 Sammlung Darmstaedter 2n 1884: Fritz von
 Uhde

STADTARCHIV MÜNCHEN (SAM), MUNICH
Kulturamt
 Nr. 119 Verein Bildender Künstler Sezession,
 1892–1942
 Nr. 899 Ausstellung, Die III. internationale
 und Münchener Jubiläums Kun-
 stausstellung 1888
 Nr. 901 Ausstellung, Die Erste Jahresausstel-
 lung von Kunstwerken aller Nationen
 im kgl. Glaspalast zu München, 1889
Secession
 Nr. 356 Ausstellungen
 Nr. 360 Statuten des Vereins Bildender
 Künstler Münchens (Secession), 1900
 Nr. 376 Bestand der Secessions-Galerie,
 August 1940
 Nr. 377 Gründungsmemorandum, Mitglieder-
 verzeichnis, Statuten des Vereins
 Bildender Künstler Münchens, 1892
 Nr. 1541 Protokolle des Vereins Bildender
 Künstler Münchens, Secession,
 Generalversammlungen

STÄDTISCHE GALERIE IM LENBACHHAUS,
MUNICH
 Gabriele Münter- und Johannes Eichner-
 Stiftung

STÄDTISCHE GALERIE WÜRZBURG, WÜRZBURG
Nachlass Hugo von Habermann

Serials and Ephemeral Publications

Allgemeine Zeitung
Anzeiger der Münchener Künstlergenossenschaft.
 Organ für die Interessen der bildenden Künstler
Das Bayerische Vaterland
Deutsche Kunst und Dekoration. Illustrirte
 Monatshefte zur Förderung deutscher Kunst und
 Formensprache in neuzeitlich. Auffassung aus
 Deutschland, Schweiz, den deutsch sprech-
 enden Kronländern österreich-Ungarns, den
 Niederlanden und skandinavischen Ländern
Fliegende Blätter
General-Anzeiger der Haupt- und Residenz-
 stadt München. Unparteiisches Organ für Jeder-
 mann
Die Gesellschaft. Monatschrift für Literatur, Kunst
 und Sozialpolitik
Jugend. Münchner illustrierte Wochenschrift für
 Kunst und Leben
Die Kunst. Monatshefte für freie und angewandte
 Kunst

Kunstchronik. Wochenschrift für Kunst und
 Kunstgewerbe
Die Kunst für Alle
Der Kunstwart. Rundschau über alle Gebiete des
 Schönen
Münchener Fremdenblatt
Münchener Neueste Nachrichten
Simplicissimus. Illustrierte Wochenschrift
Sodom und Gomorrha oder Der Untergang des
 guten Geschmacks in Kunst, Literatur und
 Presse
Statistik des deutschen Reiches
Stenographische Berichte über die Verhandlungen
 der bayerischen Kammer der Abgeordneten
 (VdKdAbg)
Stenographische Berichte über die Verhandlungen
 der bayerischen Kammer der Reichsräthe
 (VdKdRr)
The Studio. An Illustrated Magazine of Fine and
 Applied Art
Über Land und Meer. Deutsche Illustrirte
 Zeitung
Zeitschrift für Bildende Kunst

Books, Catalogues, Articles, and Printed Documents

Ahlers-Hestermann, Friedrich. *Stilwende: Auf-
bruch der Jugend um 1900*. Berlin: Gebr.
Mann, 1956.
Albrecht, Dieter. "Von der Reichsgründung bis
zum Ende des Ersten Weltkrieges (1871–
1918)." In *Handbuch der bayerischen
Geschichte*, vol. IV. Ed. Max Spindler. Munich:
C. H. Beck, 1974, pp. 283–386.
Amt für Statistik und Datenanalyse der Landes-
hauptstadt München, ed. *1875–1975. 100 Jahre
Städtestatistik in München. Statistisches Hand-
buch der Landeshauptstadt München*. Munich:
Amt für Statistik und Datenanalyse der
Landeshauptstadt München, 1974.
Angerer, Birgit. *Die Münchner Kunstakademie
zwischen Aufklärung und Romantik: Ein Bei-
trag zur Kunsttheorie und Kunstpolitik unter
Max I. Joseph*. Miscellanea Bavarica Monacen-
sia, No. 123. Ed. Karl Bosl and Richard Bauer.
Munich: Stadtarchiv München, 1984.
Apelles der Jüngere. *Habt Acht*. Munich: Verlag
der Graphischen Kunst- und Verlags-Anstalt
von Wenng und Wild, 1890.
Baedeker, Karl. *Southern Germany (Wurtemberg
and Bavaria): Handbook for Travellers*, 11th
rev. ed. Leipzig: Baedeker, 1910.
Barnhart, Janet. "Art Beyond Art's Sake: Mod-
ernism and Politics in Munich, 1890–1924."
Diss. Harvard University 1981.
Bauer, Richard, ed. *Prinzregentenzeit. München
und die Münchner in Fotografien*. Munich:
Verlag C. H. Beck, 1988.

Bayerischer Architekten- und Ingenieur-Verein. *München und seine Bauten*. Munich: F. Bruckmann, 1912.

Bazin, Germain. "Le Salon de 1830 à 1900." *Scritti di storia dell'arte in onore die Lionello Venturi*, vol. II. Rome: De Luca, 1956, pp. 117–23.

Becker, Benno. "Die Sezession." *Pan*, 2 (1896–97), pp. 243–47.

Beetschen, Alfred. *Glaskasten Scherben und Secessiönliches*. Illus. Georg Ritzer. Munich: Druck und Verlag der Pössenbacherschen Buchdruckerei, 1898.

———. *Scherben aus dem Münchner Glaskasten*. Illus. Georg Ritzer. Munich: Druck und Verlag der Pössenbacherschen Buchdruckerei, 1897.

Beissel, St. "Die zweite Münchener Jahres-Ausstellung von Kunstwerken aller Nationen." *Stimmen aus Maria-Laach*, 39 (1890), pp. 521–36.

Bekh, Wolfgang Johannes. *Die Münchner Maler von Jan Pollak bis Franz Marc*. Pfaffenhofen/Ilm: Ilmgau Verlag, 1974.

Berdahl, Robert. "New Thoughts on German Nationalism." *American Historical Review*, 77 (1972), pp. 65–80.

Bergmann, Klaus. *Agrarromantik und Grossstadtfeindschaft*. Meisenheim am Glan: Verlag Anton Hain, 1970.

Berlepsch, H. E. von. *Die erste Münchener Jahres-Ausstellung*. Die Kunst unserer Zeit. Munich: Hanfstaengl Kunstverlag, 1889.

———. *Die Münchener Jahresausstellung von Kunstwerken aller Nationen 1890*. Kunst-Beilage der *Allgemeinen Zeitung*, Nos. 1–4, July, August, October 1890.

Berlin, Nationalgalerie Berlin. *Max Liebermann in seiner Zeit*. 6 September – 4 November 1979.

Berliner Sezession. Berlin: Neuer Berliner Kunstverein, n.d.

Bernstein, Max. *Albert's "Münchener Jahres-Ausstellung" 1889*. Munich: Münchener Kunst- und Verlags-Anstalt, E. Albert & Co., 1889).

Betz, Esther. "Kunstausstellungswesen und Tagespresse in München um die Wende des 19. Jahrhunderts: Ein Beitrag zum Kunst- und Kulturleben der bayrischen Hauptstadt." Diss. Ludwig-Maximilians-Universität zu München 1953.

Bierbaum, Otto Julius. *Albert's Münchener Jahres-Ausstellung 1890*. Munich: Münchener Kunst- und Verlags-Anstalt, E. Albert & Co., 1890.

———. *Aus beiden Lagern. Betrachtungen, Karikteristiken und Stimmungen aus dem ersten Doppel-Ausstellungsjahre in München 1893*. Munich: K. Schüler, 1893.

———, intro. *Secession. Eine Sammlung von Photogravuren nach Bildern und Studien von Mitgliedern des Vereins "Bildender Künstler Münchens"*. Berlin: Photographische Gesellschaft, 1893.

———. *Stuck*. 2d ed. Künstler-Monographien, No. 42. Bielefeld and Leipzig: Velhagen & Klasing, 1901.

Billcliffe, Roger. *The Glasgow Boys*. London: John Murray, 1985.

Bisanz, Rudolf M. *The René von Schleinitz Collection of the Milwaukee Art Center: Major Schools of German Nineteenth Century Popular Painting*. Milwaukee: University of Wisconsin Press, 1980.

Blackbourn, David. *Class, Religion and Local Politics in Wilhelmine Germany: The Centre Party in Württemberg before 1914*. New Haven: Yale University Press, 1980.

———, and Geoff Eley. *The Peculiarities of German History: Bourgeois Society and Politics in Nineteenth-Century Germany*. Oxford: Oxford University Press, 1984.

Block, Jane. *Les XX and Belgian Avant-Gardism 1868–1894*. Studies in the Fine Arts: The Avant-Garde, No. 41. Ed. Stephen C. Foster. Ann Arbor: UMI Research Press, 1984.

Boime, Albert. *The Academy and French Painting in the Nineteenth Century*. London: Phaidon, 1971.

Borchardt, Knut. "The Industrial Revolution in Germany." In *The Fontana Economic History of Europe*, vol. IV pt. 1: *The Emergence of Industrial Societies*. Ed. Carlo M. Cipolla. London: Collins, 1973, pp. 76–160.

Bosl, Karl. *Bayerische Geschichte*. Munich: Deutscher Taschenbuch Verlag, 1980.

———. "München, Deutschlands heimliche Hauptstadt. Bemerkungen zur Strukturanalyse des modernen Hauptstadt- und Grossstadt-Typus in Deutschland." *Zeitschrift für Bayerische Landesgeschichte*, 30 (1967), pp. 298–313.

Brand, Bettina. *Fritz von Uhde. Das religiöse Werk zwischen künstlerischer Intention und Öffentlichkeit*. Hefte des Kunstgeschichtlichen Instituts der Universität Mainz, No. 7. Ed. Richard Hamann-MacLean. Mainz: Kunstgeschichtliches Institut der Universität Mainz, 1983.

Bredt, Ernst W. *Zum Abbruch des Secessionsgebäudes in München. Ein offenes Wort*. Munich: Im Selbstverlage, n.d.

Bringmann, M., ed. *Münchener Fassaden. Bürgerhäuser des Historismus und des Jugendstils*. Munich: Prestel-Verlag, 1974.

Brooklyn, Brooklyn Museum. *Belgian Art 1880–1914*. 23 April – 29 June 1980.

———. *Northern Light. Realism and Symbolism in Scandinavian Painting 1880–1910*. 10 November 1982 – 6 January 1983.

Brougier, Adolf. *Gedanken über die fernere*

Entwickelung Münchens als Kunst- und Indus-trie-Stadt. Munich: n.p., 1905.

Brück, Ulrich von. "Gestaltwandel der säch-sischen Diakonie." In *Verantwortung. Unter-suchung über Fragen aus Theologie und Ge-schichte. Zum sechzigsten Geburtstag von Lan-desbischof D. Gottfried Noth DD.* Ed. Evange-lisch-Lutherisches Landeskirchenamt Sachsens. Berlin: Evangelische Verlagsanstalt, 1964, pp. 24–39.

Bruckmanns Lexikon der Münchner Kunst. Münchner Maler im 19. Jahrhundert. 4 vols. Ed. Horst Ludwig. Munich: Bruckmann, 1981–83.

Buch- und Kunstdruckerei Knorr und Hirth, Verlag der Münchener Neuesten Nachrichten. *Rückblicke und Erinnerungen anlässlich ihres 25jährigen Jubiläums.* Munich: Knorr und Hirth, 1900.

Buddensieg, Tilmann. "The Early Years of August Endell: Letters to Kurt Breysig from Munich." *Art Journal,* 43 (Spring 1983), pp. 41–49.

———. "Zur Frühzeit von August Endell. Seine Münchener Briefe an Kurt Breysig." In *Fest-schrift für Eduard Trier zum 60. Geburtstag.* Ed. Justus Müller Hofstede and Werner Spies. Berlin: Gebr. Mann, 1981, pp. 223–50.

Cassius, K. *Spottvogel im Glaspalast. Epigramme in Wort und Bild auf die III. internationale Kunstausstellung in München, 1888.* Munich: 1888.

———. *Spottvogel im Glaspalast. Epigramme in Wort und Bild auf die Münchener Jahres-Aus-stellung, 1889.* Munich: 1889.

Caw, James Lewis. *Sir James Guthrie.* Foreword by D. Y. Cameron. London: Macmillan, 1932.

Collection Georg Hirth. 3 vols. Munich and Leipzig: G. Hirth, 1898.

Conrad, M. G. *Die Sozialdemokratie und die Moderne. Münchener Flugschrift.* Munich: C. Mehrlich, 1893.

Corinth, Lovis. *Legenden aus dem Künstlerleben.* Berlin: Bruno Cassirer, 1909.

———. *Lovis Corinth. Eine Dokumentation.* Ed. Thomas Corinth. Tübingen: Verlag Ernst Was-muth, 1979.

———. *Meine frühen Jahre.* Hamburg: Claasen Verlag, 1954.

———. *Selbstbiographie.* Leipzig: S. Hirzel, 1926.

———. "Thomas Theodor Heine und Münchens Künstlerleben am Ende des vorigen Jahrhun-derts." *Kunst und Künstler,* 4 (1905–1906), pp. 143–56.

Craig, Gordon. *The Germans.* New York: Merid-ian, 1983.

———. *Germany, 1866–1945.* New York: Oxford University Press, 1978.

Darmstadt, Kunsthalle. *Akademie—Secession—*

Avant-Garde um 1900. Vol. III of *Ein Dokument deutscher Kunst 1901–1976.* 22 October 1976 – 30 January 1977.

Deiters, Heinrich. *Geschichte der Allgemeinen Deutschen Kunstgenossenschaft.* Düsseldorf: Bagel, 1906.

———. *Künstler, Kunstschreiber und der gesunde Menschenverstand.* Munich: J. Seiling, 1898 and 1899.

Denkmäler in Bayern. Landeshauptstadt Mün-chen. Ed. Michael Petzet. Munich: R. Olden-bourg, 1985.

Dirrigl, Michael. *Residenz der Musen: München—Magnet für Musiker, Dichter und Denker.* Munich: Bruckmann, 1968.

Dix, Eva. "Die Künstlerkolonie Dachau und die Münchner Secession." Thesis Ludwig-Maxi-milians-Universität zu München 1985.

Doeberl, Michael. *Entwicklungsgeschichte Bay-erns,* vol. III. Munich and Berlin: Oldenbourg, 1931.

Drey, Paul. *Die wirtschaftlichen Grundlagen der Malkunst. Versuch einer Kunstökonomie.* Stutt-gart and Berlin: J. G. Cotta'sche Buchhandlung Nachfolger, 1910.

Dube, Wolf-Dieter, intro. *Pinakothek. Munich.* Milan: Newsweek, Inc., and Arnoldo Mondadori Editore, 1969, pp. 9–15.

Duncker, D. *Über die Bedeutung der Deutschen Ausstellung in München.* Berlin: Carl Duncker, 1876.

Eberle, Matthias. "Max Liebermann zwischen Tradition und Opposition." In Berlin, National-galerie Berlin, *Max Liebermann in seiner Zeit,* 6 September – 4 November 1979, pp. 11–40.

Ebertshäuser, Heidi C. *Malerei im 19. Jahrhun-dert. Münchner Schule.* Munich: Keysersche Verlagsbuchhandlung, 1979.

Endell, August. *Um die Schönheit. Eine Para-phrase über die Münchener Kunstausstellungen.* Munich: Verlag Emil Franke, 1896.

Endres, Franz Carl. *Georg Hirth: Ein deutscher Publizist.* Munich: Walter C. F. Hirth, 1921.

Endres, Fritz. *Prinzregent Luitpold und die Entwicklung des modernen Bayern.* Munich: C. H. Beck'sche Verlagsbuchhandlung, 1916.

Engels, Eduard. *Münchens "Niedergang als Kunststadt." Eine Rundfrage.* Munich: Ver-lagsanstalt F. Bruckmann, 1902.

Engelsing, R. "Lebenshaltungen und Lebens-haltungskosten im 18. und 19. Jahrhundert in den Hansestädten Bremen und Hamburg." *International Review of Social History,* 11, No. 1 (1966), pp. 73–107.

Erste Hindernationale Kunstausstellung des Vereins "Nachempfindenden Künstler." Erste Dachauer Secession am Maximilians Keller 1895. Munich: R. Oldenbourg, 1895.

Evans, Richard, ed. *Society and Politics in Wil-helmine Germany.* London: Croom Helm, 1978.

Expressionism. A German Intuition 1905–1920. New York: Solomon R. Guggenheim Foundation, 1980.

Feddersen, Martin. *Die Entartung der Münchener Kunst.* München: 1894.

Franz, Eugen. *München als deutsche Kulturstadt im 19. Jahrhundert.* Berlin and Leipzig: Walter de Grunter & Co., 1936.

Freihofer, Alfred. *Die sechste internationale Kunstausstellung in München 1892.* Separatdruck aus dem *Staatsanzeiger für Württemberg.* Stuttgart: Druck der Stuttgarter Buchdruckerei-Gesellschaft, 1892.

"Frühlingswogen in der Kunst." Aufstieg und Fall der Münchner Secession. Radio script by Annette Lettau. Bayerischer Rundfunk Sendung, Land und Leute Serie. 27 January 1985.

Fuchs, Georg. *Sturm und Drang in Munchen um die Jahrhundertwende.* Munich: Georg D. W. Callwey, 1936.

Die Galerie Thomas Knorr in München. Ed. Fritz von Ostini. Munich: Knorr & Hirth, 1906.

Gasser, Manuel, ed. *München um 1900.* Bern: Hallwag, 1977.

Ghattas, Monika White. "Patronage and Painters in Munich, 1870–1910." Diss. University of New Mexico 1986.

Glaser, Hermann. *Die Kultur der Wilhelminischen Zeit. Topographie einer Epoche.* Frankfurt am Main: S. Fischer, 1984.

Glasgow, The Art Gallery and Museum. *The Glasgow Boys 1880–1900,* vol. I: *The Artists and Their Works.* Edinburgh: Scottish Arts Council, 1968; vol. II: *The History of the Group; Illustrations.* Edinburgh: Scottish Arts Council, 1971.

Goering, Theodor. *Dreissig Jahre München. Kultur- und kunstgeschichtliche Betrachtungen.* Munich: C. H. Beck'sche Verlag, 1904.

Gollwitzer, Heinz. *Ludwig I. von Bayern. Königtum im Vormärz. Eine politische Biographie.* Munich: Süddeutscher Verlag, 1987.

Green, Nicholas. " 'All the Flowers of the Field': The State, Liberalism and Art in France under the Early Third Republic." *Oxford Art Journal,* 10, No. 1 (1987), pp. 71–84.

Günther, Sonja. *Interieurs um 1900. Bernhard Pankok, Bruno Paul und Richard Riemerschmid als Mitarbeiter der Vereinigten Werkstätten für Kunst im Handwerk.* Munich: Wilhelm Fink Verlag, 1971.

The Hague School: Dutch Masters of the Nineteenth Century. Ed. Ronald de Leeuw, John Sillevis, and Charles Dumas. London: Weidenfeld and Nicolson, 1983.

Halbe, Max. *Jahrhundertwende: Erinerrungen an einer Epoche.* 1935; rpt. Munich: Langen Müller, 1976.

Ein Halbes Jahrhundert Münchner Kulturgeschichte erlebt mit der Künstlergesellschaft Allotria. Munich: Verlag Karl Thiemig, 1959.

Hamann, Richard, and Jost Hermand. *Naturalismus.* Deutsche Kunst und Kultur von der Gründerzeit bis zum Expressionismus, No. 2. Berlin: Akademie-Verlag, 1959.

———. *Stilkunst um 1900.* Deutsche Kunst und Kultur von der Gründerzeit bis zum Expressionismus, No. 4. Berlin: Akademie-Verlag, 1967.

Hamburg, Kunsthalle. *Luther und die Folgen für die Kunst.* 11 November 1983 – 8 January 1984.

Hancke, Erich. *Max Liebermann. Sein Leben und seine Werke,* 2d ed. Berlin: B. Cassirer, 1923.

Hartmann, Kristina. *Deutsche Gartenstadtbewegung.* Munich: H. Moos, 1976.

Helferich, Hermann. "Studie über den Naturalismus und Max Liebermann." *Kunst für Alle,* 12 (October 1896 – September 1897), pp. 225–28.

Heller, Reinhold. *Munch, His Life and Work.* London: John Murray, 1984.

Henning, Hansjoachim. *Das Bildungsbürgertum in den preussischen Westprovinzen.* Vol. I of *Das westdeutsche Bürgertum in der Epoche der Hochindustrialisierung 1860–1914. Soziales Verhalten und soziale Strukturen.* Historische Forschungen, No. 6. Wiesbaden: F. Steiner, 1972.

Heres, Horst. *Dachauer Gemäldegalerie.* n.p.: Museumsverein Dachau e.V., 1985.

Hermand, Jost. *Jugendstil.* Darmstadt: Wissenschaftliche Buchgesellschaft, 1971.

Hermann Obrist. Wegbereiter der Moderne. Ed. Siegfried Wichmann. Munich: Stuck-Jugendstil Verein, 1968.

Heskett, John. *Design in Germany, 1870–1908.* London: Trefoil, 1986.

Hirth, Georg. *Berufungsschrift an das k. Landgericht München.* Munich: Knorr & Hirth, 1892.

Höfele, Karl Heinz. *Geist und Gesellschaft der Bismarckzeit 1870–90.* Quellensammlungen zur Kulturgeschichte, No. 18. Ed. Wilhelm Treue. Göttingen: Musterschmidt, 1967.

Hummel, Rita. "Die Anfänge der Münchener Secession: Eine kulturpolitische Studie." Thesis Ludwig-Maximilians-Universität zu München 1982.

H.V. "Hofrat Paulus." *Moderne Kunst,* 1901, p. 258.

Imiela, Hans-Jürgen. *Max Slevogt.* Karlsruhe: G. Braun, 1968.

Irwin, David, and Francina Irwin. "The Glasgow School," chapter 20 in *Scottish Painters at Home and Abroad 1700–1900.* London: Faber and Faber, 1975, pp. 372–94.

Jelavich, Peter. " 'Die Elf Scharfrichter': The Political and Sociopolitical Dimensions of Caba-

ret in Wilhelmine Germany." In *The Turn of the Century: German Literature and Art 1890–1915*. McMaster Colloquium on German Literature, II. Ed. Gerald Chapple and Hans H. Schulte. Foreword by Alvin A. Lee. Bonn: Bouvier, 1981, pp. 507–25.

————. *Munich and Theatrical Modernism. Politics, Playwriting and Performance, 1890–1914*. Cambridge, Mass.: Harvard University Press, 1985.

————. "Munich as Cultural Center: Politics and the Arts." In *Kandinsky in Munich: 1886–1914*. New York: Solomon R. Guggenheim Foundation, 1982, pp. 17–26.

————. "Popular Dimensions of Modernist Elite Culture. The Case of Theater in Fin-de-Siècle Munich." In *Modern European Intellectual History. Reappraisal and New Perspectives*. Ed. Dominick LaCapra and Steve L. Kaplan. Ithaca: Cornell University Press, 1982, pp. 220–50.

Kalckreuth, Johannes. *Wesen und Werk meines Vaters: Lebensbild des Malers Graf Leopold von Kalckreuth*. Hamburg: Hans Christians Verlag, n.d.

Kandinsky, Wassily. *Kandinsky. Complete Writings on Art*. 2 vols. Ed. Kenneth C. Lindsay and Peter Vergo. Boston: G. K. Hall, 1982.

Karlinger, H. *München und die Kunst des 19. Jahrhunderts*. 1933; rpt. Munich: H. Thoma, 1966.

Keller, Gottfried. *Green Henry*. Trans. A. M. Holt. New York: Grove Press, 1960.

Klee, Paul. *The Diaries of Paul Klee 1898–1918*. Ed. and intro. Felix Klee. Berkeley: University of California Press, 1968.

————. *Paul Klee: Briefe an die Familie 1893–1940*. 2 vols. Ed. Felix Klee. Cologne: DuMont Buchverlag, 1979.

Koeppen, Alfred. *Die moderne Malerei in Deutschland*. Sammlung illustrirter Monographien, No. 7. Ed. Hanns von Zobeltitz. Bielefeld and Leipzig: Velhagen & Klasing, 1902.

Kolbe, Jürgen. *Heller Zauber. Thomas Mann in München 1894–1933*. Berlin: Siedler Verlag, 1987.

Koreska-Hartmann, Linda. *Jugendstil—Stil der "Jugend."* Munich: Deutscher Taschenbuch Verlag, 1969.

Körner, Hans-Michael. *Staat und Kirche in Bayern 1886–1918*. Mainz: Matthias-Grünewald-Verlag, 1969.

Krieger, Peter. "Max Liebermanns Impressionisten-Sammlung und ihre Bedeutung für sein Werk." In Berlin, Nationalgalerie Berlin, *Max Liebermann in seiner Zeit*, 6 September – 4 November 1979, pp. 60–71.

Kunstpolitik und Kunstförderung im Kaiserreich. Kunst im Wandel der Sozial- und Wirtschaftsgeschichte. Kunst, Kultur und Politik im deutschen Kaiserreich, No. 2. Ed. Ekkehard Mai, Hans Pohl, and Stephan Waetzoldt. Berlin: Gebr. Mann Verlag, 1982.

Kunstschul-Reform 1900–1933. Fünf Beispiele ihrer Verwirklichung. Ed. H. M. Wingler. Berlin: Gebr. Mann, 1977.

"Kunstvereine, Sammlungen und Ausstellungen." *Kunstchronik*, 4 (1868), p. 12.

Kunstverwaltung, Bau- und Denkmal-Politik im Kaiserreich. Kunst, Kultur, und Politik im deutschen Kaiserreich, No. 1. Ed. Ekkehard Mai and Stephan Waetzoldt. Berlin: Gebr. Mann, 1981.

Kutter, Paul. *Das materielle Elend der jungen münchener Maler*. Munich: Max Engl, 1912.

Lampe-von Bennigsen, Silvie. *Hermann Obrist, Erinnerungen*. Munich: Verlag Herbert Post Presse, 1970.

Landes, David. *The Unbound Prometheus. Technical Change and Industrial Development in Western Europe from 1750 to the Present*. Cambridge: Cambridge University Press, 1969.

Langenstein, York. *Der Münchner Kunstverein im 19. Jahrhundert: Ein Beitrag zur Entwicklung des Kunstmarkts und des Ausstellungswesens*. Miscellanea Bavarica Monacensia, No. 122. Ed. Karl Bosl and Richard Bauer. Munich: Stadtarchiv München, 1983.

Lankheit, Klaus, ed. and intro. *The "Blaue Reiter" Almanac*. New York: Viking, 1974.

Lavery, John. *The Life of a Painter*. London: Cassel, 1940.

Lees, Andrew. "Debates about the Big City in Germany, 1890–1914." *Societas*, 5 (1975), pp. 31–47.

Leiss, Ludwig. *Kunst im Konflikt: Kunst und Künstler im Widerstreit mit der Obrigkeit*. Berlin: Walter de Gruyter, 1971.

Lenk, Leonhard. "Katholizismus und Liberalismus: Zur Auseinandersetzung mit dem Zeitgeist in München 1848–1918." In *Der Mönch im Wappen. Aus Geschichte und Gegenwart des katholischen München*. Munich: Schnell & Steiner, 1960, pp. 375–408.

Lenman, Robin. "Art, Society, and the Law in Wilhelmine Germany: The Lex Heinze." *Oxford German Studies*, 8 (1973–74), pp. 86–113.

————. "A Community in Transition: Painters in Munich, 1886–1924." *Central European History*, 16 (March 1983), pp. 3–33.

————. "Politics and Culture. The State and the Avant-Garde in Munich 1886–1914." In *Society and Politics in Wilhelmine Germany*. Ed. Richard J. Evans. New York: Barnes and Noble, 1978, pp. 90–111.

Leypoldt, Winfried. " 'Münchens Niedergang als Kunststadt.' Kunsthistorische, kunstpolitische und kunstsoziologische Aspekte der Debatte um 1900." Diss. Ludwig-Maximilians-Universität zu München, 1987.

Lichtwark, Alfred. "Aus München." *Pan*, 2 (1896), pp. 253–56.

———. *Briefe an Leopold Graf von Kalckreuth.* Ed. Carl Schellenberg. Hamburg: Christian Wegner Verlag, 1957.

———. *Briefe an Max Liebermann.* Ed. Carl Schellenberg. Hamburg: Johann Trautmann Verlag, 1947.

London, Hayward Gallery. *Dreams of a Summer Night. Scandinavian Painting at the Turn of the Century.* 10 July – 5 October 1986.

Ludwig, Horst. *Kunst, Geld und Politik um 1900 in München. Formen und Ziele der Kunstfinanzierung und Kunstpolitik während der Prinzregenten-Ära (1886–1912).* Kunst, Kultur und Politik im deutschen Kaiserreich, No. 8. Ed. Ekkehard Mai and Stephan Waetzoldt. Berlin: Gebr. Mann Verlag, 1986.

———. *Münchner Malerei im 19. Jahrhundert.* Munich: Hirmer Verlag, 1978.

———. "Die Münchener Secession und ihre Maler." *Weltkunst*, 53 (1983), pp. 24–26, 1360–62, 1934–36; 54 (1984), pp. 1115–17.

Mai, Ekkehard. "Akademie, Sezession und Avantgarde—München um 1900." In *Tradition und Widerspruch. 175 Jahre Kunstakademie München.* Ed. Thomas Zacharias. Munich: Prestel-Verlag, 1985, pp. 145–77.

———. "Problemgeschichte der Münchner Kunstakademie bis in die zwanziger Jahre." In *Tradition und Widerspruch*, pp. 103–43.

Mainardi, Patricia. *Art and Politics of the Second Empire. The Universal Expositions of 1855 and 1867.* New Haven: Yale University Press, 1987.

Makela, Maria. "The Founding and Early Years of the Munich Secession." Diss. Stanford University 1987.

———. "Munich's Design for Living." *Art in America*, 77, No. 2 (February 1989), pp. 144–51.

———. "Wilhelm Trübner: A Link Between Realism and Impressionism in Germany." Thesis Tulane University 1981.

Max und Moritz im Glaspalast und in der Secession 1893. Munich: Dr. E. Albert & Co., 1893.

Meissner, Hermann. *Franz von Stuck. Ein modernes Künstlerbildnis.* Die Kunst unserer Zeit, No. 9. Munich: Franz Hanfstaengl, n.d.

Mittlmeier, Werner. *Die Neue Pinakothek in München 1843–1854.* Studien zur Kunst des neunzehnten Jahrhunderts, No. 16. Munich: Prestel-Verlag, 1977.

Mochon, Anne. "Fritz von Uhde and Plein-Air Painting in Munich, 1880–1900." Diss. Yale University 1973.

Möckl, Karl. *Die Prinzregentenzeit. Gesellschaft und Politik während der Ära des Prinzregenten Luitpold in Bayern.* Munich and Vienna: R. Oldenbourg, 1972.

Mosse, George L. *The Crisis of German Ideology. Intellectual Origins of the Third Reich.* New York: Grosset & Dunlap, 1964.

Müller, Karl Alexander von. *Aus Gärten der Vergangenheit.* Stuttgart: W. Kohlhammer, 1952.

Münchener Künstlergenossenschaft. Annual reports (variously titled: *Rechenschaftsbericht der Münchener Künstlergenossenschaft; Rechenschafts-Bericht der Münchener Künstlergenossenschaft; Bericht des Vorstands über das Verwaltungs-Jahr*), 1873–94. Printed copies in Münchner Stadtbibliothek, Monacensia Abteilung.

———. Exhibition catalogues (variously titled), 1869–1905.

Munich, Haus der Kunst. *100 Jahre Münchener Künstlergenossenschaft.* 9 March – 12 May 1968.

———. *München 1869–1958. Aufbruch zur modernen Kunst.* 21 June – 5 October 1958.

———. *"München leuchtete." Karl Caspar und die Erneuerung christlicher Kunst in München um 1900.* 8 June – 22 July 1984.

———. *Die Münchner Schule 1850–1914.* 28 July – 7 October 1979.

———. *Secession. Europäische Kunst um die Jahrhundertwende.* 14 March – 10 May 1964.

Munich, Münchner Stadtmuseum. *Bayern. Kunst und Kultur.* 9 June – 15 October 1972.

———. *Der Münchner Glaspalast 1854–1931. Geschichte und Bedeutung.* 5 June – 30 August 1981.

———. *Die Münchner Secession und ihre Galerie.* 10 July – 14 September 1975.

———. *Plakate in München 1840–1940.* 16 October 1975 – 6 January 1976.

———. *Die Prinzregentenzeit.* 15 December 1988 – 16 April 1989.

———. *Richard Riemerschmid. Vom Jugendstil zum Werkbund. Werke und Dokumente.* Ed. Winfried Nerdinger. 26 November 1982 – 27 February 1983.

Munich, Neue Pinakothek, Bayerische Staatsgemäldesammlungen. *Malerei der Gründerzeit.* Vol. VI of *Gemäldekataloge.* Munich: Hirmer, 1977.

Munich, Städtische Galerie im Lenbachhaus. *Die Münchner Secession, 1892–1952.* 1 September – 21 October 1951.

———. *Paul Klee. Das Frühwerk 1883–1922.* 12 December 1979 – 2 March 1980.

Museum Villa Stuck. *Franz von Stuck 1863–1928.* Munich: Karl M. Lipp Verlag, 1984.

Muther, Richard. *The History of Modern Painting.* 4 vols. London: J. M. Dent, 1907.

Nerdinger, Winfried. "Die 'Kunststadt' München." In Munich, Münchner Stadtmuseum, *Die Zwanziger Jahre in München*, May–September 1979, pp. 93–119.

———. "Richard Riemerschmid und der Jugendstil." *Die Weltkunst*, 52 (1982), pp. 894–97.

———. "Riemerschmids Weg vom Jugendstil zum Werkbund." In Munich, Münchner Stadtmuseum, *Richard Riemerschmid. Vom Jugendstil zum Werkbund*, 26 November 1982 – 27 February 1983, pp. 13–26.

Neumann, Carl. "Von moderner Malerei. Betrachtungen über die Münchener Kunstausstellung von 1888." *Preussische Jahrbücher*, 62 (1888), pp. 259–79.

New Haven, Yale University Art Gallery. *German Painting of the Nineteenth Century*. 15 October – 22 November 1970.

New York, Metropolitan Museum of Art. *German Masters of the Nineteenth Century*. 2 May – 5 July 1981.

New York, Museum of Modern Art. *Vienna 1900. Art, Architecture and Design*. 3 July – 21 October 1986.

Nipperdey, Thomas. *Gesellschaft, Kultur, Theorie*. Göttingen: Vandenhoeck & Ruprecht, 1976.

Obermeier, Siegfried. *Münchens goldene Jahre, 1871–1914*. Munich: Bertelsmann, 1976.

Obrist, Hermann. "Die Antwort durch die That." *Münchener Neueste Nachrichten*, No. 213, Morgenblatt, 7 May 1901, p. 2, and No. 214, Vorabendblatt, 8 May 1901, p. 3.

———. *Neue Möglichkeiten in der bildenden Kunst. Aufsätze*. Leipzig: Eugen Diederichs, 1903.

Oldenbourg, Rudolf. *Die Münchner Malerei im 19. Jahrhundert*, I: *Die Epoche Max Josephs und Ludwigs I.*, ed. Eberhard Ruhmer. 1923; rpt. Munich: Bruckmann, 1983. [*See also* Uhde-Bernays, below.]

Oslo, Nasjonalgalleriet. *1880–årene i nordisk maleri*. 24 August – 13 October 1985.

Ostwald, Hans. *Das Liebermann Buch*. Berlin: Paul Franke Verlag, 1930.

Paret, Peter. *The Berlin Secession: Modernism and Its Enemies in Imperial Germany*. Cambridge, Mass.: Harvard University Press, 1980.

———. " 'The Enemy Within'—Max Liebermann as President of the Prussian Academy of Arts." Leo Baeck Memorial Lecture 28, Leo Baeck Institute, New York. 1984.

———. "Historischer Überblick." In *Berliner Sezession*. Berlin: Neuer Berliner Kunstverein, n.d., unpaged.

Paris, Musée du Petit Palais. *Lumières du Nord. Le peinture scandinave 1885–1905*. 21 February – 17 May 1987.

Paulus, Adolf. "Zwanzig Jahre Münchner Secession 1893–1913." *Die Kunst*, 27 (October 1912 – September 1913), pp. 326–36.

Pecht, Friedrich. *Aus meiner Zeit*. 2 vols. Munich: Verlagsanstalt für Kunst und Wissenschaft, 1894.

———. *Geschichte der Münchener Kunst im 19. Jahrhundert*. Munich: Bruckmann, 1888.

Peters, Hans. "Ausstellungsgebäude der Sezes-sionisten in München." *Über Land und Meer: Deutsche Illustrirte Zeitung*, 70 (1893), p. 788.

Pevsner, Nikolaus. *Academies of Art, Past and Present*. Cambridge: Cambridge University Press, 1940.

Pfefferkorn, Rudolf. *Die Berliner Secession. Eine Epoche deutscher Kunstgeschichte*. Berlin: Haude & Spenersche Verlagsbuchhandlung, 1972.

Philadelphia, Philadelphia Museum of Art. *Art Nouveau in Munich. Masters of Jugendstil*. 25 September – 27 November 1988.

Pixis, Erwin. *Verzeichnis der von Weiland Seiner Königlichen Hoheit dem Prinzregenten Luitpold von Bayern aus privaten Mittlen erworbenen Werken der bildenden Kunst*. Munich: n.p., 1915.

Plagemann, Volker. *Das deutsche Kunstmuseum 1790–1870*. Studien zur Kunst des neunzehnten Jahrhunderts, No. 3. Munich: Prestel-Verlag, 1967.

Prinz, Friedrich. "Bayern und München am Ende der Prinzregentenzeit." In Munich, Haus der Kunst, *"München leuchtete." Karl Caspar und die Erneuerung christlicher Kunst in München um 1900*. 8 June – 22 July 1984.

———, and Marita Krauss, eds. *München—Musenstadt mit Hinterhöfen. Die Prinzregentenzeit 1886 bis 1912*. Munich: Verlag C. H. Beck and Münchner Stadtmuseum, 1988.

Quast, Rudolf. "Studien zur Geschichte der deutschen Kunstkritik in der 2. Hälfte des 19. Jahrhunderts." Diss. Westfälische Wilhelms-Universität zu Münster 1936.

Ramberg, Gerhard. *Hellmalerei. Ein Spaziergang durch den Münchener Glaspalast im Sommer 1889*. Munich: G. Franz'scher Verlag, 1889.

Reiser, Rudolf. *Die Wittelsbacher 1180–1918. Ihre Geschichte in Bildern*. Munich: Bruckmann, 1979.

Rewald, John. *The History of Impressionism*. 4th rev. ed. New York: Museum of Modern Art, 1973.

Riehl, Hans. *Märchenkönig und Bürgerkönige. Wittelsbacher Geschichte(n) 1806–1918*. Pfaffenhofen: Verlag W. Ludwig, 1979.

Riezler, Walter. "Rundschau. Berlin und München." *Süddeutsche Monatshefte*, October 1913, pp. 108–16.

R.M. *Eine Muster-Jury. Beitrag zur Geschichte der internationalen Kunst-Ausstellung in München 1879*. Munich: Rudolf Fried, 1879.

Roessler, Arthur. *Neu-Dachau: Ludwig Dill, Adolf Hölzel, Arthur Langhammer*. Knackfuss Künstler Monographien, No. 78. Bielefeld and Leipzig: Velhagen & Klasing, 1905.

Rohrandt, Klaus. "Wilhelm Trübner. Kritischer und beschreibender Katalog sämtlicher Gemälde, Zeichnungen und Druckgraphik.

Biographie und Studien zum Werk." Diss.
Christian-Albrechts-Universität 1972.

Rosenblum, Robert, and H. W. Janson. *Nineteenth Century Art*. New York: Harry N. Abrams, 1984.

Rosenhagen, Hans. "Münchens Niedergang als Kunststadt." *Der Tag*, No. 143, 13 April 1901, pp. 1–3, and No. 145, 14 April 1901, pp. 1–2.

———. *Uhde. Des Meisters Gemälde in 285 Abbildungen*. Stuttgart and Leipzig: Deutsche Verlags-Anstalt, 1908.

Roth, Eugen. *Der Glaspalast in München: Glanz und Ende 1854–1931*. Munich: Süddeutscher Verlag, 1971.

Ruederer, Joseph. *Höllischer Spuk. Ein Münchener Erlebnis*. Berlin: Georg Bondi, 1957.

Sackett, Robert Eben. *Popular Entertainment, Class, and Politics in Munich, 1900–1923*. Cambridge, Mass.: Harvard University Press, 1982.

Sapporo, Museum of Modern Art. *Münchner Malerei 1892–1914*. 21 July – 21 August 1977.

Scheffler, Karl. *Die fetten und die mageren Jahre*. Leipzig and Munich: P. List, 1946.

Schieder, Theodor. *Das deutsche Kaiserreich von 1871 als Nationalstaat*. Wissenschaftliche Abhandlungen der Arbeitsgemeinschaft für Forschung des Landes Nordrhein-Westfalen, No. 20. Cologne: Westdeutscher Verlag, 1961.

Schlittgen, Hermann. *Erinnerungen*. Munich: Albert Langen, 1926.

Schmoll, J. A., gen. Eisenwerth. *Das Phänomen Franz Stuck*. Munich: 1972.

Schorske, Carl. *Fin-de-Siècle Vienna: Politics and Culture*. New York: Vintage, 1981.

Schramm, Percy Ernst. *Hamburg, Deutschland und die Welt*. Munich: Georg D. W. Callwey, 1943.

Schrott, Ludwig. *Der Prinzregent. Ein Lebensbild aus Stimmen seiner Zeit*. Munich: Süddeutscher Verlag, 1962.

Seidlitz, Waldemar von. "Die Münchener Kunstausstellung." *Preussischer Jahrbücher*, 68 (1891), pp. 396–403.

Serenus. *In arte voluptas? Drei Kapitel aus dem Münchener Kunstleben*. Munich: Staegmeyr'sche Verlagshandlung, 1898.

Shapiro, Theda. *Painters and Politics: The European Avant-Garde and Society, 1900–1925*. New York: Elsevier, 1976.

Shedel, James. *Art and Society. The New Art Movement in Vienna, 1897–1914*. Palo Alto: Society for the Promotion of Science and Scholarship, 1981.

Sheehan, James J. *German Liberalism in the Nineteenth Century*. Chicago: University of Chicago Press, 1978.

———. "Liberalism and the City in Nineteenth-Century Germany." *Past and Present*, 51 (May 1971), pp. 116–37.

———. "What is German History? Reflections on the Role of the *Nation* in German History and Historiography." *Journal of Modern History*, 53 (1981), pp. 1–23.

Simon, Hans Ulrich. *Sezessionismus: Kunstgewerbe in literarischer und bildender Kunst*. Stuttgart: T. B. Metzler, 1976.

Smoot, Myrna. "The First International Art Exhibition in Munich 1869." *Salons, Galleries, Museums and Their Influence in the Development of 19th and 20th Century Art*. Proceedings of the 24th International Congress of the History of Art 1979, vol. VII. Bologna: Cooperativa Libraria Universitaria Editrice, n.d., pp. 109–14.

Spindler, Max, ed. *Bayerische Geschichte im 19. und 20. Jahrhundert, 1800–1970*. 2 vols. Munich: C. H. Beck, 1978.

Steinborn, Peter. *Grundlagen und Grundzüge Münchener Kommunalpolitik in den Jahren der Weimarer Republik. Zur Geschichte der bayerischen Landeshauptstadt im 20. Jahrhundert*. Miscellanea Bavarica Monacensia, No. 5. Ed. Karl Bosl and Michael Schattenhofer. Munich: Stadtarchiv München, 1968.

Stern, Fritz. *The Politics of Cultural Despair: A Study in the Rise of the Germanic Ideology*. Berkeley: University of California Press, 1961, rpt. 1974.

Stieler, Eugen. "Die Entstehung der Münchener Jahresausstellungen." *Das Bayerland*, 39 (1928), pp. 308–10.

———. *Die königliche Akademie der bildenden Künste zu München: Festschrift zur Hundertjahrfeier*. Munich: Bruckmann, 1909.

Stürmer, Michael. *Das ruhelose Reich 1866–1918*. Berlin: Severin & Siedler, 1983.

Teeuwisse, Klaas [Nicolaas]. "Berliner Kunstleben zur Zeit Max Liebermanns." In Berlin, Nationalgalerie Berlin, *Max Liebermann in seiner Zeit*, 6 September – 4 November 1979, pp. 72–87.

———. *Vom Salon zur Secession. Berliner Kunstleben zwischen Tradition und Aufbruch zur Moderne 1871–1900*. Berlin: Deutscher Verlag für Kunstwissenschaft, 1986.

Thoma, Hans. *Aus achtzig Lebensjahren*. Ed. Josef August Beringer. Leipzig: Köhler and Amelang, n.d.

———. *Im Herbste des Lebens*. Munich: Süddeutsche Monatshefte, 1909.

Tornow, Ingo. *Das Münchner Vereinswesen in der ersten Hälfte des 19. Jahrhunderts, mit einem Ausblick auf die zweite Jahrhunderthälfte*. Miscellanea Bavarica Monacensia, No. 75. Ed. Karl Bosl and Richard Bauer. Munich: Stadtarchiv München, 1977.

Tradition und Widerspruch: 175 Jahre Kunstakademie München. Ed. Thomas Zacharias. Munich: Prestel-Verlag, 1985.

Trübner, Wilhelm. *Personalien und Prinzipien*.

Intro. by Emil Waldmann. Berlin: Bruno Cassirer, 1907.

Uhde-Bernays, Hermann. *Die Münchner Malerei im 19. Jahrhundert,* II: *1850–1900,* ed. Eberhard Ruhmer. 1927; rpt. Munich: Bruckmann, 1983. [*See also* Oldenbourg, above.]

Vaisse, Pierre, "Salons, Expositions et Sociétés d'Artistes en France 1871–1914." *Salons, Galleries, Museums and Their Influence in the Development of 19th and 20th Century Art.* Proceedings of the 24th International Congress of the History of Art 1979, vol. VII. Bologna: Cooperativa Libraria Universitaria Editrice, n.d., pp. 141–55.

Vaube, E. *Dr. van der Bleckn im Glaspalast und in der Secession 1894.* Munich: Verlag von Hermann Lukaschik,1894.

Velde, Henry van de. *Geschichte meines Lebens.* Munich: R. Piper & Co. Verlag, 1962.

Venzmer, Wolfgang. *Adolf Hölzel, Leben und Werk.* Stuttgart: Deutsche Verlags-Anstalt, 1982.

——. *Neu-Dachau, 1895–1905. Ludwig Dill, Adolf Hölzel, Arthur Langhammer in der Künstlerkolonie Dachau.* Dachau: Kreis- und Stadtsparkasse Dachau-Indersdorf, 1984.

Verein Bildender Künstler Münchens, Secession. Exhibition catalogues (variously titled), 1893–1905.

Vinnen, Carl. *Ein Protest deutscher Künstler.* Jena: Eugen Diederichs, 1911.

Voss, Heinrich. *Franz von Stuck 1863–1928. Werkkatalog der Gemälde mit einer Einführung in seinen Symbolismus.* Materialien zur Kunst des 19. Jahrhunderts, No. 1. Munich: Prestel-Verlag, 1973.

Wadleigh, Henry Rawle. *Munich: History, Monuments and Art.* New York: Frederick A. Stokes, 1910.

Waetzoldt, Stephan. *Meisterwerke deutscher Malerei des 19. Jahrhunderts.* Stuttgart: Klett-Cotta, 1981.

Weiss, Peg. "Kandinsky and the 'Jugendstil' Arts and Crafts Movement." *Burlington Magazine,* 117 (May 1975), pp. 270–79.

——. "Kandinsky in Munich: Encounters and Transformations." In *Kandinsky in Munich 1896–1914.* New York: Solomon R. Guggenheim Museum, 1982, pp. 28–82.

——. *Kandinsky in Munich. The Formative Jugendstil Years.* Princeton: Princeton University Press, 1979.

——. "Wassily Kandinsky, The Utopian Focus: Jugendstil, Art Deco, and the Centre Pompidou." *Arts Magazine,* 51 (April 1977), pp. 102–7.

Wichmann, Siegfried. *Meister, Schulen, Themen. Münchner Landschaftsmaler im 19. Jahrhundert.* Herrschung: Schuler Verlagsgesellschaft, 1981.

——. *Realismus und Impressionismus in Deutschland.* Stuttgart: J. E. Schuler, 1964.

Wiegenstein, Jane Theresa. "Artists in a Changing Environment: The Viennese Art World, 1860–1918." Diss. Indiana University 1980.

Willey, Thomas E. "Thomas Mann's Munich." In *The Turn of the Century: German Literature and Art 1890–1915.* McMaster Colloquium on German Literature, II. Ed. Gerald Chapple and Hans H. Schulte. Foreword by Alvin A. Lee. Bonn: Bouvier, 1981, pp. 477–91.

Wir fingen einfach an. Arbeiten und Aufsätze von Freunden und Schülern um Richard Riemerschmid zu dessen 85. Geburtstag. Ed. Heinz Thiersch. Munich: Richard Pflaum Verlag, 1953.

With, Christopher B. *The Prussian Landeskunstkommision 1862–1911. A Study in State Subvention of the Arts.* Kunst, Kultur und Politik im deutschen Kaiserreich, No. 6. Ed. Ekkehard Mai and Stephan Waetzoldt. Berlin: Gebr. Mann Verlag, 1986.

Wolf, Georg Jacob. *Kunst und Künstler in München. Studien und Essays.* Strassburg: Heitz, 1908.

——. *Münchener Künstlergenossenschaft und Secession.* Munich: Drei Eulen-Verlag, n.d.

——. "The 'Secessionists' of Germany." *The Studio,* 4 (October 1894), pp. 24–28.

——. "Sechzig Jahre Münchner Künstlergenossenschaft." *Das Bayerland,* 39 (1928), pp. 291–304.

Zils, W., ed. *Geistiges und Künstlerisches München in Selbstbiographien.* Munich: M. Kellerer, 1913.

Zimmerman, Reinhard Sebastien. *Erinnerungen eines alten Malers 1815–1893.* Munich, Berlin, and Leipzig: Verlag für Praktische Kunstwissenschaft F. Schmidt, 1922.

Zunkel, Friedrich. *Der Rheinisch-Westfälische Unternehmer 1834–1879: Ein Beitrag zur Geschichte des deutschen Bürgertums im 19. Jahrhundert.* Cologne and Opladen: Westdeutscher Verlag, 1962.

"Zur Geschichte der deutschen Kunstgenossenschaft." *Kunstchronik,* 3 (1868), pp. 185–86.

Index

Academy of Arts, Berlin. *See* Royal Academy of Arts, Berlin
Academy of Fine Arts, Munich. *See* Royal Academy of the Fine Arts, Munich
The Accident (Echtler), 35 fig.15, 37
Achenbach, Oswald, 164 n.41
"Achtundvierziger" ("the Forty-Eight"), 58–59, 170 nn. 1, 2; Trübner as a member of, 171 n.20
"Allegorien und Embleme," artists' works in, 105–6
Allgemeine Deutsche Kunstgenossenschaft, 7–8, 45, 157 n.18, 183–84 n.34; 1858 exhibition of, 7–8, 156 n.17, 157 n.18; Münchener Künstlergenossenschaft local chapter of, 157 n.21
Allgemeine Zeitung, 20, 21, 29, 33, 45, 77
Allotments Near the Hague (J. Maris), 69 fig.40
Allotria, 159 n.43
Alte Pinakothek. *See* Pinakothek (Alte)
Aman-Jean, Edmond, 126, 133
American Realists in Munich, 5
Ancher, Anna, 49
Ancher, Michael, 133
"And the Lord God Planted a Garden in Eden." Genesis 2:8 (Riemerschmid), 114, 116, 116 fig.91, 162 n.7
"And the Lord God Planted a Garden in Eden." Genesis 2:8, Study for (Riemerschmid), 117 fig.92
Angélique on Her Deathbed (Schwabe), 75, 77 fig.51, 176 n.71
Antiquity, classical art of, 137, 183 n.26; Stuck interested in, 110, 112–13
Arnulf, Prince, 181–82 n.5
Art and Industry Exhibition Building (Kunst-und Industrieausstellungsgebäude), 6 fig.1
"Art Appreciation Today" (Trübner). *See* "Das Kunstverständnis von Heute"
Art sales and prices, 17, 32, 44, 68, 54–55, 139–41, 161 nn.70, 73, 75, 165 n.44, 167 n.68, 169 n.100, 184 n.36
Arts and crafts movement. *See* Modern arts and crafts movement
Artz, Adolf, 54
Auf dem Heimwege (Homeward Bound) (Zügel), 164 n.36
Ausschuss für Kunst im Handwerk (Committee for Art in Craft), 125, 180 n.47
Avenarius, Friedrich, 51–52
Azbe, Anton, Kandinsky as student of, 127

Baer, Fritz, 163 n.19
Bakst, Lev, 128
Bankel, Johann, 164, n.26, 167 n.79
Barbizon painters, 6
Bartels, Hans von, 170 n.1
Bastien-Lepage, Jules, 28, 39, 49, 157 n.28
Bauernfeind, Gustav, 167 n.79
Baur, Karl Albert, 56–57
Bavarian Center Party. *See* Center Party
Bavarian kings, role in nineteenth century Munich art community, 4–8, 10, 14, 16, 19–20, 32–33, 62. *See also* Ludwig I; Ludwig II, Luitpold; Maximilian I (1756-1825); Maximilian II
Beardsley, Aubrey, 125
Beckmann, Max, 138
Beer Garden, The, "Oude Vinck" (Liebermann), 86 fig.59
Behrens, Peter, 180 n.55; leaves Secession, 136
Benois, Alexandre, 128
Bergh, Richard, 126
Berlepsch, Hans Eduard von, 45, 106–7, 124, 136, 180 n.50
Berlin, size of art community, 15, 184 n.35
Berlin Academy. *See* Royal Academy of Arts, Berlin
Berlin Secession, controversy with Munich Secession, 137–39, 141; French Impressionists exhibited at, 138; Liebermann, as president of, 82; Post-Impressionists exhibited at, 138
Bernstein, Carl, 177 n.4
Bernstein, Felicie, 177 n.4
Besnard, Paul Albert, 28, 126, 133
Bierbaum, Otto Julius, 25, 26
Big Sister, The (Uhde), 89, 91 fig.63
Bildung, 13, 14
Birches in the Moor (Hölzel), 94 fig.67, 96, 131–32
Black Ornaments on Brown Ground (Hölzel), 95 fig.68, 96
Blanche, Jacques-Emile, 126, 133
Blaue Reiter almanac, 129, 132
Blind Woman, The (Piglhein), 108, 108 fig.82
Block, Josef, 59, 170 n.8
Blue Hour, The (Klinger), 51, 55 fig.37
Böcklin, Arnold, 26, 54, 126
Boime, Albert, 28
Bonnard, Pierre, 182 n.7
Borscht, Wilhelm von, mayor of Munich, 62–63
Braith, Anton, 166 n.57

Brandl, Franz von, 67; provides site for Munich Secession Gallery, 65, 67, 173 nn.41, 42
Brandt, Joseph, 166 n.57
Brangwyn, Frank, 133
Brauerei in Stockholm (*Brewery in Stockholm*) (Zorn), 167 n.81
Breitner, George Hendrik, 126
Breton Women at a Pardon (Dagnan-Bouveret), 25 fig.7, 26
Brücke artists, 132
Buehlmann, Joseph, 164 n.26
Buffet (Riemerschmid), 120 fig.96, 123–24
Bühlmann, Joseph, 167 n.79
Buttersack, Bernhard, 59, 170 n.10

Calm at Sea (Böcklin), 25 fig.6, 26
Carrière, Eugène, 28, 126, 133
Cassirer, Paul, 138, 185 n.44
Catholic Church in Bavaria: as art patron, 4; and the Center Party, 14, 32–35, 62; creates Puritanical climate in the 1890s, 109–10; Uhde painting outrages, 39. *See also* Center Party
Center Party, 14, 139, 184 n.37; Catholic Church and, 32–35; creates Puritanical climate in the 1890s, 109–10; and Genossenschaft petition of 1889 for increased arts funding, 32–35; and *Jesus in the Temple* (Liebermann), 33–34; and the *Lex Heinze*, 109; and the Naturalists, 33–35, 62; third Munich annual attacked by, 62, 171 n.23. *See also* Catholic Church in Bavaria
Cézanne, Paul, 133, 182 n.7
Charpentier, François, 125
Cheers (Grützner), 29, 29 fig.11
Christ and the Magdalene (Edelfelt), 46 fig.27, 49
Christian Social Workers' Party, 96
Clausen, George, 133
Conrad, Michael George, 55
Corinth, Lovis, 169 n.110, 180 n.55
Cornelius, Peter von, 156 n.14
Corot, Camille, 6
Cottet, Charles, 73–74, 126, 133, 176 n.69
Country Funeral, A (Werenskiold), 45 fig.26, 49
Courbet, Gustave, 6
Crailsheim, Krafft von, 15, 35, 64, 184 n.37
Crane, Walter, 124

Dachau, 134; painter's retreat in early nineteenth century, 94, 96, 104
Dagnan-Bouveret, P.A.J., 26
Dahl, Hans, 167 n.80
Daller, Balthasar, 33, 35
Danae (Slevogt), 158 n.35
Dantan, Edouard, 26
"Das Kunstverständnis von Heute" ("Art Appreciation Today") (Trübner), aesthetic premises of Secession outlined in, 61, 86
Das Liebeskonzil (*The Council of Love*) (Panizza), 109–10

Days of Our Years Are Threescore Years and Ten, The (Kalckreuth), 100–101, 100–101 fig.73
Dead Toreador (Manet), 49
Debschitz, Wilhelm von, 135
Decorative arts in the 1890s, 119–20, 123–25, 135–36, 180 n.50; Dill supports, 134; Uhde opposes, 136. *See also* Modern arts and crafts movement
Defense of the Sampo (Gallen-Kallela), 128 fig.103
Defregger, Franz von, 10, 29, 58, 84, 90, 171–72 n.24
Degas, Edgar, 180 n.53
Deininger, Jakob, 166 n.57
Delville, Jean, 126
Denis, Maurice, 41
Departure from Boulogne Harbor (Manet), 49, 50 fig.31, 168 n.82
Der Kunstwart, 51
Deutsche Kunst-Ausstellung (German Art Exhibition), Dresden, 1899, Riemerschmid furniture displayed at, 119-20
Deutsche Künstlerbund (German Federation of Artists), 183–84 n.34
Devotions at Home (Hölzel), 86, 87 fig.60, 96
Diaghilev, Sergei, 128
Dietz, Feodor, 8
Diez, Wilhelm, 5, 127
Difficult Path (Uhde), 37 fig.17, 39, 94, 96
Dill, Ludwig, 24, 59, 61, 66–67, 131–32, 135–36, 170 nn.9, 10, 171 n.14, 173 nn.40, 41, 174 nn.48, 51; negotiates for Secession exhibition in Berlin, 64; paints at Dachau, 94, 96; in Paris as a German juror for 1900 World's Fair, 134; supports decorative arts movement, 134
Doorway to the Room for an Art-Lover at the Paris World's Fair, 1900 (Riemerschmid), 120, 123 fig.100
Dow, Thomas Millie, 39
drei-Bilder-System, 11, 38–39, 54, 58
Dresden: Deutsche Kunst-Ausstellung 1899 with Riemerschmid furniture, 119–20; Gemäldegalerie, 116, 162 n.7; interest in Munich Secession, 63, 172 nn. 30, 31, 33; size of art community, 15
Drinking Cow (W. Maris), 70, 70 fig.41
Druids, The (Henry and Hornel), 41, 41 fig.22
DuBois, Paul Maurice, 125
Duez, Ernest Ange, 157 n.28
Dülfer, Martin, 124, 180 nn.47, 50
Dupré, Jules, 6
Düsseldorf: academy in, 5; size of art community, 15
Dutch and Flemish masters, collected by Maximilian II Emanuel, 4

Echtler, Adolf, 37, 52, 58, 166 n.57
Eckmann, Otto, 74, 120, 124, 125, 136, 180 n.55
École des Beaux-Arts, 157 n.28
Edelfelt, Albert, 49, 126
Eden colony, 122–23

Egidy, Moritz von, 98
Ein Protest deutscher Künstler (A Protest by German Artists), 140, 184–85 nn.41, 42
Endell, August, 15, 67–68, 136
Engel, J. F., 167 n.79
Ensor, James, 126, 132
Erler, Fritz, 125
Erotic art of the 1880s and 1890s, 106–10, 178 nn.21, 22
Eulenburg, Philip, 64, 173 n.39
European art, collected by the Wittelsbachs, 4–5
Evening Light: The Port of Camaret (Cottet), 73–74, 73 fig.46, 176 n.69
Exter, Julius, 180 n.55

Fabergé, Peter Carl, 125
Feilitzsch, Max von, 11
Fink, August, 166 n.57
Finnish Symbolist painting, Secession show of, 128
Firle, Walter, 166 n.57, 170 n.1
First Munich annual: 23–36; financial success of, 32, 165 n.44; foreign artists in, 24, 26, 164 nn.29, 30; jury of, 23–25, 36, 37, 164 n.26
Fischer, Theodor, 124, 180 n.47, 50
Fliegende Blätter, 49
Flight into Egypt (Uhde), 62
"Forty-Eight, The" *See* "Achtundvierziger"
Four Apostles (Dürer), 4
Francke, Ernst, 56–57, 169 n.108
Frankfurt: interest in Munich Secession, 63, 172 nn.30, 31; size of art community, 15, 184 n.35
Frederick William IV, King of Prussia, 13
Freie Vereinigung (Free Association), 127, 180 n.55
Freihofer, Alfred, 69, 77
Fröhlicher, Otto, 163 n. 19
Fruhlings Erwachen: Eine Kindertragödie (Spring Awakening: A Children's Tragedy) (Wedekind), 109

Gabriel, Paul, 126
Gallé, Emile, 124–25
Gallen-Kallela, Akseli, 128–29
Galloway Landscape (Henry), 41, 42
Game for the Fatherland (Pro Patria Ludus) (Puvis de Chavannes), 50, 53 fig.35
Garden of the Retirement Home for Men in Amsterdam (Liebermann), 83, 83 fig.56
Gartenstadtbewegung (Garden City Movement), 123
Gärtner, Friedrich von, 156 n.14
Gauguin, Paul, 108, 126, 127, 138
Gauld, David, 41
General German Art Association. *See* Allgemeine Deutsche Kunstgenossenschaft
Genossenschaft. *See* Münchener Künstlergenossenschaft
Gennossenschaft "annuals." *See* Münchener Künstlergenossenschaft, annual exhibitions

Gennossenschaft der Bildenden Künstler Wiens, 159 n.39
Germany: anti-urban sentiment in 1890s, 56, 120–23; industrialization of, 12–13; military values in, 53, 168 n.92; socio-political climate of, 12–14, 77–79; unification of, and the Munich art community, 15–16
Gervex, Henri, 126
Gesamtkunstwerk movement. *See* Modern arts and crafts movement
Gesellige Vereinigung, 159 n.43
Die Gesellschaft, 55
Glasgow Boys, 51; influence on Stuck, 107; in second Munich annual, 39, 41–42, 166 n.61
Glaspalast, 5–6, 7 fig.2, 8–9, 12 fig.3, 17, 22, 23–24, 29, 158 n.32, 161 n.75, 164 n.27
Glass Palace. *See* Glaspalast
Gleaners, The (Uhde), 89–90, 92 fig.64
Glyptothek, 4–5
Goering, Theodor, 15, 140
Gogh, Vincent van, 100, 126, 132, 138
Goosepluckers, The (Liebermann), 80 fig.54, 81, 82–83, 85
Grace (Uhde), 93–94, 93 fig.66
Grand Duchess Caroline von Sachsen-Weimar (Olde), 117, 118 fig.94
Grosse Berliner Kunst-Ausstellung 1893, 64, 173 n.40
Grützner, Eduard, 29, 84, 164 n.41, 171–72 n.24
Guardian of Paradise, The (Stuck), 30 fig.12, 31, 106–7, 110
Gumppenberg, Hanns von, 109
Guthrie, James, 39
Gysis, Nicolaus, 105, 164 n.26

Haas, J.H.L. de, 20, 54, 174–75 n.54
Habermann, Hugo von, 59, 60, 134, 161 n.69, 163 n.19, 164 n.26, 170 n.10, 171 n.12
Hackl, Gabriel, 127, 166 n.57
Hague School, The, 39, 65–66, 70, 126. *See also* Maris brothers
Haider, Karl, 103, 105 fig.78, 171–72 n.24
Halm, Peter, 167 n.79
Hamburg, Kunsthalle, 5; size of art community, 15
Haniel, E. J., 174 n.53
Hannover, size of art community, 15
Harburger, Edmund, 166 n.57
Hauptmann, Gerhard, 81
Haushamer Spring Landscape (Haider), 103, 105 fig.78
Haying (Clausen), 70, 71 fig.43
Heckel, Erich, 132
Heine, Thomas Theodor, 161 n.69, 180 n.55
Helleu, Paul, 126
Henckell, Karl, 109
Henneberg, Rudolf, 106
Henry, George, 41
Herkomer, Hubert von, 174 n.49

Herterich, Ludwig, 59, 108–9, 127, 164 n.26, 170 n.10
Herzl, Theodor, 78
Hesperides, The (Marées), 51, 54 fig.36
Hess, Anton, 166 n.57
Hierl-Deronco, Otto, 59
Hildebrand, Adolf von, 127
Hirth, Georg, 21–22, 51, 65, 124, 163 n.17, 170 n.2; *Jugend* journal of, 17, 22, 68, 114, 124, 127; moving force behind early secessionists, 59; trial of, 56–57, 169 n.108; underwrites cost of Secession gallery, 65, 173–74 n.46. *See also* Knorr und Hirth, firm of
"Hirth-Uhde'sche Hetze," 169 n.109
His Everything (Schmädel), 68 fig.39, 69–70, 100
Hocheder, Karl, 180 n.50
Hodler, Ferdinand, 108, 126, 180 n.52
Hoecker, Paul, 59, 108–9, 110, 163 n.19, 164 n.26, 170 n.10
Hoffman, Julius, 167 n.79
Hofmann, Ida, marries Riemerschmid, 119
Hofmann, Ludwig von, 117, 138
Holmberg, August, 170 n.1
Holzapfel, Michael, 164 n.26
Hölzel, Adolf, 131–32, 161 n.69; Kandinsky's non-objective art presaged by, 86, 96; paints at Dachau, 86, 94, 96, 103–4
Horse of Hades (Munthe), 75, 79 fig.53
Huber, V. A., 96
Hunt, The (Stuck), 105–6, 107 fig.80
Hunt for Good Fortune, The (*Die Jagd nach dem Glück*) (Henneberg), 106

I Lock My Door upon Myself (Khnopff), 76
Ilsted, Peter, 126
In Arcadia (Riemerschmid), 114, 114 fig.89
Innocence (Stuck), 106–7, 107 fig.81, 110
Institute for the Fine Arts in Berlin, 21, 46
Interior of Glass Palace, Seventh International Exhibition of 1897, 12 fig.3
In the Autumn Sun (Uhde), 98 fig.71, 100
In the Open (Riemerschmid), 113 fig.88, 114
Israels, Josef, 126

Jäger, Eugen, 34–35, 165 n.54
Jawlensky, Alexei von, 68
Jesus in the Temple (Liebermann), 33, 34 fig.14
J. Mayer & Co., Riemerschmid commissioned to design furniture for, 119–20
Journey to Bethlehem, The (Uhde), 94
Jugend, 17, 22, 68, 114, 124, 127
Jugendstil, derivation of term, 22, 123–24
Juste milieu painting, 28–29, 31

Kalckreuth, Count Stanislaus von, 101–2
Kalckreuth, Leopold von, 59, 100–4, 126
Kampf, Arthur, 42
Kandinsky, Wassily, 68, 138; *Blaue Reiter* alma-nac and, 129; describes Secession salons of the 1890s, 127, 180 n.56; describes Secession's 1907

salon, 133; Secession rejects work of, 133, 181 nn.58, 2; Stuck teaches, 112; studied in Munich, 127–32
Kaulbach, Fritz August von, 10, 17
Kaulbach, Hermann, 53, 168 n.93, 170 n.1
Kaulbach, Wilhelm von, 89, 156 n.14
Keller, Albert von, 108–9, 110, 170 nn.1, 10
Keller-Reutlingen, Paul Wilhelm, 59, 163 n.19, 167 n.79, 170 n.10
Kennedy, William, 39
Khnopff, Ferdinand, 75–76, 108, 126, 176 n.73
Kirchgang (Procession to the Church) (Kuehl), 164 n.36
Kirchner, Ernst Ludwig, 132
Klee, Paul, 68, 127, 131–32, 180–81 n.57, 181 n.58, 182 n.7; Secession rejects, 133, 181 n.58
Klenze, Hippolyte von, 170 n.1
Klenze, Leo von, 4
Klimt, Gustav, 105; Stuck's poster adopted by, 110
Klinger, Max, 51, 105, 108
Knaus, Ludwig, 53, 84
Knirr, Heinrich, teaches Klee, 127
Knorr, Thomas, 17, 161 n.69; underwrites cost of Secession gallery, 65, 173–74 n.46
Knorr und Hirth, firm of, 22, 162–63 n.16
Knucklebones (Steer), 75, 176 n.73
Kollwitz, Käthe, 138
König, Hugo, 59, 163 n.19, 167 n.79
Kowalski-Wierusz, Alfred von, 164 n.26, 170 n.1
Kramer, Joseph von, 164 n.26, 167 n.79
Kroyer, Peder Severin, 73–74, 133, 176 n.70
Kuehl, Gotthard, 24, 25–26, 59, 60, 100, 126, 170 n.10, 171 n.12
Kunst für Alle, 20, 138, 183 n.28
Künstlergenossenschaft. *See* Münchener Künstlergenossenschaft
Kunst- und Industrieausstellungsgebäude, 5, 6 fig.1, 7, 17, 161 n.75; exhibitions of Munich Academy in, 156 n.15; exhibitions of Genossen-schaft in, 8, 157 n.25; Munich Secession's per-manent gallery space in, 67, 133, 175 n.57, 181–82 n.5, 182 n.6
Kunstverein, 165 n.45

Ladies' Club, The. See *Monkeys as Critics*
Lagarde, Paul, 78–79, 177 n.78
Lalique, Renée, 125
Landesausstellungspalast in Berlin, 6, 17, 156 n.11, 161 n.75
Landmann, Robert von, 139
Landscape Near Cloister Seeon, with Telegraph Pole (Trübner), 70, 71 fig.44
Landsknechtskittel, 29
Lang, Otto, 164 n.26, 167 n.79
Langbehn, Julius, 56, 78–79, 85, 122, 177 n.79
Langer, Johann Peter, 7, 156 n.14
Langhammer, Arthur, 59, 108, 163 n.19, 170 n.10
Large Brewery, The (Zorn), 47 fig.28, 49, 167–68 n.81

Larsson, Carl, 133
Laube, Heinrich, 4
Laverenz, G., 163 n.19
Lavery, John, 15, 39, 42, 133, 160 n.63
Lederhosen painting, genre of, 29, 31, 70, 100, 164–65 n.41
Lehr- und Versuch-Ateliers für Angewandte und Freie Kunst (Teaching and Experimental Studios for Applied and Fine Art), 135
Leibl, Wilhelm, 6, 60
Leibl-Kreis, 60
Leistikow, Walter, 103, 131–32, 138
Lemmen, Georges, 124
Lenbach, Franz von, 11, 17, 58, 71, 73, 82, 176 n.68; criticized as retrogressive, 134, 137; Secession's retrospective exhibition of, 133, 182 n.6
Lerchenfeld-Köfering, Hugo, 173 n.39
Le Rêve (The Dream) (Zola), 176 n.71
Levitan, Isaak, 128
Lex Heinze law, 109
Lhermitte, Léon, 126
Liberalism, German, 13–14; decline of, 77–79; influence on the Genossenschaft program, 14
Lichtwark, Alfred, 5, 53, 161 n.75, 175 n.66
Liebermann, Louis, 81
Liebermann, Max, 33, 39, 42, 65–66, 70, 71, 81–89, 125–26, 137–38, 161 n.69, 175 n.66, 183 n.25; "apostle of ugliness," 84; changing style of, 82–86; early life of, 81–82; French Impressionists' influence on, 85, 177 n.4; *Jesus in the Temple* controversy in Parliament, 33–34; Kalckreuth meets, 102; non political, 85–86; technical shift in style of, 85; Uhde's aesthetic compared to, 89–90, 100; Uhde's *plein air* painting encouraged by, 89
Liljefors, Bruno, 126
Lindenschmit, Wilhelm, 5, 20, 163 n.19; Stuck replaces at Munich Academy, 113; teaches Stuck, 105
Littauer Gallery, 135
Löfftz, Ludwig, teaches Stuck, 105
"Lokalausstellungen," 157 n.25
Love in the Village (Bastien-Lepage), 49, 49 fig.30
Lucifer (Stuck), 38 fig.19, 39
Ludwig I, King of Bavaria, 7, 16, 156 n.15; impact of on Munich's artistic culture, 4–5, 155 n.6; "Schönheitsgalerie" of, 165 n.45
Ludwig II, King of Bavaria, 8, 32–33, 109, 121; castles of, 16; impact on Munich's art market, 16
Ludwig-Maximilians University, 4
Ludwigskirche, 4
Ludwig von Hessen, Grand Duke, 181–82 n.5
Lueger, Karl, 78
Luitpold, Prince Regent of Bavaria, 8, 32–33, 64, 66, 67, 121, 137, 139, 165–66 n.56, 172 n.25, 174 nn. 49, 53, 174–75 n.54, 175 nn.55, 56, 179 n.26; as a patron of the arts, 16, 175 n.56, 181–82 n.5; relationship to Paulus, 19–20, 162 n.6

Lutheran Church in Saxony, 96, 98
Lutz, Johann von, 9, 32, 33, 165 n.49
Lützow, Carl von, 68
Lying-in-State of Kaiser Wilhelm I in the Berlin Cathedral, The (Kampf), 42, 44 fig.25

Macdonald sisters, The, 125
Macgregor, W. Y., 39
Mackintosh, Charles Rennie, 125
Maffei, Guido von, 59, 167 n.79
Maid in the Kitchen, The (Ancher), 48 fig.29, 49
Maison, Rudolf, 164 n.26, 166 n.57
Manet, Edouard, 49
Mann, Thomas, 1, 15
Marc, Franz, 68, 127, 129–132; *Blaue Reiter* almanac and, 129
Marc, Wilhelm, 167 n.79
Marées, Hans von, 50–51
Maris brothers, 126; Jacob, 69, 70, Willem, 70
Marr, Karl, 58, 166 n.57
Martin, Henry, 126
Max, Gabriel, 31–32, 110, 165 n.43
Maximilian I (1573–1651), 4
Maximilian I (1756–1825), King of Bavaria, 4–5
Maximilian II, King of Bavaria, 8, 16
Maximilian II Emanuel, 4
Maximilian IV Joseph. *See* Maximilian I, King of Bavaria
Mayor Carl Friedrich Petersen (Liebermann), 71, 72 fig.45, 85, 175 nn.66, 67
Mayr, Franz, 125
Meisel, Ernst, 164 n.26
Mellery, Xavier, 126
Menpes, Mortimer, 54
Mesdag, Hendrik Willem, 126
Meyer, Klaus, 166 n.57
Minne, George, 182 n.7
Mir Iskusstva (World of Art), 128, 137, 180 n.56
Modern arts and crafts movement, 123–25, 129, 134–36, 141; Genossenschaft support of, 125, 180 n.50; Secession's initial support of, 124–25; Secession's later rejection of, 135–36. *See also* Jugendstil
Monet, Claude, 49, 140, 168 n.83, 180 n.53
Monkeys as Critics (Max), 31–32, 31 fig.13
Moonlit Night at the Dam Near Besigheim (Schönleber), 42, 43 fig.24
Morris, William, 124
Mother Utne (Peterssen), 70, 70 fig.42
Müller, August Ludwig von, 62–64, 67, 139, 171–72 n.24, 172 n.25, 173 nn.36, 38, 41, 174 n.53
Müller, Peter Paul, 164 n.26
Munch, Edvard, 50, 126, 132, 138, 180 n.51
Münchener Künstlergenossenschaft: annual exhibitions of, 19–57; exhibition of 1893, compared to 1893 Secession exhibition, 75–77; origins, organization and policies of, 6–14; rupture of, 58–60. *See also* First, Second, and Third Munich annuals

Münchener Neueste Nachrichten, 13, 17, 21, 24–25, 43, 51, 56, 160 n.57. *See also Neueste Nachrichten*

Munich Academy. *See* Royal Academy of the Fine Arts, Munich

Munich Artists' Association. *See* Münchener Künstlergenossenschaft

Munich Genossenschaft. *See* Münchener Künstler-genossenschaft

Munich Secession: aesthetic trends in exhibitions of, 125–27; applied arts movement, initial commitment to, 124–25, applied arts movement, later rejection of, 135–36; Berlin hosts first exhibition of, 64, 173 nn.39, 40; builds own gallery, 65, 67, 173 nn.41, 42, 43, 45, 46; controversy with Berlin Secession, 137–39, 141; first exhibition in Berlin in 1893, 64, 173 nn.39, 40; founding of, 58–79; Genossenschaft, and joint exhibition of, 124; historical exhibitions of 1899, 1900 and 1901, 133, 181 nn.4, 5, 182 n.7; Kunst- und Industrieausstellungsgebäude provides permanent gallery space for, 67, 175 n.57; Lenbach exhibition of, 133, 182 n.6; move to Frankfurt or Dresden considered, 63, 172 nn.30, 31, 33; Russian and Finnish painting exhibition of, 128–29; title formally adopted by, 60, 171 n.13

Munich Secession, first Munich exhibition of, 67–79; elitism of, 77–79; Genossenschaft exhibition compared to, 75–77, 79, 176 n.74, 177 n.80; installation of, 68–69; Naturalism in, 69–71; preparations for, 64–67; progessive focus of, 67–77; size of, 69; Symbolism in, 73–75

Munich Secession, in the 1890s, 80–132; Jugendstil designers in, 123–25; Kalckreuth in, 100–104; Liebermann in, 81–89; lyric tradition of, 80–81, 125–32; Riemerschmid in, 113–25; Stuck in, 104–13; Uhde in, 81–89

Munich Secession's demise after 1900, causes of, 133–41; art market declines, 139–41; conservative political climate, 139–40; cultural chauvinism, 137–39; Uhde's impact on, 134–38

Munich Secession Gallery, photograph of 1893, 66 fig.38

Munich Society of Visual Artists. *See* Verein Bildender Künstler Münchens

Munkácsy, Michael, Uhde as student of, 53, 89

Munsch, Joseph, 167 n.79

Munthe, Gerhard, 75, 126

Music Room at the Deutsche Kunst-Ausstellung, Dresden (Riemerschmid), 119–20, 122 figs.98, 99

Muther, Richard, 41

Nationalgalerie, in Berlin, 5

National Social Association, 96, 122

Naturalism: Center Party and, 33–35, 62; in first Munich annual, 25–31; Liebermann as exponent of, 81–89; in Munich Secession in the 1890s, 81–100, 125–26; in Secession's first Munich exhibition, 69–71; in second Munich annual, 39, 41; in third Munich annual, 47–50; socialism linked with, 62; Uhde as exponent of, 89–100. *See also* Realism

Naumann, Friederich, 96, 122

Near the Veranda Door (Uhde), 97 fig.70, 100

Neo-Romantic agrarianism, 122–23

Neo-Romantic artists, at the Secession, 73–74, 103–4, 123, 131–32

The Netmenders (Liebermann), 38 fig.18, 39

Neue Pinakothek, 5, 67, 155 n.5, 158 n.33, 160 n.63; purchasing grants for collection of, 32, 36, 165 nn.46, 56; *Woman with Goats in the Dunes* (Liebermann) purchased for, 84

Neueste Nachrichten, 59, 60, 63, 67, 136, 170 n.2, 174 n.49. *See also Münchener Neueste Nachrichten*

Neupert-Watty, Anna, 162 n.5

New Generation, The (Toorop), 76, 176 n.73

Night in St. Cloud (Munch), 50

Nocq, Henry, 125

Nolde, Emil, 138

Obrist, Hermann, 120, 124, 125, 180 n.47; attacks Secession's conservatism, 136; on decorative arts, 123, 179–80 n.45; Secession rebuffs, 135–36

Olde, Hans, 117, 119, 180 n.55

On Sunday Afternoon (Kalckreuth), 102, 103 fig.75

Ostini, Fritz von, 17, 43

Otto, W., Riemerschmid commissioned to design furniture for, 119

Otto I, 16

Outlet of Boulogne Harbor, The. See *Departure from Boulogne Harbor*

Pallas Athena (Klimt), 110, 179 n.29

Panizza, Oscar, 109–10

Pankok, Bernhard, 120, 124, 125, 136, 161 n.69

Papperitz, Georg, 166 n.57

Park, Stuart, 41

Parlor at the 1899 Secession Salon (Erler), 125, 125 fig.102

Parrot Way (Liebermann), 85, 85 fig.58

Particularism in Bavaria, and competition with Prussia for cultural hegemony of Germany, 15, 21, 35, 45–47, 62–63, 67, 137–39, 165–66 n.56, 167 n.76, 182 n.20, 182–83 n.21

Paterson, James, 39

Paul, Bruno, 120, 125, 136

Paulus, Adolf, 19–20, 66–67, 162 nn.3, 4, 5, 6, 7, 8, 173 n. 40, 174 nn.48, 49, 174–75 n.54, 175 n.56; Glasgow boys discovered by, 166 n.61; leaves Genossenschaft, 59, 60, 61, 170 nn.3, 4, 7, 9, 171 nn.12, 13, 14; negotiates for Secession exhibition in Berlin, 64

Paulus, Adolf Karl, 162 n.4

Paulus, Heinrich Eberhard Gottlob, 162 n.4

Paysage intime, 51
Peasant Girls from Dachau (Langhammer), 108, 109 fig.83
Pechstein, Max, 132
Pecht, Friedrich, 20–21, 25, 43, 49, 68, 77, 169 n.110, 176 n.76, 177 n.79
"Permanentausstellungen," 157 n.25
Peterssen, Eilif, 50, 70, 126
Pfann, Paul, designs Munich Secession's gallery, 65, 173 n.45
Piglhein, Bruno, 24, 59, 60, 108, 163 n.19, 170 nn.4, 10, 172 n.25, 173 n.39, 174 n.47; as Munich Secession president, 66, 108, 134, 170 n.10, 171 n.12, 172 n.25, 174 n.47; negotiates for Secession exhibition in Berlin, 64
Piloty, Karl Theodor von, 5
Pinakothek (Alte), 4–5, 134, 158 n.33
Piper Verlag, publishes *Blaue Reiter* almanac, 129
Pissarro, Camille, 140, 180 n.53
Playroom, The (Uhde), 26–28, 27 fig.9, 89
Plein air painters: Glasgow boys as, 39, 41, Kalckreuth as, 102; Uhde as, 26, 38, 89, 96, 100; Weishaupt as, 24, 113, 163 n.19; Zügel as, 25–26, 100, 170 n.10
Plein air painting, 26, 27, 35, 75
Podewils, Clemens von, 184 n.37
Poetzelberger, Robert, 59, 163 n.19, 167 n.79, 170 n.10
Poplar Forest (Dill), 96 fig.69, 131–32
Porträt meiner Frau (Portrait of My Wife) (Kroyer), 176 n.70
Poster for the First Secession Salon of 1893 (Stuck), 110, 111 fig.84
Poster for the Seventh International Exhibition of 1897 (Stuck), 110, 112 fig.85
Potato Harvest, The (Liebermann), 90, 92 fig.65
Pottery Workshop (Dantan), 26, 26 fig.8
Prince Regent Luitpold of Bavaria (Trübner), 86, 88 fig.61, 89
Prodigal Son in Modern Life, The (Tissot), 168 n.83
Puvis de Chavannes, Pierre, 50

Raczynski, Athanasius, 5
Rainbow, The (Kalckreuth), 102, 104 fig.76
Ranson, Paul-Élie, 41
Rape of the Daughters of Leucippus (Rubens), 4
Rau, Emil, 167 n.79
Raube, Wilhelm, 164 n.26
Realism, and the *Leibl-Kreis,* 60. *See also* Naturalism
Recess at the Amsterdam Orphanage (Liebermann), 82 fig.55, 83
Reid, John, 54
Rembrandt als Erzieher (Rembrandt as Educator) (Langbehn), 56, 78, 85, 122, 177 n.79
Renan, Ary, 126
Riding Amazon (Stuck), 113, 113 fig.87
Riedel, Emil von, 165 n.49

Riemerschmid, Richard, 17, 113–25, 126, 129, 136, 161 n.69, 162 n.7, 170 n.7, 180 n.47; abandons painting for decorative arts and architecture, 120; designs the community of Hellerau, 120; designs furniture, 119–20, 123–24; early life of, 113; joins National Social Association, 122; marries Ida Hofmann, 119; in Munich Secession in the 1890s, 113–25; Naturalism rejected by, 113–14, 116; Nature deified by, 114, 116
Roche, Alexander, 39
Rohr, Wilhelm, 164 n.26, 166 n.57
Rolfs, Friedrich Wilhelm, 180 n.47
Roll, Alfred Philippe, 28, 157 n.28
Romeis, Leonhard, 164 n.26, 166 n.57
Rops, Felicien, 125
Rose + Croix exhibition, 75
Rosenhagen, Hans, 134, 137–38, 182 n.20
Röth, Philipp, 51, 167 n.79
Rousseau, Theadore, 6
Roussel, Ker-Xavier, 182 n.7
Royal Academy of Arts, Berlin, 9–10, 45–46, 156 n.11, 161 n.75
Royal Academy of the Fine Arts, Munich, 5, 6–8, 9; Stuck as a student of, 105; Stuck as a teacher at, 113
Rümann, Wilhelm, 166 n.57
Russian Symbolist painting, Secession show of, 128

St. Agnes (Gauld), 40 fig.21, 41
St. Louis World Exposition, German participation in, 138, 183 n.34
Salon des Refusés, in Munich in 1888, 11, 159 n.45; in Paris in 1863, 11
Samlinger, Rasmus Meyers, 50
"Sammlung von Bildern aus Hamburg," 175 n.66
Scandinavian Neo-Romantic mood painters, in third Munich annual, 50
Scheffler, Karl, 81
Schelling, Friedrich, 156 n.12
Schels, August, 162 n.12
Schlachtensee (Leistikow), 103, 106 fig.79, 131–32
Schleich, Robert, 166 n.57
Schlittgen, Hermann, 127
Schmädel, Max von, 69, 100
Schmidt, Heinrich von, 167 n.79
Schmidt, Matthius, 164 n.26
Schönerer, Georg von, 78
"Schönheitengalerie," of Ludwig I, 165 n.45
Schönlin, Julie von, 162 n.4
Schuch, Carl, 6
Schultheiss, Albrecht, 166 n.57
Schwabe, Carlos, 75
Schwabenmeyer, Gustave, 20
Screen with Aare River Landscape Scenes (Klee), 130–31 fig.106
Secession. *See* Munich Secession
Secession Gallery, photograph of 1893, 66 fig.38

Second Munich annual, 36–45; awards of, 43–44, 166 n.67; Echtler as jury chairman of, 37–38, 52, 58; foreign artists in, 39, 41–42, 43–44, 166 nn.65, 67, 167 nn.68, 69, 70; Glasgow boys in, 39, 41–42, 166 n.61; jury of, 36–39, 42–43, 44, 166 nn.57, 58, 59
Segantini, Giovanni, 126
Seidl, Emanuel, 164 n.26, 180 n.50
Seidl, Gabriel, 170 n.1
Seitz, Otto, 170 n.1
Sermon on the Mount (Uhde), 165 n.54
Serov, Valentin, 128
Seurat, Georges, 126
Shepherdess at the Fence (Zügel), 23 fig.4, 25
Sickert, Walter, 133
Signac, Paul, 125
Simplicissimus, 68, 127
Sinding, Otto, 167 n.80
Singer, The (Uhde), 89, 90 fig.62
Sin (Stuck), 74, 75 fig.49, 107–8, 174 n.53
Sisley, Alfred, 49, 140, 168 n.83, 180 n.53
Skredsvig, Christian, 133
Sleigh Ride (Olde), 117, 119, 119 fig.95
Slevogt, Max, 138, 158 n.35, 161 n.69, 180 n.55
Smith, Karl Frithjof, 166 n.57
Social Democratic Party, 98
Société des Artistes Français, 9, 157 n.28
Sodom und Gomorrha oder Der Untergang des guten Geschmacks in Kunst, Literatur und Presse, 168 n.89, 169 n.109
Somov, Konstantin, 128
Spirit of the Times, The, or: The Thief in the Studio, Part I, 51 fig.32
Spirit of the Times, The, or: The Thief in the Studio, Part II, 51 fig.33
Spring Dance (Hofmann), 117, 117 fig.93
Spring (Eckmann), 74, 75 fig.48, 117
Stäbli, Adolf, 167 n.79
"Ständige Ausstellungen," 157 n.25
Status of artists in Munich, 15–16
Steer, P. Wilson, 75
Steinlen, Theophile Alexandre, 125
Stieler, Eugen von, president of Genossenchaft, 32, 35, 56–57, 59, 162 n.3, 165 nn.45, 46, 49
Stieler, Josef Karl, 165 n.45
Stoecker, Adolf, 96, 98
Stonebreakers (Courbet), 6
Storm Clouds (Kalckreuth), 102–3, 105 fig.77
Strathmann, Carl, 74–75, 161 n.69, 180 n.55
Stuck, Franz von, 17, 31, 39, 47, 51, 59, 104–13, 125–26, 127, 136, 161 n.69, 167 n.79, 170 n.10, 182 n.18; begins to make sculpture, 113; decorative arts of, 104–5, 113; dislike of the Vereinigte Werkstätten, 136, 182 n.18; early life of, 104–5; erotic art of, 106–10, 113, 178 nn.21, 22; *femme fatale* image of, 106; Glasgow Boys' influence on, 107; interest in Antiquity, 110, 112–13; Kandinsky as a pupil of, 112, 127; Klee as a pupil of, 127; as Munich Academy student, 105; as Munich Academy teacher, 113; in Munich Secession in the 1890s, 104–13
Studio Elvira, 68
Study at the 1899 Secession Salon (van de Velde, Henry), 124 fig.101
Study for Composition II (Kandinsky), 129 fig.104, 130
Stühlmuller, Karl, 166 n.57
Suffer Little Children to Come unto Me (Uhde), 26–28, 28 fig.10, 93, 100
Suitors, The (Munthe), 75, 78 fig.52
Summer (Kalckreuth), 102, 102 fig.74
Summer Evening on the South Beach at Skagen (Kroyer), 74 fig.47
Summer Night (Peterssen), 50, 52 fig.34
Summer Night: Inger at the Seashore (Munch), 50
Sunday Afternoon in Holland (Kuehl), 99 fig.72
"Swinemünde Telegram" affair, 184, n.37
Symbolism: in first Munich annual, 31; Kalckreuth as exponent of, 100–104; in Munich Secession in the 1890s, 100–25, 126; Riemerschmid as exponent of, 113–25; in Secession's first Munich exhibition, 73–75; in second Munich annual, 41–42; Stuck as exponent of, 104–13; in third Munich annual, 50–51

Tennis Party, The (Lavery), 39 fig.20, 41, 160 n.63
Thief in the Studio, The. *See* Spirit of the Times, The
Thiersch, Friedrich von, 166 n.57, 180 n.50
Third Munich annual, 45–57, 58; Bavarian Center Party attacks, 62, 171 n.23, 171–72 n.24; financial deficit of, 54, 55, 56, 167 n.70, 169 n.99; foreign artists in, 47, 54–57, 58, 61, 62, 168 n.97, 169 n.99, 102; Impressionism in, 47, 49, 50; jury of, 47, 49, 51, 52, 54, 167 n.79; Naturalism in, 51; poor sales of Munich art at, 54–55, 58, 169 n.100; Realist orientation of, 47, 49–50, 51; Symbolists in, 50–51; Uhde as chairman of jury of, 52, 53, 58; Verein Berliner Künstler and, 45–47, 49, 54, 55, 167 n.76
Tiffany Glass and Decorating Company, 124–25
Tissot, James Joseph Jacques, 49, 168 n.83
Title page to Die Jugend. 19 June 1897 (Riemerschmid), 114, 115 fig.90, 116, 131
Toorop, Jan, 76, 108, 126, 176 n.73
Toulouse-Lautrec, Henri de, 126, 132, 138
Trip to Bethlehem, The. See Difficult Path
Trübner, Wilhelm, 47, 60–61, 70–71, 86, 140, 167 n.79, 170 n.1, 175 n.65, 180 n.55; outlines aesthetic premises of Munich Secession in "Das Kunstverständnis von Heute," 60–61, 171 n.20; as an "Achtundvierziger" member, 171 n.20
Tschudi, Hugo von, 5, 185 n.44

Uhde, Bernhard von, 89, 93
Uhde, Fritz von, 38, 39, 42, 47, 52, 53–54, 57, 59, 62, 127, 161 n.69, 163 n.19, 167 n.79, 168

nn.92, 93, 94, 169 n.109, 170 n.10; Defregger's renderings compared to, 90; early life of, 89; Liebermann's renderings compared to, 89–90, 100; military career of, 52–53, 89, 177 n.8; Munich Secession affected by, 133–39; in Munich Secession in the 1890s, 89–100; paints "from nature," 89, 178 n.10; personality of, 52–54, 134–39; *plein air* paintings of, 26, 38, 39, 96, 100; political statement in paintings of, 89–90, 96, 98; religious imagery of, 90, 93–94, 96, 98, 100, 101; as Secession president, 134–39; social realism of, 89–90; as third Munich annual jury chairman, 52, 53, 58; training of, 52–53, 89, 177 nn.8, 9

Ule, Carl, 124

Ungerer, Jakob, 167 n.79

Vallgren, V., 125

Vallotton, Felix, 182 n.7

Velde, Henry van de, 76, 176 n.73; exhibits his furniture at Secession, 125

Velten, Wilhelm, 167 n.79

Verein Berliner Künstler, 9–10, 14, 21, 45–47, 55, 137, 138, 156 n.11, 157 n.21, 180 n.51

Verein Bildender Künstler Munchens (Munich Society of Visual Artists). *See* Munich Secession

Vereinigte Werkstätten für Kunst im Handwerk (United Workshops for Art in Craft), 125, 133, 134–36, 180 n.50, 183–84 n.34

Veth, Jan, 66

Victor (Strathmann), 76 fig.50

Vienna Secession, 134; Kalckreuth retrospective at, 103

View of the St. Jacobikirche in Hamburg (Kuehl), 24 fig.5, 26, 164 n.36

Vingt, Les (*Les XX*), 159 n.47

Vinnen, Carl, 140, 184–85 nn.41, 42

Voellmy, Fritz, 59

Voit, August, 5

Vrubel, Mikhail, 128

Vuillard, Edouard, 125, 182 n.7

Wagener, J.H.W., collection of contemporary art of, 5, 155 n.6

Wagenmann, Adolf, 167 n.79

Wagner, Richard, 16

Walton, E. A., 39

Wandervögel, 123

Watty, Richard, 162 n.5

Wedekind, Frank, 109

Weimar Academy: Kalckreuth at, 102; Liebermann at, 81

Weiser, Joseph, 166 n.57

Weishaupt, Victor, 59, *plein air* painter, 24, 113, 163 n.19; Riemerschmid's uncle, 113, 170 n.7

Weissenbruch, Johannes, 126

Welti, Albert, 126

Wenglein, Josef, 51, 170 n.1

Werenskiold, Erik, 49

Werner, Anton von, 21, 46, 47, 167 n.80

Whiplash (Obrist), 135, 135 fig.107

Whistler, James Abbott McNeill, 11

White Bull (Marc), 129 fig.105, 130–31

Wichern, Johann H., 96

William I, Emperor of Germany, 15, 42

William II, Emperor of Germany, 64, 137, 183 n.26, 183–84 n.34

Willroider, Ludwig, 51, 58, 164 n.26, 166 n.57

Wittelsbachs. *See* Ludwig I, Ludwig II, Luitpold, Maximilian I (1573–1651), Maximilian I (1756–1825), Maximilian II, Maximilian II Emanuel

Wolfe, Thomas, 4

Wolfers, Philippe, 125

Woman at the Window (van de Velde), 76, 176 n.73

Woman by the Fireplace (Echtler), 36 fig.16, 37

Woman with a Parrot (Courbet), 6

Woman with Goats in the Dunes (Liebermann), 84–85, 84 fig.57; purchased for Neue Pinakothek, 84

Wopfner, Joseph, 170 n.1

Worpsweder School, 140

Zeitschrift für bildende Kunst, 68

Zentralstelle für Münchens Kunst und Kunstindustrie (Central Office for Munich's Art and Art Industry), 140

Zola, Emile, 75, 176 n.71

Zorn, Anders, 49, 126, 133, 167 n.81

Zügel, Heinrich von, 59; a *plein air* painter, 25–26, 100, 170 n.10

Zumbusch, Ludwig, 163 n.19